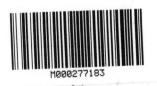

The Venice Secret

ANITA CHAPMAN

NEETS PRESS

The Venice Secret

By Anita Chapman

978-1-7391745-0-7 Paperback

978-1-7391745-1-4 e-book

Published by Neets Press

Stock image copyright Shutterstock.com

Praise for The Venice Secret

'A beautifully-crafted story of love, loyalty and self-discovery, drawing together past and present in an irresistible romantic mystery.' **Nicola Cornick**

'Past and present intertwine in this fabulously intriguing mix of history, mystery and romance.' **Celia Rees**

'An intriguing tale of secrets and love.' **Liz Fenwick**

'A fascinating dual time debut with enchanting descriptions of a vibrant eighteenth century Venice. Beautifully researched and interspersed with an engaging present day mystery, this was a charming read.' **Jenni Keer**

'A well-researched and beautifully told dual timeline story which takes the reader from present day England to 18th century Venice. Combining intrigue, romance and mystery I was hooked from the very first page!' **Clare Marchant**

'*The Venice Secret* is a thoroughly engaging dual time story set partly in the 18th century and partly in the present. Full of romance, secrets and intrigue, it takes the reader on an exhilarating journey to solve a historical mystery – and what a journey it is! Following the chance discovery by the heroine in the present of a painting that could possibly be by the famous artist Canaletto, she sets out to prove its provenance. Along the way, she also finds herself and new purpose to her life.

Meanwhile, the heroine in the past has to navigate a difficult path between what is right and what her heart tells her to do. We follow both of them via sumptuous country mansions in the UK, across Europe and to the stunning city of Venice, the sights and sounds beautifully described by the author. I felt as though I was there, walking down those narrow alleys, visiting the famous piazzas and travelling along the canals. And as someone who loves programmes like Fake or Fortune, this book was right up my street!' **Christina Courtenay**

'Meticulously researched and a brilliant, intriguing plot that had me turning the pages as fast as I could.' **Jules Wake aka Julie Caplin**

'Anita Chapman takes us on a mystery journey, linked by a painting. A strongly contrasted story with a rich mix of Grand Tours, country houses and genteel eighteenth-century behaviour, threaded with a modern-day heroine and her chaotic lifestyle. Travel from your sofa with this intriguing romance.' **Angela Petch**

'Anita Chapman sweeps the reader backward and forward in time in this well-researched story. Each character plays her or his part in bringing the dual timelines together beautifully. I recommend you read it!' **Sue Moorcroft**

'A delightful dual timeline debut. Impeccably researched and perfectly plotted with sumptuous descriptions, fascinating characters, plenty of romance and a captivating mystery. It's got everything I love in a story.' **Donna Ashcroft**

Real Location of the Canalettos referred to in *The Venice Secret*

(Images used with permission)

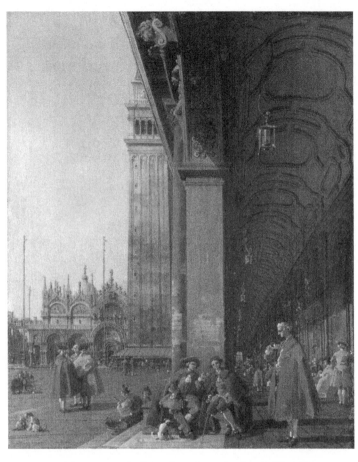

Piazza San Marco: looking East from the South-West Corner.
Oil on canvas. c. 1760. © The National Gallery, London.

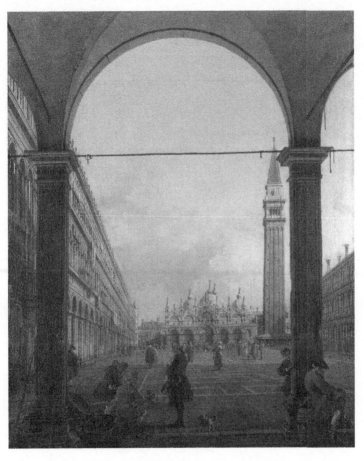

Piazza San Marco: looking East from the North-West Corner.
Oil on canvas. c. 1760. © The National Gallery, London.

Piazza San Marco: looking East from the South-West Corner.
Pen and ink with washes. c. 1760. The Royal Collection, London.
Royal Collection Trust / © His Majesty King Charles III 2023

The author, Anita Chapman, age seven on first visit to Venice in
the scene from the painting found in the loft in this novel.

To my mother, who used to take me to see the Canalettos at The National Gallery.

Chapter One
April 2019

Shining my torch around Gran's loft, I took care not to brush my hand against the pink clumps of fibreglass resembling candyfloss. It could make your skin itch for days, and I'd found this out the hard way when visiting Gran as a child. Having carried the last of my boxes up the ladder, I was ready to explore. This loft was filled with memories and ripping masking tape off the nearest box, I lifted the flaps, curious to see what Gran had left behind. Inside lay green wallets, stacked neatly, and I pulled faded photos from one of them with dates and locations written on the back. *Sarah in Bournemouth, August 1975.* Mum in a pinafore and buckled brown shoes on a beach, blonde curls blowing away from her face as she crouched over a bucket, wielding a spade. Wanting to study the photos further, I was about to carry the box into the house when the familiar jingle-jangle of a tiny bell interrupted my plan.

The sound passed me and became more distant, and pointing the torch in its direction, I spotted the next-door neighbour's cat, Saffy. She'd often sneak in through the open kitchen window, a hangover from when Gran used to feed her tins of sardines when looking for company. Saffy tiptoed slowly along the beams, one

1

paw perfectly placed in front of the other, venturing into what Gran had called a no-go area because it wasn't boarded. When helping get Christmas decorations down as a child, I'd made up silly stories in my head about the corner being a magical place where you could enter another world like Narnia.

There was no way I could leave Saffy in the loft and, pursuing her along the beams, I endeavoured to be careful, placing one Conversed foot in front of the other. Saffy had long since disappeared, but the bell betrayed her presence, and I followed its sound. Shining the torch around, there she was, rubbing her ear against an object and purring. Moving closer, I saw she'd found a wooden trunk, resting on a couple of planks placed across two beams. She proceeded to sharpen each of her claws on the trunk without a care in the world. Somehow, I needed to pick up the cat with her likely to resist while holding the torch and balancing on the beams. But this trunk intrigued me. Why was it placed so far away from everything else? Lifting the lid, I saw it was filled with a pile of old clothes smelling as musty as the cast-offs in a charity shop. Stifling a cough, I swiftly closed it. Gran's house had been built in the 1700s and passed down generations, so the loft had never been properly cleared out. The trunk was beautifully made from what appeared to be oak, and after a polish it would make a nice coffee table, but I'd need help moving it. Saffy disappeared behind the trunk, and when I pulled it forwards in order to grab hold of her, something fell against the back of it with a soft thud. She scurried past me and I turned to see her tiptoeing her way back along the beams towards the hatch. My torch revealed a rectangular object, wrapped in brown paper and string. Now this discovery, clearly hidden intentionally outranked the photos and the trunk, and I couldn't wait to see what was inside. The object wasn't too heavy, and I clutched it

2

to my side under an arm while balancing my way back along the beams and carried it through the hatch and down the ladder to the kitchen to find a pair of scissors. The trunk and Gran's photos could wait.

Cutting the string, I unwrapped the brown paper on the kitchen table to reveal a gold-framed painting of a cathedral and a tower with cloisters running down the right-hand side. In the foreground, two men wearing hats and cloaks were sitting and talking. Nearby, a man in a cloak and wig stood holding a cup and saucer. The setting looked familiar, but I couldn't place it. Mum had dragged me around enough art galleries over the years, and there was no doubt this painting was old and created by an artist with real talent. But there was no signature. Saffy appeared at my feet, meowing, and brushing her head against my calf.

'Yes, you deserve a reward, Saffy,' I said, opening the fridge. After filling a saucer with milk and putting it on the floor, I turned the frame over to look at the other side. An envelope dropped onto the table, made out to a Mrs Philippa Giles. On the back was a broken red-wax seal with a coat of arms embedded, and I ran my finger over its rough surface before lifting the flap and pulling out a sheet of paper, folded into four parts. A note.

1st April 1782
Dear Philippa,
I hereby declare that this Canaletto, your favourite of the pair, now belongs to you, a symbol of my gratitude.
Yours, R

The handwriting was cursive, of a bygone era with the 's' in the word 'symbol' looking like an 'f'. I'd seen this before when looking at old historical sources as part of my degree. There had

to be a story behind this note. Why would I, Rachel Brown be in possession of a real Canaletto? The paintings I'd seen at The National Gallery were huge, not small enough to tuck under my arm and carry through a loft hatch. It couldn't be real, could it? And how would I find out if it was?

Chapter Two
February 1780

'What do you think he will say, Mama?' I said.

Mama gathered the skirts of her black crêpe dress and raised her chin. Of course she was worthy of taking afternoon tea at Chipford Hall. Usually, when paying a visit to the duke, Mama, a woman who had always taken an interest in fashion, would be attired in a dress like the blue one tucked away in her closet, made from silk and gifted to her by a friend who had visited Paris. But if she were not mourning Papa, whose debts threatened us with destitution, she would not be paying the duke a visit in the first place.

'Let us pray he can save us, my dear Philippa.'

She kissed me on the cheek and forced a smile, her skin paler than usual in contrast with her black bonnet. The groom took her hand, and helped her into Doctor Braithwaite's chaise as ours had been sold shortly after Papa's passing. Doctor and Mrs Braithwaite had certainly demonstrated how friends could be there in times of need.

I returned to the kitchen and watched Mama through the window as she left, her face without expression, her chin still raised, shoulders pushed back. Recent months had been

challenging and Mama was a shadow of her former self. On occasion, when considering the situation Papa had left us in, fury passed through me but then I reminded myself of how he had been an exceptional father in other ways, raising me on Shakespeare and Chaucer and every other book he could set his hands upon. Most importantly, he gave me the opportunity to teach at his school for the poor. I sieved flour into a bowl, added yeast and a dash of tepid water from the jug on the table. Our cook would usually have made the bread, but we had let her go the previous week. I used my hands to bind the mixture into a dough, pushing in my knuckles, kneading, pulling, stretching to assuage my fear that Mama would return shaking her head. *Dear Father, please ask the duke to help us.* The Duke of Oxon had lost his wife to childbirth a few months before we lost Papa, so it might not be the time to ask for a favour. The most we could hope for was employment on his estate. Surely there was room for us amongst the sea of domestic staff at Chipford Hall?

Mama returned with good news that day. By mid-March, the new vicar, Mr Brigstock and his wife had moved into the parsonage, and I was established as governess at Chipford Hall to the duke's daughters, Lady Emily and Lady Sophie. Mama now resided in Yorkshire as companion to the duke's mother, the Dowager Duchess of Oxon. The duke had been searching for some time for a woman willing to be a companion to his mother, who had become increasingly cantankerous with age. Papa had visited the chapel at Chipford Hall more often than usual when the duke's wife and unborn child passed away, and received him at the parsonage to talk about his loss. The duke kindly took Glebe Farm off our hands, and cleared our debts; we were to reimburse him when we were able. He would start by taking a small amount

from our salaries.

Despite my gratitude to the duke for saving us from destitution, loneliness had set in since moving into a modest room in the east wing of Chipford Hall a few weeks earlier. My grief for Papa consumed me, and daily life without Mama's presence and guidance had become a reality.

During lessons, I had no time to think about myself, and took my duty as governess seriously. Now here, I was charged with the responsibility of educating two young ladies. I closed *The Misanthrope* and placed the book on my writing table. Sophie chewed her fingernails and looked through the window at the gardens, where green patches broke up the white blanket. Emily plaited her doll's hair. Neither seemed to care about Oronte filing a lawsuit against Alceste for saying bad things about his poem.

'The sun is shining. Why not go and play outside until luncheon is served?' I said.

'Does that mean no more Molière, Miss Elliott?' Sophie said.

'No more French today, Sophie. I expect you are glad of that. Off you go, girls, before I change my mind. Mrs Baxter will assist with your coats and boots.'

Emily and Sophie pushed their chairs out from under the table and raced for the door, skirts whirling around their ankles.

Chipford Hall had been isolated for weeks, but the temperature had risen overnight and outside water dripped onto the windowsill. The duke would be glad to return to the House of Lords after being confined to Chipford Hall during the winter months, and I wondered how the absence of my master would change daily life.

Seizing the moment, I went downstairs and along the east corridor into the library. Most rooms on the ground floor were decorated in gloomy colours such as deep red or pea-soup green,

but around the vast bookcases the walls were as yellow as the skin on a lemon. Paintings and maps from faraway places complemented the marble fireplace and I would often admire the pen-and-ink drawing of Mount Vesuvius. The library welcomed natural light through its tall windows, the sun illuminating gold swirls on the rug. I liked to escape into this land of books and sit at the walnut writing table to read the duke's journals from Italy.

When seeing a gentleman at the writing table, holding a quill, I put a hand to my mouth and gasped. It was the duke's son Rupert, the Earl of Chipford and I instantly recognised him from the portrait of the man in the red coat in the Grand Hall. Mrs Baxter, the housekeeper had told me about when he was left for dead at the Battle of St Malo. His best friend from Eton, Charles, Lord Heybury found him amongst the sea of bodies, saving his life and the earl returned to England a hero. He had recuperated at the house with a nurse employed to care for him, who told Mrs Baxter about a scar on his chest where he had been wounded within inches of his heart. There were whispers amongst the servants of a liaison with Sally, a scullery maid, shortly after his recovery. This culminated in her dismissal by the duke, and the prompt departure of the earl on the Grand Tour with Lord Heybury, a year earlier than planned. Mrs Baxter had talked about the earl returning when the snow cleared, but I had not expected his arrival to be imminent.

'Good morning,' he said.

He was as handsome as his portrait, studied many times when I was waiting by the main door for the girls before venturing outside. And I reminded myself he was a gentleman far above my station. His nose was long and refined, his complexion ruddy as if he had just come in from the cold.

'Good morning, my lord.' I bowed my head. 'I am Miss Elliott, the new governess.'

He sat upright, his chin lifted and studied me with eyes as brown as cocoa. He assessed my face and dress as if drinking me into his memory.

'I know who you are. My sisters' letters informed me they are fond of you.'

The poor girls had lost their mother and unborn sibling shortly before I took the governess position, and there was no doubt the earl had received the tragic news by letter whilst abroad. The duke had requested I use more affection with Sophie and Emily than a governess traditionally would, until their grief had dwindled. The girls had been a pleasure to care for, although Sophie tended to need a gentle nudge to pay attention during lessons.

'I am glad. They are dear to me.'

'My father said you have looked after them especially well and I thank you, Miss Elliott.'

'Your sisters are a joy to teach, my lord. May I offer my sincere condolences?'

'And I am sorry for the loss of your father. I met your parents at the midsummer ball before departing for Venice, but I do not recall your presence that evening, Miss Elliott.'

I had been bedridden with a fever and remembered hearing about the earl, whom we had not met when moving to Chipford due to his being at university. Mama had enthused about his charm and told me how Lord Chesterton's daughters pursued him like the ugly sisters in Cinderella.

'I had a fever,' I said.

'If we had met, I would certainly remember.' His gaze fell briefly to the neckline of my dress, then he looked out of the window.

I clasped my hands behind my back, squeezing my fingers together, unsure how to respond.

'I heard your father delivered a fine sermon,' he said.

The villagers of Chipford had mourned my father, a gentle man who inspired when he spoke and lent his ear to those in need. I read his sermons before retiring to bed on days when my heart longed for him to return, his words acting as a guide.

'I still read them on occasion.'

'His words are no doubt a comfort to you. Where are my sisters, may I ask?'

'They are playing in the gardens, my lord.'

He dipped his quill in the ink.

'The fresh air will do them good, to be sure.'

A moment of silence fell between us, discomfort overwhelming me, and he looked at me as if it were my turn to speak. It occurred to me then that my comportment was ill-mannered. This was his house, and using the library as and when I wished had become a habit in his absence.

'May I offer my apologies for disturbing you. I did not hear your carriage approach the house this morning and so was not aware of your presence,' I said.

'My valet, Rogers, and I came by horseback from Heybury House, staying at inns en route. Having been stuck there for weeks, I could not wait to return home when the thaw began.'

Heybury House was home to Charles, Lord Heybury and his wife, Cordelia. Mrs Baxter had informed me they were frequent guests, and Lady Cordelia, an acquaintance of the earl since

childhood, was a bluestocking who liked to entertain artists and writers.

He began to write, indicating I had overstayed my welcome.

'I must fetch the girls for luncheon. Good morning to you, my lord,' I said.

I walked towards the door, wondering how his presence would change life at Chipford Hall.

'Forgive my rudeness,' he said. 'I am writing up my journal and my head was in Venice when you entered the room. Do join my sisters and me for dinner. My father departs for London this afternoon and we would appreciate your company.'

'It would be an honour, my lord.'

As I went to find the girls, I considered how the earl's journal might differ from his father's. He seemed less formal than the duke and dining in the company of others would be a break from my routine. Until now, I had spent evenings in my bedchamber, writing letters until the candle went out.

Our spoons clinked against dessert bowls as we finished the blancmange, the earl's favourite which the cook, Mrs Henderson had prepared to celebrate his return. I tried not to look at the painting of the fox hunt on the wall opposite. It was rather graphic, the fox's intestines there for all to see as the hounds ripped the poor animal apart. Why should such a scene be on the wall of a dining room?

During dinner, the girls sat quietly while I responded to the earl's questions about my background to say Papa had died of tuberculosis, leaving me and Mama in debt. When pressed, I informed him that Papa had not run our Glebe Farm as efficiently as he could, instead pouring money into his school for the poor where I worked as a teacher. This was an honourable gesture, but

11

it left me and Mama in danger of destitution after he died because of the bad harvest. My brothers, Thomas, a naval officer, and Matthew, a curate needed their incomes to support their wives and children.

'I am sorry to hear you have experienced so much difficulty,' he said.

'Thank you, my lord. I am most grateful to your father for what he has done for me and my mother.'

He gestured to the butler, Mr Banks, who stood in the corner.

'Now, on to other matters. I have a surprise for my sisters, brought from Heybury House. Ask Mrs Baxter to bring it in,' the earl said.

'Yes, my lord.'

The housekeeper, Mrs Baxter entered the room holding a puppy. It was a brown pug, adorable and just what the girls needed, although I doubted they would help to care for it. The girls squealed and climbed down from their chairs.

'What shall we call it?' Sophie said.

'George, like the King!' Emily said.

'It is a girl,' Mrs Baxter said.

Emily frowned, her face scrunching up.

'Go into the parlour with Mrs Baxter and think of a name,' the earl said.

The girls ran off and I remained at the table, ready to be dismissed. Being alone with the earl unnerved me, and I pulled a handkerchief out of my pocket, pressing it to my nose to stifle an imaginary sniffle. Mr Banks and a footman cleared the dishes from the table.

'I have some items from Italy which may interest you, Miss Elliott,' the earl said. 'Let us retire to the drawing room. Fetch me a knife, will you, Banks?'

12

'Certainly, my lord.'

Mr Banks led me and the earl into the drawing room and gestured to me to sit in the chair farthest from the fire, shielded by the screen. The fire crackled, the scent of burning wood monopolising the air and I appreciated its heat. During evenings spent in my room, it had been so cold, I wrapped a blanket around my shoulders when writing letters. The earl sank into the chair opposite. Two items wrapped in brown paper rested against the wall, under the window. Mr Banks brought in a knife and the earl cut around the brown paper to reveal two paintings. A tower with a pointed top and a cathedral featured in both. They were of the same scene, from different angles.

'They are magnificent. Where did you get them?' I said.

'From Count Monte, my host in Venice and a personal friend of the artist, Canaletto, who died in 1768. The count, an avid collector of Canaletto's work lost the paintings to me in a game of whist and wishes for the opportunity to win them back when he visits Chipford Hall next year. Both paintings are of La Piazza San Marco, the square in the centre of Venice. The tall building is the Campanile, a bell tower; and the cathedral is St Mark's Basilica. Each painting is a companion of the other. The one with the view through the arch is called, *Looking East from the North-West Corner,* and the one with the men talking under the colonnade is called, *Looking East from the South-West Corner*. I did take pity on the count and allowed him to keep the pen-and-ink drawing matching the latter. Which is your favourite?'

I studied them. *From the North-West Corner*: the view through an arch; darkness in the foreground highlighting the brightness of the light in the square. None of the people scattered around could be seen clearly. The bell tower rose above St

13

Mark's Basilica at the far end of the square, and much of the painting was taken up by sky.

From the South-West Corner: a pillar in the foreground with darkness on the right under cloisters. In this painting, the viewer was brought closer to the bell tower and St Mark's Basilica, both dominating the left-hand side of the pillar. Two men sat at its base, conversing, while a man stood nearby, a cup and saucer in his hand.

'By using darkness and light with the arch and the pillar, Canaletto draws the viewer into the scenes,' I said.

'He used to paint sets for the theatre; the reason his paintings work in a similar way,' the earl said.

'If I had to choose a favourite, I would pick this one.' I pointed to the one of the men under the pillar, *From the South-West Corner*.

'Why?'

'Because I can almost hear their voices echoing around the cloisters.'

'What could they be talking about?' he said.

I shrugged. 'Maybe they are saying, "Why is that man painting a picture of us?"'

He laughed.

'It is more likely they are discussing women, politics or money.'

'Or how the coffee tastes?'

'Women, such simple creatures,' he said.

I did not appreciate his tone, but expected it. For I was merely a woman, and of inferior rank to him too. How could I expect to converse with him at an equal level? Being invited to his drawing room was a privilege in itself.

'And where will you display these beautiful works of art?'

14

'In here, of course. I shall replace those ghastly paintings of the English countryside, gifted to my father by a business acquaintance.'

He gestured towards a couple of paintings on the inside wall, and I agreed the Canalettos would look better in their position.

'What is Venice like?' I said.

'Complete madness, not a place for a young gentlewoman like yourself, Miss Elliott.'

The Merchant of Venice was my favourite Shakespeare play, and I longed to see the city with my own eyes.

'I doubt very much that I shall have the opportunity to visit.'

'The only women who make it there are bluestockings and surely you are not one of those, Miss Elliott?'

My cheeks warmed. 'No, my lord. Venice is beautiful, I dare say?'

'The lagoon is spectacular, but the streets twist and wind like a maze and it is easy to get lost.'

Mrs Baxter had told me what men got up to on the Grand Tour, climbing into the beds of one woman after another. Was the earl that kind of man? The thought of him in bed without his clothes, with a woman, made me warmer still, and I mopped my brow with a handkerchief.

'At least I shall see Venice at the theatre this spring,' I said. 'Your father has given me leave in June to see *The Merchant of Venice* with my sister-in-law.'

'Yes, you deserve the chance to escape this house, which becomes a prison during the winter months. Take the carriage and stay at our London residence, if you wish.'

'Will your father mind?'

'He will be in Antigua with my uncle. I shall be at our London residence then, however.'

The earl was being kind, although I could not ascertain his reasons. What if tonight was part of a scheme to groom me to be his mistress? The rumours about the scullery maid came to mind and, even if they were servant gossip, he struck me as a man who seized opportunities with the fairer sex.

'Can I interest you in a game of draughts, Miss Elliott?'

Groom me to be his mistress? A ridiculous thought indeed! He was a man in need of a companion and I had been chosen due to lack of competition. When spring came, he would no doubt invite visitors more worthy than me to Chipford Hall.

'That would be agreeable, my lord.'

Mr Banks placed the trestle table between us and set out the draughts on the board, white for me, black for the earl. He placed a glass on the table beside the earl, and filled it from a decanter.

'Your brandy, my lord.'

'Would you care for a beverage, Miss Elliott?' Mr Banks said.

Asking a colleague to serve me would be acting above my station and goodness knows what they would say in the servants' hall.

'No, thank you, Mr Banks,' I said.

'You are dismissed, Banks,' the earl said.

The butler left the room, closing the door quietly behind him, and the earl fixed his eyes on me across the table.

'Now it is time to show your mettle, Miss Elliott.'

Chapter Three

If only Mum wasn't on a yoga retreat in Jaipur with her latest boyfriend, Malcolm. Being a lover of art, she'd be so excited and would know what to do next. Who could I ask for advice in Chipford? With no Wi-Fi and the only certainty of a phone signal being outside the bakery on the high street, I resorted to perusing the previous year's Yellow Pages, running my finger down the list of businesses until it landed on Chipford Art Gallery. After being made redundant and subsequently splitting up with Chris, my only choice had been to move in with Mum, and lately, I hadn't left the house much. But finding this painting had my adrenalin racing for the first time in quite a while, and I slid the frame into an orange Bag for Life from Sainsbury's.

Pulling on my denim jacket, I locked the front door behind me and climbed the hill leading to the high street. The sky was a deep blue that afternoon with birds singing in the cherry trees lining the pavement of Sidney Road, their branches showing the beginnings of blossom, but a cool breeze brushed my neck and I pulled up the collar on my jacket. As I approached the bakery, the comforting scent of fresh bread and cakes overwhelmed my senses, and then I spotted a blue door and matching window frames with big white letters, saying Chipford Art Gallery. All

those times standing outside the bakery checking my phone and I hadn't noticed this place's existence.

A bell jangled as I pushed open the door and a piano concerto played. Spotlights shone down on a vast selection of paintings, crammed together on whitewashed walls and there were loads of them on the floor, leaning against the walls in rows. Whoever worked here wasn't very organised. My eyes were drawn to a modern painting of New York with yellow taxis. I approached the counter and called out, 'Hello?' A rustling came from a room out the back and a man in a red and white checked shirt appeared, placing a couple of frame samples on the counter. He had thick stubble on his face and he was around my age or perhaps a bit older. Brushing hair out of his eyes, he threw me a look that implied he was not in the best of moods.

'How can I help?' he said.

'What do you know about old paintings?' I said.

'It depends what you're asking.'

He collected papers scattered around the counter, making a pile.

'I'd like your opinion on the painting in this bag,' I said.

'Do you want to sell it to me?'

'Not exactly.'

'I'm closing in a minute, so you'd better tell me why you're here,' he said, putting frame samples into a box.

Placing the carrier bag on the counter, I took out the painting, still wrapped in brown paper.

'I found this in my gran's loft and think it's a Canaletto.'

When said aloud, this sentence sounded far-fetched. Why would my gran, a tailor's widow, own a Canaletto?

'Really?' He laughed. 'I'd be surprised if that's the case.'

18

I unwrapped the paper, and presented him with the painting, allowing it to do the talking. The elaborate gold frame with swirls all around made it look like a museum piece, out of place on the counter made from MDF. He drew in his breath and pushed his lips together.

'Everything about it says Canaletto: Venice, how darkness and light have been used to draw in the viewer. He painted theatre sets before he was an artist, but it has to be a fake. Or stolen.' He threw me a look of disapproval as if I'd just nicked it from The National Gallery, then leant forward and put his hands around the frame. 'May I?'

'Of course.'

He switched on a desk lamp and held the painting under it.

'It could be real, I suppose. Do you know how this ended up in your gran's loft?'

'No, she died a couple of years ago. I only found it today when putting boxes up there.'

'If the painting's an original, I doubt anyone would have just given it to your gran. No offence.' He looked at me, eyebrows raised.

Gran wasn't a thief.

'It's not stolen,' I said.

'But you don't know how it came into your gran's possession?'

'No.'

'Perhaps her ancestors stole it?'

Shaking my head, I said, 'I don't believe that.'

His eyes displayed a flicker of amusement. Here I was, the pain in the arse interrupting his end-of-day clearing up.

'Look, if the painting's real, it would be extremely valuable, of course,' he said. 'But you'd need to find an expert on Canaletto to prove it.'

'Thanks.' I folded the brown paper loosely around the painting and put it back in the carrier bag. Then I remembered the note, and placed the envelope on the counter.

'And there's this.'

He turned the envelope over in his hands, and ran a finger over the red-wax seal, then pulled the note out and unfolded it, smoothing it down on the counter as he read the words written by the mysterious 'R'.

'This note certainly helps with establishing provenance.'

I looked at him blankly.

'Provenance basically means a record of ownership of a work of art used as a guide to authenticity or quality,' he added.

'Oh, right.'

'Perhaps Philippa put it in your loft.'

He handed the note back to me and I put it away.

'It's a possibility. The house has been in our family for years, passed down with the local tailor's business, which closed after my grandad died.'

'I remember. The shop on the corner, where the newsagent is now?'

'Yes.'

'I hired a dinner jacket from there once. As there's a coat of arms in this wax seal, I'd hedge a bet that 'R' was a member of the aristocracy. You could look at the history of country houses around here. There's Wentworth Manor, Seeley House, Chipford Hall. I can't recall the name of the family at Chipford Hall, but it's only down the road, now owned by the Association of Treasured Properties so worth a look.' His tone of voice warmed.

20

'Why don't you have another look in your loft in case you find anything else?'

'Good idea. I'll do all that. Thanks.'

'And if the painting's one of a pair, it would be interesting to know what its companion looks like, and where it could be.'

This hadn't occurred to me and there was a lot to investigate. All the note told us was that this painting was Philippa's favourite of the pair. I explained about recently moving into Gran's cottage, omitting the part about having no choice due to my redundancy.

'Oh, you seem familiar though. Hold on, haven't I seen you outside the bakery, checking your phone?'

I smiled. 'It's the only place I can get a signal round here.'

'Whereabouts do you live?'

'In the pink cottage halfway down the hill.'

'Ah yes, I used to see your gran watering the window boxes sometimes when I was out for a run. If you find anything out, get in touch and I can try to help you further.' He handed me a business card.

'Thank you, will do.' I slipped the card into my pocket and headed for the door. Did he mean help me unpaid, or would he charge some kind of fee?

'What's your name?' he said.

I stopped and turned to face him.

'Rachel Brown.'

'See you, Rachel.'

'Bye.' I closed the door behind me.

That was the most interaction I'd had with anyone in person, apart from Mum and Malcolm, since moving to Chipford and it felt a little draining after all the time spent alone at Ivy Cottage feeling sorry for myself. As I walked down the high street, I took

out the business card and saw the man in the art gallery was called Jake Holmes. A great deal of effort seemed to be required to investigate my discovery and the thought of finding any motivation to do what Jake suggested seemed too much for now. On arriving home, I carried the painting upstairs and leant it against the wall in the spare room, leaving it in the Bag for Life from Sainsbury's until able to muster up the energy to find out more.

Chapter Four

I first met the earl's valet, Rogers, one morning in Mrs Baxter's parlour. Since my arrival at Chipford Hall, the housekeeper had taken me under her wing, and she often invited me into her parlour for tea and whatever cake or biscuit Mrs Henderson was making that day. That morning, when I entered the parlour, Rogers was seated at the table, his teacup empty and side plate scattered with crumbs. He rose to acknowledge my presence, and pushed his chair under the table with great care.

'Miss Elliott, allow me to introduce the earl's valet, and my nephew, Mr Rogers,' Mrs Baxter said.

I tipped my head.

'Good morning.'

He reciprocated and raised a smile.

'I'm delighted to make your acquaintance, Miss Elliott. Lady Emily and Lady Sophie have taken you to their hearts, according to his lordship.'

'Thank you, Mr Rogers. Your kind words are a comfort to me.'

He cast me a fixed look, and I registered a potential ally in a world where I was not yet certain of whom I could trust. Being

Mrs Baxter's nephew made him especially worthy, because she was someone I could confide in with no qualms.

'Now, you must excuse me. I need to attend to some business in the village on behalf of my master.' Rogers picked up the cup, saucer, and plate and headed towards the door.

'Goodbye, Mr Rogers,' I said.

'I wish you a good day, Miss Elliott,' he said. 'Goodbye, dear aunt.'

He walked with ease as he left the room, his air assured. I pulled out a chair and sat at the table while Mrs Baxter presented me with tea and shortbread. She took a seat opposite and removed the cosy from the teapot.

'I secured Mr Rogers the position of valet when his predecessor retired due to ill health last year.'

'How kind of you.'

'One has to look after one's own. I have no children, and my only nephew is like a son to me.' She sipped her tea. 'Previously he was employed as a footman at Seeley House, home to Lord Tankford who owns land neighbouring Chipford Hall.'

'A promotion then,' I said.

'Quite, although he is entirely worthy. My nephew is a good, hard-working man, just like his father, my brother.'

I envied Rogers for accompanying the earl on his Grand Tour. He would be trusted with the earl's secrets and I imagined him to be on his guard around the other servants. Presumably, he distanced himself from the idle gossip which took place in the servants' hall during mealtimes. Rogers, Mr Banks, and Mrs Baxter were the *crème de la crème* below-stairs, and they had been employed for their discretion as well as their capabilities. Furthermore, they benefitted from privileges denied to other servants: Mr Banks with his butler's pantry, Mrs Baxter with her

24

parlour; and Rogers shared the life experienced by the earl when he travelled.

I had not seen the earl since we spent that evening together. He had won our game of draughts, but only just and we laughed at how skilled I was for a woman. Every evening since, I had been relegated to my room whilst he wrote up his journal in the library, my modest fire built from a couple of logs failing to combat the sub-zero temperature. To take my mind off the cold, I wrote letters to Mama, my sisters-in-law, and to acquaintances, describing the evening with the earl and the Canalettos. Mama would treasure such a letter and I looked forward to her reply. If only I were at liberty to enter the drawing room whenever I desired, to study those Canaletto paintings. Alas, it was not a room I could use without being issued with an invitation. I almost wished the earl had not been so attentive. Now I had tasted what life could be like for women of a superior rank, the reality of life as a governess with no dowry seemed more of a challenge. My role had been as companion that evening and nothing more.

A few days later, on Saturday morning, a day off from teaching the girls as they took dance lessons, I called on Mrs Braithwaite in the village where we talked about Mama, with whom she corresponded, and the new vicar, Mr Brigstock, whom she found a little dull compared to Papa.

After bidding goodbye, I walked down the high street, past St Andrew's Church and the parsonage. The yew trees at the front of the parsonage had been cut considerably shorter than my parents had kept them, and a pair of terracotta pots stood outside the doorway, hosting matching round-shaped trees. These minor changes antagonised me somewhat and I took them personally, perhaps because I still grieved for Papa. Nostalgia consumed me

there in the street, and I pulled a handkerchief from the pocket of my cloak, dabbing tears from my eyes. Two years earlier, when we had first moved to Chipford, Papa was proud to take on the Glebe Farm behind St Andrew's Church, working hard to establish his school for the poor. I honed my skills as a teacher in that school, and Mama embraced the role of vicar's wife, for she was a woman who liked to socialise and converse about a variety of subjects. How life had changed since my brothers left home to get married, and now my parents had deserted me, leaving me to fend for myself. A new era had begun before I was ready.

'Miss Elliott!' A man called my name, and I fought to prevent the tears from running down my face, blotting my eyes and nose with the handkerchief.

He repeated my name and I turned to see Rogers. If he enquired after my wellbeing, I would blame the puffiness of my eyes on the cold weather.

'Good morning, Mr Rogers,' I said. 'What a pleasant surprise.'

'Are you quite all right, Miss Elliott?'

'Thank you for your concern, Mr Rogers, but allow me to reassure you that I am merely cold. What, may I ask, is your business in the village?'

'I have been visiting the tailor, Mr Wicks, on behalf of his lordship.' He pointed to the shop on the other side of the road, behind Market House. 'And yours?'

'I was invited to take tea with the doctor's wife, Mrs Braithwaite, a family friend.'

'Do you mind my accompanying you back to Chipford Hall?'

'Not at all, Mr Rogers.'

'In that case, you ought to hold on to me to prevent you from slipping on the ice.'

'Very well,' I said.

He proffered an arm and I gripped it, and as we touched, he looked at me with a certain fondness and a frisson passed through me, taking me by surprise. Mr Rogers was merely a new acquaintance, and I put the unfamiliar feeling down to loss of control of my emotions outside the parsonage. We followed the road where the snow had thawed enough along the centre for us to tread without slipping and sliding. The route across the fields would have taken less time, but the snow was too deep.

'Have you settled in at Chipford Hall?' he said.

'Yes, thank you. The girls are a delight.'

'And you feel at home? I would have found it difficult without my aunt's presence.'

'Mrs Baxter has been kind to me, but I miss my parents.'

'And where are they?'

I told him, adding that frequent correspondence with Mama brought a small reward. 'And your mother and father?' I said.

'My mother passed away ten years ago and my father recently commenced employment at Seeley House.' He stopped walking for a moment, and let out a sigh, then added, 'As a footman.'

I sensed he was trusting me to keep this to myself, without judging him or his father, who must be in his fifties or sixties, far too old for such a role. Expecting there was more to what he was saying, but not wanting to pry, I changed the subject.

'May I ask how you found Venice?'

'The tour to Italy was a wonderful experience, indeed, and Venice is a magical place. Being the earl's valet gains me privileges many would never enjoy.'

'Seeing Venice is merely a dream for me,' I said.

'The earl has a passion for art, and he plans to fill Chipford Hall with paintings and objets d'art from Italy. He has

commissioned a sculpture of Bacchus, the Roman god of agriculture and wine, and hopes that placing such a sculpture in the Grand Hall will bring fortune to his father's land, as the harvest has been poor in recent years.'

He did not need to tell me about the impact of the poor harvest.

We passed through the main gates to the drive and Chipford Hall came into view. Snow covered the hills around us and it was a blessing to experience the beauty of nature.

'It seems his lordship is well informed when it comes to matters of art and culture,' I said.

Rogers stopped walking momentarily, and looked at me, his countenance rather serious. Could he sense my infatuation with the earl?

'Yes, well of course, he has the best advisors, as would be expected for someone in his position.'

'Chipford Hall has certainly woken from its winter sleep since his return,' I said as we continued to walk towards the house.

Rogers inhaled.

'My master is a man with an abundance of charisma. Everyone is drawn to him, wherever he goes. He brings life to any dull situation.'

'It is clear he is much admired.'

'Women especially are taken in by his charm and good looks, but…' He hesitated, as if unsure whether to continue.

'Go on,' I said.

'He is my master, and my loyalties lie with him, but seeing as you have recently arrived at Chipford Hall, and haven't experienced much of life beyond the walls of your parents' home, I imagine…?'

I nodded, feeling a little naïve.

'I must inform you that the earl is a cad. However charming he may appear to be, he leaves a trail of devastated women in his wake.'

Unsure of why Rogers was choosing to divulge this information, I was caught unawares, and said nothing in return. It seemed he was trying to warn me about the earl, as if he might attempt to pursue me.

As we approached the house, snow had been cleared in the area around the main door and no longer requiring his support, I removed my hand from his arm. He looked at me once again in a way that displayed affection, a faint smile on his lips.

'Your company has been most enjoyable, Miss Elliott.'

'And conversing with you has been insightful, Mr Rogers.'

We approached the servants' entrance, and he held open the door while I passed into the passage linking the below-stairs' quarters.

'Another time, we could take a walk in the gardens after dinner, now the evenings are lighter?'

Certain to never tire of his company, I said, 'That would be most agreeable,' as I removed my bonnet.

'Then I look forward to our next walk. Good day, Miss Elliott.'

'Good day, Mr Rogers.'

Climbing the stairs to my bedchamber, I smiled to myself. His companionship was bound to ease any loneliness I had felt since moving into Chipford Hall, and there was no doubt in my mind that he would be an ally for the foreseeable future.

Chapter Five

One morning, a few days after finding the painting, I got up late and made some toast, then dressed and stood at the kitchen sink to wash up, looking onto the back garden at the pink and white flowers blooming on the apple trees. A memory flashed into my mind of picking apples with Gran at the end of August and making crumble with them, rubbing cold cubes of butter into the flour while she told me stories of being a teenager during the war. Those weeks during the summer had produced the most special memories of my childhood. And now here I was in this Disney-esque setting, alone at the end of another week. I missed the buzz and thrill of working in London along with money for as many weekend coffees as I liked from the range of cafés lining Battersea Rise. Usually on a Friday, I'd go for work drinks with colleagues or meet friends in the West End. My redundancy package had run out and having broken significantly into my overdraft, I needed to find a job although the thought of going through the application process was daunting.

The potential Canaletto remained in the spare room, still leaning against the wall in the Sainsbury's Bag for Life, and I'd spent the past few days considering how much effort it would take to find out if the painting was real. If it was, the reward

would be very worthwhile indeed. But with the loss of my job, I'd lost my confidence, and leaving the house had been difficult most of the time recently. For now, I'd leave the painting until able to muster up the energy to do what Jake suggested.

The doorbell rang and expecting *that man* offering to power-wash the drive again, I opened the door with a frown, ready to send him on his way. But it was Jake from Chipford Art Gallery, still as unkempt as when I'd seen him the previous week, his hair straggly and with several days' worth of stubble covering his face.

'Hello, Jake.'

'Sorry to bother you, Rachel. I had to drop a painting round the corner and wondered if you'd found anything else in the loft?'

'I haven't got round to going back up there.'

Looking uphill towards the high street, he seemed almost ready to make an excuse and leave, but having company might do me good. I wasn't used to spending so much time by myself and living with my thoughts twenty-four hours a day was getting a bit much.

'But...' I said, considering how to invite him in. Should I do that? I mean, he could be anyone.

He held up a battered brown-leather briefcase.

'You might be interested in looking at some information I found,' he said. 'I'm going back to London on Sunday so thought I'd drop by and see if you were in.'

What the hell. He seemed harmless, and I was curious to know what he'd brought.

'Why don't you come in and I'll make coffee?' I said, fully opening the door.

'Okay, thanks.'

31

He stepped into the hall and followed me to the kitchen, placing the briefcase on the floor.

'I'll get the painting,' I said.

I fetched it from the spare room and ran a hand over the table to check it was dry before unwrapping the brown paper and placing the painting before him. He studied it while I filled the kettle and got out the fancy floral mugs given to Mum for her birthday. This was an occasion for the cafetière and I spooned in a generous amount of ground coffee before filling it with hot water. While leaving the coffee to brew, I turned to face him. Leaning against the counter, I ran a hand through my hair, encountering a few days' worth of grease. There hadn't been a reason to wash my hair lately. For some reason I found myself caring about this in his presence, although I shouldn't as he really wasn't my type. Usually, I went for men who were a little bit older, and more aloof. Jake moved the painting to the dresser and undid the latch on the briefcase before pulling out a book entitled *Canaletto's Work*. He opened the page marked with a yellow Post-it and handed the book to me.

'My dad collects art books, and I found this.'

Why was he going to all this trouble? Perhaps he'd send me an invoice.

'Oh, interesting. Thanks.'

'Can you see the photo of the pen-and-ink drawing, identical at a glance to your painting?'

I found the photo he mentioned, and it was uncannily similar to my painting with more of the square included on the left.

'Yes.'

'Read the paragraph next to it,' he said.

32

Plate 14: A pen-and-ink drawing with wash on paper, "Piazza San Marco: looking East from the South-West Corner" *(owned by the Galleria di San Marco in Venice, Italy). It's more than likely that Canaletto produced a matching painting although its location is unknown.*

'You think my painting could be the one they refer to with an unknown location?' I said.

He shrugged.

'It's hard to believe, I mean what would it be doing in my loft?'

'And look at this,' he said, pointing further down the page. 'Remember the note referred to your painting being one of a pair?'

Plate 15: "Piazza San Marco: looking East from the North-West Corner", *owned by Galleria di San Marco in Venice, Italy. The painting was sold to the Galleria di San Marco by the Monte family in the 1950s.*

The painting was similar to mine with the tower and cathedral in the distance through an arch.

'You think this is its companion?' I said.

Jake shrugged.

'This book is fifteen years old, so there may be more up-to-date information somewhere. Perhaps we should check online. Where's your computer?'

I pulled a face. 'It broke.'

'Let's try my phone.' He pulled one out of his pocket and used his thumbs to type.

'Ah, no signal.' He rolled his eyes. 'What's your Wi-Fi code?'

'We don't have it yet,' I said.

He sat back in the chair and I put the cafetière on the table with the mugs, teaspoons and a carton of milk. As I plunged, Jake looked across at me and despite the silence, his presence was undemanding. I filled the mugs and put the biscuit tin on the table.

'Help yourself.'

He pulled off the lid and peered inside before selecting a custard cream. I joined him and we munched our biscuits, dunking them in the coffee.

'Well, you could come over and use my laptop, if you wanted to.'

'Yes, I could do that, but do you think it's worth all this…?'

'What?'

'Effort.'

'Yeah, what do you have to lose? And you're forgetting about the note.'

'I guess so.'

'And I don't mind helping.'

'You're not going to charge me are you? I can't afford any more bills.'

He laughed.

'Not at all. After you left the gallery, I couldn't stop thinking about your painting and racked my brains on how to help.'

'Why would you do that, though?' I said, sipping my coffee.

'Boredom, mainly.'

'Yeah, this isn't the most exciting town. How long have you lived here for?'

'I only work here at weekends. But this week, I'm covering the manager, Vera, while she recovers from cataract surgery.'

'So, you're going back to London soon?'

'Yes, on Sunday. That's where my life is.'

'Oh, lucky you. I used to live in Clapham, and miss the buzz of London.'

'I know what you mean. Chipford seems very quiet in comparison. Why did you leave?' he said.

'I'm in between jobs,' I said, keeping the redundancy to myself. Telling other people about it was embarrassing and for some reason I felt ashamed even though it wasn't my fault they'd moved the whole department to Scotland.

'Oh right, are you looking for something round here?'

'I could do with earning some money, yes.'

'What experience do you have?'

'Selling insurance, mainly, apart from waitressing as a student.'

'There's a waitressing job going at Peaches and Cream, opposite the art gallery.'

Despite being qualified for the role, I needed to find a new career, something fulfilling that ideally made use of my history degree. But with losing my job, I'd lost my confidence and maybe I should apply for a chance to earn money and get my mojo back?

'Thanks, I'll give them a call.'

He stood up, his chair scraping the flagstone floor and picked up his briefcase.

'Do you want to come over and use the laptop tomorrow?'

It would be good to get out of the house, although I still couldn't work out why he was so keen to help, unpaid.

'If it's no trouble.'

'It's no trouble. I don't need to work in the gallery tomorrow morning.' He smiled and headed for the door and I followed. 'Oh,

and don't forget to go back in the loft, in case you find anything else.'

He was being a bit bossy, and I wasn't sure if I liked him telling me what to do. Although maybe I needed a positive influence after wasting so much time sitting around feeling sorry for myself.

'Will do. Do you need your book back?'

He opened the door and went outside, turning to face me.

'Keep it for now. My dad doesn't exactly need it in Tuscany.'

'Oh, lucky him.'

'Yes, hope to visit one of these days. I'll see you tomorrow, about ten o'clock? It's the blue door next to the gallery.'

'Okay, see you in the morning.'

He threw me a smile before heading uphill towards the high street and I went back into the house with a spring in my step, my mood enhanced by his visit. I'd keep my word and go back into the loft, although I didn't expect to find anything. And I'd apply for the waitressing job. But first, I must wash my hair.

Chapter Six

The following Saturday, the girls had their dance lesson and I spent the morning reading the duke's journal in the library, one of the warmest rooms in the house with the sun streaming through its windows. I enjoyed tales from the duke's descent into Italy from the Alps, to the Aosta valley and on to Genoa. When it was time for luncheon, I pushed the journal back onto the shelf and made my way to the dining room, but the girls were not there. Mr Banks came in and placed a jug of water on the table.

'Have you seen the girls, Mr Banks?' I said.

'I expect they are looking for Polly, Miss Elliott.'

The girls had agreed to a name for the dog, after a favourite nanny from when they were younger.

'Why did they take the dog?'

'The earl thought it a good idea. Although I said they were not ready to take her outside, the earl insisted it would do them good. When he took Polly out the day before last, I spent some time searching the woods after she ran off.'

'Where is his lordship at present?' I said.

'He and Mr Rogers have taken horses into the village to visit the tailor for a fitting for the wedding.'

'His lordship is betrothed?' I said.

'Yes, to Lady Eliza Asquith.'

This news surprised me.

'I had no idea.'

'His father arranged the betrothal whilst his lordship was in Venice. His Grace's brother has a joint venture in Antigua with Lady Eliza's father.'

My appetite dissipated, but I failed to understand why this information should impact on me. The other evening, I had been carried away by the wine at dinner, by the warmth of the fire and by the production of the Canalettos. Why would his lordship feel an obligation to update me on his impending nuptials? I needed to get past my infatuation with a man beyond my reach. No doubt Lady Eliza's face matched her social status. Mr Banks fussed around the table, adjusting napkins and cutlery, standing back to admire his handiwork.

'I shall go and look for the girls,' I said.

'Very well, Miss Elliott,' he said.

I got my cloak from the parlour and pulled it over my head in the hall, choosing not to look at the earl's portrait for once. As I opened the door, the bitter wind pushed against my face. I pulled on my gloves and gripped the handrail as I went down the steps, treading carefully in case of ice. Mr Banks opened the door and called after me, 'Miss Elliott?'

I stopped and turned around.

'Yes, Mr Banks?'

'Mrs Henderson said the girls asked for bread to feed the ducks, so they will be at the lake.'

A thick sheet of ice covered the lake and a worrying thought entered my mind, but I reminded myself that the girls were sensible, especially when told daily to stay off the lake now the thaw had begun.

'Thank you, Mr Banks.'

To avoid water seeping into my boots, I made my way along the drive as the gardeners had pressed the snow down to form a path. I passed the red-brick wall enclosing the kitchen garden and stable yard, then turned right through the arch before the gatehouse, taking the path through the Italianate gardens to the lake. Keeping an eye on the ground, I stepped on the pressed snow, taking care to avoid shinier parts. Snow blanketed the surrounding hills and I could not wait to see daffodils and snowdrops, blossom on the apple trees in the orchard. Mrs Baxter had told me the woods by the lake would be carpeted with bluebells and I had pictured walking through those woods, my arm linked through the earl's. One could only dream of such a man taking an interest in me, and the news of his betrothal should assist with casting such thoughts from my mind.

The clippity-clop of horses' hooves brought me back to the present. I turned to see the earl through the arch, trotting towards the stables, with Rogers following. They didn't see me, but I stopped to admire the earl as he passed. He suited being on a horse, his back straight as he sat in the saddle, holding the reins in one hand, his boots with the brown strip at the top pushed into the stirrups. He disappeared from sight and I remembered my mission.

As I neared the lake I heard Emily call out, 'Help, somebody help us, please.' I picked up my skirts and ran, leaving the path and taking a short cut across the grass and through the orchard. Snow covered my boots, melting and trickling inside them, soaking my feet through my stockings. Sophie stood on the ice in the centre of the lake, as stiff as the scarecrow in the kitchen garden. The scene ripped at my insides.

'Miss Elliott, thank goodness you are here,' Emily said. 'Polly chased a duck onto the ice and Sophie went to fetch her. Now the dog has run into the woods and Sophie is stuck.'

A pair of ducks quacked around Sophie, oblivious to her plight.

'Do come off the ice Sophie,' I shouted, my voice echoing around the valley.

'Every time I move, it cracks. I am scared to fall through,' she said.

I turned to Emily.

'Get your brother, quick, he is in the stable yard. Tell him to bring a length of rope and Rogers, if they are still together. Hurry, go.'

Emily raced through the orchard, pressing footprints between the apple trees.

'Now Sophie, stay calm. Do not move,' I said. 'Emily has gone to get your brother.' Sophie sobbed. What could I do?

The ice cracked near Sophie and she screamed, stepping backwards. My only choice was to fetch the girl myself. I stepped onto the ice, praying to the Lord that it would not crack. Clutching the cross around my neck for a mere moment, I thought of Papa: *please help me reach Sophie and bring her back safely.*

'Do not worry dear girl, I am coming.'

She wiped her face with her sleeve, still sobbing, her shoulders shaking. I crept across the ice, remembering the dance lessons Mama had obliged me to take, doing my best to step lightly, heart thumping, my breath shortening. *Please, ice do not crack beneath Sophie or me.* I reached her and we embraced, Sophie trembling and sobbing in my arms.

'Hurry, you run back to the path. Go the way I came and I shall follow,' I said.

40

Sophie hesitated.

'I am too scared,' she said.

'You must go or we shall drown beneath the ice. Please, Sophie, I am right behind you.'

She stepped carefully and I followed, then I saw the earl running towards the lake, still in riding attire, with Rogers, who held a length of rope, and Emily following behind. Sophie broke into a run, clearly emboldened by the appearance of her brother and reached the edge of the lake safely. *Thank you, Papa.*

Before I had chance to join her, the ice cracked and I found myself in the water, so very cold. I kicked my legs, desperately trying to stay afloat, consumed by the fear that I would sink.

The earl called out, 'Miss Elliott. No! Wait.' I tried to grip the edge of the ice, so cold through my gloves, my fingers slipping. Rogers lassoed the rope over me and pulled it taut as if I were a deer being captured for supper. 'Hold onto the rope,' the earl shouted. I did as he said. He and Rogers used all their might to pull me onto the ice. Then the earl picked me up, and took me to the path by the lake. He gently laid me down on the ground and slapped me across the face, stinging my cheeks.

'Ow, that hurt,' I whispered.

'Stay awake, Miss Elliott. For the love of God.' The slap had been for my own good, but my face smarted from its intensity. 'Emily and Sophie, find Mrs Baxter and tell her to send Mr Banks for Doctor Braithwaite. Go on, I beg you, please make haste,' he said.

The girls ran ahead with Rogers following behind and the earl lifted me back up and carried me through the orchard, ducking under trees with low branches. I shivered through sodden clothes, my teeth chattering, fingers numb, but I relished the moment as

he held me, looking up at his flawless face, raw from the wind. So very tired, I closed my eyes.

The earl glanced down at me.

'Stay awake, Miss Elliott.' He quickened his pace, and I bumped up and down in his arms. 'Please, you cannot sleep.'

Fighting to keep my eyes open, I studied every part of his countenance: his furrowed brow, his regal nose, those brown eyes. But he was engaged to Lady Eliza and I would never be closer to him than at this very moment. We passed through the arch, then past the stable yard and the kitchen garden to the steps leading to the front door where Mrs Baxter stood, holding a blanket.

Chapter Seven

The following morning, I made my way to Jake's flat, eyeing a client at Sally's Salon through the window with envy, wishing I could still afford to have my hair bleached. The roots had grown out several inches since leaving London, and after a mishap aged fourteen when my hair went green, I would never dye it myself. On reaching the blue door next to Chipford Art Gallery, I pressed the intercom but there was no answer. Did I have the right address? I looked around, unable to see any other blue doors and tried again until Jake said, 'Hello' and buzzed me in. When I reached the top of the steep staircase, embarrassingly out of breath—I needed to go for a run and soon—he opened the door in tracksuit bottoms. He was bare-chested and clearly worked out as his torso was exceptionally toned in all the right places. His state of undress made me feel a bit awkward and I couldn't look him in the face. As if sensing my discomfort, he picked a T-shirt off the sofa and pulled it over his head.

'Sorry, Rachel, I overslept. Went out with an old school friend last night.'

'Okay, shall I come back later?'

'Of course not.' He ushered me into his flat, open plan with sofas to sink into and a big TV in the lounge area, and a kitchen in the corner with breakfast bar and stools. It was surprisingly

tidy, apart from a pile of dirty plates on the kitchen worktop. 'You can use the computer while I take a shower.' He approached a desk in the corner and logged in to a laptop.

'There you are. Did you go back in the loft?'

After he'd left the previous day, I took his advice, armed with a bigger torch than before, checking the trunk again but it was only filled with old clothes.

'Couldn't find a thing,' I said.

'Oh, never mind. At least we can eliminate that off the list of things to do. Fancy a coffee?'

He seemed keen to be involved with the use of the word 'we', but what was the real reason for this? Could he be bored, or was he hoping the painting would be an original and then he could share proceeds from the sale? I shouldn't be so cynical, but after Chris, I wasn't very trusting when it came to men and finances.

What had I been thinking of, lending him the ten thousand pounds left to me by Gran for investing in property? Chris had used it to top up his deposit at the last minute when the price of a house he was buying in Dorking went up, and I stopped him from being gazumped. Stupidly, my assumption had been that one day we'd get married, and my contribution was nothing compared to what he was paying. He allowed me to live there rent free, but the property was in his name, and when we split up, he said Gran's money should cover any rent due. This wasn't fair as we'd only been living there for around a year. Dorking was expensive, but not that pricey, and I'd paid for some of the bills and most of the food shopping.

'Yes, thanks.'

He put on the kettle and it boiled, making a din and so I made no attempt at small talk. For some reason conversation seemed more difficult than the previous day, perhaps because I was on

44

his territory? Or did he need the chance to wake up? I sat in the swivel chair, and pressed the lever to lower the height, then got the book, *Canaletto's Work* out of my bag. He placed a coffee with milk in front of me, clearly remembering how I took it from the previous day and we exchanged a smile.

'I'll leave you to it.'

He disappeared into the bathroom and I lifted the book open at the page marked by the Post-it, my plan being to google the companion painting. I typed, *Looking East from the North-West Corner Venice Canaletto* into the search box. The website for Galleria di San Marco, an art gallery in Venice came up and when clicking on the English translation of its description, it said the same as the book.

This painting was purchased from the Monte family in 1958.

I took the note out of my bag, and unfolded it. Who was the mysterious 'R'? I typed, *Country houses Chipford Cotswolds* and a link to Chipford Hall's website came up, a house owned by The Association of Treasured Properties (ATP). It was a ten-minute drive, according to Google Maps. I clicked on the link:

The Duke of Oxon's wife, Melissa, died in 1779 and they had a son, Rupert Wootton, Earl of Chipford as well as two daughters, Lady Emily and Lady Sophie. The earl married Lady Eliza Asquith in 1780 and was succeeded by two daughters. He travelled extensively across Europe and was particularly fond of Venice. The house is filled with works of art, Roman statues including one of Bacchus, and other artefacts transporting you back to the eighteenth century. We know little about the Wootton family and displays in the house

focus mainly on the Willowbys who purchased Chipford Hall
in 1890. The Willowbys owned the house throughout both
World Wars, and bequeathed the house and land to the ATP
in 1945, complete with its belongings, due to inheritance tax.

So 'R' could be Rupert. The note was written in 1782, after Earl
Rupert had married Lady Eliza Asquith, so was Philippa his
mistress? If I checked the family's coat of arms against the wax
seal on my envelope, this would confirm it was him. There was
no information about the coat of arms on the website, but
someone at Chipford Hall could probably tell me.

Jake came back into the room, dressed in jeans and a T-shirt,
rubbing his hair with a towel and smelling of a sweet scent,
sandalwood, I noted. Having grown up in a house where incense
and candles were always burning, I had become an inadvertent
expert on smells.

'Did you find anything?' he said.

Showing him the websites for the art gallery in Venice and
Chipford Hall, I told him what I'd discovered.

'Well, it would be nice to start our investigation in Venice,
but we'll have to settle for Chipford Hall. Shall I drive you
there?'

'You want to come with me?'

'Why not? The manager, Vera is back at the gallery this
morning, so I can take a couple of hours, if you like?'

Mum's car needed filling with petrol, so this worked well for
me.

'I'd need to get the painting on the way.'

'If you head back home now, I'll grab my car and pick you
up in a bit?'

'Okay.'

46

'See you in a minute, then,' he said, closing the door behind me.

As I went downstairs, it still niggled that he was going out of his way to help me, but he was probably a decent person who needed something to do. I mean, Chipford had driven me to immense boredom too. But I told myself to be careful in case he had an ulterior motive.

Chapter Eight

When I woke, a man was reading aloud. The words sounded familiar, Shakespearean perhaps.

Shall I compare thee to a summer's day? Thou art more lovely and more temperate.

A Shakespeare sonnet, number eighteen, a favourite piece. When I opened my eyes, a man, presumably the earl, stood by a candle on the mantelpiece, holding a book. The sound of his voice was intoxicating, deep yet with a certain softness, and my infatuation with this man showed no sign of lessening. While asleep, I had dreamt of falling through a gaping hole in the ice covering a lake. Or was I still dreaming? Crackles and pops came from the hearth, gargantuan flames casting light on two women, presumably servants as they added a blanket to my bed. Never had such a vibrant fire breathed life in a bedchamber of mine. The servants edged around the bed, tucking the blanket in as I shivered and brought forth a cough so intense it moved from my navel up to my chest. I was not at all well. One of the women leant over me.

'You are awake, dear Philippa, thank the Lord. We are doing

our best to keep you warm, as advised by Doctor Braithwaite. Maud will bring more logs for the fire.' The voice belonged to Mrs Baxter, a comfort at least.

Smoke from the fire drifted up my nose and into the back of my throat. The inside of my mouth was as dry as the skin on a foot squeezed into boots all winter and I needed to quench my thirst.

'Why are you all in my bedchamber?' My voice croaked and it did not sound like me, at all. The cough returned and my chest ached.

'Do you remember what happened at the lake?' Mrs Baxter said.

So it had not been a dream.

'Please may I have some water?' I whispered to save my throat.

'Allow me to fetch you some,' Mrs Baxter said.

She approached my nightstand and picked up a copper mug. I tried to sit up, but weakness prevailed. 'Could you assist me, Mrs Baxter?'

Putting down the mug, she took my arm.

'Maud, please can you help me with Miss Elliott?'

Maud took the other arm, and they put their hands behind my back to push me up until I was in a sitting position. Someone must have removed my wet clothes as I was wearing my nightgown. Mrs Baxter propped some pillows behind my neck, and felt my pulse.

'You have improved already. Take this.'

When she tried to hand me the mug, my right hand could not grip it.

'My fingers are tingling and my wrist hurts,' I said.

'You still need to recover from the frostbite, and it sounds as though you damaged your wrist when attempting to grip the ice.

49

We can ask Doctor Braithwaite to take a look in the morning.'
As she held the mug to my lips, I sipped and never had water
tasted so good.

'Doctor Braithwaite said you will feel cold, and there is a risk
of you catching a fever. Although the smoke from the fire
exacerbates your cough, we cannot open the window. Maud, can
you open the door momentarily?'

'Yes, Mrs Baxter,' Maud said.

'We shall take turns watching you for the rest of the night.
Thank heavens there are no house guests this weekend.'

She put the mug back on the bedside table, and I whispered,
'Thank you for all you have done, Mrs Baxter.'

'My pleasure, dear girl. You were lucky that his lordship and
Mr Rogers were able to rescue you, such heroes they were. The
pair of them being in close proximity was a blessing, otherwise
your fate could have been different indeed. Everyone in this
house has prayed for you tonight. Now you are awake, Maud can
ask Mrs Henderson for your soup.'

'Very well, Mrs Baxter,' Maud said, leaving the room.

'In the meantime, I shall remain here while Mr Rogers reads
to you, and we shall ensure the fire doesn't go out. Maud will add
logs when needed. His lordship has specified that you must be
given whatever is required. He is most grateful to you for saving
Sophie's life, and will visit you personally in due course.'

How presumptuous to think the earl was reading to me. But I
had been certain of my infatuation with the man who owned that
voice. Rogers was merely a friend, was he not? Mrs Baxter
approached the fireplace and pushed the logs about with a poker
before sinking into the chair by the window, clearly fatigued.

'Would you be so kind as to add another log to the fire, dear
nephew?'

Rogers put down the book and fulfilled her request then approached my bed, his silhouette on the wall above the fireplace. He wore breeches and riding boots, a white shirt, a cravat undone. Thick hair fell around his face, his wig absent and it was as if I were seeing him for the very first time. Through the dim light, his hunched shoulders and countenance reflected concern.

'Is Sophie all right?' I whispered.

'Sophie remains unscathed thanks to your bravery, Miss Elliott. You put yourself at risk and the Chipford family is forever in your debt.'

'Thank the Lord,' I said.

'We have been concerned for your welfare. Do you remember us keeping you awake until Doctor Braithwaite came?'

A blurred vision of Doctor Braithwaite leaning over me came to mind. I remembered him being closer than a gentleman should be, his ear pressed to my chest, presumably to listen to my heartbeat.

'How long have you all been here?'

'A few hours.'

Perhaps I should not have been in the library, perhaps I should have collected the girls from their dance lesson.

'I was in the library when I ought to have been waiting for the girls,' I said.

'You are quite mistaken, Miss Elliott. The girls finished their dance lesson early this week because the teacher had an appointment in the village. They should have gone straight in to luncheon. Instead, they chose to feed the ducks unsupervised when they have been told many times not to go near the lake when it is frozen. You are not responsible for their folly.'

'Children are entitled to be foolish. As their governess, I should always think of them before myself.'

'Guilt will not assist your recovery, Miss Elliott. Everyone in this house knows you care for those girls as if they were your own. Now, it is time for me to retire so I can attend to his lordship when he wakes.'

'Thank you for reading to me, Mr Rogers.'

'You are welcome. Doctor Braithwaite said you may be bedridden for several days and I shall select some books for you from the library. Mrs Baxter will tell me when to visit tomorrow.'

'I shall look forward to it.'

'Until then.'

He placed the book on my nightstand and left the room, holding a candle.

I spent a fortnight confined to my room, bedridden most of the time. For one day and one night, I endured a fever and Mrs Baxter kindly arranged for maids to take turns holding a damp cloth to my forehead. They said the fever made me delirious and I mumbled rubbish, speaking to my father as if he were present. Afterwards, my cough persevered and I followed Doctor Braithwaite's advice to remain warm and drink hot fluids. Rogers brought a pile of books, including *Gulliver's Travels, The Merchant of Venice*, and *The Canterbury Tales*. There was plenty to keep me occupied.

During the second week, I would move to the chair by the fire and read one of the books, or sit at the writing table in front of the window, studying the rolling hills, the fields green now the snow had cleared. Trees lining the drive boasted pink blossom and spring came. I would watch Home Farm deliveries and letters being delivered to the servants' entrance. Papa's replacement, Mr

Brigstock visited often and on occasion the earl would ride into Chipford with Rogers to visit Mr Wicks. During the second week, on hearing the clippity-clop of a horse's hooves, I would shuffle to the chair at my writing table to see who it was. This trifle of excitement broke up the endless hours of lying in bed.

Maud brought meals and took care of the fire and although I failed to entice her into conversation, her presence was a comfort. Mrs Baxter sent Rogers up with my letters once a day with Maud as chaperone, using the time to rebuild the fire and sweep the floor. I regained the feeling in the fingers of my right hand, but my wrist was slow to recover, and Doctor Braithwaite wrapped it in bandages, advising me to refrain from writing. Rogers kindly offered to write my letters, and he would sit at the writing table, with his back to me, a back broad and strong, the queue from his wig resting on his neck whilst I dictated replies. This kind endeavour made me feel above my station.

One afternoon, not wishing to worry Mama, I asked him to inform her of what had happened at the lake, but to reassure her I had almost recovered.

'It will not be long before you are back in Mrs Baxter's parlour with us,' Rogers said, turning around to face me, and I recalled my reaction to his voice when waking up after the lake. Seeing him in this new light confused me.

'I very much look forward to spending time with you both again,' I said.

'You have been greatly missed,' he said. And then he took a deep breath, adding, 'Especially by me, Miss Elliott.'

His eyes as blue as the sea on a warm day locked with mine and caught unawares, all I could do was take a sip of water from the glass on my nightstand. It was clear he liked me more than I had previously thought and I was flattered, for he was a good

53

man, and rather handsome. But what kind of future would we have in this house? Surely, servants were not encouraged to have romantic liaisons? For now, all I could do was enjoy his company when the opportunity arose.

Emily and Sophie brought handkerchiefs they had embroidered with daisies and buttercups respectively, and they read *The Misanthrope* aloud in French, knowing this pleased me. The earl had replaced me, temporarily they insisted with a French woman, Madame Dubois, an old spinster who was very strict. She had a rasping voice, and they called her 'The Dragon' out of earshot. I urged them to refrain from disrespecting their elders, and they urged me to recover quickly so they could banish her from Chipford Hall.

'They much prefer you,' the earl said when he finally visited with Maud one afternoon during the second week. He stood looking out of the window, hands clasped behind his back and as I studied his profile, the chink in his nose endearing, I questioned my reaction on waking after the lake incident. I had been certain of my infatuation with him, but Rogers had been reading to me. Which one of them did I like more?

'That is kind of you to say, my lord, although they will benefit from the tuition of a native French speaker.'

'Since you saved Sophie's life, and I, along with Rogers, saved yours, you may address me as Earl Rupert.'

'Thank you, my lord.' He glared at me teasingly, then smiled. 'Earl Rupert,' I corrected myself.

He approached the hearth and addressed Maud, who was polishing the surrounding tiles.

'Would you be so kind as to add more logs to the fire?'

'Certainly, my lord,' she said.

She stood up and he studied her as he had me that time in the library, and I pushed a pang of envy out of my mind. Maud was rather pretty, after all.

'I am not aware of your name, young lady,' he said.

'Maud, my lord,' she said, looking at the floor, her voice wavering.

The poor girl seemed unnerved by their encounter as he could be intimidating to someone in her position.

'Thank you, Maud,' he said, his eyes following her as she went about doing as he had asked. He went to sit in the chair by the window and proceeded to read a passage from *King Lear*, a miserable but compelling story he seemed fond of. Our discussion of the text afterwards made the hands on the clock move faster. Before he left that day, he said, 'Do you know, Philippa, I am enjoying your company immensely.'

'Thank you, Earl Rupert,' I said. 'And I am grateful to you for visiting.'

'There is something rather endearing about you,' he said. My cheeks warmed at his compliment. I wondered why he was being so attentive all of a sudden and did not know how to respond. And so I said nothing. He left shortly afterwards, and returned a few days later, with Maud as chaperone, to read further passages. She brought us tea and cake, laying it out on a trestle table by the window with a white cloth and napkins, and I observed them exchange a smile as she poured the tea through a strainer into his cup. My period of recuperation had at least brought her the gift of confidence, I noted. When I joined him at the table, instead of launching into a discussion of the text, he said, 'How long must you remain in this room, Philippa?'

'Doctor Braithwaite will visit tomorrow, hopefully for the final time,' I said.

'Let us pray for good news,' he said. 'And when you are ready, we shall go for a walk as I have something to show you.'

'I shall look forward to that, Earl Rupert,' I said, curious to know where we would be going and what his intentions were.

Chapter Nine

It was one of those chilly winter-becomes-spring days and Jake turned up the heating in his car to full blast. The sky was a deep blue and I dug around in my bag for sunglasses and put them on. The road meandered through woodland where light dappled through gaps in tree branches. We passed fields of grass, a luscious green from the recent bout of rain and dotted with sheep and lambs, and I spotted a nice-looking pub displaying a sausage and mash special on its board outside.

'What do you think they'll say when we turn up?' Jake said.

'They could tell us we're wasting our time.'

'Or they could say the painting stands a chance of being an original.'

His optimism was strangely infectious and being around him was bound to be good for me. Before he turned up with the Canaletto book, I'd been unable to motivate myself to do much for days.

'Maybe you're right.'

Following the brown sign, Jake took a left and we reached black and gold gates marking the entrance to Chipford Hall.

'This brings back memories,' Jake said.

'You've been before?'

'I grew up in Chipford, so yes. My mum used to bring me here after school in the summer and we'd eat ice cream on the deckchairs overlooking the valley.'

He sighed, and I detected a sadness in his voice when he mentioned his mother but didn't know him well enough to probe further. We parked and I got the painting out of the boot, still in its carrier bag. Jake kindly bought me a ticket along with his without asking, and I thanked him. We followed a series of paths, past a kitchen garden, through an arch, past stables, until we reached the house, built in Palladian style from sand-coloured stone and with immense pillars at the front. Steps led to the front door, and we passed through the entrance into a Grand Hall with marble flooring and walls painted in a deep-red colour. A portrait of a man in red soldier's uniform caught my eye at the bottom of the stairs and a lady of retirement age, wearing an ATP lime-green fleece and matching lanyard approached.

'Can I offer you a map of the house?' she said, holding out a leaflet with a shaky hand, and I took it. The lanyard said her name was Betty.

'Thank you, we're here to talk to someone about a painting.' I went on to explain.

'That sounds interesting, dear. Let's call Mike, the house steward.' Betty detached a radio from her belt, and spoke into it.

'There are some important visitors for you, Mike. Over.' She waved us to a sofa in front of the fireplace.

'Do you think he'll laugh at us?' I said to Jake as we sat down.

Jake smiled, and I was glad he was with me. There was no way I'd have done this on my own, my confidence severely lacking lately.

'I don't think so.'

Before long, a man appeared through a side door, dressed in a suit, and Betty directed him to us.

'I'm Mike. How can I help?'

We stood up, and he shook our hands.

'I'm Rachel, and this is Jake, and I've found what could be a potential Canaletto, possibly once owned by Chipford Hall, in my loft.'

He glanced at the carrier bag I was holding and sucked air through his teeth.

'Why don't you come into my office?' His flat tone of voice implied people often came out of the woodwork clutching false clues about the history of the house.

He led us through a door, marked 'Staff Only' into a magnolia hall with thin grey carpet and we went into a tiny room with a couple of computer monitors and swivel chairs. Shelves of books lined the walls, on history, art, the ATP. Mike gestured for us to sit down and I got the painting out of the carrier bag and passed it to him. He studied it and nodded.

'We get a few people coming in with objects relating to the house, but this one has potential. Caroline, our art expert is on annual leave so won't be in until next Sunday and you can see her when she's back. Why don't I hold on to the painting until then? We can put it in the safe.'

Jake tapped my ankle with his foot and shook his head.

'I'd think carefully about leaving it here,' he said.

'You do realise this painting needs to be locked up?' Mike said. 'Even though you don't know whether it's an original yet.'

Of course, once word got out, I could have art thieves or crime organisations trying to get their hands on it, but Jake was right. Did I want to leave it here? I pulled a face, not knowing what to do.

'There's a safe at the art gallery, if that helps,' Jake said.

'That's a nice offer, thank you. Let's do that,' I said.

Mike handed me the painting, and I put it away.

'So, if that's all, I'll see you out.'

I didn't want to leave without finding out more about the earl, and remembered the note.

'Oh, hold on, there's a note as well,' I said.

'Do you have it with you?' Mike said.

I handed the note to him and he read it.

'This is good stuff,' he said, stroking his chin.

'Do you think 'R' is Earl Rupert?' I said.

'It could be,' he said.

'There's a coat of arms on the seal,' I said, and he studied the back of the envelope. 'How would I check to see if it's from this house?'

'Daphne, our tour guide would know,' he said.

'How do I contact her?'

He gave me the envelope back.

'She's here most days, but covering someone at Seeley House on Tuesdays at the moment.'

'Okay. While we're here, can you direct us to more information about Earl Rupert?'

'If you look around the house, you'll see our "house story"— a term the ATP likes to use—is based around the Willowby family who owned Chipford Hall during the World Wars. We try our utmost to cash in on what I like to call "The Downton Effect".'

'Hasn't *Downton Abbey* finished?' I said.

'Its popularity is likely to continue for a while, especially now with the films. The general public remains obsessed with the

Downton era for some reason along with World War II. Other eras don't seem to garner as much interest.'

'So, what do you know about Earl Rupert?' I said.

'The portrait in the Grand Hall of the man in the red coat is of him.'

'Anything else?'

Mike scratched his head.

'There is information which might reveal more, but we haven't read it yet.' He opened a drawer in his desk and took out a set of keys. 'Follow me.'

When we went back into the house, the contrast between new and old was striking and it was as if we were walking onto a film set. Mike took us back through the Grand Hall where I snapped a photo of Earl Rupert's portrait, flash switched off, as ordered by Betty, and we passed the statue of Bacchus mentioned on the website. A broad muscular man held a goblet in one hand and a bunch of grapes in the other. Mike led us down a narrow corridor to a library, where sun streamed through the window, lighting a gold rug.

'This rug is a replica of the original, but the wall covering dates back to 1765. Don't touch it. The oil from your fingers will make the silk damask deteriorate further,' he said as if switching to tour-guide mode. Then he pointed to a bookcase, protected by glass doors with keyholes. 'These books are journals written by Earl Rupert and his father, the Duke of Oxon on their Grand Tours. The assumption is they haven't been read by anyone in over two hundred years. It's on our list of things to do, with other tasks outranking it, unfortunately.'

Surely any clues about the painting would be in the earl's journals?

'How about if I read them?' I said.

'If you don't mind me asking, what's your background?' Mike said.

'Mainly selling insurance, but I do have a history degree.'

'You're welcome to, subject to references, but only when the house is open to the public, at the writing table, here in the library. The duty manager would need to unlock the case before you begin and we'd need to cover the writing table with something. Perhaps you'd like to be our eighteenth-century volunteer and make notes for a new display? We can offer you ATP membership and a discount in the shop and café. I suggest three days per week?'

The discount would be handy for birthday cards and my coffee habit, but three days unpaid seemed a bit much. While trying to work out how to avoid doing three days, I looked at Jake.

'Don't forget Peaches and Cream,' he said.

'Oh yes, although I haven't applied for that job yet.'

'You'll get it.'

'Mike, do you mind if I have a quick word with Jake?'

He nodded, and approached an elderly couple who were studying the photographs on the desk, proceeding to give them a rundown of who everyone was.

'What if I don't get the waitressing job?' I said.

'You've waitressed before, right? If you volunteer here for three days a week, that's limiting your earning ability.'

'You're right.'

Mike stood by the door, looking at his watch.

'I can only do one weekday, Mike. Is that all right?'

'Okay, shall we put you down for Tuesdays, starting next week, when the house opens from eleven until three?'

'That works well. What about seeing Caroline next Sunday?'

'Bring the painting in and she'll be here.' He looked at his watch. 'Right, I'll see you both out as there's a staff meeting shortly. Come to my office at half past ten on Tuesday, Rachel. There will be some forms to fill in, naturally, and I'll need names of your referees.' He led us back to the Grand Hall and shook our hands.

Betty came over. 'How did your meeting go?' she said.

'Rachel will be volunteering here on Tuesdays,' Mike said.

'How wonderful. We look forward to having you with us,' Betty said, before approaching a couple coming through the door.

'Can I tempt you to do some volunteering, Jake? A spot of gardening perhaps?' Mike said.

Jake laughed.

'Thanks for the offer, but I already have two jobs.'

'Fair enough. Have either of you seen the bluebells yet?' he said.

'No,' I said.

'They're really quite stunning. A chance to impress your girlfriend.' He winked at Jake.

'Oh, we're not together,' we said in unison.

'We're friends,' I added, my cheeks warming.

'Well, you could have fooled me,' Mike said. 'Don't miss out, they won't be around for long. See you on Tuesday, Rachel.' He went back into the staff quarters and we walked to the car, silenced by Mike's assumption. It would have been nice to see the bluebells, but I couldn't suggest that after what he'd said. We made our way back to the car park.

'A worthwhile trip,' Jake said.

'Indeed.'

'So you have a history degree?'

'Yes, but I haven't used it since graduating.'

63

'Well, maybe this is your chance.'

I hadn't done anything relating to my knowledge of history in years but the idea of being the first person to experience reading the earl's journals was quite exciting. After getting a job at Here for You Insurance on graduating, the long hours and constant targets had meant I was always too exhausted to even contemplate changing career.

'You're right. It will be nice to do something I'm interested in, even if it is unpaid.'

'But who knows what it might lead to? Sometimes, all you have to do is get your foot in the door and prove yourself.'

We crossed the car park. Getting a paid job at Chipford Hall would be a dream, and I couldn't believe the thought of working for the ATP hadn't occurred to me before. The only thing was Mike might not be the easiest boss to work for as he seemed quite cold and moody, and I wasn't always good at playing the game at work. My colleague, Sue, at Here for You had told me that if I sucked up to the bosses like she did, I'd stand more of a chance of being promoted. We reached the car and Jake started the engine.

'Yeah, who knows?' I said.

For the first time in ages, I was optimistic about my future. Finding the painting and subsequently meeting Jake had somehow set wheels in motion to get me out of the rut I'd been in.

'Would you like me to put the painting in the safe when we get back to Chipford?'

'Yes please. Thanks for stopping me from leaving it there.'

'No problem,' he said.

Why was Jake doing all this for me? He seemed a decent enough bloke and perhaps he was only trying to help. But the

thought lingered that although I didn't think he'd run off with the painting, was he offering to help in case he got some of the proceeds from a sale, if it did indeed turn out to be a real Canaletto?

When we got back to the art gallery, Jake led me down to the basement. I took a photo of the painting and note before he placed them inside the safe. He closed the door, twisted the dial and wrote on a piece of paper.

I, Jake Holmes, declare that I am holding a possible Canaletto painting and accompanying note owned by Rachel Brown in the Chipford Art Gallery safe, and will return the painting whenever Rachel requires me to.

'It's not exactly a proper legal contract, but hopefully it would hold up in court,' he said, handing the note to me.

I read it, impressed he'd remembered my surname from the day we met. We went up the stairs and into the gallery.

'I'm sure it wouldn't come to that anyway.'

Again, the thought of him letting me down niggled, but where else would I store the painting?

'Only my dad and I can open the safe,' he said. 'Do you want my mobile number as I'm going back to London tomorrow?'

'Okay.'

I handed him my phone, and he tapped in his number.

Giving it back to me, he said, 'Ring me now and then I'll have yours.' I did just that. 'I'll be back on Friday night so you can get your painting before going to see Caroline on Sunday.'

'That would be good, thanks.' He walked me to the front door, and folding up his note, I said, 'Bye then.'

'Bye, Rachel. And I hope you get the waitressing job, then you can give me a discount.' He grinned. 'I'll text you on Friday.'

We stood there for a moment, looking at each other awkwardly, and Mike's words about the bluebell woods came into my head and I pushed my hands into the back pockets of my jeans, racking my brain for the right thing to say. The gallery's landline rang, saving us both and he rushed to the counter. I walked down the high street, without the painting and the earl's note, but now I had one from Jake.

Chapter Ten

On Saturday, after Doctor Braithwaite gave me permission to resume my role as governess, Earl Rupert invited me to take a walk while the girls had their dance lesson. We met in the Grand Hall, beside his portrait. As I walked out of the main door and down the steps, I saw the land in all its glory for the first time. During my confinement, new-born lambs had arrived, and they waddled in the field beyond the ha-ha, the cacophony of bleating breaking any silence the snow had brought. Lukewarm air brushed my face as we walked along the drive, its edge bordered by trees bursting with pink blossom, crocuses circling their bases. Birds tweeted the arrival of spring as they darted in and out of trees and daffodils sprang from the grass, their yellow heads looking in all directions.

Earl Rupert led me through the stable yard towards the path behind the house and beyond the lake. My breath shortened and I coughed. Doctor Braithwaite had said the cough would remain for some time and I needed to avoid being outside in cooler temperatures and to ensure I ate and slept well. He had recommended a visit to the sea, but I could not take any more time off. I stopped to retrieve a handkerchief and coughed into it, producing a lump of phlegm.

'Are you all right, Philippa?' Earl Rupert said.

'The thought of returning to the lake fills me with anxiety and, as this cough persists, perhaps I ought to return to the house?'

'My dear, it is best to get back on a horse as soon as you can when you have fallen off it. Besides, we shall only pass by the lake en route to elsewhere and the fresh air will do you good.'

Bracing myself, I started to walk again, focussing on the flora and fauna, admiring purple rhododendron bushes as bees hovered over them and azaleas, a shock of red blooms along with the reflection of trees in the lake. We passed a magnolia tree bursting with flowers, shaped like little teacups as they were only slightly open, their petals a delicate pink, rising up towards the sky. Although I appreciated their sweet scent, it tickled my vulnerable nose and sniffing, I stifled a sneeze.

'This summer, we shall build a grotto twenty feet high with a waterfall there, opposite the boathouse. A path will encircle the entire lake and more trees will be planted, especially those bringing colour in autumn and spring. Only then will our lake be grander than my neighbour, Lord Tankford's.'

'I look forward to seeing it,' I said.

The ice sheet had melted, and glancing at the spot where I fell in that day sent a shudder through my whole being. A swan landed on the water with a whoosh, ducks quacking as they scattered, wings flapping. I did not blame Sophie for what had happened as she was merely a girl of ten years, and her judgement had been affected by Polly. But how could I avoid reliving that day for the rest of my time at Chipford Hall?

The earl proceeded uphill and we left the lake behind us. It was a joy to be released from a bedchamber reeking of smoke from the constant fire in its hearth. That morning, with Maud's assistance, I had washed my hair to remove the unpleasant odour.

'Come, Philippa. I have a surprise to celebrate your recovery.'

He approached a stile and climbed over it into Hunters Field. As I hitched up my skirts, he took my hand and helped me to the other side, onto the long grass. We approached the woods, past a huddle of brown cows, dew dampening my stockings above the line of my boots. He opened a gate and I passed through. When he closed it, fastening the bolt, something rustled in the undergrowth, and a deer ran away from us. Wild garlic monopolised the air, and I crouched down to pick one of the long green leaves, holding it under my nose, savouring its raucous scent. I had ventured into those woods before with Emily and Sophie, when snow had covered the ground and dropped in splats from the trees. Now, snowdrops sprouted, a brook babbled nearby, and a chaffinch called, 'chip chip chip, cherry erry erry, cherry erry eee' from the silver birch above. When we turned the corner, we were gifted a carpet of bluebells, a purple haze.

'How magnificent,' I said.

'Remember, I promised?' Earl Rupert said.

He retrieved a basket from behind the trunk of a pine tree, beside a small clearing.

'Where did that come from?' I said.

'Mrs Henderson put together a selection of cakes and one of the maids brought the basket here this morning.'

Clearly, I was not the first woman to be treated to this grand gesture. No man of the earl's stature had paid me attention before and I melted, like the snow blanketing the ground only days earlier. He spread out a blanket, and gestured for me to sit down. I picked up a pine cone and turned it in my hand, planning on taking it as a keepsake. As I ran my fingers over the scales, perfectly formed like a series of wings, the ends sharp to touch, the earl said, 'Before we eat, I have a proposition.'

'Go on.'

'While you were bedridden, I thought about how to repay you for saving the life of my sister.'

'There is no need,' I said.

'And as I enjoyed the time spent in your bedchamber, reading and discussing *King Lear*, I have decided to make you an offer.'

'What is it?'

'With my nuptials being only weeks away, I would like to suggest you become my mistress, with my setting you up with a house in London.' Dumbfounded by his sudden proposition, I wrapped my fingers around the pine cone and looked away, lost for words. 'A penny for your thoughts, Philippa?'

What was he thinking, making such an offer to a woman like me?

'It would be immoral for me to become your mistress. Do you not recall my father's occupation?'

'I understand this is a big decision for you, and perhaps you should mull over my suggestion?'

Nothing would change my mind.

'No amount of mulling will make me your other woman.'

'I must divulge where the idea came from. After my nuptials in June, Lady Eliza will appoint Madame Dubois as governess to my sisters as she does not want a young, desirable woman to spend so much time in the main house.'

Any other time, it would have been flattering to be referred to as desirable by a man like the earl, but I was to be ousted, with the offer of becoming his mistress as compensation. Why would I want to own a house in London under immoral circumstances? For a moment, I allowed myself to picture the walks, the theatre, art galleries, allowing myself to dream of what my life could be, but no, Earl Rupert could not have me. Not like this.

'In that case, I shall seek another position immediately. I can leave in the morning to stay with a relative.'

'That will not be necessary. Please reconsider my generous offer.'

'My mind is made up, I am afraid.'

'If you insist on declining, at least remain at Chipford Hall until June and allow me to secure you another position. I feel responsible for your welfare, and after you saved my sister at the lake, I am in your debt.'

Did he really care about my welfare?

'No, my lord.' I reverted to addressing him formally. 'I am quite capable of finding myself a position. However, a reference would be gratefully received. Please inform your sisters on my behalf as' —I put a hand on my chest— 'it would break my heart to do so myself.'

Standing up, I cast the pine cone to the ground and walked away from the woods, away from the bluebells, and away from the earl.

'As you wish,' he called after me.

That night I wrote letters in my bedchamber to my sisters-in-law, to aunts and cousins, to friends. Writing so many letters made my wrist ache as it was more sensitive since the lake incident and I wriggled my fingers and moved my hand in circles clockwise then anticlockwise in an attempt to relieve the pain. In the letters, I asked if anyone knew of a live-in position as schoolteacher or governess starting as soon as possible. After reading one of Papa's sermons on self-control and saying a prayer, I cried myself to sleep, clutching a handkerchief, tears dampening my pillow.

The next morning, I breakfasted on pancakes with Mrs Baxter in the parlour, and Rogers joined us, to sew a button onto one of the earl's jackets.

'It is good to have you back, Miss Elliott,' Rogers said, threading a needle.

I studied him as he concentrated, thinking back to my reaction to his voice when waking from the incident at the lake. His quiet confidence was assuring and I trusted him implicitly. This was a man who, unlike the earl, would never let me down. But now I was leaving Chipford Hall and we would no longer see each other.

'Thank you, Mr Rogers, and I am grateful to you for bringing me books, and for writing my letters.'

'It was my pleasure to assist you during your time of need. Are you now recovered?'

'Apart from a lingering cough, my health has greatly improved, thank you, Mr Rogers.'

Mrs Baxter read out a letter from her niece, Fanny Smith who worked in the kitchen at Heybury House in Surrey. The snow had not yet cleared because the house backed onto the Surrey Hills. Items of jewellery belonging to Lady Cordelia Heybury had gone missing, and all below-stairs were under suspicion. The servants worried about being wrongly accused of stealing, because it would mean dismissal without a reference, and having a thief in their midst was a concern for all. Fanny hoped the culprit would be discovered soon.

Rogers used a pair of scissors to snip the thread and returned the sewing items to a tin. He stood up and cleared his plate.

'Your needlework skills are to be admired, Mr Rogers,' I said.

'One day I wish to fulfil my dream of becoming a tailor,' he said.

'And that day will come, dear nephew,' Mrs Baxter said.

'I wish you a good day, ladies, as I must accompany his lordship into the village.'

'You are visiting Mr Wicks?' Mrs Baxter said.

'We are, dear aunt, but soon preparations for his lordship's nuptials will be complete. Then perhaps we shall not need to visit quite so frequently.'

'Good day, Mr Rogers,' I said.

He threw me a smile as he closed the door behind him and I reciprocated. It struck me that the hardest part about leaving Chipford Hall would be the loss of his company. A vision of him taking me into his arms flashed before me, and although Mrs Baxter could not read my mind, this left me a little flustered and I fidgeted with my napkin.

'Do you know about Mr Wicks, Philippa?'

'Only that he is the village tailor.'

'He wronged my brother.'

'Mr Rogers' father?'

'Yes, my brother was a tailor for many years in the village but made an ill-judged investment with Mr Wicks, a shrewd businessman.'

My heart melted with empathy for Rogers, and his father as well.

'It must be difficult having to visit him with the earl.'

'Indeed. One day he hopes to earn enough money to buy back the business and manage it himself.'

'What happened with the investment?'

'Mr Wicks persuaded my brother to invest every spare penny he had in a shipment of silk, promising there was a fortune to be made. But the ship failed to reach British shores and so my

brother was forced to give up his business. Mr Wicks was more than willing to take it from him as you might imagine.'

'What a terrible story.'

'The only consolation is that my nephew is more determined than ever to buy the business back, achieving his dream of being a tailor. Fortunately, he was able to secure his father the position of footman at Seeley House, although the role is sadly beneath a man of his age and experience. The humiliation of the whole episode has impacted his father's health and he is not the man he once was.' There was much to admire about Mr Rogers, someone who cared deeply about his father, but also a man who was driven to succeed and any woman would be lucky to become his wife. 'Now, let's have another cup of tea and I shall tell you about my dear niece, Fanny, who makes me so proud.'

Beaming, she picked up the teapot and filled our cups. I added the milk and gave my tea a stir.

'Now, Fanny is being taught to read and write by one of the teachers at Heybury's school for the poor. She makes cakes as payment, using ingredients provided by her teacher. Until recently, the housekeeper has read and written letters for her, but now she is able to read the letters herself and only needs assistance with writing.'

It dawned upon me that I could ask about a teaching position in that school. If only I could tell Mrs Baxter about my predicament, but I did not wish to inadvertently reveal Earl Rupert's proposition made in the bluebell woods, despite his poor judgement. All I could do was remain patient, and see if my letters yielded results. She removed her spectacles and put them on the table.

'Speaking of Heybury House, did you know the Heyburys will be our guests this weekend?'

74

I recalled that Lord Heybury was the man who had saved Earl Rupert's life.

'No, I was not aware.'

'Have you heard much about Lady Cordelia Heybury?'

'You mentioned she is a bluestocking.'

'Lady Cordelia writes novels and has been to Europe with her husband, the baron. She is always pleasant towards us below-stairs and I cannot imagine why anyone would steal from her.'

'She sounds like an inspiration.'

'Oh, yes, she is living the life we would all like to live,' Mrs Baxter said, tipping her head to one side, wistfully.

Chapter Eleven

When I woke the next morning after sleeping like a log for the first time in ages, I didn't want to leave the warmth of my duvet as the heating hadn't been on and it would be chilly. Built in 1750, the house was badly insulated and the old sash windows made it draughty. When I reached for my phone, a message from my bank had made its way through the poor phone signal—ooh, there were two bars—to say I'd gone over my overdraft limit again and would be charged, prompting me to remember Peaches and Cream. Would there be anyone there on a Sunday?

I pulled on my dressing gown and went downstairs to make a mug of tea, and returned to the warmth of my bed, then googled Peaches and Cream and gave them a call.

'Melanie speaking. How can I help?'

A coffee machine gurgled in the background.

'Hi, I heard there might be a waitressing job going?'

'Do you have any experience?'

'Yes. I've worked at Pizza Town in London.'

'Okay good, we have one position available. Why don't you come in at one o'clock and ask for Melanie? I'm the manager, and we'll do an interview.'

'That would be great, thanks.'

'What's your name?'

'Rachel Brown.'

'See you in a bit.' She hung up.

After weeks of moping about, I was getting my act together and my life was beginning to have purpose again. I got dressed and loaded the washing machine and put clothes from the drying rack into my drawers. A strange desire to clean overwhelmed me, and I hoovered downstairs and mopped the kitchen floor.

When it was time to leave, I grabbed an umbrella as it was pouring with rain. Despite the weather, Chipford's narrow pavements were congested with people out for Sunday lunch, leaving me to step into the road to get around pushchairs and pensioners, raising my umbrella above theirs. A traffic jam blocked the high street due to the zebra crossing being almost permanently occupied and the market was in full swing under the columns at Market House with traders shouting about their wares. On passing Chipford Art Gallery, I spotted Jake with a customer and thought about how I'd got to know him over the past few days. He was all right and maybe seeing him when he returned the following weekend would be something to look forward to.

On pushing open the door to Peaches and Cream, I was confronted with a queue of people waited to be seated. Red leather banquettes lined the edge of the room and wine bottles with candles pushed into them decorated the tables. The speakers played Ed Sheeran and combined with the chattering of customers and the tiled floor, it was a noisy place to be, but as close to the buzz of the restaurants lining Battersea Rise as Chipford was likely to get. As I hung up my coat and pushed my umbrella into a stand, I saw a few tables needed to be cleared and a man waved his credit card at a waitress as she sped past with garlic bread. The place was in chaos.

Making my way around the queue, I approached the counter where a lady with dyed-red hair in a bob spoke on the phone, while writing in a notebook, 'Two for eight o'clock tonight. What's your mobile number, please?' Her badge said *Melanie, Manager*.

Worried that the couple at the front of the queue would think I was pushing in, I put my CV in front of her and she smiled at me as she wrote down a booking and hung up.

'Ah, Rachel?'

'That's me.'

She put the CV under the counter.

'Thank goodness. Since our waitress, Sophie, walked out, this place has fallen apart. Would you mind doing a trial shift now?'

'Just tell me what to do,' I said, eager to get stuck in.

She handed me a tea towel.

'Tuck that into your back pocket.' I did just that, and she handed me a notepad and pen. At Pizza Town, I'd used a machine, and this was a novelty, but it couldn't be too difficult, surely?

'You're on Section One over there by the kitchen. You'll find table numbers on the map by the coffee machine. The specials are on the chalkboard and keep checking with Chef, Jean-Claude, about how many are left. He can get stressed, so tread carefully with him and don't wander into his kitchen without permission. Don't promise a special to someone if he's run out or he'll bite your head off.' The phone rang and more people came through the door. 'If you've worked at Pizza Town you should be able to work everything out. Good luck!' Melanie picked up the phone.

After clearing the tables, I approached the queue and seated four women and two couples. Then I took their orders. Four Caesar salads, a bottle of sparkling water, two Cokes. The couple

wanted the monkfish and a jug of tap water. I took the slips to the kitchen hatch and placed them on the counter. A chef wearing a tall hat, presumably Jean-Claude shouted at two sous-chefs.

'No, that steak is supposed to be medium rare. Do it again. They wanted sweet potato fries, not chunky chips. I need two portions of deep-fried courgettes and an onion rings. Now!'

He approached me and, as he got closer, I saw he was attractive in a mean and moody way. The man had presence.

'And you are?'

'Rachel.' I smiled, and he didn't reciprocate, but he looked me up and down with his hazel eyes and he had thick, dark lashes. 'These are my orders.'

I pushed the slips towards him and he glared at me.

'This order is for two monkfish.'

'I know.'

'Nadia has just put in an order for two monkfish, so there's only one left.'

'Oh, sorry.'

'The number of times I have told Melanie about this.'

It wouldn't have happened if they had a more up-to-date system, but it wasn't the time to say this. I picked up two menus.

'Don't worry. I'll ask them to order something else.'

He shrugged.

'I am not worried. It is you who looks like the imbecile.'

I went back to the couple, and they changed their order without minding at all. Returning to the hatch, I amended the order slip.

'Sorted,' I shouted over to Jean-Claude. He came over.

'They did not care?'

'One of them is having risotto instead.'

'Well, okay. Thank you, Rachel.'

Again, he didn't reciprocate when I smiled at him, but for the first time in ages, it was good to feel useful again. I delivered drinks to the tables, then sliced a baguette and threw it into baskets. As I distributed the bread with butter bowls, everyone in my section seemed happy, and I cleared tables in another section, taking dirty plates and glasses into the kitchen, dumping them by the pot wash. Jean-Claude shouted at a sous-chef, 'No, that burger bun is burnt. Make another. This béarnaise needs more salt.'

'Yes, Chef,' he said.

After a couple of hours, the customers on my section had left and I approached Melanie.

'Great work, Rachel,' she said. 'Can you fill in this form while you eat? And make sure you put down two referees. We need you to start tomorrow.'

'I've got the job?'

'Yes, and you've earned it.'

Relieved, I took the form, intending to put down my former bosses at Pizza Town and Here for You as references as I'd planned to do for the volunteering role at Chipford Hall. They'd wonder why I was suddenly so active.

'Why don't you choose one of the specials and have lunch over there? Nadia's got clearing up to do, but Chef will keep you company.'

She pointed to a table where Jean-Claude sat. I went to the hatch and asked for penne with gorgonzola sauce, then pulled up a chair at his table, hoping he'd be nicer now his shift had finished. He worked his way through a bowl of mussels, using a shell as a pincer.

'Sorry about the monkfish fiasco,' I said.

'It was not your fault, but we do need to keep count of the specials. I shall bring it up with Melanie in our next meeting.'

I pushed my fork into the penne. Although the sauce was rich with more cream than I'd include, it was delicious.

'You like my pasta?'

'It's good,' I said. 'Where are you from?'

'Grenoble.'

'Whereabouts is that?'

'Rachel, it is a beautiful city in south-east France, in a valley, surrounded by mountains.' He dipped baguette in the juice accompanying his mussels. 'And you?' he said.

I told him about living in London and being from Surrey. There was no point in telling him how we'd followed Mum's boyfriends around the country, until she met Nigel and settled in Dorking for a while.

'You know many people in Chipford?'

'Not really.'

He stood up. 'I have to make *crème brûlées* for later, but perhaps we can go for a drink at The Old Bear one night?'

He was attractive, especially now he'd removed the hat and his accent and aloofness added appeal. He was a few years older than me, usually what I went for, but he wasn't boyfriend material and that was fine as after Chris I didn't want anything serious.

'Yeah, that would be nice.'

He grabbed his bowl and went into the kitchen. Having a drink with him would no doubt be fun. I filled in the form and, on handing it to Melanie at the front desk, she gave me a clipboard.

'Thanks for saving us today, Rachel. Can you fill in your shifts for this week?'

I put myself down for lunchtimes each day, apart from on Tuesday where I selected an evening shift because of Chipford Hall. Melanie took the clipboard and handed me a ten-pound note.

'Tips.'

'Thanks.'

Grateful for a reason not to use my bank card, I pushed the note into the back pocket of my jeans, and grabbed my coat and umbrella. It was three o'clock and I imagined Jake would be close to settling up for the day.

'Can I get a coffee to take away?' I said.

'Filter coffee is on the house. Help yourself.'

I filled a cup, went outside and crossed the road at the zebra crossing. The sign said 'Closed', but Jake was at the counter, clearing up. I tapped on the glass and he approached to open the door.

'Rachel, I didn't expect to see you this afternoon.'

'I just finished my first shift at Peaches and Cream.' I handed him the cup. 'And thought you might like your first free coffee before the journey back to London.'

'You got the job. Lots of free coffee for me, then.' He raised the cup and winked.

He seemed genuinely pleased for me, even though we hardly knew each other.

'Well, thanks for everything, Jake.'

'No problem. I appreciate the coffee, thanks. Maybe we can go to The Old Bear on Friday night, if I can get away from work early enough?'

Two invitations to The Old Bear within half an hour. Although I fancied Jean-Claude, Jake seemed more like friend material and it would be good to get to know him.

'Sure, that would be good.'

'Great, bye, Rachel. I'll text when leaving London. Have a good week.'

He closed the door and we waved at each other and I walked towards the Co-op to get something nice for dinner with my tenner. For the first time in ages, I'd accomplished something with my day.

Chapter Twelve

Preparations for the Heybury visit were extensive. Gardeners brought in baskets of fresh flowers and Mrs Baxter organised their arrangement in vases by the servants. Plants in the herbaceous border were deadheaded and weeds around them pulled up. Grass was cut and hedges were trimmed. Vegetables were gathered from the kitchen garden and succession houses and assessed for suitability. Only those of the finest quality would be used for the Heyburys and the rest would do for servants' meals. The statue of Bacchus, Roman God of Wine arrived, sculpted from white marble, and was established in the Grand Hall. In one hand he held a bunch of grapes, in the other a goblet and he boasted a physique to be admired with broad shoulders and muscular legs.

Lady Cordelia Heybury and her lady's maid were allocated the Lake View Suite, recently refurbished by Hunter and Son, south-facing and overlooking the Italianate gardens with a view of the lake beyond. The baron was allocated a room on the other side of the house, above the gun room so he could return from hunting, hang up his shotgun and remove his muddy boots. Then he would head upstairs to change his clothes and recuperate

without disturbing ladies who might be resting before evening festivities.

Mrs Baxter and Mrs Henderson discussed menus at length and they ordered legs of lamb from Home Farm, to be served for supper on the Friday evening, and hams to be used for the gentlemen's picnic on Saturday. Roast ducks and other delicacies including venison from the game larder would be served for dinner that night. Mr Banks selected wine from the cellar to match each course. He brought up bottles from France and dusted them off, ready to discuss their contents with Earl Rupert. They sampled a few together, and the earl nodded his approval of those deemed suitable from a chair by the fire in the library. Rejected bottles were gifted to Mr Banks to drink in his pantry, after he had completed his tasks for the day. My father's replacement, Mr Brigstock and his wife were invited to join the Heyburys for dinner on Saturday evening. And an invitation was dispatched to Lord and Lady Tankford, who lived at Seeley House, on the neighbouring estate, as the baron wished to ask Lord Tankford's advice on a shipping investment. How did I know all of this? Because Mrs Baxter told me every last detail in her parlour.

This flurry of activity marked the transition from winter to spring at Chipford Hall and I could not wait for the guests to arrive. Although I would be excluded from festivities, I anticipated hearing laughter and the murmur of conversation, rather than the silence I had become accustomed to when not in the servants' quarters.

The following afternoon, I watched the Heyburys arrive from my bedchamber window. Mr Banks and the footmen organised the trunks attached to the rear of the chaise delivering Lady Cordelia and the baron to us, along with his valet and her lady's maid. Once they had disappeared to their bedchambers to settle

in, I took a walk through the Italianate gardens and the memory of the earl's proposition crept into my mind. None of my letters seeking employment had been fruitful and he had offered me a future free from preoccupation over finances. But how could I damage Papa's memory by accepting such an offer?

When I returned through the main door into the Grand Hall, Lady Cordelia Heybury was descending the stairs wearing a mint green dress, followed by her lady's maid. She stopped, and I waited for her to address me.

'How do you do,' she said.

'Good afternoon, your ladyship. I am Philippa Elliott, governess to Lady Emily and Lady Sophie.'

'Oh, the governess I have heard so much about,' she said.

Had Earl Rupert told her about me, or the girls?

She proffered a white-gloved hand and I shook it.

'The girls have mentioned you in their letters. They write to me often, as I am their godmother and now the duchess has died, it is my duty to keep an eye on them. God rest her soul. We must have tea during my stay. The girls inform me you are well read.' She lowered her voice to a whisper, 'No one here is much interested in books, apart from us, you know.'

Had the girls told Lady Cordelia of my predicament? Even if this was the case, she did not have children, so there would be no position available. Perhaps she might be able to assist with securing a position at Heybury's school for the poor, mentioned in Fanny Smith's letters to Mrs Baxter.

'I would be delighted and honoured to join you for tea, ma'am.'

'Very well, let us meet at five o'clock tomorrow in the drawing room.' She walked down the hall, her lady's maid in

tow. To be given an ounce of respect by a woman of her stature was a feeling quite foreign.

The next morning, I established myself in Mrs Baxter's parlour; my body present, my head elsewhere. I had lain awake since a quarter past three, considering my options. A week had passed since learning of my impending departure, yet my position remained unchanged. Lack of sleep had worsened my cough, and swallowing brought about an ache in my tonsils. Rogers read letters at the table, and I fixed my gaze on the dancing flames in the fireplace, searching for an answer to my dilemma. The parlour faced north, windows bringing in barely any light and I longed to venture outdoors and see the sun shine, to inhale spring air into my lungs, but this morning I had to teach the girls. Perhaps I would take a walk after luncheon.

Mrs Baxter entered, following her meeting with Mr Banks. After some organisation, the deer hunt was underway, but they still had much to discuss. Her cheeks were rosy from all the rushing about, and she seemed especially short of breath. Considering her advancing years, I wondered if she ought to delegate more. She liked to perform tasks to her own high standard and I doubted she would entertain such a suggestion. She joined us at the table, let out a sigh and poured herself a cup of tea from the pot.

'How are you both?' she said.

Rogers glanced up from the letter he was reading. 'Very well, Aunt.'

'I am well, thank you, Mrs Baxter, apart from a trifle of a cough.' Stifling a yawn with my hand, I said, 'Will the opportunity arise for you to rest before they return from the hunt?'

'There is no time for rest, my dear, although it appears you are in need of some.'

'I struggled to sleep last night. Are the guests not absent until five o'clock?' I said.

'Indeed, then we shall serve tea in the library. Mrs Henderson prepared a picnic, so we shall not cater for them until then. Lady Cordelia will spend most of today in the library, apart from a mid-afternoon rest in her suite, and we shall provide her with a small luncheon and the occasional beverage.' She picked up the top letter in her pile and opened it. 'I expect you could not sleep because of your situation. When were you going to tell us your news, Philippa?' she said.

How did she know? My throat dry, I coughed again and again, unable to stop. Putting a hand over my mouth, I turned away from them both momentarily.

Rogers looked at me across the table.

'Are you all right, Miss Elliott? Can I fetch anything for you?' he said, his concern a comfort.

I sipped my tea. 'No, thank you, Mr Rogers. What news do you speak of, Mrs Baxter?' I said.

'I have been informed you are to leave us in June, or even before that,' Mrs Baxter said.

Rogers put down the letter he was reading, and scrunched his blue eyes together

'You are leaving us, Miss Elliott?' he said, his tone of voice higher than usual.

If I were not mistaken, this revelation disappointed him and his reaction touched me. Perhaps we would remain in contact and one day be something more? Rogers got up and added more logs to the fire, poking them about as if he were affected by my news

and Mrs Baxter looked at him and sighed. Did he care for me that much?

'Emily and Sophie came to the kitchen last night to try Mrs Henderson's shortbread,' Mrs Baxter said. 'They disapprove of his lordship's decision to replace you with Madame Dubois.'

It had not occurred to me that once the earl informed the girls, they would inform everyone else. Of course, children were not known for their discretion. Now my task was to reveal my predicament, whilst concealing the earl's proposition.

'Lady Eliza has requested that her ex-governess tutor the girls,' I said. 'She is a native French speaker, unlike myself.'

'That may be so, but the girls do not care for her as they do for you,' Mrs Baxter said. 'When you were bedridden, they complained about her lack of compassion, and how she never smiles. Whereas you inspire them.'

Madame Dubois would not have received the same briefing as I had from the duke, but it seemed unlikely this would have made a difference. Lady Eliza's demand would take me away from these girls, and I could not do anything about it. Although the earl's proposition had been unwelcome, his course of action was more than likely due to Lady Eliza's decision to oust me.

'I did not inform you because I thought his lordship wanted me to be discreet. For a week, I have been seeking a position, to no avail,' I said.

Sharing the news with them brought relief.

'You have written to your friends, relatives and acquaintances, I presume?' Rogers said, returning to the table.

'Yes, and if all else fails, I shall stay with my brother and sister-in-law in Brighthelmstone. Doctor Braithwaite did recommend sea air for this cough, so my situation might be for the best.'

'How can we help, Aunt?' he said.

'You can start by asking your father if there's a position at Seeley House.'

'I shall mention it during my visit tomorrow afternoon, and I have acquaintances around the country. You were previously employed as a teacher, Miss Elliott?'

I nodded.

'A teacher or governess position then, living in?' he said.

'That would be preferable. You are too kind,' I said.

'I shall write to Fanny at Heybury House and ask whether she can have a word with that teacher at the school for the poor,' Mrs Baxter said. 'We shall do our best to find you a position before the nuptials, Philippa, however we shall be disappointed to see you leave this house.'

'Thank you, both. Your friendship has boosted my time at Chipford Hall and I hope we can correspond.'

'I, for one shall write regularly. I hear Lady Cordelia has asked to take tea with you in the drawing room at five o'clock?' Mrs Baxter said.

'Yes.'

'Perhaps she will offer you a role,' Mrs Baxter said.

'That would be wonderful, but she has no children.'

'She may have some influence over Heybury's school for the poor. It is worth a try, although I shall write to Fanny as well,' Mrs Baxter said.

'If the opportunity arises, I shall enquire.'

A thought occurred to me. What would the earl's father think about his son removing me from Chipford Hall? Currently, ten per cent of my salary was kept back by the duke towards Papa's debts. I would have to raise the subject with the earl as it was unlikely I would find such a generous salary elsewhere. What if

I were not in a position to repay the debt? Most governesses' salaries were much lower than what I had been receiving. Yet another reason to lie awake at night.

Chapter Thirteen

On Tuesday, my first day volunteering at Chipford Hall, I woke with a knot in my stomach. Dithering over smart versus comfortable, I selected a pair of jeans from my drawer along with a short-sleeved shirt and a jumper. I'd put twenty quid-worth of petrol in the car the day before, paid for with tips and it made a change to embark on a journey without the dread of the warning light coming on. As I pulled onto the high street and took the road to Bath, I spotted the brown sign for Chipford Hall. A light aircraft took off from Cotswold Airport, rising into the blue sky, and I wondered what the day might bring. What if Mike was horrible to work for and reading the journals turned out to be a waste of time? All I could do was try to maintain some of the positive attitude gained from spending time in Jake's company. After entering through the black and gold gates, I parked and followed the path to the staff entrance, tucked away at the back of the house where I found Mike in his office. This time, I saw it was labelled 'The Housekeeper's Parlour' and he looked up from his computer screen.

'Morning, Rachel, sign yourself in by the entrance, please.' I did as he said, and he passed me a pile of forms to complete and a lanyard saying *Rachel Brown, 18thc volunteer*. 'You can fill in the forms over there in the servants' hall, then I'll set you up in

the library.' He waved me into a room opposite, where two women and two men of pension age sat at a long, narrow table with mugs and plates of cake.

'This is Rachel, our new eighteenth-century volunteer,' Mike said. 'These are today's stewards and they can introduce themselves.' He disappeared and I pulled up a chair at the table, smiling.

'Ooh, that sounds interesting,' the lady opposite said. 'I'm Edith and this is Betty. Over there, you have Harry on the left and Jack on the right.'

'Hello,' I said, recognising Betty from my visit with Jake. Harry and Jack were deep in conversation about whether you should keep a dog on or off its lead when in a field full of cows and they didn't reply. Edith rolled her eyes and dismissed them with a wave of her hand. 'Best leave them to it. How did you get this new role?'

'It's a funny story. I found an old painting in my gran's loft.'

'Oh, you're the girl who came in last week,' Betty said.

'Yes, that's right,' I said.

'And was that your boyfriend who came with you?'

'What? Oh no, that was my friend who works at an art gallery.'

'Oh right,' Betty said, giving Edith a nudge. 'He was a dish, he was.'

'Do you think so?' I said.

'Oh, yes, not in an obvious way, but those ones should be avoided at all costs.'

'She should know,' Edith said. 'Betty has been married three times.' I laughed. Dating advice was an unexpected start to the day, and thankfully Edith changed the subject.

'So, tell us, who is the artist of this painting?' she said.

'Canaletto, supposedly.'

'You found a Canaletto in the loft?' Edith said.

She and Betty looked at each other and laughed.

'Are you sure it's real, dear?' Betty said.

Harry and Jack stopped talking.

'Did I hear that right?' Jack said. 'You found a Canaletto in your loft?'

'Sounds ridiculous, I know.'

'It can't be an original, can it?' Betty said. 'Mind you, our tour guide, Daphne knows someone who found a Van Dyck in a charity shop, apparently.'

Edith tutted. 'That story is nonsense.'

'It's true. She's going on the *Antiques Roadshow*, I heard,' Betty said.

'You should get it verified,' Edith said.

'Go on the *Antiques Roadshow*, like Daphne's friend,' Harry said.

'You'd have to wait a while to find out probably, and I expect you want to know now?' Betty said.

'Just an idea.' Harry shrugged.

'There's always *Fake or Fortune*?' Betty said.

The attention from a television programme would be overwhelming, but I didn't want to be rude.

'Yes, possibly,' I said.

'How will being here help then, Rachel?' Edith said.

'There was a note with the painting, written by someone with the initial 'R', who I hope is the earl.' This made the story more convincing.

'Earl Rupert?' Betty said, her eyes shining. 'He's the handsome one in the portrait in the Grand Hall. What did it say?'

'The note, addressed to a woman called Philippa says the painting was a gift and one of a pair.'

'Well, you have provenance, but will need more, of course. I wonder who Philippa was?' Edith said.

'That's what I'm trying to find out,' I said.

'What about the other painting?' Betty said.

'It's in Venice, according to Google,' I said.

'You'll have to go there and bring it back,' Betty said.

'I doubt that would be easy,' Jack said.

'Well, I'd love to go to Venice, but in the meantime, I'm going to read through the earl's journals in the library, to see if I can find any clues. And on Sunday, I'll bring the painting in to show Caroline, the art expert.'

'Caroline knows what she's talking about and has friends in high places,' Edith said.

'And you should have a chat with our tour guide, Daphne,' Harry said.

'Oh, yes, speak to Daphne, who is generous with her knowledge. She knows a great deal about this house and has been volunteering here for twenty years,' Betty said.

'Does she know about the eighteenth-century history though?' Edith said.

'A little, but I believe she's been nagging Mike to tell more of the eighteenth-century story on her tours for a long time, so she'll be pleased with this development,' Betty said.

'Mike said we can use information I find in a special display,' I said.

'Daphne will be delighted,' Edith said. 'She will be able to direct you to an inventory,' Betty said. 'When was the note written?'

'1782.'

'Well, they used to do annual inventories, and we still do them now, listing everything in the house, to keep a record in case anything gets nicked. Daphne can direct you to what you need.'

'Fantastic, thanks very much.' I got a pen out of my bag. 'Mike wants me to fill in these forms so I'd better get started.'

'The ATP likes form-filling. Get yourself a strong coffee in the kitchen through there.' Edith pointed to an open door. Although I'd had coffee already, another one wouldn't hurt. I got up and did as she suggested.

'Help yourself to my lemon drizzle cake,' Betty called after me.

The friendly welcome was a comfort and the volunteering role seemed as though it might be okay after all. Here for You had been nowhere near as friendly with staff members jostling for promotion the whole time, but I reminded myself this was day one.

I poured out a coffee from the pot and cut a slice of cake. When I returned, Edith and Betty were discussing a book festival in Bath. The forms asked for the usual information and as I set about filling them in, Mike appeared.

'Stewards, take your positions please.' Then he went off again. They all took their time to stand up. Jack grabbed a walking stick and I wondered how he managed to be a house steward. Perhaps he got to sit down?

'A man of few words, that Mike,' Betty said.

'He's a good egg, just not much of a people person,' Edith said. 'Hope to see you later, Rachel.'

'It's nice to have some young blood around here,' Betty said.

'Good luck with that painting,' Harry said.

'Thanks, it's been nice to meet you all.'

Jack nodded goodbye and they left me alone. The coffee was bitter and lukewarm, but strong and needed. The cake was moist and tangy and I finished it in two mouthfuls, savouring the sugar rush, but it left my hands sticky and I washed them in the kitchen. I found Mike at the computer in his office and placed the forms on his desk. He clicked his computer mouse and stood up.

'Right, let's go.' He led the way through a door marked, 'Mansion', passing Earl Rupert's portrait in the Grand Hall, and we walked along a passage to the library, where sun streamed through the window onto the gold rug. He pulled at a bunch of keys hanging from his belt and unlocked the bookcase, then lifted a handful of red hardbacks from the shelf and piled them on the desk, which had been covered in a thin plastic sheet. I got a notepad and biro out of my bag while he relocked the bookcase.

'See you later, then, Rachel.'

Was that it? As he started to leave, I said, 'Don't I need gloves or anything else in order to handle these old books?'

'Oh no, the official advice, according to the British Library and the National Archives is not to use gloves. Are your hands clean?'

'I just washed them.'

'Gloves are likely to catch on small tears and they hold onto dust and grit, causing abrasion. Just be careful, obviously.'

'Thank you, Mike.'

'Oh, and food and drink aren't allowed in here, and you mustn't leave the room unattended. Find someone to cover for you if you need the bathroom. Betty is in the drawing room next door. We won't need a steward in here while you're working so you can fulfil that role too, if you don't mind. There's a blue book by the door with all you need to know.' He left before I could

protest and an elderly couple stepped into the room and looked around.

'What can you tell us about the library?' the man said. Mike had really dropped me in it. I racked my brain for the facts he reeled off on Sunday.

'Well, the rug is a replica of the one that was here in the eighteenth century.'

They glanced at the rug, seemingly unimpressed and the man lifted his eyebrows. 'Anything else?'

Then I remembered the blue book by the door and handed it to him, open at the first page, revealing photographs and descriptions of objects.

'All the information is here.'

'Thank you.' They followed the objects around the room: vases, the cabinet of ceramics, portraits, the Georgian writing table. After that, they studied photographs of royal family members who'd visited the house; the Queen and Princess Margaret as children; Edward VII, George V and George VI. They handed the folder back and I kept it beside me, ready to pass to the next visitor. Later on, I'd ask Mike for a copy of this information to memorise.

The couple moved onto the drawing room and I was alone again in the beautiful library, with a view of the countryside beyond the gardens, where I made out sheep on the hill. It wasn't that warm in the room, and I made a mental note to wear a thicker jumper next time. The journal on top of the pile was Volume I, and I carefully flicked through the pages, handwritten of course in ink, presumably with a quill, and I wondered who last did what I was doing. The pages were uncreased and without fingerprints, and the 's' looked like an 'f' as I'd seen before when reading historical sources and in the note found with the painting.

Checking the photo of the note on my phone, it was clear the writing style matched. Had anyone read this journal before me? I turned back to the first page.

Tomorrow, I leave for Italy, a year earlier than planned for reasons I am unable to divulge, but fortunately Lord Heybury, the man who saved my life at St Malo, and my best friend from Eton has cleared his schedule in order to accompany me. I look forward to following in my father's footsteps, and to making him proud of me. Here is a chance to demonstrate my capabilities and I shall bring back works of art and ideas on how to make Chipford Hall the finest country house in England.

He went on to describe his journey to Italy, through France and Switzerland, staying at inns on the way. They went over the Alps in a sedan chair, before visiting Turin, Milan, Verona, and finally Venice. Then I reached the first paragraph to give me something.

Count Monte, my host showed me around his house today, and I admired his collection of work by the artist, Canaletto. I asked if he would be interested in selling companion paintings of St Mark's Square from different views. He said Canaletto was his friend and he believed the paintings should remain in Venice, adding that too many of Italy's treasures had been taken away by English aristocrats to display in their country mansions, designed to look like Italian houses which did not fit in with English scenery. I endeavoured to persuade him to sell them to me. Perhaps I could offer him an object acquired on my journey, a Roman statue bought in Verona or a sculpture of a beautiful Greek goddess, purchased in Turin.

From googling at Jake's flat, I'd discovered the companion painting had been sold to the art gallery in Venice by the Monte family, but I needed to find evidence of the earl purchasing the painting that he then gave to Philippa. I took photos of the text to add to the album created on my phone. At one o'clock, Betty appeared.

'Time for lunch, my love. I'm here to relieve you. Come back at half past.'

'Thanks Betty.'

I bought an egg sandwich in the café and went to the servants' hall to eat it. Edith was already established with sandwiches in a plastic container, pen poised over a newspaper crossword. Although it was delicious, the egg sandwich cost a small fortune, even with my discount. I'd bring a packed lunch in future.

'How was your morning?' Edith said.

'Good thanks, I found a few snippets of information already.'

'Sounds good. So, where are you keeping the painting?'

'In a friend's safe.'

'I hope you trust them?'

I laughed.

'Yes, of course.' Once again, I considered whether Jake was trustworthy, but pushed the thought out of my mind. 'How long have you been volunteering here?'

'Five years. I used to be a primary school teacher, and since losing my husband, the staff and volunteers at Chipford Hall have become my family.'

'It sounds like a nice community,' I said.

'Oh yes. There are quiz nights, days out in London and to other ATP properties. It's wonderful for us oldies who might otherwise be lonely,' Edith said. 'And it enables us to give something back, to feel useful in some small way.'

'It's quite cold in the house though, isn't it?'

'Oh yes, that's because they have to keep temperatures low for conservation purposes, in order to preserve the textiles etcetera.'

'That makes sense,' I said.

'Get yourself a thermal vest,' Edith said. 'We all wear them.'

'Sounds like a good idea.' I glanced at the clock to see it was almost half past one. 'It's been lovely talking to you, but I must get back to work,' I said, standing up and putting my rubbish in the bin.

'See you later,' Edith said.

'Bye.' I went to relieve Betty and continued to work my way through the pages of Earl Rupert's journal until I reached:

Tonight, as the result of inebriation which led to the loss of a game of whist, Count Monte gave me the Canaletto companion paintings. He tried to offload a pen-and-ink drawing matching Looking East from the South-West Corner *in its place, but I declined. It is no substitute. When he asked for the opportunity to win them back on his next visit to England, I told him in no uncertain terms that this would be out of the question.*

This was a winning paragraph, and I photographed it on my phone. At three o'clock, Mike came to lock the journals back in the bookcase. So, I'd learnt the earl won both paintings from a Count Monte in Venice whilst on the Grand Tour. And the count kept the pen-and-ink drawing matching my painting and mentioned in the book lent to me by Jake. I needed to ask Daphne about inventories. Mike led me down the corridor and we stopped outside his office.

101

'See you next week, Rachel,' he said.

'Can I still bring my painting to show Caroline on Sunday?'

'Yep, I'll let her know. She'll be here from ten o'clock.'

'Thanks, Mike. Oh and do you have information on the library that I can take home and memorise?'

He opened a filing cabinet, retrieved a bound notebook and handed it to me.

'Great, thank you,' I said.

He sat down at his computer and started to type.

'Goodbye. Thanks for today.'

If I saw Jake on Friday night, I'd need to remind him to get the painting out of the safe on Sunday morning. It had been a good day, and far more uplifting than working at Here for You, although being unpaid removed the pressure to perform, of course. Would Mike ever consider me for a paid position? He didn't seem to like me, but then again, he didn't seem to like anyone. Maybe after a few weeks, I'd pluck up the courage to ask about applying for such a role.

Chapter Fourteen

That afternoon, at a quarter to five, I went downstairs to the drawing room. Being tardy would not do for my rendezvous with Lady Cordelia Heybury. Maud squatted by the fireplace, coaxing the fire with a poker. She stood up and wobbled about, clutching the arm of a chair to steady herself.

'Are you all right, Maud?' I said.

'Merely a little fatigued, Miss Elliott.'

'Have you not been sleeping?'

Maud hesitated, as if composing herself, and I pressed further.

'Is something the matter?'

'I cannot complain. Tonight, I am sure Daisy will not snore as she did during the early hours of this morning due to her cold.'

Sharing a room with another servant could not be easy, and I was grateful to have a bedchamber to myself.

'You have my sympathy, Maud, and I hope Daisy will snore less tonight. You could give her a little push onto her side if she lies on her back. Shall I ask Mrs Baxter to relieve you from your chores for the rest of the day?'

'There is no need.' Forcing a smile, she adjusted the screen, shielding me from the intensity of the heat from the fire. 'In due course, I shall return with more logs.'

'Very well.'

Maud gave me a nod as she left the room, and I sat down. Spring temperatures failed to penetrate the house due to its tall windows, vast spaces and high ceilings and the heat from the hearth was a comfort. The sun was moving towards the horizon, darkness only a hour or two away, and Maud had lit candles on the mantelpiece and in the chandelier. The Canalettos were displayed beside each other on the inside wall, the paintings of the English countryside replaced, although they were too far away for me to study them, and I did not want to be doing that when Lady Cordelia arrived. I thought back to our conversation as the earl revealed the paintings to me; before the lake, his proposition, and now the predicament keeping me awake at night. So much had happened since.

Lady Cordelia arrived at five minutes after five o'clock with Mr Banks in tow, carrying a tray. Her silk dress rustled as she crossed the room and a diamond pendant decorated her neck. I stood to greet her.

'Good afternoon, Miss Elliott,' she said.

'Good afternoon, ma'am. Thank you for your kind invitation.'

'I am delighted to make your acquaintance.'

We sat down, and she took the chair opposite me.

'Emily and Sophie have praised your teaching and your bravery at the lake is to be commended. Are you now recovered?'

'Apart from a lingering cough, yes.'

'The spring air will send your cough away, to be sure,' she said.

Mr Banks laid out cups from the Sevres set and poured tea from the pot. He placed slices of cake onto side plates using a pair of tongs, then left us, closing the door behind him.

'I hear you lost your father shortly before commencing employment at Chipford Hall?' she said.

'Yes, and my mother has moved to Yorkshire, so it is as if I have lost them both.'

'May I offer my condolences? Losing a parent is most difficult. My mother is deceased, and her absence has left a vacuum in my life.'

She displayed a vulnerability rarely seen amongst those of her class, and I could not fathom why she chose to divulge this information to me. Perhaps she was lonely. Since their arrival, she and the baron had not spent a moment together, apparently.

'Might I ask about your education?' she said.

'I went to school in Claydale, a village near Bath, part of my father's old parish. My teacher had been to Europe with her husband and she taught me French and Italian, and about art and history. When we moved to Chipford, I taught at my father's school for the poor, until he passed away.'

'How fortunate to be taught by a woman so well-travelled.'

'Indeed. I hear you write and that you have been to Europe?'

'From a young age, I knew I was destined to be a writer. My head was always in books, and I liked to write stories. I tussle with poetry, although prose is my forte and I have written a series of journals during my travels, focussing on the reality of life as well as the beauty we find along the way. My husband and I invite artists and writers to our home to inspire me but I have not yet discovered the muse for which I yearn. He takes guests shooting and hunting and to the races and invites politicians and members of the royal family to our home as well. In May, we shall return to Venice to have our portraits painted by the up-and-coming artist, Massimo Collina. And I shall write a journal as part of the research for my novel.'

105

'How inspiring,' I said, longing to be in her shoes.

'Even Earl Rupert does not have a Collina yet,' she whispered. 'Apparently, you are soon to be replaced by Lady Eliza's former governess. Emily and Sophie asked if I could assist you with securing a position.'

'How kind of the girls, and of you. I am waiting for replies to my letters,' I said.

'I shall endeavour to find you a role by writing letters on my return to Heybury House.' She smiled, her positivity encouraging me to ask my question.

'Our housekeeper's niece, Fanny Smith who is a cook at your house said there is a school for the poor in Heybury. Might there be a teaching position there?' I said.

'My husband and I are well acquainted with the vicar who manages that school, and I can make enquiries on your behalf.'

'That would be most kind, ma'am.'

'The way my goddaughters care for you is enough of a reference for me. And you saved Sophie's life at the lake, almost losing your own life in the process. Devotion indeed. Tell me, what are you reading at the moment?'

'Being the daughter of a vicar, I read the bible along with my father's sermons.'

'And any novels?'

'I have not read a novel since I was bedridden after falling in the lake, ma'am.'

The truth was the earl did not have any novels in his library that I had not read. I needed something new, but did not want to appear disrespectful towards him.

'Are you looking for recommendations?'

'Yes, ma'am.'

'Well, my favourite novels read this year include *Clarissa* and *Moll Flanders*. Oh, and *Tom Jones* is a must-read.'

'Thank you, ma'am.'

'And now, I am afraid, I must go to lie down. A wave of fatigue has overcome me all of a sudden.'

'Oh, are you quite all right?'

'Of course, it is merely from travelling.'

I rang the bell, and Mr Banks entered.

'Her ladyship is in need of rest, Mr Banks. Please can she be escorted upstairs?'

'Certainly.'

He proffered an arm for Lady Cordelia to take as she stood up. On doing so, she put a hand to her forehead and steadied herself. Mr Banks and I exchanged a glance.

'You do not seem at all well,' I said.

'Thank you for your concern, my dear, but I am as fit as a fiddle,' she said. As Mr Banks led her out of the room, she turned to face me. 'I am sorry we did not have more time to talk, Philippa. Rest assured, you will hear from me in due course.'

'Thank you, ma'am,' I said.

Support received from Mrs Baxter, Rogers and Lady Cordelia had brought some relief and I prayed sleep would return that night. Maud appeared, carrying a basket of logs and approached the fireplace.

'Are you feeling better, Maud?' I said.

She squatted as she transferred each log, one by one to the larger basket.

'I am managing, and thank you for asking, Miss Elliott,' she said.

'When I was bedridden, after the lake, you cared for me with compassion, Maud, and I shall not forget how you helped me to

107

recuperate. Please do not hesitate to ask if you ever need anything in return.'

'That is most kind, Miss Elliott.'

She removed the last log and stood up, but wobbled from side to side as she had earlier. Before I had chance to get up, she clutched her stomach and fell to the floor, thankfully missing the marble surface surrounding the hearth, and landed on the rug.

'Maud!' I said, running towards her. She lay on the floor, eyes shut and I rang the bell to summon Mr Banks. John, the footman entered.

'Where is Mr Banks?' I said.

'He is assisting Lady Cordelia, Miss Elliott.'

'Very well, bring me Mrs Baxter, John. Tell her Maud has fainted.'

His face reflected concern, and I recalled he and Maud were firm friends.

'Certainly, Miss Elliott.'

'Make haste,' I called after him.

As I placed a cushion under Maud's head, she opened her eyes.

'My dear girl, you fainted. Remain still. Help is coming.'

'I am sorry to be an inconvenience, Miss Elliott,' she said.

'There is nothing to be sorry about. You clearly need to see a doctor.'

'No, I am absolutely fine. I did not have chance to eat earlier, that is all.'

'That, my dear is for Mrs Baxter to decide. She will not allow you to work if you are unwell.'

'But I need the money, Miss Elliott. I cannot afford to take any time off.'

'I am sure Earl Rupert will take care of you financially during any break you take, Maud.'

'Do not be so sure of that.'

Mrs Baxter rushed into the room, her cheeks rosy. The poor woman was run off her feet already, and now she had this to deal with.

'What is wrong with our Maud, Philippa?'

I explained what had happened.

'Well, I have already sent for Doctor Braithwaite to visit Lady Cordelia after she took a turn for the worse upstairs, so I shall ask him to see Maud afterwards.'

'But I am quite all right, Mrs Baxter, really,' Maud said.

'His lordship, like his father will take care of any bills so there is no need to worry,' Mrs Baxter said. 'In the meantime, let us take Maud to her room, Philippa, where she can rest until the doctor arrives.'

Maud linked arms with one of us on either side and we led her upstairs where at least she could sleep without Daisy snoring in the bed beside her until the doctor arrived.

Chapter Fifteen

After my day at Chipford Hall, I passed the week doing shifts at Peaches and Cream, settling into a comfortable routine, but by Friday morning, tiredness had hit and I stood at the kitchen sink, running late after pressing snooze on my alarm too many times. It hadn't taken long to slip back into bad habits. Timekeeping had always been an issue for me, especially in the mornings and somehow although I didn't mean to be late, often this is what occurred. Although it hadn't happened at Chipford Hall yet, and I put this down to finding the work interesting and the later start. A university friend had advised me to see a therapist about my lateness once. She was studying psychology and thought it related to my mother dragging me round the country to follow her series of boyfriends, making me change school again and again. We hadn't spoken much since. I raced through a bowl of cornflakes as rain pummelled the kitchen window, the *leylandii* in the garden swaying from side to side. April showers showed no sign of going anywhere. On Sunday, Mum was due to return from the yoga retreat and Malcolm would move in shortly after that. They'd agreed between them that as his Tenancy Agreement was coming up for renewal, and they spent most of the time together, it made sense for him to live at Ivy Cottage to save

money as then he could contribute to bills. Later, I needed to get the local paper and look at places to rent as before leaving for Jaipur, Mum had hinted it might work better if I moved out shortly after Malcolm moved in. The letterbox clattered and an envelope dropped onto the mat. Bracing myself, I bent down to pick up a red version of the water bill. The following Friday, I'd be able to pay it and this brought a sense of achievement for the first time in a while.

The music for the ten o'clock news played on the radio, and I was supposed to be at work. I zipped up my jacket and locked the door behind me. Pushing up my umbrella, I headed for the high street, walking as fast as I could. When I passed Chipford Art Gallery, I thought of Jake and that he'd be back later. Would he text about meeting at The Old Bear? Taking the zebra crossing, I sheltered under the awning at Peaches and Cream, collapsing the umbrella and giving it a shake. Outside, chairs were tipped against tables, rain running off them to form puddles on the pavement. I pushed open the door and put my umbrella into the stand. Melanie was chatting to JC at a table, and the radio played Lionel Richie, *Hello*. I hung up my coat.

'Morning,' I said.

'Hi, Rachel,' Melanie said, glancing at her watch.

'Sorry I'm a bit late,' I said.

'Good morning,' JC said.

'We're having our weekly meeting,' Melanie said. 'Can you make a start on polishing the cutlery? Thanks, Rachel.'

Grabbing a tea towel, I polished knives, forks, spoons to remove dishwasher smears and laid them neatly in the plastic tray. It was difficult not to eavesdrop on Melanie and JC's meeting, and he said, 'Specials and monkfish and not good enough.' Melanie said, 'Rachel knows what's she's doing. She

111

used to work at Pizza Town, although I might have to talk to her about timekeeping.'

It was nice to be respected, but I needed to make more effort to be on time. Chairs scraped the floor as they got up, and JC headed upstairs 'for a fag'. While admiring his toned backside, I failed to notice Melanie approaching.

'It's good to see you get on with JC,' she said. 'He can come across as arrogant, but I think it's often a case of lost in translation.'

'You're probably right,' I said.

'And he's a damn good chef so if there's ever a disagreement between him and a waitress, guess who gets fired?'

It sounded as though she was giving me a warning, but I couldn't imagine JC and I would fall out enough for me to need to leave.

'Err, not him?' I said.

'Exactly right. And you've been late a couple of times this week. Please can you make more of an effort?'

'Yes, sorry,' I said, trying to come up with an excuse in my head, but there was no point. Melanie wasn't to be messed with. Lateness had been one of my downfalls at Here for You and I mustn't fall back into old habits, however hard it was to get up in the mornings. Mum had struggled with me during school years and even went to the trouble of setting clocks at home twenty minutes fast.

'Now, I have a mountain of paperwork to catch up with, so can you set the tables and fill up the salt and pepper shakers?'

'No problem.'

Melanie went upstairs, and JC reappeared, pulling on his chef's hat and threw me a smile as he headed for the kitchen. Through the hatch, sous-chefs banged about pots and pans.

'Come on guys, hurry, we don't have long to make some incredible food,' he shouted.

'Yes, Chef!' they chorused.

At two o'clock, my feet were sore and I was hungry. We'd only done ten covers due to the torrential rain, so I chose the infamous monkfish with baby potatoes and carrots, eager to know what all the fuss was about. JC sat at a table in the back, and as I joined him, he looked up from the newspaper he was reading.

'Hi, Jean-Claude.'

'Afternoon Rachel. Everyone calls me JC. It is easier, don't you think?'

He twisted spaghetti around his fork, and continued to read, thick chestnut hair falling into his eyes. Would he ask me out again? I hoped so as he was the kind of man I went for: good-looking and a bit full of himself. Although I knew fit bad boys weren't good for me, I couldn't help going for them, again and again. Once Mum had said I feared commitment so went for men who were bound to let me down, and perhaps she was right. But so what? After all the men I'd been through, I'd given up on finding 'The One' as he didn't seem to exist. Chris had made me more certain of that than ever. JC pushed a lock of hair behind his right ear as he read, but it kept falling back, and he had to do it again. The monkfish was chewy, but I ate it with as much enthusiasm as I could muster.

'Is that the local paper?' I said.

'It is. You want to read it after me?'

'Yes, I need to look at adverts for places to rent.'

'Let's look now.' He turned to the pages at the back and put the paper in front of me. 'You need to move soon?'

'If possible.'

'Your landlord does not like you?'

'My mum's boyfriend is moving in.'

'How old are you?'

'Twenty-six.'

'Time to leave the nest, eh?'

'Lack of money doesn't help.'

'You have saved a deposit?'

'Not yet,' I said.

He shrugged.

'You'll have to work harder for your tips, smile a bit more, perhaps?'

I rolled my eyes.

'At least you get free meals cooked by me. What could be better?'

I laughed. 'Well, of course.'

He put down his fork. 'I have my own place above the stationery shop. You can always sleep on my sofa.'

'That's kind of you, thanks.'

If I accepted his offer, I'd end up in his bed.

He got up. 'You like my food?'

'Delicious.' How could I say otherwise?

He pulled a face.

'The monkfish is chewy, is it not?'

I tried to think of the right thing to say.

'That is because it needs to be served straight out of the pan, and that piece, made by my sous-chef, Ralph, has been sitting on the side while you finished your shift. One day soon, I shall make it for you properly, at my place.' He looked me in the eye, lifted the corner of his mouth and lowered his voice. 'Or, better still, a steak cooked rare with béarnaise sauce on the side. With it, a bottle of Bordeaux, opened early to breathe.'

'Sounds good, although you may have to cook my steak medium.'

'Medium? What is this madness?'

I smiled.

'To cook a steak anything other than rare is committing a crime. Do you smoke?'

'No.'

'I must have a fag before going back to work.'

'Don't you want your paper?'

'It is yours.'

He took his plate to the kitchen and headed upstairs, leaving me to wonder when I'd be invited for dinner. Lifting the biro from behind my ear, I scanned the ads. A room for rent on Chipford High Street in a shared house cost way more than a month's earnings at Peaches and Cream, and the landlord wanted one month's deposit as well. There were a lot of second homes in Chipford due to rail links to London and the trendy Soho Farmhouse nearby, and this drove up prices. Rent was lower in surrounding villages, but I didn't have my own car. Moving out was an impossible dream. After dumping my plate in the kitchen, I grabbed my things, and said goodbye to Melanie, who handed me a fiver tip. The weather wasn't doing much for my finances.

When I stepped onto the pavement, the sun was out and I continued to walk down the hill past Ivy Cottage, inhaling the scent of flowers in front gardens, brought out by all the rain and then I saw it: my dream home, a terraced cottage for sale. The front garden was overgrown with grass and weeds and all sorts of foliage and the white paint was peeling. It was clear no one had lived there for months. But what potential, and such a good location at the quieter end of Chipford. If only I could afford it, I would clear the garden and give it a coat of paint inside and out.

How I'd love to live here with my own cat for company. It started to rain again and I put up my umbrella and made my way back to the house where I made a cup of tea and lay on the sofa. What an exhausting week it had been.

The sound of the doorbell woke me, and the time on my phone said seven-thirty. I'd been asleep for almost two hours. I went to open the door and Jake stood there in a suit, his hair soaking wet from the rain, a carrier bag in one hand and a four-pack of beer in the other. He'd shaved and had a haircut and this change of appearance threw me for a minute, the now familiar scent of sandalwood overwhelming my senses. Was this the real him and did I prefer it to the unkempt look?

'Food delivery?'

He handed me the carrier bag.

'Jake, hi, sorry I fell asleep and just woke up. Come on in.'

'Did you get my text?' he said.

'Nope.'

'Thought so. When you didn't reply, I hoped you wouldn't mind me coming over seeing as we made vague plans to meet up tonight.'

'Of course not. Let's have a drink and' —I raised the carrier bag to my nose— 'yum, Chinese takeaway, my favourite. Thanks for bringing it over.'

In the kitchen, I put cutlery and plates on the table, grabbed a bottle of red wine from the sideboard, and poured myself a glass. He took off his jacket and wrapped it around the back of a chair, then flicked the ring pull on a can of beer. He wore a white shirt, undone a couple of buttons at the collar, and I had to admit to myself he seemed like a completely different person, more together than when we first met. I unpacked the takeaway to find

116

a large bag of prawn crackers along with plenty of foil trays. He peeled the lids off the trays to display chicken satay, spring rolls, crispy seaweed, Singapore noodles, sweet and sour chicken, egg-fried rice. It was all perfect. Pulling up a chair, he dipped a chicken stick into satay sauce.

'Good choices,' I said, adding spoons to the trays.

He undid the buttons on his shirt cuffs and rolled up his sleeves.

'This is my treat, by the way.'

'Thanks. It's just what I fancy.'

'How's your week been?' he said.

Selecting a spring roll, I said, 'Good, although tiring and it hasn't stopped raining.'

He piled his plate with food.

'Did you find anything out at Chipford Hall?'

'The earl wanted to buy the paintings from a count who refused to sell, but then won them in a game of whist, although he didn't take the pen-and-ink drawing matching my painting.'

'And then one of them somehow made its way back to Venice?'

'The count wanted the opportunity to win them back when visiting England so maybe that has something to do with it. We need to know how Philippa got her hands on my painting. Who even was she? Did she live in this house?'

I put rice and chicken onto my plate, adding sweet and sour sauce.

'So, what next?'

'On Sunday, I'm taking the painting in to show Caroline, the art expert. Is it still okay if I get it from your safe that morning?'

'Sure, no problem.'

'So how has work been?'

He twisted noodles around his fork, and sighed.

'I work for a law firm and when I was here last week, a contract needed to be drafted urgently so I asked my assistant to do it and checked it on my laptop, bypassing my usual rule of printing documents for a final read. I missed something important.'

'Oh, what went wrong?'

'A vital paragraph was excluded and the client has lost money over it.'

'Is your boss pissed off?'

'Yes, very. We lost the client to another firm.'

'Ouch.'

'So,' he said, opening another can of beer. 'I'm shutting it out of my mind until Monday.'

'Good idea.'

He raised his beer can and I raised my glass, and clinked and said, 'Cheers!' He reached for the local paper at the end of the table, marked by my highlighter.

'Are you moving out?'

'My mum's boyfriend, Malcolm, is moving in.'

'Do you not get on with him?'

'My mum's had a series of boyfriends over the years and I'd rather live somewhere else if I can. It's awkward otherwise.'

'That's difficult. My dad remarried and at first, I didn't give my stepmother a chance but she's mostly good for him.'

'Where's your mum?'

'She left a few years ago.'

'Oh, sorry to hear that.'

He inhaled deeply.

'Anyway, my dad and stepmother have an art school in Tuscany and I hope to visit one of these days.'

118

'Sounds nice.'

'Yes, hopefully I can get some time over there at Easter.'

He emptied the rest of the egg-fried rice onto his plate and added chicken and sauce.

'Fingers crossed.'

'Are you going to look at places this weekend?'

Shaking my head, I refilled my glass with wine.

'Rent is far too expensive round here and I'd need a deposit, so doubt it will happen.'

'That's too bad.'

'Yeah.'

I thought back to what Chris had done and felt a surge of annoyance, but no, now wasn't the time to offload on a man I hardly knew.

At eleven o'clock, when Jake had emptied the last can of beer, he pushed back his chair and stood up, putting his plate and the foil trays on the side in some attempt to clear up.

'Well, I'd better go as there's loads to do at the gallery tomorrow,' he said.

'I'll be at Peaches and Cream from ten.'

'Come in and say hello. Bring me a free coffee and some cake.'

'I might just do that.'

He put on his jacket and headed for the front door and I followed. In the entrance hall, he turned round to face me. We stood there and he threw me a look of such longing, it left me in no doubt that he fancied me. Was this why he was helping with the painting? Before tonight, I'd only seen him as friend material, but now able to see his face properly after all the hair removal, I found him quite attractive.

'If you're not doing anything tomorrow night, we could go to The Old Bear?' he said.

'I'd like that.'

For the first time, I registered his eyes were a shade of grey-blue and he leant forwards and moved back again as if he'd been about to kiss me, but changed his mind.

He opened the door and stepped outside, turning to face me, and I switched on the light in order to see him.

'Seven-thirty?' he said.

'Great, see you there.'

He smiled and gave me a nod and set off up the hill. I closed the door behind him, mentally running through my wardrobe as I locked up. Had he been about to make his move then and if so, why did he change his mind? He'd caught me off guard and my non-reaction had probably made him unsure about whether I was interested. Something was bound to happen the following night with my encouragement and my gut hopped at the thought of kissing him. Perhaps it was time to drop the bad boys and let a decent man into my life.

Chapter Sixteen

That evening, I ate leftover venison stew with Mrs Baxter in her parlour. Rogers dined in the servants' hall because he liked to socialise with the baron's valet, Mr Jackson, as they had got to know each other well over the years, especially during the journey to Venice with their masters. They were due to play cards after supper whilst sharing a bottle of wine provided by Mr Banks.

'Will Doctor Braithwaite be visiting Lady Cordelia and Maud this evening, Mrs Baxter?' I said.

'Yes, he has been in Bath today, and his wife will send him over on his return,' she said. 'Maud has not been in good spirits recently, but I have been so preoccupied with the Heybury visit, I cast the thought out of my mind.'

I hoped Maud was merely fatigued due to overwork and in need of a rest.

That night, I sat at my writing table and wrote to Mama, giving an overview of tea with Lady Cordelia as she would enjoy reading about such an interesting and strong woman. I omitted to mention my predicament because worrying Mama was out of the question. Still grieving heavily for Papa, she did not need to be

preoccupied with my dilemmas. My next letter was to Tabitha, a cousin once removed to ask about a position. She was married to a vicar in Hertfordshire and well connected within their community, they might know of a suitable role for me. Slow, heavy footsteps tapped along the corridor and I put down my quill. The bedchambers neighbouring mine belonged to female servants and presumably the feet in question belonged to Doctor Braithwaite. Picking up my candle holder, I pressed my ear to the door to hear Mrs Baxter and the doctor conversing.

'I have my suspicions, Doctor, but being the expert, you will draw your own conclusion,' she said.

'Let us hope your suspicions are without foundation, Mrs Baxter.'

What suspicions did she refer to exactly? Did Mrs Baxter think Maud had a serious illness? A door closed and presumably they had entered Maud's bedchamber so I returned to my writing table. Then it dawned upon me. The way she'd clutched her stomach before fainting as if attempting to protect it from the fall. How could I have been so blind? What if she were with child? Without a doubt, she would be ousted first thing in the morning. And then, who could the father be? That footman, John, her friend and a young man who liked to flirt with female servants, or could it be the earl? The rumours about Sally, the scullery maid meant he was not above suspicion. Then I recalled the look they exchanged in my bedchamber during my recuperation. Perhaps they were having intimate relations then? Her bump would not be showing yet, but she would certainly be nauseous. As I folded up my letters to put in envelopes, a door closed and once again I went to eavesdrop.

'Thank you, Doctor, for extending your visit,' Mrs Baxter said.

'Unfortunate news for you, Mrs Baxter, but at least now you can take the necessary action.'

'Indeed, she is a good worker, and I will be sad to see her leave.'

Through the keyhole, I watched them walk away and dithered over whether to check on Maud. My parents had raised me to show compassion to those in need and this was my duty. After placing the blanket from around my shoulders on the bed, I went to tap quietly on Maud's door. She opened it wearing a cotton nightgown, her face as white as milk, and sniffed, a handkerchief scrunched in her hand.

'May I come in?' I whispered.

'Yes, Miss Elliott.'

She blew her nose and perched on the edge of a bed. The other bed was empty, and I presumed Daisy had been given somewhere else to sleep for the night. As if sensing that I knew the truth, she placed an arm around her middle. I sat in the only chair, by the window.

'I heard the doctor outside your room, and wanted to enquire about your welfare.'

'Mrs Baxter will return when she has seen the doctor out, Miss Elliott, so I would not stay for long.'

'Reassure me you are all right and I shall go.'

'I am forbidden to divulge the reason for Doctor Braithwaite's visit to anyone in this house, Miss Elliott, but I am grateful for your concern. It is likely I shall leave in the morning to stay with my mother.' A tear ran down her cheek.

'I am sorry to hear this, Maud. You will be greatly missed by the below-stairs staff,' I said.

'Thank you for your kindness, Miss Elliott.'

Aware of Mrs Baxter's impending return, I stood up.

'You cared for me during my recuperation and I wish you well, dear girl.'

'I was merely doing my job.'

Placing a hand upon her shoulder, I said, 'But you conducted your tasks with compassion, Maud, and your calming presence was a comfort. I shall ask Mrs Baxter for your mother's address, so we can correspond.'

Maud forced a weak smile. 'I cannot read or write, but my sister-in-law, Freda, will read your letters to me and reply on my behalf.'

'Very well. Good night,' I said.

'Good night, Miss Elliott.' Closing the door behind me, I returned to my bedchamber. If the child belonged to the earl, would he not contribute to its upbringing? John, the footman was in no position to contribute to her finances if indeed he were the father. When she had fainted in the drawing room that afternoon, it was me who asked Mr Banks to call Mrs Baxter. Being aware of her situation would have meant I could help conceal it for longer, allowing her to earn more money. How foolish of me to be so blind.

The next morning, on the way back from St Andrew's after a rather mediocre sermon delivered by Mr Brigstock, I walked with Mrs Baxter and Rogers followed behind with the baron's valet, Mr Jackson. Apparently, they had consumed three bottles of claret the night before with Mr Banks and they had stripped off all their clothes and gone for a midnight swim in the lake. Unable to remove an image of Rogers swimming in the nude from my mind, I found my cheeks warming and initiated a conversation with Mrs Baxter as a distraction.

'How is Lady Cordelia?' I said as Chipford Hall came into view. Although the daffodils of early spring had since gone, we passed a lilac bush in full bloom and the scent consumed my senses.

'Doctor Braithwaite said she merely needs rest. She will depart this morning, a day early, and the baron will follow.'

'Did Maud see the doctor?' I added, casting a glance at the lambs as they gambolled on the grass verges flanking the drive. Lying was not an occupation I was accustomed to.

'Yes, she will leave this morning as well.'

'Maud is leaving?' I said, glancing at her briefly, before looking away again.

At that moment as we approached the house, Rogers joined us, leaving Mr Jackson to converse with his master, the baron, and still the image persisted of him swimming in the nude and I refrained from looking at him directly.

'Is your head still aching after last night's tomfoolery?' Mrs Baxter said to Rogers.

'A little,' he said.

'I shall fix you one of my concoctions,' she said. 'Philippa and I were just discussing the plight of poor Maud,' Mrs Baxter said.

'Right,' he said, adjusting his wig with a hand.

'A carriage will take Maud to her mother's house shortly, and I shall seek her replacement with immediate effect. A good housemaid is hard to find, but such is life,' Mrs Baxter said with a sigh as she shook her head.

I continued our role play.

'Is she so unwell she has to leave?' I said.

'I think we all know Maud is not unwell,' Mrs Baxter said.

Rogers coughed and looked away, prompting me to suspect that he knew the truth.

'Oh,' I said.

We entered the house via the servants' entrance and they headed for Mrs Baxter's parlour.

'Please excuse me, both of you.'

'See you at luncheon, Philippa,' Mrs Baxter said.

'Have a good day, Miss Elliott,' Rogers said.

Taking the stairs, I headed for my bedchamber and climbed onto the bed. Pulling my legs to my chest, I sobbed. Tears ran down my face and conscious of being heard, I pulled the blanket over my head, the darkness a comfort. Like Maud, I was to be ousted but at least I was not carrying a child. Thank the Lord.

Chapter Seventeen

On Saturday morning, while I was setting tables at Peaches and Cream, the door pinged and I turned round to see Jake. His hair was sticking up all over the place and he wore tracksuit bottoms and a crumpled T-shirt. Chipford Art Gallery had been closed on my way to work and I assumed he'd overslept.

'Hello, there,' I said, in a voice that implied we were going out that night and who knew what might happen? Moving to the counter, I said, 'What can I get you?'

'Morning, Rachel,' he said, his tone serious, as though we barely knew each other. 'One Americano with milk and a soya latte, please.'

Wasn't this usually how men behaved after you'd slept with them? Perhaps I'd misread him the night before.

'Right away.'

As I wiped the wand on the coffee machine with a cloth and filled the jug with soya milk, I wondered who the latte was for as it didn't seem like Vera's thing. Out of the corner of my eye, I saw him pull out his phone and scan the screen. His manner irritated me, and I didn't know what to say to him. After filling the cups, I pressed lids onto them and placed them in a cardboard holder. He pushed his phone into the pocket of his tracksuit bottoms and looked up.

'I'm sorry, Rachel, but do you mind if we cancel tonight?'

So this was the reason for his odd behaviour. At least he hadn't cancelled via text.

'Is everything okay, Jake?'

He sighed.

'My ex-girlfriend, Penny, turned up late last night out of the blue.'

Hearing that there was still an ex-girlfriend in the picture caught me off guard. Removing the tea towel from my back pocket, I made a meal of refolding it neatly while saying, 'Oh, I had no idea about…'

'We split up a few months ago, but more recently we've been seeing each other, casually,' he said, almost apologetically. A pang of jealousy rose up inside me as I pictured him with the ex he'd never mentioned. What a kick in the teeth after I'd convinced myself that I liked him.

'Another time,' I said, forcing a smile.

'Next weekend, we're going to our mutual friends' wedding, so maybe you and me can reschedule for the week after?' he said.

If he thought he could mess me about like this, he had another think coming.

'Let's play it by ear. Can I still collect the painting tomorrow morning?' I said.

'Sure, we can text about timings.' He tapped his card on the machine. 'I'm going to Chipford Hall today, actually. Penny saw a flyer come through the door and asked to take a walk in the bluebell woods. See you tomorrow.'

And to top it all, she was going to see the bluebells with him. As he left, I sprayed all of the surfaces around the coffee machine and gave them a thorough wipe down, shaking my head. What a nerve he had.

During my morning break, I sipped coffee in the staff room and pulled bits off a croissant. A woman, presumably Penny, lifted the sash window in Jake's flat opposite and leant out to look below. Her blonde hair cascaded Rapunzel-like down the back of Jake's red and white shirt, and I was so confused. This time yesterday, I'd only thought of Jake as a friend, but now he had me in what could only be described as a state of mixed emotions.

JC stomped up the stairs. 'Good morning, Rachel.'

'How's it going, JC?'

He opened the fire-exit door, leant against it and lit a cigarette.

'One of my sous-chefs has called in sick, the cod hasn't turned up from Cornwall, and the specials menu needs to be changed. It's a disaster.'

'Sorry to hear that.'

He puffed away for a few minutes, then dropped the butt onto the ground and flattened it with his boot.

'Would you like to go to The Old Bear tonight, Rachel?'

What did I have to lose?

'Okay.'

'I need to help Ralph prepare for tonight's service and will meet you there afterwards, at seven o'clock?'

'All right.'

'Good evening, Rachel.' JC stood up to double kiss me, still wearing his checked trousers and reeking of booze and cigarettes.

'Did I get the time wrong?' I said.

'No, I finished work earlier than expected. He filled a glass from the half-empty bottle of Syrah on the table, then refilled his. The wine tasted warm and rich and called for some of those posh crisps to go with it, as I hadn't eaten. The queue at the bar was two people deep and I spotted Jake and Penny at a table in the

129

corner. He had his back to me, but the broad shoulders and the familiar red and white shirt gave away it was him. And I knew it was her, in a low-cut cream top, her blonde hair scraped into a ponytail. She rested her chin in her hands as he talked, and I couldn't help wishing I was in her place.

'Do you like working at Peaches and Cream?' JC said.

'Yes, I'm grateful for the job.'

'What did you do before?'

'I used to sell insurance but was made redundant.'

'I am sorry.'

'Thanks. I didn't enjoy it much anyway. How did you get to be a chef?'

'My father owned a bistro in Grenoble.'

'Really?'

'As a child, I used to help in the kitchen, but then I wanted to make more sophisticated dishes than omelettes and burgers and chips. When I went to cookery school in Paris, my father thought I was looking down on his bistro. We fell out and he died before we had a chance to make friends.'

'That's so sad,' I said.

'Let's talk about something else.'

'You lived in Paris?'

'For a year, then I got a job as a sous-chef at The Ritz. When Peaches and Cream opened last year, I jumped at the chance to be head chef as well as get a whole flat to myself.'

'Don't you miss the buzz of London?'

'Yes, there's nothing to do in Chipford, apart from come to The Old Bear and get wasted.'

I laughed.

JC clearly enjoyed talking about himself and as he rambled on, I resorted to nodding and knocking back the wine,

occasionally looking over at Jake and Penny, and saying, 'Oh, really?' quite a lot, but he didn't seem to notice my boredom or care. Then he stopped and looked up as someone tapped me on the shoulder. I turned round to see Jake standing there.

'Jake.' I feigned surprise, and introduced them to each other.

JC proffered a hand and Jake leant over me to shake it. I caught a whiff of the sandalwood aftershave he wore. That scent did something to me and it was impossible not to feel annoyed by the way the day had gone.

'Pleased to meet you,' Jake said.

'Likewise,' JC said.

Neither of them seemed to mean what they were saying.

'I'm buying drinks for me and Penny,' Jake said. 'Can I get you something or would you like to join us even?'

JC shrugged. 'We could do.'

The thought of the four of us at the same table was too much, so I pushed back my chair and stood up.

'That's a nice idea, but I need to go,' I said, clocking Penny as she stared straight at me.

'Are you sure?' Jake said.

'So soon?' JC said.

'Yes.' I looked at Jake. 'Remember, I'm going to Chipford Hall tomorrow?' I hadn't told JC about the painting and couldn't be bothered to explain.

'Oh yes,' Jake said. 'What time are you going?'

'Around ten-thirty.' I put on my coat, and JC pulled on his brown leather jacket. 'When shall I come to the gallery?'

'Penny's leaving first thing to visit her parents, so come over at ten?'

'All right.'

'See you then.'

131

He headed for the bar and JC followed me out of the pub, holding open the door, and gesturing for me to go first. When we got outside, he pulled me to him, and kissed me on the lips. After seeing Jake with Penny, I allowed him to push his tongue into my mouth. He wasn't a bad kisser, firm but tender. Snogging outside the pub made me feel a bit like a teenager though. The door creaked open behind us.

'Rachel?' It was Jake's voice, and I released myself from JC, but it was too late. 'You left your scarf on the chair.' He swallowed and raised his eyebrows.

'Oh, thanks, Jake.' I took it, unable to look him in the eye.

'No problem,' he said, his tone of voice neutral and he went back inside, leaving me embarrassed and again confused. Did he care about me kissing JC?

'Why don't you come back to mine?' JC said. The alternative was returning home alone to empty the biscuit tin. 'I have tequila.'

'Okay, let's go.'

We sat on JC's sofa, giggling. After a few shots of tequila, he'd become more entertaining, as he regaled me with stories of his teenage years in Grenoble.

'And there was a time when we were the coolest boys in the city. Me, Laurent, Philippe and Marc. We went everywhere on our skateboards.' He leant forwards to kiss me, as if I'd be impressed by this information, and before I knew it, we were in his room and he was pulling my top over my head.

I woke up naked, sensing by the smell of cigarettes mixed with a musky scent that I was not at home. What had I done? When I

opened my eyes, JC stood at the end of the bed, spraying himself liberally with an aerosol before pulling on his checked trousers. He seemed to live in them. The deodorant made me cough, especially as my throat was as dry as sandpaper. My head throbbed and spotting a glass of water on the bedside table, I sat up to have a drink. Red numbers on the radio clock glowed 7:30, too early for a Sunday.

'Ah, you are awake, Rachel. Before you say anything, I cannot be in a relationship with you,' JC said.

Straight to the point as always, but this didn't bother me, at all.

'That's fine,' I said, my voice croaky.

'Most girls say that but then they get angry when I don't text. Sophie made my life hell at work.'

So that was why she'd left.

'You slept with Sophie?'

'Of course. She was very pretty. Thank goodness her boyfriend never found out, because he is a big man and if he hit me I would end up in hospital.' So I was a waitress conquest. 'You can still make a booty call whenever you wish.' He smiled, and I raised my eyebrows. What was I supposed to say?

'All right, JC.' I downed the glass of water, desperate for some ibuprofen to go with it.

'Now, I have to go and make a tarte tatin. Let yourself out, whenever you want.' He leant over and kissed me on the lips, his breath fresh with toothpaste, lingering for longer than a man usually would after a one-night stand. 'Ah Rachel, if only we had more time, but Melanie will give me shit if I am late.'

He left and looking in his bathroom mirror, I could see my mascara had run, making me look a right mess. I needed to get home and clean myself up and consume some carbs. Mum would

133

be back from Jaipur later, and although it would be good to see her, I still needed to find somewhere to rent when Malcolm moved in.

As I shut the door to JC's flat, I spotted Jake walking towards me, wheeling a suitcase. Damn. I scanned the street for an alleyway to escape into, but there was nowhere to go. The shops hadn't opened yet, otherwise I'd slip through the door of one. My only option was to face him, wearing last night's clothes and make-up. Judging by the grin on his face, he knew exactly what I'd been up to.

'Morning,' he said.

'Hi,' I said, my voice still croaky.

'You had a good night, I see? What happened to your voice?'

'Too much booze.'

He studied me.

'You look like shit.'

'Why, thank you.'

'How much did you drink last night?'

'Quite a lot of Syrah.'

'And?'

'A few shots of tequila.'

'At the chef's place?'

I fidgeted with the scarf around my neck; *that* scarf.

'Yep.'

'You don't look fit to drive. I need to put this case in Penny's car, but why don't I drive you to Chipford Hall after she's left? I'll bring the painting and pick you up at ten-thirty?'

It was a generous offer.

'That would be good, thanks.'

As he wheeled the case away, he said, 'Drink some coffee.'

Despite my terrible headache, I couldn't help feeling uplifted by the prospect of spending time with him.

While waiting for Jake, I ate a slice of marmalade on toast on the sofa and sipped my second mug of coffee. A text popped up on my phone screen to say he was parked in the drive, and I put on my Converse before going outside and locking the door.

'Thanks for picking me up,' I said, getting into his car.

'Well, I couldn't let you drive in that state.'

As we drove along country lanes, I looked out of the window as the fields passed by, unable to wipe a picture of him and Penny in bed together from my mind. Had they arranged to see each other again? A nice-looking pub displayed a sign advertising Sunday roasts.

'I wouldn't mind one of those roasts to sort out my hangover,' I said.

'Why don't we stop there on the way back?' Jake said.

He pulled into the car park at Chipford Hall and got the painting out of the boot. Now it was in a fancy case with handles. We walked down to the staff entrance where I signed us in. In Mike's office, a girl with dark hair in a bob who was nauseatingly pretty sat at the computer. I tapped on the open door, and she looked up.

'Hi, Caroline?'

'Yes.'

'I'm Rachel, the new eighteenth-century volunteer. Mike said I could ask you to look at my painting, to see if it's a real Canaletto?'

'Oh, yes.' She smiled. 'Come in and sit down. I took the chair, and Jake leant on the door. I introduced them to each other and she said, 'Hi,' in a rather coy way as she threw him a look. It

135

struck me that Jake was quite a catch. He smiled as though he was used to this kind of attention from women. A flash of irritation registered in my gut. Why hadn't I seen him in this way until the other night? I could only put it down to him being moody and unkempt when we first met. Now Penny was back on the scene, it was too late for me. He passed me the carrier, and I removed the painting. Caroline sat up in her chair.

'Where did you get this?' she said.

'My loft. The house has been in my family for generations.'

'Okay. May I?'

I passed her the painting and she held it under the lamp on her desk, then turned it over and looked at the back of the frame.

'Do you think it's an original?' I said.

'It's certainly possible, but you need provenance.'

'Ah, there's also a note.' I took the envelope out of the case and gave it to her, explaining that I was going through the earl's journals and planned to ask Daphne about inventories.

'This looks rather promising,' Caroline said.

She handed everything back to me and scribbled on a Post-it. 'You need to go and see my friend, Randolph Tanner, who works at the auction house, Pimsy's in Old Bond Street. Email him to arrange a meeting, saying you know me, Caroline Ross, and he'll get your painting checked by an expert.'

I put the Post-it in my pocket. 'Thanks very much.' She turned back to her computer screen. Jake and I exchanged a grin.

'No problem, good luck and say hello to Randy from me,' she said, flashing Jake a smile as we left.

When we got outside, the sun was shining and despite my hangover and the way Caroline had made eyes at Jake, my mood was fairly positive. There was a strong chance I had a real

Canaletto in my hands. I couldn't wait to tell Mum the news when she got back from Jaipur that afternoon.

'Well, that's promising. How about that Sunday roast?' Jake said.

'Definitely,' I said.

Chapter Eighteen

A fortnight passed, my letters failing to bring news of a position. And Lady Cordelia had not written. Six weeks remained until the earl's nuptials so I wrote to my brother, Thomas, and his wife, Mary, to ask if I could reside with them until a position became available. The following day, Mary, a kind and gentle soul replied to say I would be welcome to stay as their guest and she offered to arrange introductions to members of the community.

That night, kneeling on the floor of my bedchamber, I prayed that a position would present itself before money ran out. Payment from my salary, after the deduction for debt repayment would last for around a month, stretching to six weeks if I were especially frugal. Money had become a worry once again, and I lay awake most nights studying shadows made from the light of the moon, flipping options in my mind. Surely, I had not exhausted all of them yet?

The following Tuesday after supper, I met Rogers and Mrs Baxter in her parlour by the fire, for our weekly sewing evening. The wood in the hearth produced a great deal of smoke, the fumes aggravating my throat. They both eyed me with pity, as I coughed over and over again, clutching my chest which had not recovered

since the incident at the lake. The need for warmth made the fire something to endure and I sipped a concoction of ginger, lemon and honey mixed with hot water, made by Mrs Baxter.

'If only we could find a way to banish your cough, Philippa.' Mrs Baxter stitched neatly around a square of cornflowers on a white background, adding it to the quilt she was making for her goddaughter's wedding gift. The hem of my dress had caught on a rusty nail when climbing over a stile a few days earlier, and I cut out a piece of material to patch it up with.

'I long to be cured, Mrs Baxter, and expect warmer weather delivered by spring will cement my recovery. However, your hot concoctions soothe my throat and ease the ache in my chest, and I thank you for preparing them.'

'You need sea air, my dear,' Mrs Baxter said.

'My brother and sister-in-law have offered to provide me with a temporary home in Brighthelmstone, if I do not find a position before the earl's nuptials.'

'How fortunate,' Mrs Baxter said.

'May you be so kind as to pass the scissors, Miss Elliott?' Rogers said.

Doing as he asked, I gripped the sharp ends so he could slide his finger and thumb through the handles.

He snipped cotton from a reel and threaded a needle. 'You have a place to go to, at least.'

'For that I am thankful, Mr Rogers. However, I do not wish to outstay my welcome, nor accept charity.'

'Have you not heard from Lady Cordelia?' Mrs Baxter said.

'No, but presumably she has not recovered from her exhaustion,' I said.

Rogers pushed the thread through a button and proceeded to sew it to the earl's red jacket and I admired how skilled he was

with a needle. There was something about a man who knew how to work with his hands.

'His lordship thinks highly of Lady Cordelia, and I am certain she will write,' he said.

'Fanny said in a letter last week that Lady Cordelia will soon depart for Italy with her lady's maid. The baron is going to Antigua instead on business,' Mrs Baxter said.

'She is leaving, despite her poor health?' I said. 'And without her husband?'

'Indeed, she is a bluestocking, a strong woman inspiring us all,' Mrs Baxter said.

Oh, to live the life of Lady Cordelia Heybury, or even to be in the position of her lady's maid.

'I am certain, therefore, that she has forgotten my plight,' I said.

'Do not dismiss her quite yet, Philippa,' Mrs Baxter said. 'She seems to be a woman of her word.'

The next day, the dear Lord gifted us a blue sky with a scattering of puffy white clouds, the first warm day of the season and Rogers invited me to take a turn around the gardens after tea. Spring brought with it a veritable palette to Chipford Hall. We ambled through the orchard where trees boasted white blossom tinged with pink, their branches filling with green buds soon to grow into apples. We followed the path through the Italianate gardens, passing rose bushes, their scent a delight at first, but then their pungency tickled my throat. I stifled a cough and as the lake came into view, my mind flashed back to that dreadful day.

However, my heart did not race as it once had. Anxiety now came from the future rather than the past. My brother would never make me destitute, however being a burden was not in my

character. Since I had exhausted my list of contacts, only hope and prayer could rescue my situation. We walked in silence until we reached the purple rhododendrons surrounding the lake, Rogers' company as undemanding as ever. The air did not need to be punctuated with conversation. He made a gesture in the direction of the folly, completed only weeks before.

'Shall we sit and admire the view, momentarily?' he said.

'That is a fine idea, Mr Rogers,' I said.

We climbed uphill to the folly, stopping a couple of times in order for me to catch my breath, and then we sat side by side under the cloisters blessed with the most wonderful view of the lake with a reflection of the clouds and trees and flora in the water. The only sound came from the geese honking on the grass banks as they organised their offspring, the dear goslings scattering in all directions. If only we could spend more time together like this, but before long we would only be able to communicate by letter.

'Tomorrow, I shall visit my aunt in Bath,' he said.

'How fortunate you are to have a day off.'

'If you were not teaching the girls, you could accompany me.'

An excursion to Bath with Rogers would be time well spent indeed and I pictured us walking around the beautiful city together, regaling each other with anecdotes.

'With regret, I cannot join you, although I would like to,' I said.

'That is a pity,' he said, looking across at me.

Maud lived in a village on the road to Bath, and it occurred to me to ask him a favour. Guilt had consumed me since her departure and the role I had played in its occurring sooner than necessary.

'May I request that you do something for me?'

'You know my answer, if your request is not beyond the realms of possibility.'

As he raised a hand to adjust his wig and put it down again, his fingers brushed my forearm and our eyes met momentarily, but I could not be sure whether this was intentional or not. There was no doubt that if I were staying at Chipford Hall, our friendship would grow into something more, and this saddened me, but being strong was my only option.

'Would you be so kind as to take a letter to Maud's house in Crinklewood?'

'Your wish is my command,' he said. 'Does your letter have an urgent message?'

My cheeks warmed. I had not intended to inform him of my plan to enclose money. Sending such a letter with a mail rider was too much of a risk.

'I feel responsible for the suddenness of Maud's departure, and wish to send her money to compensate, and selfishly to alleviate my guilt.'

'A kind gesture, and not at all selfish, but you may soon need it more yourself.'

'You make a good point, but I have faith that my situation will improve. Maud cannot seek employment until after the birth, and I fear she is not gaining enough nourishment for a woman with child.'

'You are so persuasive that I shall add a contribution of my own. The girl was an asset to this house and I felt nothing but pity when she departed.' He almost certainly knew whether the earl might be responsible for her situation, but I was not in a position to press him further.

'That would be most kind.'

'My coach will depart shortly after dawn, Miss Elliott, so do give me your letter this evening, before you retire.'

'You do not need to tell me twice, Mr Rogers. Let us return to the house so I can write it before supper.'

The day after Rogers visited Bath, a letter from Maud, written by her sister-in-law, Freda, arrived to thank me for the money. She wanted to repay me when the child was born and she could work again, but the money was a gift and I would not accept any repayment. The receipt of her letter lifted my spirits as doing a good turn often does, easing my guilt a little. Still, no letters arrived with news of a position, and it was time to accept my fate of staying with Thomas and Mary, the prospect of the sea benefitting my cough at least.

That morning, I took the girls into the garden to read from *A Midsummer Night's Dream*. We had such fun, and afterwards, I dispatched them to play before luncheon while I sat on a blanket under the oak tree on the lawn. Inspired by the azure sky with not a cloud to be seen and the flush of flora around me, I attempted to compose a poem about spring but the words refused to arrange themselves and I sighed, a happy sigh for this was the least of my troubles. Laying down my quill, I watched the girls seek hiding places within the hedges, reappearing with giggles and squeals. They raised buttercups and daisies to their noses, stuffing them into pockets with clumps of grass and twigs. Oh to see the world with such simplicity, to see only the now rather than the was and the when. To be a child was to see beauty all around and to enthuse about those things adults often forgot to appreciate.

Footsteps crunched on the gravel behind me, and I glanced over my shoulder to see Rogers clutching a letter.

'Good morning, Miss Elliott. This has been delivered from Heybury House.' He handed the letter to me. 'I hope the news is what you wish for.'

Perhaps Lady Cordelia had found me a role at the school in Heybury, after all. Or was she writing to advise me that she had failed in her endeavours?

'Thank you, Mr Rogers. How thoughtful of you to bring it out to me.'

'May I stay to hear what it says?'

'Of course, and if the news is desirable, we can celebrate. If not, you must console me,' I said, with a smile.

He sat beside me on the blanket, and I lifted the back of the envelope away from the Heybury House seal. At first, I read the letter to myself, then aloud, to Rogers, pausing a few times to catch my breath as the news was completely unexpected.

Heybury House
3 May, 1780

Dear Miss Elliott,

Please forgive me for not writing to you sooner. I enquired about a position at the local school, to no avail. But, I have news, at least. I am feeling much better and have made the decision to proceed with my journey to Venice, especially as the renowned artist, Massimo Collina has already set aside time to paint my portrait and rescheduling would be difficult. However, my lady's maid will not be able to accompany me due to unforeseen circumstances. Furthermore, her replacement, my late mother's lady's maid is unable to escape the notice period she is serving for her current employers.

My boat sails on 8th May, and seeing as the role is to be more of a companion than lady's maid, I would be most

grateful for your companionship in her place. Your knowledge of French and Italian would allow you to take notes on my behalf for my journal, and you could assist with research for my novel.

If you agree to accompany me on this Grand Tour, I would be delighted and your salary would be fifty per cent more than what you are receiving at Chipford Hall. Do reply in haste and inform me of your answer. If you accept my offer, I shall expect you to arrive at Heybury House with immediate effect so we are able to commence our journey. I can send a carriage to collect you from Chipford Hall. Our return to England would be at the beginning of September, allowing us a few months to complete our work.

Yours sincerely,
Cordelia Heybury

'At last, you have everything you want, and more,' Rogers said.

To see Venice with my own eyes would be a privilege indeed, but the letter did not lift my spirits as much as it should have. Instead, my mind began to compile a list of tasks to undertake in the short time allowed to me.

'The opportunity to visit Venice is a privilege, indeed.'

'I must confess,' Rogers said, his blue eyes locking with mine, 'that I have become rather fond of you, Miss Elliott, and when you return, I hope we can meet again.'

Flustered, I said, 'September is not far away, Mr Rogers, and as soon as I set foot in England, I shall inform you of my arrival.' There was no doubt our feelings for each other reached beyond friendship and I hoped we would have the opportunity to explore

them on my return. In the meantime, I needed to focus on preparing for my departure. 'I must inform the earl of my news.'

'Allow me to pass on a message immediately.'

'If he is able to meet me later today, I would appreciate it.'

He stood up.

'Very well, I shall do my best.'

During this meeting, I would need to ask the earl what to do about money owed to his father.

'Thank you. I shall now go and tell your aunt.'

'She will be delighted for you, but at the same time disappointed to see you go.'

We stood up and he helped me to fold up the blanket, a certain sadness lingering in the air. Leaving Mrs Baxter and Rogers, my surrogate family at Chipford Hall, would be tough. What if Lady Cordelia did not treat me well? All I could do was dust off such thoughts, and act as though I were overjoyed by the news.

The earl met me in the library before dinner. We sat beside the fire, facing one another and I thought back to when we first met in the very same room. Much had changed in a matter of weeks in a way I could never have predicted. Mr Banks handed the earl a glass of brandy and left a tumbler of water on the trestle table for me, then adjusted the screen in front of the fire before leaving the room. The earl swirled his brandy around the balloon.

'My valet informs me that you have news, Philippa?' he said.

'Indeed, my lord. Lady Cordelia has invited me to be her companion on a journey to Venice.'

'Firstly, I am delighted for you, Philippa, because you have secured a position with someone who I know will treat you with the respect you deserve. Secondly, I know how much you wished to see Venice. When will you depart?'

'The day after tomorrow.'

'Is there anything I can do to ease your transition?'

'His Grace cleared my father's debt and I have been paying him back from my salary. However, I shall not return to England until September. Would it be possible to postpone my payments until then?'

'The least I can do under the circumstances is to pay off your debt immediately.'

'But I cannot allow you to do that.'

'I insist, for it is I who have put you in this position,' he said.

Although his offer was most generous, I would be indebted to him.

'That is kind of you, but I shall pay you back.'

'There is no need. You did save the life of my sister, after all.'

The idea of being in his debt did not sit comfortably with me, but my only choice was to accept for now.

'And do not forget to visit the scene from my Canalettos when you are in Venice.'

'I cannot wait to do that.'

He drank his brandy.

'When I look at those paintings, I shall think of you, Philippa,' he said.

His words took me back to our rendezvous in the bluebell woods. As if reading my thoughts, he said, 'Philippa, please accept my apology for what has passed between us. I was merely trying to compensate for my fiancée employing Madame Dubois in your place. You clearly did not have anywhere to go, and I wanted to assist you financially without treating you like a charity case.'

Although he appeared to mean well, I could not forget the way his proposition had made me feel. But parting on good terms would be to our mutual benefit.

'Thank you, my lord. I am flattered that you would consider me worthy of such a position and your proposition no longer offends me.' My mouth dry, I picked up the glass of water and sipped it. 'I shall especially miss the dear girls, and hope to see them in September.'

Who knew what would happen to me on returning from Italy? No doubt, I would need to stay with Thomas and Mary until I found a new position.

Mr Banks entered.

'Mr Brigstock awaits you in the drawing room, my lord.'

'Thank you, Banks.'

He put his brandy glass on the trestle table.

'If you will excuse me, Philippa, the vicar has arrived for our meeting.' He stood up, and I did the same. 'I bid you farewell, and *bon voyage*.'

He took my hand and kissed it gently, studying me with those eyes as brown as cocoa. A moment passed between us, and I sensed we might meet again, as friends. He left the room, and I finished my water. The remainder of my evening would be spent writing letters to inform family, friends, and acquaintances of my news, and I would gather a pile of candle-ends stored in the kitchen to last until I had finished. No one could deny me that extravagance on my penultimate night at Chipford Hall. The first letter would be addressed to Lady Cordelia to accept the role. The second would be for Thomas and Mary, declining their invitation, but asking if I might stay in September instead. The third letter would be for Mama, who would be overjoyed to see me undertake such an adventure. Suddenly consumed with

excitement, I could not wait to go to my bedchamber and prepare for my escapade.

Chapter Nineteen

Jake's phone rang as I stepped onto the gravel of the pub car park. On the other side of the road the hedgerows had been recently cut into a rigid rectangular shape and poppies poked out of the grass along the embankment and I studied the patchwork quilt of fields beyond, dotted with sheep and lambs. Ravenous from the hangover, I approached the glass case outside the entrance to the pub and scanned the menu options, instantly deciding on roast beef and Yorkshire pudding. As I dithered over what to drink, a glass of red wine, perhaps, Jake called out.

'Rachel?' I turned to face him. 'I need to go back to Chipford.'

Well, that was the end of that idea.

'Is everything all right?'

'Penny is back at my flat and wants to talk. She's been trying to call for the past hour, but I had no signal.' He rolled his eyes.

Bloody Penny, messing up my plans again. I got in the car.

'Oh, right.'

'I wanted to buy you lunch to make up for cancelling last night so am really sorry.'

'It's okay.'

He started the engine, and pulled onto the country lane. As my stomach rumbled, I mentally ran through the contents of the fridge at home. Lunch was likely to be a cheese sandwich, but I couldn't be sure if the bread had mould on it or not. What a weekend of ups and downs.

'Hopefully I can make up for it next time I'm in Chipford?' he said.

'Sounds good. Will you be putting the painting in the safe when you get back?'

'Yes of course.'

With Penny there, would he bother to put it in the safe straight away? Now, there was a chance the painting might be valuable, I ought to watch it carefully.

'Thanks, I'll come with you, if that's all right.'

'If that's what you want.'

'Yeah, it's just…'

'What?'

'It's potentially worth so much money and…'

'Yeah, I could be anyone.'

His tone was sarcastic and I wasn't sure if he was pissed off with me or Penny. This was the first time any conflict had passed between us and tears pricked my eyes, probably because I was so very tired and to top it all Mum was coming back today. It was all a bit much.

'Are you heading back to London tonight?' I said, attempting to change the subject.

'Yes. I'll take Penny out for a late lunch first before finishing up at the gallery.' Lunch that was supposed to be with me. 'What will you do this afternoon?'

'My mum's coming back from Jaipur, so I'll be catching up with her.'

151

'Are you looking forward to seeing her again?'

'Yes, but I'm not bothered about seeing her boyfriend.'

'I used to feel like that about Maria, my dad's wife. Now I hate to admit it, but she's all right.'

'That won't be the case with Malcolm.'

'You should give the poor man a chance, at least,' he said, overstepping the mark.

'Well, that's up to me.'

We arrived back in Chipford, and he parked. After getting the painting from the boot, he unlocked the back door and we went down to the basement where he twisted the dial on the safe.

'Thanks for doing this,' I said.

'Hopefully you won't need it next weekend as I'll be at that wedding.'

Two weeks without seeing him seemed like a long time.

'At some point, I'll probably need to take it to Pimsy's.'

'Let me know, and I can take it back to London for you next time I'm here.'

'How would that work?'

'I could keep it in a safe place in my flat and meet you at the auction house.'

He squatted to put the painting in the safe and closed the door.

'You'd be able to get time off work?'

'Yeah, I could take a long lunch,' he said, twisting the dial.

'What's all this?' a female voice said.

Penny came down the stairs and Jake stood up.

'What are you doing down here, Pen?'

'Looking for you, Jakey.'

Yuck. All I wanted to do was leave the room, but needed to get past them both.

'So, what is going on here, exactly?' she said.

152

'Um, well,' he said, leaving me to explain.

'I'm Rachel, and Jake's looking after something in the safe for me.'

'What needs to be put in there on a Sunday?'

'It's confidential, Pen. Don't probe too much.'

'I found a painting in my loft and Jake's looking after it for me.'

'It must be some painting,' she said.

'Anyway, I've taken up enough of your time,' I said. After squeezing past Jake, I arrived face-to-face with Penny.

'Where have you both been?'

'I drove Rachel to Chipford Hall to see an art expert,' he said.

'And what did they say?' she said.

'She referred me to an auction house,' I said. 'Not that it's any of your business.'

Who did Penny think she was, poking her nose in and acting as though she owned Jake when they weren't even properly together? She reluctantly moved out of the way as I pushed past her and went up the stairs with Jake following.

'Well, I was only asking,' she said.

'Bye, Rachel,' Jake said, and the door closed behind me.

Breathless with fury, I walked down the high street, the smell of frying food drawing me into the chippy and I ordered cod and chips with lots of salt and vinegar, accompanied by a can of Coke straight out of the fridge. For as long as Penny was pursuing Jake, I didn't stand a chance.

When I got home, Malcolm's green TR8 was there, squeezed so close to Mum's car that I had to move sideways to get in between them. As I unlocked the front door, the scent of vanilla hit me.

153

Mum was in a downward dog position and tealights glowed along the mantelpiece and windowsills.

'Hi, Mum.'

'Rachel.'

She dropped into a plank, then lowered herself down to the mat, and rose to a standing position, pressing her palms into prayer.

'Do you want to share my fish and chips?' I said.

'I've already eaten. Give me five minutes and I'll join you in the kitchen, darling.'

She leant forwards to kiss me on the cheek, and studied me as a mother does.

'You look tired, but glowing. Got a new boyfriend?'

'Nope. Where's Malcolm?'

'In bed.'

'All right, see you in a minute.'

In the kitchen, I put the fish and chips on a plate and opened the can of Coke, then sat down and ate. The influx of carbs combined with caffeine and sugar made everything feel better. The encounter with Penny came into my head and, determined to enjoy my lunch, I tried not to think about it. Mum mopped her brow with a towel as she came into the kitchen before wrapping it round her neck. She kissed me on the top of my head.

'Where have you been, darling?'

'At Chipford Hall.' She raised her eyebrows, probably because this wouldn't be my usual choice for a day out, despite the history degree. She leant against the counter.

'On your own?'

'No, with Jake who works in the art gallery. I have something to tell you, actually, Mum.'

'What's that then? Is he your boyfriend?'

I sighed.

'No. Why don't you sit down?'

She filled a glass with water and joined me at the table.

'You know how you can't stand Saffy, the cat from next door?'

'I don't mind her. It's Malcolm. You know he has a thing about animals. He thinks they're unhygienic.'

'Well if it wasn't for Saffy, I wouldn't have found a painting in the loft.'

'One of Gran's silly purchases from a car boot sale, I expect.'

'I don't think so.' I told her the whole story as she drank her water, ending with, 'And it might be a real Canaletto.'

Mum spat out her water and I burst out laughing. She dabbed her mouth with the towel.

'You're having me on!'

'Nope. That's why I went to Chipford Hall, to show the painting to an art expert.'

'And they said it might be real?' she said.

'Yes, she said to email her contact at Pimsy's.'

'Pimsy's?'

'The auction house in London.'

'Of course, I've heard of Pimsy's, but then she must think it's real to suggest that. Where's the painting now?'

'In the safe at the art gallery, where Jake works.'

'And you trust him?'

'Of course.'

'What if he runs off with it?'

'He wouldn't do that.'

'What if he did?'

'I have to trust him. It's potentially too valuable to keep in the house.'

'It's been in the loft for over two hundred years, darling,' Mum said.

'Yes, but nobody knew it was there, did they?'

'Who would know now?'

'Well, I've told a few people at Chipford Hall, and Jake, and he's told his dad on the phone, and now his ex knows as she walked in on us when he was putting it in the safe. Word can get around, can't it?'

'She walked in on you just now?'

'Yes, it's complicated, Mum.'

'I get the feeling you like this Jake, and perhaps he's giving you signals that he likes you, and he'll have to choose between you both.'

'You get all that from what I've just said?'

'At my age, you can work things out pretty quickly. Did something happen with him last night, then?'

'No, Mum.'

'But where did you stay?'

'What do you mean?'

'Rachel, a mother knows.'

I shook my head. How?

'Were you with someone else?' she said.

'Yes,' I said, quietly.

'Who?'

'The chef at work.'

'What chef? You have a job?'

'Quite a lot has happened since you went to Jaipur.'

'You were stuck in such a rut. I knew my going away would be good for you.'

Her not being around had made me get my act together, but finding the painting and meeting Jake had helped as well. I told her about volunteering and the waitressing job.

'I'm so pleased you've pulled yourself out of that hole you were in.' Mum hadn't said a word before leaving, but thinking back, she'd dropped a few hints. Her parenting approach had always been to coerce me gently into doing the right thing as she said her parents being overly strict had sent her in the wrong direction when she left home.

'And imagine if this painting is real. It's about time we had some money round here. When can I see it?'

'When Jake gets back from London in a couple of weeks.'

'Do I have to wait until then?' she said.

'He's the only person who can open the safe. But I have a photo.'

I showed it to her on my phone along with a photo of the note.

'Wow, it looks really special,' she said. 'And the note certainly helps. I have a good feeling about this.'

'That's encouraging,' I said, used to her good feelings often resulting in nothing. 'In the meantime, I need to email the bloke at Pimsy's,' I said. 'Do you think Philippa from the note could be our ancestor?'

Mum shrugged.

'This house has been in the family for generations. You could always ask Uncle Pete. He's got a family tree on that My Lineage website and keeps emailing me invitations. I've ignored it all, as you can imagine.'

'Do you think he'd mind me calling him?'

'Of course not. I'll give you his mobile number.'

'Are we eating together tonight?'

157

'Malcolm's got a dodgy tummy and he's in bed trying to regain strength so he can go cycling tomorrow.'

Lucky me, having Mum to myself for a whole evening.

'I'll make us a niçoise salad as you won't need much after that,' she said, eyeing my fish and chips. 'Shall we find a nice film to watch?'

'Sounds good.'

'And we can open a bottle of red.'

I put down my knife and fork and downed the rest of my Coke, boosted by the food and Mum's company, but also sleepy.

'All right, I need a nap now.'

'You go and have a snuggle in bed, darling, and I'll see you later.'

It was difficult not to sense Mum and Malcolm's presence at Ivy Cottage the next morning, even though they were still in bed. Although I was lonely before the painting led me to Jake, and all that followed, I'd got used to Ivy Cottage being all mine. I dressed and went downstairs to eat a slice of toast, standing up staring out of the kitchen window. The apple trees were pink with blossom and tulips had popped up in the flower beds. A sense of dread filled me as I thought about the prospect of seeing JC at work, hoping it wouldn't be awkward between us.

When I arrived at Peaches and Cream, Melanie threw me a wave from behind the front desk, the phone receiver pressed to her ear. Through the hatch, I spotted JC preparing lunch. He didn't see me and after pushing a tea towel into my back pocket, I grabbed a coffee and set the tables.

A handful of customers came in for coffee and cake that morning and as I served them, I worried about coming face-to-face with JC. During my break, I sat in the staff room, looking

158

across at Jake's flat. With Penny in the picture, there was no point in hoping something might happen between us and I should settle for a platonic relationship with him. The Venetian blinds were pulled shut, and it occurred to me that the flat was empty most of the time, and I needed somewhere to live. Would he consider renting one of the rooms to me? It was an idea to mull over with a view to plucking up the confidence to ask him. He could put my rent back into the gallery, so there was a chance he'd say yes. JC stomped upstairs, pushed open the fire-exit door, lit a fag and set eyes on me.

'Rachel, how are you?'

'Okay, you?'

'Not bad.'

He drew on his cigarette. 'I had a good time the other night. We should do it again.'

'We could do.'

'Tonight?'

'What time?'

'Nine-thirty at mine?'

'Okay.'

The next morning, I woke up to JC pulling on his checked trousers and spraying his aerosol can around. Déjà-vu. I'd warned Mum I might stay out overnight so she wouldn't worry. Texts didn't work with her as she never looked at her mobile.

'I have to get to work, Rachel, so see yourself out.'

'All right, bye.'

He leant over to kiss me on the lips.

'Let's do it again sometime?'

'All right.'

159

With Mum and Malcolm at home, I made the decision to hang around for a bit. After pulling on a T-shirt, draped over the back of a chair, I went to make coffee. Then, I retreated to the bed, propping up a couple of pillows, and switched on my phone. A thought occurred to me and I drafted an email to Randolph Tanner at Pimsy's, the caffeine clearing the fog induced by red wine and being up half the night. If only I'd brought clothes for work, then I could shower and dress without having to return home.

Dear Randolph,

Caroline Ross at Chipford Hall gave me your email address and I hope you don't mind me contacting you directly. I recently found a painting in my grandmother's loft, which I and others believe could be a real Canaletto. Would you be interested in me visiting Pimsy's to show you the painting, and to get your expert opinion on how to proceed with verifying whether it is an original or not? There was a note with it dated in 1782 which may help with provenance, mentioning a companion painting.

If you refer to the book, Canaletto's Work, *you will see that Plate 14 is a pen-and-ink drawing with wash on paper:* Piazza San Marco: looking East from the South-West Corner *(owned by the Galleria di San Marco in Venice, Italy). The book says, 'It's more than likely that Canaletto produced a matching painting although its location is unknown.' I believe this text might refer to my painting. Furthermore, I think the companion painting referred to in the note is Plate 15 in the aforementioned book,* Piazza San Marco: looking East from the North-West Corner, *also owned by the Galleria di San Marco.*

Best wishes,
Rachel Brown

I deleted 'sent from my iPhone', giving it more of a professional edge, and copied his email address from the Post-it in my bag, then clicked 'send'. After pulling on my clothes, I headed home. Mum and Malcolm were in the kitchen with the papers and a cafetière in between them. The radio was on Classic FM, and the sink was clear of dirty dishes for the first time in ages.

Mum looked up from the crossword.

'Hello, darling,' she said.

'Good to see you again, Rachel,' Malcolm said, his eyes glued to the page he was reading.

'Have fun?' Mum said.

'Yes, thanks,' I said.

'What's his name?' Mum said.

Not wanting to talk about my love life in front of Malcolm, I said, 'Stop prying, Mum.'

'I deserve to know where my daughter stayed the night, surely?'

'He's called JC.'

'JC?' she said.

'It's short for Jean-Claude: he's French.'

'Ooh, very nice.' Mum exchanged a smile with Malcolm and when I glared at him, he awkwardly shifted in his chair, rustling the paper. His face was shiny with sweat and he wore a Lycra outfit, his uniform of choice.

'Been cycling, Malcolm?'

'Yes, got up at dawn. Feels good to get back out there.'

He was superfit, twelve years younger than Mum and divorced. As a personal trainer at the gym, he'd joined one of Mum's yoga classes and asked her out for a drink with one thing leading to another. After losing my job and then being let down

161

by Chris, those weeks alone with Mum at Ivy Cottage had been special as it was her first gap between relationships for years. She'd been incredibly low on discovering Nigel's affair and had to move out of his house in Dorking, but now, she seemed happier than ever. There was a sparkle in her eye once again and perhaps, like Jake said, I should give Malcolm a chance and stop being so selfish.

'I'm off to shower and change for work,' I said.

'All right, see you later,' Mum said.

As I headed upstairs, she called after me, 'Don't forget to leave some hot water for Malcolm. You are jumping ahead of him in the queue.'

Oh for goodness' sake. My old thoughts on Malcolm returned. Now I couldn't have a shower in my own home without feeling bad. Tough luck, you should have washed before I got back, Malcolm. Their voices lowered and I hovered at the top of the stairs, but couldn't hear what they were saying. No doubt they were talking about me and JC or was he moaning about me hogging the shower? I needed to move out soon, and Jake's flat seemed to be the only feasible option. When he returned to Chipford, I'd be ready with my proposal.

Chapter Twenty

John and Michael, the footmen picked up my modest trunk inherited from an aunt and carried it downstairs. I surveyed the bedchamber, emptied of my belongings. All that remained were the bed, nightstand, wardrobe and writing table. This room no longer belonged to me. Only two months had passed since my arrival; however, so much had occurred. Initially, I had been consumed with grief and grateful to be saved from destitution. My grief had lessened during that time, but it would take much longer before Papa did not occupy my thoughts for a significant part of each day.

Lady Cordelia's offer of a position had saved me from destitution once again and I prayed this would be the last time anyone would need to rescue me from such a fate. My goal must be to save as much of my salary as possible, giving me some security on my return. Closing the door to my bedchamber, I went downstairs to Mrs Baxter's parlour, where I would wait for Lady Cordelia's carriage to arrive. Rogers sat at the table, reading, and when I walked in, he put the book down and stood to greet me. Although I could not be certain, sadness appeared to reside in his eyes.

'Good morning to you both, for the last time,' I said.

'Good morning, Miss Elliott,' Rogers said.

'Do sit down,' Mrs Baxter said. She handed me a package wrapped in brown paper.

'This is something to remember me by, dear Philippa.' I had not expected a parting gift. 'Do open it now as I am eager to see what you think.'

'It is most kind of you to give me a gift. Thank you.'

'In your short time at Chipford Hall, you have become like a niece to me.'

Placing a hand on my chest, I said, 'Mrs Baxter, your words are most heartening.' I unwrapped the package to reveal a cream dress with sleeves and a collar made from lace. This was a dress she had described to me, worn the night she met her husband at a servants' ball. He died of scarlet fever before she could produce a child, leaving her widowed at the age of twenty-two. Considering her misfortune, she did not appear to possess an ounce of bitterness.

'This is your special dress.'

Standing up, I held it in front of me and checked my reflection in the looking glass above the fireplace, picturing my hair in a French knot and a dash of rouge on my lips.

'Wearing it will be an honour.'

'And when you do, think of us,' she said.

'You will look most elegant,' Rogers said. 'And if I encountered you at a ball, I would certainly ask you for a dance.'

'Thank you, and I would accept.'

He adjusted his wig and looked over at the hearth. Tears welled in my eyes, and I dabbed them with a handkerchief. Had I become so fond of Rogers that leaving him would impact my heart? I folded up the dress and rewrapped it, then Rogers handed me a white box.

'May I present you with my gift?' he said.

Looking from him to Mrs Baxter, I said, 'I did not expect gifts from either of you.'

'I hope you like it,' he said.

On lifting the lid, a brown book lay nestled in tissue paper.

'It is a journal,' he said.

From the cut of the leather, the neat stitching and its earthy, sweet scent on holding it to my nose, there was no doubt he had spent a significant part of his income on me.

'This is a most generous and thoughtful gift, Mr Rogers, as I shall endeavour to log every moment of my journey. I can only blame not having gifts for you both on departing at such short notice.'

'We only expect you to be safe and well on your travels,' Mrs Baxter said.

'My sentiments entirely,' Rogers said.

When Mrs Baxter got up and poked the fire, he leaned towards me.

'I shall think about you when you are gone, Miss Elliott,' he said in a low voice.

Before I could respond, Mr Banks knocked on the door, entered and cleared his throat.

'Lady Cordelia's carriage awaits, Miss Elliott.'

'Thank you, Mr Banks,' I said.

'We shall come to bid you farewell,' Mrs Baxter said.

I carried the gifts with me, comforted to have them on the journey. A coachman waited, clutching reins attached to the horses. Gripping John the footman's proffered hand, I ascended the step and sat inside. My departure marked the end of one era, but the beginning of another. The carriage had not been converted from a pumpkin and I did not wear a gown and glass

165

slippers, but with Mrs Baxter's divine dress under my arm, I was Cinderella and Lady Cordelia was my godmother.

They stood by the carriage, Mrs Baxter dabbing her eyes with a handkerchief and Rogers as still as a heron on the edge of a lake, acting as though he were devoid of emotion, as a man does, but I sensed an element of melancholy in his demeanour. The girls were taking a dance lesson and we had said our goodbyes the day before when they presented me with a book of French poetry, a gift to cherish.

The carriage moved and I waved to my friends. They raised their hands in return and despite doing my best not to break into a sob, it was no use. I gave in, allowing a flurry of tears to run down my cheeks. Excitement, anticipation, nerves consumed me and ultimately fear that I might regret my decision. Perhaps I should have stayed with Thomas and Mary after all, waiting for the right position to present itself? But how long might that have taken? From the outside looking in, this was the perfect situation for a woman like me, but there were so many what-ifs. Would Lady Cordelia treat me well once I was her employee? And would I be homesick for England after leaving its shores?

We made our way to Hertfordshire where I had arranged to stay overnight with my cousin once removed, Tabitha. The journey was one to endure. Holes formed from ice and snow of winter months provided a bumpy ride as we crossed England from west to east and I prayed no wheels would fall off the carriage. At eight o'clock, I arrived at Tabitha's house, and she presented me with a bowl of potato and leek soup with bread, in the parlour. Her husband, the local vicar was busy at the church, and so we talked in the drawing room after supper. She was older than me and her daughters had grown up and married well: one to a naval officer, and the other to a vicar in the neighbouring

village. My bedchamber overlooked a garden abundant with roses and rhododendrons in bright colours and I wrote letters until late, firstly to Rogers and Mrs Baxter to thank them for their gifts. Then I wrote to Mama, summarising my journey and my sentiments on leaving Chipford Hall. I did not mention how Rogers had shown me a different side of himself in the parlour that morning, leaving me confused about my feelings towards him. We were firm friends, to be sure, but could there ever be the possibility of romance between us?

The next day, I rose early and styled my hair into a braid and pinned it to my head in an attempt to look respectable for my arrival at Heybury House. Tabitha's husband was already at church, preparing his sermon, reminding me of how hard Papa had worked. After I had thanked Tabitha for her hospitality, the coachman returned to collect me from a nearby inn, and this time the journey only lasted a few hours. We progressed further south to Surrey along country lanes where fields were occupied by lambs and poppies grew on the grass verges. As I understood from the map, my destination stood around halfway between Dorking and Guildford, near Clandon Park. We passed through the gates in the late afternoon, approaching the house via a long and twisting drive. The carriage stopped outside Heybury House, a building half the size of Chipford Hall, nevertheless a fine-looking residence. Built in a modern style, the house was made from red bricks with pillars flanking the main door. A footman took my hand and I descended from the carriage onto the gravel. A man and woman, presumably the butler and housekeeper, greeted me.

'Good afternoon, Miss Elliott, and welcome to Heybury House. I am Mr Williams,' the butler said.

'And I am Mrs Watkins, the housekeeper. Allow me to show you to your bedchamber,' she said.

'Delighted to meet you both.'

Mrs Watkins took me into the main hall and up the stairs. We reached the landing on the first floor and, expecting to be led up another flight or two to servants' quarters, I was surprised when Mrs Watkins walked to the end of the hall and opened a door. My bedchamber had a view of the drive and of fields beyond and it boasted a four-poster bed, a writing table and a chaise longue covered in gold fabric. A jug of water and glass were set out on the nightstand on a silver tray. This was clearly a room for distinguished guests, and it was a novelty to be given such a welcome by someone of such an elevated status in society.

'I shall return in an hour to show you to the drawing room for tea. Our footmen will bring up your trunk presently, and I shall send a maid to put away your belongings.'

'Thank you, Mrs Watkins, however, there is no need to send a maid.'

'As you wish, Miss Elliott.'

She left the room, and a few minutes later, there was a knock at the door. Expecting my trunk, I went to open it, but Mrs Watkins was standing there, unable to look me in the eye, the grave expression on her face telling me something was wrong.

'Whatever is the matter, Mrs Watkins?' I said.

'I am sorry to tell you that the footmen have dropped your trunk down the stairs. Some of your clothes fell out, and a maid is rearranging them as we speak, but also the lid is cracked.'

'Accidents happen, but how will I transport my belongings to Italy now?' I said.

'Her ladyship is prepared to give you one of hers as she no longer uses it. Shall I ask the footmen to bring it in a moment?'

'All right, thank you.'

Before long, the footmen were bringing in a small trunk made from what appeared to be oak, of the finest quality. It was certainly an improvement on my trunk which probably would not have endured the journey anyway. Mrs Watkins appeared.

'One of my maids has transferred your belongings. Her ladyship wanted me to inform you of a secret compartment at the bottom of the trunk, previously used to transport her jewels when travelling to Italy. You press the screw inside which reveals a latch. If you twist the latch, the base will click open.'

I did not own any jewels, apart from the string of pearls gifted to me by my parents on my eighteenth birthday, but the compartment might be useful for storing money.

'Thank you for your kindness, Mrs Watkins.'

She nodded and left the room once again, and I set about unpacking. A knock came at the door earlier than expected and I opened it to see a young girl, dressed in a servant's clothes.

'May I help you?' I said.

'Hello, Miss Elliott. My name is Fanny Smith and I am Mrs Baxter's niece.'

'Oh, how delightful,' I said. 'Do come in and sit down.'

She entered the room and I directed her to the chaise longue.

'Are you looking forward to your Grand Tour?'

'Indeed, I am, Fanny.'

She seemed to want to tell me something, and I watched her gathering thoughts.

'Well, it is nice to meet you, Fanny. Your aunt used to read me your letters and it is good to see you developing your reading and writing skills.'

'I have been most fortunate,' she said.

'If that is all, I am sorry, but I need to finish arranging my belongings before Mrs Watkins takes me down for tea.'

Fanny stood up and approached the door.

'I wish you safe travels, Miss Elliott.'

'Why, thank you, Fanny.'

She twisted the doorknob one way and then the other as if battling with her thoughts.

'Before departing, you ought to be aware that...' She paused.

'Do go on.'

'Lady Cordelia——' She was interrupted by a knock at the door.

'That will be Mrs Watkins. Do continue, dear girl.'

'It is nothing,' she said, looking down at the floor.

Mrs Watkins entered. 'What are you doing up here, Fanny?'

'I was introducing myself to Miss Elliott who is acquainted with my aunt, Mrs Watkins.'

'Very well, do return to the kitchen as I am sure you are needed there.'

'Goodbye, Miss Elliott.'

'Goodbye, Fanny.'

As she left, I pondered upon what she had intended to say about Lady Cordelia. Clearly, she could not tell me in front of her superior. Later, I would find her in the kitchen and press further. Mrs Watkins led me downstairs to the drawing room where cherry-red walls boasted portraits of the family and ancestors, as well as a full portrait of His Majesty, the King. A portrait of Lady Cordelia and the baron consumed the wall to the left of the fireplace, and while studying it, I considered the absence of children, and how he would need an heir. Lady Cordelia entered. 'You have arrived, Miss Elliott.'

'Good afternoon, Lady Cordelia.'

We took the chairs by the window.

'Did you have a pleasant journey?'

'Yes, although the roads were riddled with holes,' I said.

'There will be many of those to endure in the coming weeks.'

Mr Williams poured tea into cups on the trestle table between us.

'Tomorrow, we shall depart, staying overnight at inns in Maidstone and Dover before taking the packet boat to Calais.'

'I am most grateful for this opportunity,' I said.

'It is I who should be grateful to you for accompanying me at such short notice. Our journey will be educational, to be sure,' she said, 'and on your return, you will have a collection of anecdotes to relate to family, friends, and acquaintances.'

No doubt there would be many tales to tell.

'This evening, you will dine alone, Philippa, as I need to finish planning my novel. You will be provided with supper in the library.'

'Thank you.'

'Now I must retire.'

'Good evening, Lady Cordelia.'

'I shall see you in the morning, bright and early. We depart at six o'clock.'

She stood up, her cup of tea untouched, leaving me alone, and I wondered if it would always be thus.

Chapter Twenty-One

Malcolm used Mum's car to bring over his belongings as he couldn't fit much in his TR8. He brought boxes of weights and weird-looking gym equipment, plus his vast trainer collection. He dumped his mountain bike in the hall, saying there was no way he was leaving it outside to be nicked. Squeezing past the damn thing whenever I entered the house was an irritation. He'd signed up for *L'Ètape du Tour*, the *Tour de France* route for amateurs, meaning he'd practise a lot, and so hopefully would be around less. He put most of his things in the spare room, my dumping ground, not his. And every time I wanted to use the bathroom he was in there or had used all the hot water on one of his extended post-cycling showers. All I could do was take on extra shifts at Peaches and Cream to get out of the house while waiting to ask Jake about moving into his flat.

Over a week had passed since sending the email to Randolph Tanner and I had begun to wonder if he'd reply at all. Then on Wednesday when checking my phone in the staff room, there was a reply from him in my inbox.

Dear Rachel,

Thank you for your email and apologies for my delay in replying. I have been in the New York office on business. I would be very interested to meet you and see the painting. Please advise a day that is convenient and we can arrange a meeting at Pimsy's. Then we can talk about provenance and the evidence required to prove the painting is an original Canaletto.

Best wishes,
Randolph

After I replied to suggest we meet the Wednesday after next, he came back with a time of 11.30 a.m. I texted Jake to let him know, asking if we could get the painting out of the safe the Sunday before. He replied to say yes and that he'd text about us having a drink on Friday.

With two days until Jake's return, I found myself searching for him on Facebook, feeling like a stalker, but just wanting to see a picture of him. Jake Holmes' came up a few times in my search, and he was the third one down. He looked gorgeous in his profile photo taken on a beach, his face golden from the sun. I allowed myself to drool over him for a few minutes, but reality kicked in when I saw he'd been tagged by Penny in a photo. He stood with his arm around her at the wedding they'd been to, his face fixed in a smile. She looked phenomenal in a low-cut lemon dress and I could never compete. I almost clicked on 'Add Friend', but decided against it as didn't want to come across as obsessed with him or anything.

On Friday, I checked my phone during breaks and there was no word from Jake. JC and I had developed a friends-with-benefits arrangement and he invited me over that evening. I said

I'd let him know. At the end of my shift, I ate alone at the usual table, and texted Jake.

'Do you still fancy that drink?'

The three dots appeared as he typed a reply.

'Was going to text when I left. 8pm at The Old Bear?'

'Okay.' I selected a glass of wine emoji, and he replied with a thumbs up.

Before leaving work, I told JC I couldn't go to his place, and he shrugged, saying, 'Fair enough.' He clearly didn't like being rejected, but this was my chance to ask Jake about renting his flat.

When I arrived at The Old Bear, Jake was already sitting at a table in the corner with a pint of lager, wearing what looked like a work shirt with a jumper over the top. He grinned as I approached.

'Hi,' I said.

Jake stood up and we kissed each other on the cheek, and I inhaled his sandalwood scent. He smelt so good, but allowing myself to be attracted to him would surely not be good for my heart.

'What can I get you?' he said.

'White wine, please,' I said.

He went to the bar, and I took the booth seat facing the room. There was a sizeable queue for drinks with the hum and buzz of people chatting in loud voices. Jake came back with a large glass of wine, and a bag of posh crisps, tearing open the packet and putting it between us.

'So, firstly, let me apologise for what happened with Penny that day. I had no idea she'd appear in the basement like that.'

I took a crisp. 'It's okay.'

'I am sorry though.' He sipped his beer.

'She has nothing to worry about with us just being friends.'

'Yep, just friends.' He threw me a look saying the exact opposite, the blue collar on his shirt bringing out the colour of his eyes, and as my gut hopped like that evening when he came over, I wondered whether he and Penny were properly together again after the wedding. As if reading my thoughts, he said, 'Although me and Penny haven't been in a relationship since before Christmas, her family dog had a stroke a few weeks ago and she came over to my flat in London, and one thing led to another.' I drank my wine, trying to shift the thought of them in bed together out of my mind. 'And then she turned up here that Friday night before visiting her parents in Oxford on the Sunday. To see the dog.'

'And there was the wedding,' I said.

'Yes, well, our mutual friends, Lisa and Nick, were getting married and we accepted the invitation as a couple last year.'

'How's the dog?' I said, registering that there seemed to be a link between its poor health and whether Jake and Penny were seeing each other. Despite my feelings towards Penny, I didn't wish her dog any harm, and hoped he or she was on the mend.

'Still in recovery, I think,' he said. And then, for some reason, he scratched his head and added, 'We're not exclusive, me and Penny. I think she still sees the bloke she was going out with before me.'

Was this some kind of half-hearted proposition? Once, perhaps, I might have pursued something with him, despite knowing he was seeing Penny casually, but with feelings involved, it could only end in disaster.

'Oh right.'

As if realising he'd said the wrong thing, he changed the subject.

'Anyway, how have you been?' he said, his voice going up an octave.

'Not bad. Working mostly. I took on some extra shifts now my mum and Malcolm are back.'

'How is it with them in the house?'

I pulled a face. 'Not great.' I needed to drink more before having the confidence to bring up his empty flat, and so I said, 'How was the wedding?'

'It was a long drive to Newcastle and the guests were mostly Penny's friends, so she left me with the husbands and boyfriends. Thankfully, a couple of them were all right.'

JC came through the door with sous-chef, Ralph, but didn't seem to spot me. Should I say hello to stop him coming over?

'Same again?' I said, standing up.

'Okay, thanks.'

I headed for the bar and tapped JC on the shoulder.

'Hi.'

'Rachel, you changed your mind. Join us.'

'I'm actually here with my friend, Jake.' He scrunched up his forehead. 'You met him before, remember?'

'Oh, yes, the art gallery guy. But is he only a friend or do we have to compete for your attention?'

'He's seeing someone else.'

'That means nothing.'

I ordered drinks and tapped my card on the machine.

'See you later then.' I returned to Jake, who was looking in the direction of the bar.

'Here you go,' I said, placing his pint on the table.

'Shall I leave you and the chef to it?'

'No.'

He picked up his pint and our eyes met as he drank, but then JC approached, and my stomach lurched at the thought of him embarrassing me. He would have downed a glass of wine at the end of his shift, and he was bound to have knocked back a post-work vodka chaser or similar before his pint.

'Just wanted to tell the art gallery guy you were supposed to be seeing me tonight.'

'JC, you don't own me.'

'Well, you were in my bed last night, eh?'

'Oh, for goodness' sake.'

Jake stood up and proffered a hand.

'Good to see you,' he said.

JC shook Jake's hand, albeit limply, looking over his shoulder at me.

'I have to play pool with Ralph, but why not come to mine later, Rachel?

'Not tonight.'

'So, at weekends, you are his? As you wish.' He headed for the pool room, and Jake threw me a that-was-awkward smile.

'Sorry about that,' I said.

'He's clearly jealous, although he doesn't have anything to worry about, does he?'

'We are just friends, after all,' I said.

We clinked glasses and he said, 'To being just friends,' but the intense look in his eyes said, *We both know that's a lie, right?*

JC had at least broken the ice for me, and I was ready to ask about the flat.

'Can I ask you something?' I said.

'What?'

'The other day I was in the staff room, looking over at your flat, and it occurred to me that no one lives there during the week.'

'And you're looking for somewhere?'

'How did you guess?'

'The thought crossed my mind, but I didn't suggest it because I'm there at weekends.'

'Malcolm's brought the whole world and his wife with him to our house and apparently, he's bringing more stuff over tomorrow. I need to make an appointment to use my own shower, and I was hoping you might make the rent a bit cheaper than other places if I help at the gallery or something?'

'There's no need to help at the gallery, and you can live there for two-fifty per month. How does that sound?'

'That doesn't seem like enough money compared to the going rate.'

'All right, you can pay for my Netflix subscription. How about that?'

'Sounds great, thanks. Would you want me to go home at weekends?'

'There's no need. In fact, I'd appreciate the company. And you'll be doing me a favour as your rent will cover some of the bills, plus it would be good to have the place occupied on weekdays.' He downed his beer. 'Why don't you move in tomorrow?'

'So soon?'

'I don't have much on, apart from paperwork for the gallery.'

'Mum and Malcolm are using the car tomorrow to move in the rest of his stuff.'

'I'll help you.'

'Thanks very much,' I said, unable to believe my luck. And he seemed to think I was doing him a favour.

'Let's get shots to celebrate.'

He went to the bar before I could stop him and we downed a shot of tequila each then he insisted on walking me home. We stopped outside the gate to Ivy Cottage and he looked down at me and swallowed before inhaling and kissing me tenderly on the cheek.

'I'll pick you up at midday?' he said.

'Okay.'

As he walked up the hill, lit by a streetlamp, I watched him, admiring the way he moved with a steady and self-assured gait. He glanced back over his shoulder and we exchanged a smile. Would something happen between us if we lived together and if it did, would that create problems if we fell out? And Penny still seemed to be in the picture anyway. If she turned up out of the blue with me living in Jake's flat, it could be very awkward indeed.

Chapter Twenty-Two

The following morning, we rose early, and embarked on the journey from Heybury House to Dover, where I could not wait to see the white cliffs. As we headed south, it dawned upon me that I had forgotten to find Fanny and I hoped her message was not significant. The bumps in and out of holes in the road did nothing to dampen my mood. I was going on an adventure one could only dream about, and Venice was my destination.

'Were you able to finish planning your novel last night, ma'am?' I said.

'My dear, if we are to spend all of this time together over the next few months, I think it wise you address me as Cordelia.'

'As you wish,' I said.

'I managed a little, Philippa, but I have reached an impasse and cannot decide which direction the plot should go in. Usually, once I start to write, all becomes clear.'

'May I ask what your novel is about?'

'I am writing about a woman who survives life against all odds. She is born illegitimate in Paris, to the mistress of an earl, a French countess who is married with children fathered by her husband. This woman, Candice grows up in Paris. When she is eighteen, her mother sends her to England to a country house near

Bath to meet her real father, who is old and frail and ready to die. The official story is that he is her godfather, and when he dies a few days after her visit, he leaves her a significant amount of money in his will. She marries a middle-aged, widowed baron with grown-up children who has spent his inheritance on gambling, and is in debt. She becomes part of high society, but when her husband is killed during a duel over an outstanding debt, she is widowed at the age of twenty. Now she is stuck because she has all of this money, but if she remarries, the money will belong to her new husband. What is she to do? Does she spend the rest of her life as a widow, with money to do as she wishes? Or does she remarry and become the wife of a man who tells her what to do? Several men with outstanding debt pursue her, and she decides to take some time to make her decision, so she embarks on a Grand Tour with her cousin.'

'That is an interesting story, and I look forward to reading it.'

'Thank you. Recently, the words have not been forthcoming and I hope our journey will provide inspiration.'

We arrived at an inn in Maidstone in the late afternoon, and the following morning progressed to Dover. When we got there, I went to the church in the next street to pray for one last time before we left England. The vicar read from psalm 121:7-8: *'The Lord keeps you from all harm and watches over your life. The Lord keeps watch over you as you come and go, both now and forever.'*

These words were a comfort during a time when, now the prospect of travelling such a great distance had become a reality, anxiety consumed every part of me. The vicar delivered a fine sermon at the altar.

'In Dover, we are used to showing hospitality to strangers here at St Martin's, and I see some of you in my congregation

this evening. As a vicar of the local community, I consider it my duty to impart words of wisdom to allay your fears. Take the words of psalm 121, verses 7-8 on your journey; the Lord will watch over you. Do not be afraid of the sea; the Lord will assist with your crossing to the other side.'

When he had finished, members of the congregation emptied the pews, gathering by the door to give money to the collection. I approached the vicar who stood at the front of the church.

'My name is Miss Elliott, and I wish to thank you for your fine sermon, Sir. Your words were a comfort to me as tomorrow I shall embark on a long journey.'

'And where, might I ask, are you going, Miss Elliott?'

'I am accompanying Lady Cordelia Heybury on a journey to Italy, as her companion.'

'You are a brave woman, Miss Elliott, and I wish you well on your journey. May the winds not prolong your crossing to France.'

'Thank you, Sir. May I light a candle for my papa, a man of the cloth like yourself, who died a few months ago?'

'Please do, my child.'

I picked up a tall white candle, and held it upside down until the wick caught the flame of one already lit. Then I placed the candle in a holder, and pressed my palms together.

Dear Papa, please remain with me on this journey to Venice, guide me across the sea, along the roads however treacherous they may be, and over the mountains which I fear most, as the grand heights of the Alps fill me with dread.

When I left the church, the congregation had dispersed, and I returned to the inn.

After supper we retired, and I wrote letters to say goodbye and to describe the journey ahead, giving the address of our *pensione* in Venice, the Italian word for boarding house. The duke had described all kinds of events occurring in his journals: a carriage turning sideways when a wheel caught in a hole, a highwayman holding up a coach, stealing everything from its passengers, but thankfully we would not travel at night. The duke wrote about bugs in the beds at the inns, being confronted by a wolf at the Mount Cenis pass, and mosquitoes biting him so many times at Lake Garda, he itched all over, all day and night. But he also wrote about the beauty of the countryside and the mountains, and the Roman ruins where once Augustus ruled, and the architecture in Venice.

There was much to anticipate, but something about Lady Cordelia's comportment made me sense our journey might not be a smooth one. Constantly on edge, she came across as an impulsive being, and initially this characteristic had warmed me to her, but now I feared her character might not bode well for me.

The following morning, we took the packet boat to Calais. We leant on the railings and watched the white cliffs of Dover fade into the distance and I left England for the very first time. We walked or rather staggered as the boat rose up and down, making us step in zigzags to the front deck where we sat on a bench. The wind blew into our faces and we pulled up the hoods on our cloaks. Lady Cordelia's face was as white as the coat on a new-born lamb, and she did not seem well.

'I have never suffered like this on the passage from Dover to Calais before,' she said.

'The winds are especially strong,' I said.

She closed her eyes. Grey clouds loomed overhead, and I prayed there would not be a storm. As we progressed towards France, the boat rose higher, and the waves crashed against the bow, white foam hitting the deck, and water running around our feet. I thought back to the vicar's words in church: 'Do not be afraid of the sea; the Lord will assist with your crossing to the other side.' I prayed he was right, and that the Lord would protect us. And I spoke to Papa as he watched from heaven, '*Please help us to cross safely, dear Papa.*' He would be proud of me.

As Lady Cordelia slept, I thought about what I would write to Mama, Mrs Baxter, Rogers, and the dear girls on arrival in Calais. Here I was gifted with an opportunity none of them, apart from Rogers were likely to experience. My aim would be to describe the passage so they could imagine they were crossing the English Channel. The outline of France with its sandy beaches came into view, taunting us, whilst the captain battled with the contrary winds. Oh, to place our feet on terra firma once again. As the boat jolted, Lady Cordelia woke with a start. 'My stomach feels tender, Philippa, and I may be sick.'

'Let me assist you with moving to the side of the boat as a precaution.'

Her face was still white, and I helped her get up, bending my arm so she could slide hers through it, and we approached the railings. Lady Cordelia retched over the side directly into the sea below and I handed her a handkerchief, thankfully not one with sentimental value, and she wiped the vomit from her mouth and face.

'Thank you, Philippa. That episode has made my throat sore.'

'Let us be seated so you may sip water from your flask.'

We linked arms and walked back to the bench, then we sat down and she picked up her flask. Pulling my cloak around me,

I studied the outline of France. My first time outside my own country brought a thrill and a burst of excitement rushed through my veins. Gulls landed on the deck and squawked and pecked at crumbs and Lady Cordelia glared at them as she took sips from her flask. When we first met, she had seemed invincible, but now a vulnerable woman sat before me.

After attempting to enter the port of Calais several times, the captain arranged for us and our trunks to be transferred to a rowing boat and we were taken to Boulogne where we took a chaise to an inn. We were served soup and bread and Lady Cordelia consumed only a few spoonfuls. Fatigued, we retired to our rooms afterwards. My mattress sank in the middle, and I tossed and turned, the odd-shaped pillow making it harder still to gain any sleep whatsoever. At three o'clock, I woke with a crick in my neck, and after moving it from side to side and massaging it with my hand, to no avail, I lit a candle and wrapped a blanket around me, then wrote on the first page of the journal given to me by Rogers. As I inhaled the sweet scent of the brown leather, I pictured him in Mrs Baxter's parlour, remembering him to be rather nice to look at. This generous gift meant I was dear to him. We had grown to know each other well in a matter of months, and all I could do was write letters to him and endeavour to nurture our friendship upon returning to England.

Chapter Twenty-Three

On Sunday morning, my phone alarm went off at nine o'clock. I pulled on my dressing gown and went downstairs, thinking about what to put in my suitcase. All I needed was enough to get by for a few days until I could come back and use Mum's car to move the rest of my things. She'd be pleased I'd found somewhere else to live, no doubt. Classic FM played in the kitchen and Mum was established in her usual spot at the end of the table, filling in the crossword. She wore yoga pants and a tight-fitting top with lace edging. Sometimes having a mother who was slimmer than me grated, but I could never eat as little as she did.

'Morning, love,' she said.

'Hi Mum. Where's Malcolm?'

'Cycling. When he gets back we're moving the rest of his stuff before having lunch at The Old Bear. Fancy joining us?'

Thank goodness I had a valid reason to decline. I filled a bowl with cornflakes and milk and sat down, shaking my head.

'I have something to tell you.'

She put down her pen and looked up at me.

'Ooh, what is it?'

'I'm moving into Jake's flat today.'

'Really?'

'I'm renting his spare room above the gallery. He lives in London during the week, so I'll have the place to myself most of the time.'

'Can you afford it?'

'He's giving me a special rate.'

'What about the ex?'

'What do you mean?'

'Is she still in the picture?'

'I think so.'

'And if she comes back at the weekend again?'

'I'll have to stay here if that's okay.'

'How does she feel about you moving in with him?'

'I've no idea. He might not have told her yet.'

'Sounds like it could get messy. I hope you know what you're doing.'

'He's picking me up at noon, so I need to pack. I'll use the car for the rest during the week, if that's all right?'

'Of course. Let me know if I can do anything, darling. It's time for my yoga practice now.'

'Thanks, Mum.'

She went into the living room, and after a couple of minutes, the scent of vanilla incense wafted into the kitchen, and the man with the deep voice chanted 'ohm'.

Jake carried my suitcase up the steep stairs, and through the living room to a whitewashed box room with Blu-Tack marks on the walls, a single bed, chest of drawers, wardrobe and bedside table. The carpet was thick and beige and although I'd have to be careful not to spill any drinks on it, I imagined the room would be cosy once I'd put my lamp on the bedside table, added my duvet to the bed and stuck a few photos on the walls. The staff

room at Peaches and Cream was directly opposite, and I made a mental note to remember that when getting changed.

'Hope it's okay for you,' Jake said.

'This is perfect, thank you.'

'Can I buy my new flatmate lunch?'

'That would be nice, but can we avoid The Old Bear, as Mum and Malcolm are going there?'

'All right. He glanced at his watch. 'Let's go to the tea room over the road in ten minutes. They do a mean ham and cheese toastie.'

He closed the door behind him and I unzipped my suitcase and put some of my clothes in the drawers. As I was about to go into the living room, I heard him speaking on the phone. Expecting by the tone of his voice that it was Penny, I started to put my toiletries on the chest of drawers. It sounded as though he was having a row with her, repeating loudly, 'I completely forgot,' over and over again. When it was clear the call had ended, I found him slumped on the sofa, tapping into his phone, feet propped up on the coffee table.

'Are you ready?' I said, sinking into the sofa opposite.

The creases on his face answered for him.

'Penny just called. It's her mum's sixtieth birthday and she wants me to go for dinner with her family tonight. Apparently, she mentioned it last week but I forgot all about it.'

'Oh, okay.'

'Penny's brother, Jim, is a good friend and he'll be there with his other half, and I can't really get out of it.'

'I understand.'

'I'd better get back to London and find something to wear. Her dad's taking us to a fancy restaurant and I'll need a jacket. Sorry about lunch, again.'

He disappeared into his room and came back with a holdall, then picked up his keys from the kitchen counter.

'I'm off then,' he said, the keys jangling in his hand.

'Are you taking the painting for my meeting at Pimsy's?'

'Yes, I'll get it out of the safe now. When is it again?'

'Half past eleven on Wednesday.'

'Right, I'll be there. And don't worry, I have a good hiding place in my flat. Dad got a carpenter to put a false wall in the back of my wardrobe so I could keep works of art for him.'

'That's good to know. I do worry about something happening to it.'

'I'll check my work diary and if I have time, we can get lunch afterwards.'

'Okay, great.'

'One of these days we shall have lunch,' he said with a laugh, but all I could do was shrug while struggling to hide my disappointment.

He opened a drawer in the kitchen and handed me a set of keys. As our hands touched, our eyes met once again and it was impossible to deny how I felt about him any longer. Moving in was only going to intensify these feelings and as Mum had pointed out, things could get messy with Penny in the frame.

'Text if you need to know anything about the flat.'

He said goodbye and I remained on the sofa as he closed the door behind him. His feet clomped on the stairs and the main door banged shut, the bottom falling out of my good mood. For as long as Penny had Jake in her clutches, I didn't stand a chance with him, and all I could do was pick up the remote control and acquaint myself with the latest on Netflix.

After an afternoon and evening watching most of the first season of *The Crown*, I went to bed at midnight, worrying I wouldn't sleep in my new surroundings, but the bed was comfy and I didn't wake up until a tractor chugged past at eight o'clock the following morning. I went for a run for the first time in ages, down the hill and along the river, pounding the pavement back to the flat, doing my best to push Jake out of my mind. At least, I still had JC for company. After showering, I headed to Peaches and Cream and he tracked me down in the staff room during my morning break.

'How are things, Rachel?' he said.

'Not bad. I moved into Jake's flat above the art gallery yesterday.'

'Really?'

'Yes, I'm keeping an eye on it when he's in London during the week.'

'So now you're living with the art gallery boy?'

'Is that a problem?' He shook his head. 'I've seen the way he looks at you, that's all.'

'He's seeing someone else, and anyway you and I aren't in a relationship, are we?'

'I suppose you're right.'

'By the way, I didn't like that stunt you pulled in the pub.'

'What do you mean?'

'Coming over and acting like you owned me in front of Jake.'

'It's no excuse, but I was very drunk. I apologise.'

'All right. Thanks,' I said.

'Shall I come over after work one night soon?' he said.

He was being a bit keen after his recent behaviour, despite the apology. Besides, I was still unpacking and didn't feel ready for visitors yet.

'Perhaps give me time to settle in.'

'As you wish.' He went downstairs and as I sipped my coffee, my attention was drawn to Jake's flat, and I thought back to when Penny leant out of the window. Who'd have thought I'd be living there a few weeks later?

On Monday, I found Daphne in the servants' hall before my shift started at Peaches and Cream. After introducing myself, I told her about the painting and the note.

'So, what do you need to know, Rachel?' she said.

I started by showing her the broken red-wax seal on the back of the envelope that came with the note.

'Is this the earl's coat of arms?' I said.

'Yes, it is.'

So, 'R' was Earl Rupert. Then I told her I was reading the earl's journals to try and find out when the painting was in the house and how it got into my gran's loft. I needed to know what happened to its companion too.

'I can look in the archives for inventories from 1780-1782, then hopefully you can see when the paintings were there and when they weren't. If I find out anything significant, we could make a display, then Chipford Hall would benefit from any work I do on this.'

'That would be great, thank you, Daphne. I'm taking the painting to an art expert at Pimsy's on Wednesday.'

'I hope that goes well for you,' she said. 'Although verifying it is likely to take a while. Let's meet next week and I'll look for those inventories in the meantime.'

On Tuesday, after my shift at Chipford Hall, Mum helped me carry my things to the car.

'Before I forget, can you give me Uncle Pete's number, Mum?'

'Of course. I'll text it to you later.'

'I need to make contact with him before the meeting at Pimsy's tomorrow as they're bound to ask about provenance. Do you think he'll have any information about Philippa?' I said.

'Well, he's spent a lot of time on that My Lineage website.'

'Okay. I'll call him later.'

A thought occurred to me. Would Uncle Pete have a claim on the painting if it was worth anything? Our house and its contents had been left to Mum by Gran so the painting belonged to her. He had been left money from the sale of the tailor's business instead, which he'd promptly invested in his luxury bathroom suite company.

'Mum, if the painting turns out to be an original, would Uncle Pete expect to share the proceeds when we sell it?'

'Ivy Cottage and its contents were left to me, so legally he wouldn't be entitled to anything, I expect. But he and your Aunt Patsy have been there for me over the years, so we'd have to make sure he got his share.'

Uncle Pete and Aunt Patsy had made us welcome at their house in Chelsea many times, especially when Mum was an emotional wreck between boyfriends and they'd always hosted at Christmas. Aunt Patsy was like a second mother to me and I'd talked through many a problem with her when not wanting to burden Mum. During my teenage years, my cousins, Tom and Mark took me on pub crawls along the King's Road with their friends and those visits helped me decide I was going to live in London after university.

When I got back to the flat, I googled once again how much Canaletto paintings went for. *Bucintoro at the Molo on Ascension Day* sold at Christie's for £11.5m in 2005, but that was a special painting and I doubted my Canaletto would be worth anywhere near that. I needed to ask Uncle Pete if he had family-tree records going back to who was living in our house in 1782. Checking my phone, I saw Mum had texted his number and I called him.

'Hi, Uncle Pete, it's Rachel.'

'Oh, hello, Rachel. Your mother said you'd call about the family tree. So you want to know more, do you?'

'Yes, please.' I went on to explain, telling him about the trip to Pimsy's.

'Well, it's been a hobby until now and there was no rush to get it completed, but now you've found the painting, I'm in the process of hiring a genealogist.'

'That sounds great.'

'So, why don't you come for dinner tomorrow and we can have a look at the computer then?'

'That would be great. Thanks, Uncle Pete.'

'Patsy will be thrilled to see you and I'm glad someone else apart from me is finally interested in finding out more about our family tree. Neither your mother, nor my sons, want to get involved. There's a client on the other line, so I'd better go. Bye, Rachel. Patsy will be in touch about timings.'

He hung up, and it was good to tick another item off the list.

Chapter Twenty-Four

'Most women do not have the opportunity to undertake this journey, and see what we are seeing. Instead, they experience the Grand Tour through letters, journals, objets d'art and paintings. Thus, they undertake this journey with their minds, the poor souls,' Lady Cordelia said.

'Indeed, the Lord has been kind to us,' I said.

Our chaise bumped along the slim road as it threaded between fields of crops, with barely a house in sight. With the land being flat, our view was mostly sky filled with vast, shallow clouds, and despite my discomfort as we were jolted about, happiness consumed every part of me.

'We have a responsibility to ensure our letters and journals bring this journey to life,' Lady Cordelia said. 'How these women experience the Grand Tour is down to us and our peers,' she said.

Mrs Baxter was one of these women, and I pictured her reading my letters in her parlour with a pot of tea by her side. Mama would grasp the paper with her shaking hand as she struggled to make out the words with her failing sight. And poor illiterate Maud, would experience our journey through the voice

of her sister-in-law, Freda. Our task was to give them an escape from the daily drudgery.

'To be sure, a man's experience would be different from ours.'

'This is why a woman would prefer to read about the Grand Tour from our point of view, *n'est-ce pas*? What can a man know about how we see the world? For our outlook is more complex. A man undertakes a Grand Tour in order to say he has done it, to sow his wild oats and to buy objets d'art for his house. A woman uses the opportunity to develop her mind,' she said.

Lady Cordelia's view of men was different to the one I had been raised with. My parents had brought me up to think for myself, but ultimately if I got married, I would belong to my husband, and my role would be to care for him and any offspring. The way Lady Cordelia dared to criticise the male sex fascinated me somewhat.

'To be sure, we have a responsibility to write to the best of our ability. Each word should be carefully considered before we place it upon the page,' I said.

'One must not forget the use of colour and light. The light in Venice is unique, as you will see, but how do I describe such a light using words? Is it easier for an artist or a wordsmith? An artist reproduces the scene before their eyes, whereas when we write, we have to translate that scene into words. As educated women, we must challenge ourselves to produce our finest work for our readers.'

'Yes, we must use similes, metaphors, alliteration, onomatopoeia; all the tools given to us by the Lord to help us to perform this task,' I said.

'And do not forget the senses, Philippa. The scent of the roses in the garden at the *pensione* where we shall stay, the sweet

195

richness of Italian coffee, the sound of oars pushing through the lagoon. The medieval walls are cool and firm as you run your fingers over them and into dips between the stone blocks. And then there is the sight of the bluest sky one has seen on a fine day, the sun so bright one cannot do without a parasol, or of the thick mist as it blankets the city during winter and the shouts as boats attempt to navigate through the lagoon. Venice will awaken our senses, to be sure. To gain the most from the experience, one must observe and reflect when the opportunity arises.'

Our conversations were mostly like this one, and to be in the company of a woman who exercised my mind in a novel way was an experience to relish. However, I appreciated time alone in the evenings to recuperate from the intensity of her company. Lady Cordelia raised her hand and gasped, then scribbled something in her journal. Moments of inspiration would often strike her like this. I looked out of the window at the fields, and saw a farmer slicing the yellowing grass with a scythe. He was the only figure in sight, for we were in the heart of the provinces. Before long, we would arrive in Paris, and I envisaged France's capital city to be noisy, dirty and foul smelling like London. At the same time, I was excited to see it with my own eyes. For now, I would enjoy the clean air and the silence, when Lady Cordelia was not speaking.

We continued to Paris, stopping at inns en route. Bedbugs fed on me through my nightgown, producing red welts all over my body, and I had to force myself not to scratch them. My face remained unscathed, a small blessing, although a welt marked the side of my neck, but this was obscured from sight by the collar of my dress.

The endless meals of broth and stale bread with the occasional morsel of cheese, sliver of ham, or an egg merged into one. More often than not, we would discover a rodent in the dining area of an inn and sometimes a family of cockroaches would grace us with their presence. I longed to eat a hearty meal and sample local wine rather than the pitchers of beer we had been subjected to. But still, I was grateful for the opportunity to undertake such a journey and continued to write letters as well as in my journal every night after supper. Before extinguishing my candle, I would read one of Papa's sermons and pray for my family and friends.

In Paris, we stayed with Lord and Lady Worthing in a six-storey town house situated in *Faubourg Saint-Germain,* the most fashionable neighbourhood in Paris according to Lady Cordelia. They had left England because of Lord Worthing's gambling debts, and he had formed a circle of local friends consisting of other English gentlemen in a similar position. This coterie often idled in coffee houses, or on benches in the Tuileries. On the evening of our arrival, Lady Cordelia ate with our hosts in the dining room. I, on the other hand was relegated to the parlour with their housekeeper, Madame Beaufort, who had a gentle demeanour, but she was no Mrs Baxter. We ate beef stew with lyonnaise potatoes and green beans accompanied by a glass of Beaujolais, a rich and sumptuous red wine. Madame Beaufort spoke in French and I answered questions about our journey. After supper, I retired to my bedchamber and wrote letters at the writing table by the open window, the chatter of carriages passing beneath. The sun had not yet set, the evening blessed with the light of spring and I rejoiced at the prospect of longer days ahead. Papa would be proud of me, making it to Paris.

The next day, Lady Cordelia and I took the path following the right bank of the Seine, cargo boats passing alongside us, until we reached the Pont Neuf. A thoroughfare of carriages occupied the bridge with people walking and conversing around them. Street vendors sold everything from apples to coffee, and we did our best to avoid their advances. However, we managed to stop momentarily to admire the equestrian statue of Henri IV, before progressing to the Louvre, where we viewed the royal collection of paintings and it was a joy to see work by Da Vinci and Michelangelo. Afterwards, we crossed the road to the Tuileries, and sat on a bench in the shade of the trees as they whispered in the breeze. Lady Cordelia closed her parasol and retrieved her journal.

'How are you enjoying Paris, Philippa?' she said.

'The architecture is *magnifique* and the history a feast for the mind.'

'Of course, I have seen Paris many times, and the novelty has worn off somewhat. I am eager to progress to Lyon tomorrow and to arrive in Venice as soon as possible. Travelling is most tiring, and I long to remain in the same location for a significant period of time.'

'That would be agreeable,' I said.

Since the crossing from Dover to Calais, Lady Cordelia seemed nauseous a great deal of the time and I worried about her health. When we arrived in Venice, I would suggest she saw a doctor if she did not improve. What would happen if she fell ill and was unable to travel home? How would I travel back to England without a chaperone? This thought preoccupied me and I sensed something was not quite right and that our Grand Tour might not go as planned.

Chapter Twenty-Five

On Wednesday, I took the train to Marylebone, then got the tube, changing at Oxford Circus and when I reached the top of the steps at the Green Park exit, it was pouring with rain. Using Google Maps, I headed along Piccadilly under the cover of my umbrella, past The Ritz until reaching Old Bond Street. Pimsy's was a few buildings down on the left, after a series of jewellery shops so flash, many had security guards manning the door. Jake stood outside, dressed in the suit he wore for work, a golf umbrella in one hand and the case containing my painting in the other. For some reason, entering such a fancy establishment made me nervous and having him by my side was reassuring. Although we'd only known each other a matter of weeks, it seemed as though he'd been in my life for years.

'Hi,' I said. We double-kissed, and I inhaled his sandalwood scent.

'Hello, Rachel,' he said, collapsing his umbrella and giving it a shake.

Despite running every day since he left Chipford and trying to shut him out of my mind and focus on JC instead, here I was once again unable to deny my attraction to him.

'How's the flat?' he said, brushing a stray hair out of my face. This move of affection sent a current through me and I did my best not to display any reaction, although my gut was all over the place.

'It's great. I moved the rest of my things in yesterday.'

We went through the revolving door and put our umbrellas in the stand. A glass teardrop chandelier hung in the lobby and two receptionists manned the desk, both with supermodel looks. One of them was on the phone, speaking French.

I approached the desk.

'Hello, we're here to see Randolph Tanner,' I said.

The receptionist picked up the phone.

'Take a seat and I'll tell him you're here.' She gestured towards a leather sofa and we sat down. Jake handed me the painting.

'You should be holding this.'

A few minutes later, a man approached. He was tall and rosy-cheeked and couldn't look more like his name suggested.

'Hello, Rachel, I'm Randolph.'

He shook our hands.

'Hi, this is Jake,' I said.

'Follow me.'

He led us up a flight of stairs and into an office overlooking Old Bond Street with a desk in front of the window. He gestured for us to sit down, and perched against the desk.

'So, you think you may have a real Canaletto in your possession?'

'Yes.' I repeated the information from my email about the note and the paragraph from the book, *Canaletto's Work*.

'Yes, it's very interesting.'

I handed him the case, and he removed the painting.

'Well, this is a beautiful work of art,' he said.

'Do you think it's a Canaletto?' I said.

'Sadly, I can't commit to anything at this stage, but off the record, I have high hopes. Can I see the note?'

I gave the note to him, and he read it.

'Well, okay. Our Canaletto expert works in the Paris office, but will be here on Friday. Do you understand the meaning of the word "provenance"?'

'Yes, it's a record of ownership of a work of art or an antique, used as a guide to authenticity or quality,' Jake said.

'Jake explained this to me when I found the painting. He knows a bit about art,' I said.

'Okay, so you have the note which is a good start. And have you tried to find out who Philippa is?' Randolph said.

I told him about reading the earl's journals at Chipford Hall.

'A tour guide is looking for inventories from 1780-1782 and my uncle is researching our family tree with a genealogist. I'm hoping he may be able to find out if Philippa is an ancestor, as the house has been in the family for generations, along with a tailor's business.'

'And the companion painting is in Venice, you believe?' Randolph said.

'According to their website, it's at the Galleria di San Marco in Venice, hanging alongside the pen-and-ink drawing that matches my painting. The earl's journal suggests the companion painting may have been taken to Italy by the count at some stage.'

'I'll ask my assistant to bring in the paperwork so you're able to leave the painting with us to be checked. I must inform you this could take some time.'

'How long?' I said.

'Around six months, or more,' he said. 'It's likely that the Canaletto expert will need to meet the curator at Galleria di San Marco and do tests on paint used in the companion painting, look at the back of the canvas etcetera. He'll also compare your painting to the pen-and-ink drawing. Another expert will compare the handwriting on the note with that used in the earl's journals. You'll need to arrange for him to meet you at Chipford Hall when we get in touch with his details.'

'All right,' I said.

'In the meantime, I suggest you follow up on everything mentioned, trying to establish facts related to the painting and its history. This means the painting would fetch a higher price, if you decide to sell it.'

'And how much do you think it could be worth?' I said.

'With no guarantee of anything, let's have a quick look at other Canalettos sold in recent years.' He went behind his desk and tapped on the computer keyboard. 'A pair of Canaletto paintings sold at Pimsy's in New York last year for just over four million dollars. That was a pair, though. Obviously, if you owned the companion painting, yours would be worth more.'

He called his assistant, who brought in the paperwork to confirm I was leaving the painting and note with them, and then led us back downstairs.

'Thank you for choosing Pimsy's,' he said, shaking our hands. 'I'll be in touch.'

We grabbed our umbrellas and went back out into the rain.

'So, how about I buy you that lunch?' Jake said, putting his umbrella up and holding it over my head.

'That would be nice,' I said.

'I know just the place,' he said.

His golf umbrella was big enough for the two of us and I found myself threading my arm through his so we could both fit underneath. We took a side street and arrived at a small Italian restaurant where we were given a table by the window. Jake recommended the spaghetti carbonara and we ordered two portions with a jug of water.

'No alcohol for me as I have a conference call with New York this afternoon.' He pulled a face. It would have been nice to share a bottle of wine, but never mind.

'Another time. How was that dinner on Sunday night?' I said.

'Oh, yes, it was okay, apart from Penny's father asking when we're getting married.'

'What, in front of Penny?'

'No, he took me to one side when we were waiting for taxis outside. He was quite drunk.'

'But isn't it a casual thing between you two?'

He nodded.

'Yes, it is.'

'So, what did you say?'

'Not a lot. I was taken by surprise.'

'I can imagine.'

'It's probably because we were heading down that path last year. She was all set to move in with me before Christmas.'

'What happened?'

'She didn't like it when Dad asked me to manage the gallery at weekends, and refused to stay in Chipford, saying it was a boring dump. So, after weeks of arguing about it, I said there was no point in us staying together.'

This reminded me of how Chris reacted when I needed to visit Mum at weekends after she split with Nigel. Chris hadn't

understood that I needed to be there for her as, between boyfriends, she often drank too much and didn't eat enough.

'When Penny visited Chipford that weekend, she said it wasn't fair how my father has placed this burden on my shoulders, and reminded me of how it affected my job that week I met you, when the deal went wrong. In a way, she's right, but at the same time, my loyalties lie with my dad.'

How could Penny not understand this?

'I've become unexpectedly fond of Chipford though.' He caught my eye, as if saying I was the reason for this.

Had he become unexpectedly fond of me? I wished.

The waiter brought over our spaghetti and grated parmesan on top, then he brought over the peppermill.

'But I need to tell you something,' Jake said, his tone of voice ominous.

'What?' I said, unable to imagine what bad news he was about to deliver.

He refilled our glasses of water. I tried the spaghetti and although it was delicious and creamy with the bacon on the right side of crunchy, I wanted Jake to spit out what he was about to tell me.

'I looked at the gallery's accounts last night for the end of the tax year and the place is on its last legs. I'll need to go to Tuscany soon and talk to Dad about what to do. He might have to sell up when the lease expires in September.'

I put down my fork. 'Meaning I'd have to move out of the flat?'

Jake nodded. 'Yes, I'm really sorry, Rachel. If he did sell, it wouldn't be until the autumn, so you'd have a few months to find somewhere.'

I sipped my water, wishing it was wine.

'Are you pissed off with me?' he said, twisting spaghetti round his fork.

'No, it's okay,' I said. Although I was grateful to Jake for giving me somewhere to live, if only he'd checked the accounts before I uprooted my whole life.

'Perhaps I was a bit hasty asking you to move in that night at The Old Bear. Now I feel bad about putting you in this situation.'

'It was kind of my idea,' I said.

'But I'd been thinking about it too, and should have done the accounts first. I'd been putting them off, almost as if I knew what to expect. Dad's been here before.'

'Well, who knows? When you go to Tuscany, your dad may have a solution.'

'Knowing my dad, I doubt that very much.'

My phone rang, and it was Aunt Patsy.

'Sorry, I have to take this,' I said to Jake. 'Hello, Aunt Patsy.'

'Hello, darling. Your mum and I have been chatting this morning and she said you're lunching with a young man. Why don't you bring him tonight at 7.30?'

'Well, that's very kind,' I said, looking over at Jake who was demolishing his spaghetti. Although I'd like him to accompany me, I doubted he'd want to spend the evening with two people he didn't know.

'Aren't you going to ask him then?'

'All right.' I put my phone on the table. 'My aunt and uncle would like you to join us for dinner later at their house.' I shook my head and mouthed, 'Don't worry about it.'

'Where do they live?'

'Chelsea.'

'What time?'

'Seven-thirty,' I said.

'I'll have finished my call with New York by then, so can get to Sloane Square station for quarter past.'

'He says yes,' I told Aunt Patsy.

'Fabulous, darling. See you later. Mwah.'

'Bye.'

Jake glanced at his watch.

'I'd better get back to work then, and I'll see you later?'

'All right. It's good of you to come with me. Aunt Patsy's an amazing cook, if that helps.'

'I can't remember the last time I had a home-cooked meal, so sounds good to me.' He stood up and pulled on his jacket, slipping his phone into the inside pocket. He placed some cash on the table. 'I'm getting this to make up for those times we had to cancel.'

'Are you sure?'

'Yes, and besides, I've put you in a terrible position with the flat.'

'Well, okay then. Thanks.'

He leant over to kiss me on the cheek and left, and I called over the waiter to order coffee. What on earth would I do if his dad sold the flat? Living with Mum and Malcolm again would probably be my only option.

When we met at Sloane Square tube station, it was still raining. Jake put up his umbrella and we walked underneath it along the King's Road, with my arm threaded through his once again, until we reached the street with pastel-coloured terraced houses. I hadn't been there since the Christmas before Gran died. Last Christmas had just been me and Mum, after her split with Nigel. She'd ordered a turkey crown from M&S and we sat on the sofa all day watching old films and drinking prosecco.

We approached the four-storey yellow townhouse, the London residence one could only dream of living in, straight out of a children's book from the 1950s. It was Georgian with tall sash windows and steps leading to the front door, flanked by terracotta pots stuffed with spring flowers. Aunt Patsy opened the door, immaculate as always in what she liked to call slacks and a low-cut top with a chunky necklace.

'Hello, darling! Do come in, both of you.' She kissed me on both cheeks, and beamed at Jake. We entered the hall where Uncle Pete greeted us.

'Hello, Rachel,' he said, giving me a hug.

'Hi, Uncle Pete,' I said.

I introduced them to Jake.

'Pleased to meet you both.' Jake shook hands with Uncle Pete, and Aunt Patsy double-kissed him with great enthusiasm.

'Come into the kitchen,' Aunt Patsy said. 'I hope you don't mind us keeping it informal as Pete wants to show you that family-tree website on the computer.'

She took us to her glorious kitchen, recently refitted, yet again. The worktops were of course made of marble as Uncle Pete could get it cheap from Carrara through the business. An island acted as centrepiece with stools, and there was a long wooden table by sliding doors leading to the back garden. Vases of tulips in red and pink and yellow were spread around the room and a couple of candles the size of doorstops flickered on the table. I registered the scents of pomegranate and orange.

'Can I interest you both in a champagne cocktail?' Uncle Pete said.

'Yes please,' I said.

'Sounds great,' Jake said.

We stood at the kitchen island while Uncle Pete assembled the cocktails with sugar cubes and brandy and angostura bitters, and we all said 'Cheers' and clinked glasses.

'Patsy needs to finish off the starters, so let's have a look at the family tree now,' Uncle Pete said. He approached a desk in the corner and tapped his password into the keyboard. We stood either side of him, while he sat in his swivel chair and brought up the My Lineage website on the vast screen.

'It's great that you're interested in this. No one else seems to care, not even my own kids. And certainly not your mum, Rachel.'

'How far back have you managed to get?'

Uncle Pete moved his finger up the family tree on the screen, taking us from Gran and Grandad back to their parents and so on.

'I've got as far back as your great-great-grandfather, Jack, who took over the tailor's business in 1899. But I've reached an impasse because I can't find evidence of his father's birth in the records so am hoping the genealogist will help when I meet her next week.'

'That's exciting,' I said, although it sounded like there was a way to go to get back to the 1780s. 'I'm hoping to find out about a woman called Mrs Philippa Giles who probably lived at Ivy Cottage in around April 1782.'

Thankfully, her full name and marital status were on the front of the envelope that came with the note. Uncle Pete scribbled on a Post-it.

'That's good information. I'll pass it on to the genealogist.' He logged off the computer. 'Right, let's top up those drinks, and I think your aunt has some blinis coming our way.'

Within the hour, we'd downed two champagne cocktails each, with smoked salmon on blinis and Uncle Pete opened a bottle of Barolo. We started with deep-fried Camembert and cranberry sauce, followed by fillet steaks and gratin dauphinoise with miniature carrots on the side. Patsy's food was as delicious as always, and I helped her clear the table while Uncle Pete asked Jake about his father's art school. She gave me a nudge when we reached the kitchen island.

'So, who is this Jake?' she said. Thankfully, the volume on the speaker, which played Frank Sinatra, was loud enough to mask our voices.

'Just a friend,' I said, slotting a plate into the dishwasher.

'Why would he accept my invitation to dinner if he doesn't want to be more than friends?'

'I don't know. He came to Pimsy's with me today as he brought the painting down from Chipford on Sunday.'

'Do you think…?'

'What?' I said.

Patsy took a deep breath. 'Could it be possible he's after money from the sale of the painting?'

'That has crossed my mind, but I don't think so.'

'Nah, I'm overthinking.' She squeezed my arm. 'But, if he isn't into that, he must be into you.'

'I'm seeing someone and he has an ex hanging around.'

'Who are you seeing?'

I told her about JC.

'Well, it seems to me that neither of you are in a serious relationship, so who knows what might happen?'

Patsy retrieved four shot glasses of chocolate mousse from the fridge.

It was already ten o'clock and I'd have to be careful not to miss the last train. We sat back down to eat dessert.

'Jake said we can get a discount at his father's art school in Tuscany, Patsy, when I visit the marble quarries in Carrara,' Uncle Pete said.

'How generous. You know how I love painting,' she said.

Aunt Patsy had been an interior designer in her youth—that's how she'd met Uncle Pete—and she'd studied art at Goldsmiths.

Jake handed Uncle Pete a business card. 'I'll give my dad a call and he'll sort it all out when you email him.'

'Thanks very much, Jake. We might just book it soon when I visit the quarries.'

'Ooh, I'll have to treat myself to new watercolours,' Patsy said.

I put down my spoon and spotted the time on the kitchen clock.

'That was delicious, Aunt Patsy. Thanks to you both for a lovely dinner, but I need to leave soon to get the last train,' I said.

'Surely you can stay for a bit longer?' Patsy said.

I checked the train app on my phone. 'Well, I have about twenty minutes, or half an hour at the most,' I said.

'One last drink, then. How about a brandy, Jake?' Pete said.

'I wouldn't say no,' Jake said.

'And you ladies can have a Baileys on ice or something.'

'I do love my Baileys,' Patsy said.

'I'll get a cab, Rachel, and drop you at Marylebone,' Jake said.

I woke up on a sofa, covered in a blanket, and looked around to see I was in a living room with a big TV. Then I remembered the night before. Once I'd hit fresh air on leaving Uncle Pete and

Aunt Patsy's house, the alcohol had taken effect and I recalled getting into a black cab with Jake, feeling wobbly and sick. He'd put his arm around my shoulder and pulled me to him, and said, 'It's okay,' and I'd sunk into him, wishing he belonged to me. Then he insisted I stay at his as he couldn't let me travel home alone on the train in that state. He set me up on the sofa with bedding and a pint glass of water before kissing me on the head and going to his room. When I reached for my phone on the coffee table, it said the time was nine-thirty. Damn, I was supposed to be at Peaches and Cream in half an hour. A yellow Post-it note was stuck next to it.

Had to leave for work. Help yourself to breakfast and close the door behind you. Great night! J x

My head throbbed when I sat up to read the note again. The kiss at least made up for me having to deal with Melanie's wrath. With this and the notching up of a few lates, my days were numbered if I didn't get my act together.

In the kitchen, I found a coffee machine and selected an extra strong pod, then pressed Peaches and Cream in my contacts.

Chapter Twenty-Six

It took a week to reach Lyon from Paris, and then we progressed through Switzerland, via the Mount Cenis pass where our carriage was dismantled and transported by mules whilst porters carried us on sedan chairs. I was at the front with Lady Cordelia following. Snow blanketed the peaks, and small drifts formed around the paths. Mountain air was the crispest I had ever breathed; so cool and clear and I inhaled it into my lungs.

As we approached the pass, Lady Cordelia cried out. 'Please stop,' she said.

The porters continued, and I gestured to one of the men who carried me. 'My companion is speaking.'

The porters shouted at each other in Italian, so fast that I could not understand a word, then they stopped and put us down.

'I feel giddy,' Lady Cordelia said.

'My friend has vertigo,' I said to one of the porters who carried me.

He waved his arms all around him and made a display of breathing in and out loudly to explain to the others that Lady Cordelia seemed to be suffering from a lack of oxygen due to our altitude, although this did not impact me. One of the porters laid out a blanket for her on the grass, and I helped her to sit down.

'This has not happened before,' she said.

I nodded and sat beside her on the blanket. Wild flowers sprang up all around us in yellow and pink and purple; a small consolation. I lifted Lady Cordelia's flask from around her neck and held it to her mouth as if she were a small child. Her face was as white as the snow on the peaks of the mountains surrounding us, and once again I questioned if she were entirely in good health. A stream babbled nearby and I went to refill our flasks. No water could be cleaner than this. I approached the stream, edged with clumps of snow and scooped up the cold, clear water into our flasks, and took a sip from mine. Water directly from a mountain stream, a new and exhilarating experience. I gave Lady Cordelia back her flask and she took a sip.

'Good clean water for us both,' I said.

'You are most kind, Philippa.'

'While you rest, I shall study the flora. Then, if you are feeling better, we should progress in order to give you access to more oxygen below,' I said.

'You are right,' she said. 'Let us continue once you are done.'

I picked a purple flower to press in my journal as a keepsake. Lady Cordelia gestured to the porters, and we returned to the sedan chairs. As we progressed along the rocky path, I refrained from looking down at the drop thousands of feet to the valleys below, green and lush with mountainsides filled with hundreds of trees, and dotted with wooden chalets. I had not seen such height, nor wonder in my lifetime, a comfort as I prayed to the Lord to keep us all safe. If one of the porters were to lose concentration for a mere moment or trip over a rock, it would be the end of us all. Casting this thought aside, I remained optimistic as we succeeded with our crossing, and then made our descent to Italy.

We spent two nights at an inn in the Valle d'Aosta where we saw the magnificent Arch of Augustus and the ruins of a Roman theatre. After progressing to Turin, Milan, and Verona, via Lake Como and Lake Garda, we took a barge along the Brenta canal until we reached Venice, where we settled in our *pensione* with rooms overlooking the Grand Canal. Our bones, chilled by England's winter, were gifted warm air, the sky a brilliant blue with barely a cloud in sight, the sun sprinkling diamonds onto the lagoon where barges and gondolas jostled for space. Bells rang for what seemed all of the time, for there were many churches. I had seen Venice in Canaletto's paintings at the Queen of England's house in St James's Park, and of course in the earl's paintings, so I had an idea of how the city would look, but Venice on canvas did not compare to being present in person.

On the morning after we arrived, we went to Café Florian in Piazza San Marco, the one featuring in my favourite of the companion Canalettos. I was accustomed to drinking tea, and found coffee bitter, but the caffeine alerted me to my surroundings, removing fuzziness acquired by sleep. A string quartet played a Vivaldi concerto, an *allegro*, number two; and quite an accompaniment to our surroundings. Lady Cordelia wrote in her journal while I studied the scene from the Canalettos. I noted the cloisters facing the bell tower and how people were scattered around the square like in the paintings. Gentlemen huddled under the cloisters, clutching cups and saucers, their murmurings echoing as I had imagined. Vivaldi's concerto drifted over, and I wondered which piece had been played when Canaletto sat at his easel. Inhabiting these scenes brought back my evening with Earl Rupert. Sometimes I pictured an alternative life as his mistress and then pushed the ridiculous thought from my mind. To think my nemesis, Lady Eliza, had

214

played a part in fulfilling my dream of visiting Venice by ousting me.

We ate a fine luncheon of tomatoes cut into thick slices and strewn with basil accompanied by a soft Italian cheese, mozzarella made from the milk of a buffalo and as much bread as we demanded. Later that afternoon, after a siesta, we visited Massimo Collina so Lady Cordelia could sit for her portrait. We walked to his studio near the Rialto Bridge, with a maid, Francesca, as chaperone, and after Lady Cordelia had entered his house, I explored the streets with Francesca guiding me. We followed a series of passages barely wider than ourselves, until we reached a square with a trickling fountain, and we sat on the steps, in the shade of a tree. Then I followed Lady Cordelia's advice: observe and reflect.

Daily life in Venice infused the senses. The canals, the bridges, the boats, the gondolas, the architecture, the churches, the squares, the coffee houses. The women were elegant, and often dressed in satin, the men well attired and more often than not handsome and mysterious. It was a joy to sample the food, the fruit plump and sweetened by the sun, and the wine passed one's lips quicker than it should. However, we were more than aware of the dangers of going out alone, of being accosted by vagabonds and thieves. For this reason, neither of us left the *pensione* without a chaperone, and we did not venture out after nightfall.

Every morning, while Lady Cordelia was at Massimo Collina's studio, I explored the streets with Francesca as she led me to the quieter squares. On days where the canals gave off a particularly bad stench, we sought refuge in a coffee house. Luncheon would take place with Lady Cordelia at the *pensione*, then we would embrace local culture and spend siesta hours in

215

our bedchambers. At four o'clock, I would take tea with Lady Cordelia in the drawing room where she recounted her observations of life in Venice. After our meetings, we took walks and observed our surroundings. Then we would dress for dinner, and afterwards spend the evening with other guests in the drawing room whilst one of us tapped out a tune on the pianoforte. Often, we played cards or draughts and, when retiring to my bedchamber, I wrote letters and tended to my journal. During that time, letters received from Rogers were a comfort. He provided updates mainly on how the girls were getting on with Madame Dubois, and he talked about his father's deteriorating health and how it made him sad. Each letter ended with the same words which I read over and over, bringing warmth into my heart.

You always remain in my thoughts and I wish you well, dear Miss Elliott. One day we shall meet again, and that day will bring me much joy.

The days continued thus for a few weeks until one afternoon in the drawing room, Lady Cordelia told me she had not been to the studio that day.

'Instead I went to a convent as research because I have decided to make my main character a nun for part of the story.'

'And how did you find it there?' I said, curious to know what a convent was like.

'Rather drab, I am afraid, but fascinating to see how nuns live.'

'They give up so much,' I said.

'Indeed. They choose the Lord over a man and the right to bear children.'

Here was my chance to ask a question.

'May I ask, Cordelia, why you and the baron do not have children?'

'Well,' she said, with a laugh, 'it is all him I can tell you that as we tried for years to produce an heir, to no avail. Between you and me, we gave up a long time ago. He says it is my fault, of course.'

'Oh, how very sad.'

'Quite, my dear.'

I could not fathom how she would know he was the reason they could not procreate, but she seemed certain of this fact. His need for an heir must have put some strain on their relationship and I wondered how she had coped with such pressure to produce a child.

That week, Lady Cordelia's mood became less cheery, and she retired earlier each night, appearing to be in desperate need of sleep.

One afternoon, she said, 'We shall not write the journal today, because I must divulge some news. My reason for visiting the convent was to ask for assistance with the position I find myself in.'

'What position might that be?' I said.

'I cannot keep from you any longer that I am with child. However, I must ask you to keep this our secret.'

The news, although a shock, made sense. Her tiredness and nausea combined with lack of appetite had continued for some time.

'Of course. May I ask who the father is?'

'The child is Earl Rupert's. We grew up together as our fathers were business acquaintances and there were many social

217

events at our houses, but His Grace would never have accepted me as a daughter-in-law, despite my father's vast wealth, because it is not inherited and Earl Rupert is heir to the Duke of Oxon. My father is an earl himself due to hard graft, but it made no difference. This child is the product of Earl Rupert's visit to Heybury House after he returned from his Grand Tour. I have arranged to spend a few months at the convent to hide my condition and to give birth in a suitable environment. This will all be under the guise of research for my novel while I wait for my portrait to be completed. As my companion, I am asking you to accompany me. Can I ask for your friendship and support during this challenging time?'

Although Lady Cordelia had brought me to Venice under false pretences as well as saying we would return to England in September, I did not feel anger towards her or the earl, only pity. For her, because she had married a man who could not give her what she wanted and for him because he was betrothed to a woman selected by his father. But they were not worthy of my pity, for they were adulterers. Casting this thought from my mind, I pictured the child growing inside her. Would I have done the same in her position? The earl was not an easy man to reject. Despite their sin, I should look at the situation from both sides. This Grand Tour was a means for Lady Cordelia to give birth and make arrangements for the child away from England, and presumably she had concocted this scheme before offering me the position of companion. Her goal had been to leave the country before anyone noticed the bump beneath her clothes, and I wondered if it had been her idea for the baron to go to Antigua rather than accompany her to Venice.

'What will become of your child?'

'The nuns will ensure he or she leads a comfortable life. I have donated a considerable sum of money to their school and to the repair of their church tower. They are grateful for my donations and want to help with my predicament even though the child is illegitimate. They know the child is not my husband's, otherwise I would keep it.'

And so I agreed to move into the convent with Lady Cordelia the following week.

Chapter Twenty-Seven

JC rang the doorbell after finishing his shift the night I returned from London, and feeling lonely, I invited him in for a glass of wine. We watched Netflix before inevitably ending up in bed together, falling asleep afterwards. A clicking sound woke me, and I sat upright. Someone was trying to get a key to fit in the front door and failing, and my stomach lurched. The radio alarm clock glowed twelve fifteen in red numbers. Who had a key apart from Jake? Possibly Vera from the gallery, but why would she try to get in at this time of night?

I said, 'JC?'

He grunted, and I poked him in the ribs.

'What is it?' he boomed.

'Shush. Someone is trying to get into the flat. Can you see who it is?'

Tutting, he got out of bed, covering his private parts with a hand as he left the bedroom at the same time as the front door creaked open. My heart racing, I wrapped my arms around my knees and pulled them to me, hoping JC would do his best to defend us.

'Who is it?' JC said.

'This is my flat. Who are you?' The voice belonged to Jake, who was very drunk by the sound of it. What a relief. Feeling a bit shaky, I breathed in through my nose and out through my mouth a few times to slow down my heart rate. Mum had taught me this when doing yoga.

'I'm JC, Rachel's friend.'

'Ah yes, the chef.'

'Rachel thought you were an intruder. I apologise.'

Pulling on my dressing gown, I joined them in the living room and stepped past JC to see Jake slumped on the sofa in a suit, shirt unbuttoned and untucked, trousers creased, hair ruffled. He stared into space, his eyes bloodshot. Despite the condition he was in, he looked sexier than ever.

'I'll take care of this, JC.'

JC raised his eyebrows and let out a huge sigh.

'He is intoxicated, but as you wish,' he said.

'I can handle it.'

'Booty calls are not supposed to be this complicated,' JC said.

He went back to bed, banging the door shut behind him.

'Handle what, exactly?' Jake slurred.

'Has something happened?' I said.

'I lost my job,' Jake said.

'You've been sacked?'

'Effectively. They made me redundant.'

'I'm sorry to hear that, but why did you come back here in the middle of the night?' His phone was buzzing and he pulled it out of his pocket. He switched the phone off and put it on the coffee table.

'Jake?' I said.

He looked at the floor. 'I don't know.'

'Can I get you something to eat?'

221

'I had a burger at Marylebone.'

'How about a cup of tea?'

'Okay.'

I went to put the kettle on. 'I'm sorry JC's here. If I'd known you were coming back, he wouldn't have stayed over, obviously.'

But Jake's head had tipped forwards and his eyes were shut. After switching off the kettle, I spread the beige throw over him, gently pushing his head back and to the side. As I put a cushion behind his head, he opened his eyes and leant forwards as if about to kiss me. I froze. Of course, I wanted him to, but JC was in the next room, and there was Penny to think about. And he was paralytic. The circumstances were not ideal, and I swerved out of the way a nanosecond before his lips reached mine.

'Thought you'd want to,' he mumbled, before closing his eyes once again.

Would he remember he tried to kiss me in the morning? Returning to my room, I climbed into bed and pulled the duvet over me. JC had already fallen back to sleep and was facing away from me, snoring.

My alarm went off at nine o'clock, and I could sense that JC was no longer in bed with me. He must have sneaked out quietly while I dozed through most of Chipford's rush hour. I'd arranged to see Daphne at Chipford Hall that morning and was working the evening shift at Peaches and Cream. Facing Melanie after letting her down the previous day was not something I looked forward to. When I pulled on my dressing gown, and went to put on the kettle, Jake was still asleep on the sofa. The throw had slid onto the floor and I tucked it back around him. He sat up and rubbed his eyes. Did he remember trying to kiss me?

'How are you feeling?' I said.

'My head hurts.'

'Do you want tea or coffee?'

'Coffee would be good, thanks.'

After filling the kettle, I leant on the kitchen counter, facing him. He removed his jacket and got up to fill a pint glass with water from the tap.

'I'm not sure what I was thinking coming back here, and sorry if I woke you up.'

'You don't remember last night?'

He pulled a face. 'Did I behave like an idiot?'

'You just seemed upset about being made redundant, understandably.'

'They made me leave immediately. I met a friend for lunch which turned into a day of drinking and couldn't face waking up in London with no job to go to. It's all because I messed up that deal when looking after the gallery the week I met you. He switched on his phone and looked at the screen as it buzzed over and over again. 'Ah, Penny.' His face dropped. 'Oh, shit.'

'What?'

'I'm supposed to be going to the theatre with her tonight.'

'Oops.'

'Yep.'

'She booked it ages ago, knowing I normally come back here on Friday nights. I would have had to drive up here early on Saturday morning.' He tapped out a message using his thumbs and placed his phone on the sofa next to him. It instantly buzzed and he pressed the screen. 'Ah, now she's trying to call me.'

'Don't you want to speak to her?'

'She'll only bite my head off. I'm sure she can take a friend instead.'

I placed his coffee in front of him. It seemed Penny had organised a series of events for him to attend in order to stay in his life.

'So what are you doing today?' I said.

He yawned.

'Sleeping. You?'

'I'm going to see Daphne at Chipford Hall shortly and tonight I'm working at Peaches and Cream, so you'll have the flat to yourself for most of today.'

'Thanks, although I don't mind you being here at all.' He stood up, leaving his coffee on the table. 'I'm going to bed. See you later, Rachel.'

He left the room, and I watched him, those feelings still tugging at me even though he wasn't in the best of moods. If anyone knew about being made redundant, it was me, and perhaps it would be helpful for him to have someone to talk to who'd been through the same experience. More importantly, how long did he plan to stay in Chipford, and would being around each other bring us closer together?

Daphne sat at the table in the servants' hall, and she pulled a few sheets of paper out of a folder. 'I spent some time in the basement last week, finding the inventories you asked for. Here are photocopies, so you can take away the information you need.'

'That's brilliant. Thanks very much, Daphne.'

She pointed to halfway down the first page, highlighted in yellow on an inventory dated September 1780, under the heading, 'Brought from Italy by Earl Rupert'.

Two Canaletto paintings:
Piazza San Marco: looking East from the North-West Corner
Piazza San Marco: looking East from the South-West Corner

Then she pulled out pages dated September 1781 and September 1782. 'Here, you can see in 1781 that the paintings are still listed on the inventory. But in September 1782, neither painting remains in the house,' Daphne said. 'It's a mystery as I can't find any documentation relating to the whereabouts of the paintings. From the note you have addressed to Philippa—from someone you think is the earl—we know your painting is likely to be one of these Canalettos, but how did its companion get to Venice? I suggest you find the earl's journal from 1782 and see if he says what happened to the painting.'

'This is great stuff, Daphne, and I'll keep looking in the journals,' I said. 'Thanks for your help.'

'You're welcome. It's exciting to find out more about the house story.' She got up from the table, and pushed in the chair. 'I'm looking forward to making a new display and it will be nice to go further back in history than before. Goodbye, Rachel. I have to start my tour now.'

'Bye.'

She left and I put the papers in my rucksack then asked Mike to open the bookcase in the library as I couldn't wait until Tuesday to look for more evidence. He got down the earl's journal from 1782 and returned to his office. I spent a couple of hours searching for information, finding no evidence of the painting being given to the count in Venice, but I located a useful paragraph:

Count Monte has written to say he will be visiting Chipford Hall in the summer and again requested to be given the

opportunity to win back his Canalettos. He shall be made
most welcome during his stay, but I shall ask Mr Banks to
check my paintings are still on the wall when he departs.

So, it was likely the count ran off with the other painting, but there was no proof, only the earl's suggestion.

When I got back to the flat, Jake was lying on the sofa, watching a cricket match on TV. He wore tracksuit bottoms and a T-shirt, and no socks, and I couldn't help noticing what nice feet he had with perfectly aligned long toes. Mine were all bent from squashing them into heels in my teens.

'Hi,' I said.

'How did it go?' he said, grabbing the remote to pause the match.

I told him about Daphne's findings.

'Sounds promising,' he said. 'I've been offered another job.'

'Oh really, already?'

'Yes, it's someone I know at another big firm.'

'Well, that's great. When will you start?'

'I have to do gardening leave for a few months. Although I'm not sure if I want to go back to living such a frenetic life. Maybe it's time I did something more fulfilling. In the meantime, I spoke to my dad who suggested I visit for a week. He wants to talk about the gallery face-to-face and whether we should sell up or get a loan to keep it open.'

On the drive back from my meeting with Daphne, I'd thought about how nice life would be with Jake in Chipford, and now here he was talking about leaving for Tuscany. Since our lunch in London, I'd been in denial about the possibility of having to move out, but now the prospect was very real. Would they really

226

go to the trouble of getting a loan? His father had probably long forgotten about the gallery, and Jake never seemed that interested in it.

'When are you going?'

'Tomorrow.'

'So soon?'

He nodded. 'Do you want to come with me?'

He raised his eyebrows, and I laughed.

'Are you serious?'

'Of course.' He looked me in the eye and my gut hopped at the thought of going away with him. Who knew what it might lead to? 'We could go to Venice and see the companion painting,' he added. 'And the pen-and-ink drawing matching your painting.'

But there was work to think about.

'I doubt Melanie would give me the time off, especially with no notice. And I missed my shift yesterday so am not in her good books.'

'I'll be driving, but you could fly out for a couple of days?'

'I can't afford to do that.'

He shrugged. 'Okay, thought it might be fun, that's all. And Dad said Pete and Patsy will be there.'

Going on a road trip to Tuscany with Jake would be an absolute dream, and seeing my aunt and uncle a bonus, but even if Melanie gave me the time off, how would I pay rent after all the missed shifts?

'Obviously, I'd love to come with you, but I can't.'

'That's a shame,' he said, unpausing the match on the remote, his attention returning to the television screen.

'I'm going to have a bath before work,' I said.

227

He didn't answer and by the serious look on his face, I sensed he was pissed off with me, but how was I supposed to wangle a week off just like that? And what would Penny think about me going anyway?

Chapter Twenty-Eight

The opening and closing of doors woke me at five o'clock, when the nuns left their rooms, shoes shuffling along the corridor as they proceeded to the chapel. They woke me most mornings and, as guests, we were not required to take part in morning prayers. Instead, I would pray in my room. That morning, I closed my eyes, imagining myself at the parsonage in Chipford, Papa still with us. The smell of bread baking wafted up to my bedchamber and Bethany, our maid tapped on my door to announce breakfast. After dressing, I went downstairs to sit with my dear parents, and we ran through our plans for the day before Papa left for church.

Back in the present, a precious hour remained until Lady Cordelia required my assistance with getting dressed, so I sat up in bed and read letters written the night before to Mama, Mrs Baxter and Rogers, checking for spelling errors and adding words here and there. Candlelight and tiredness often led to careless mistakes. These people remained at the forefront of my mind even though I had not set eyes upon them for months. I continued to treasure letters received from Rogers, and would read them again and again, visualising our reunion in England. In one of them, when describing how Madame Dubois had upset Sophie, leaving Mrs Baxter to comfort her, he said, 'You are

irreplaceable, dear Miss Elliott, to be sure,' and I smiled to myself, warmed by his generous words. Correspondence usually took an age to arrive, and frequently did not arrive at all. Often, a letter made little sense because its predecessor had gone missing. Mama had not written since my departure in May and I feared for her health, or had she simply mislaid my address? The *pensione* did not have any post from her, but I would continue to check in case anything arrived. Before long, I would write to the Dowager Duchess to ask after Mama.

At five-thirty, I said my prayers, then dressed and tapped on the door of the room neighbouring mine, where Lady Cordelia resided. Since moving into the convent, I had been demoted to lady's maid. At five months pregnant, she could not dress or undress without assistance and there were no servants to call upon, unlike in the *pensione*. After a minute—she moved at snail's pace these days—my mistress opened the door in her undergarments and I stepped into her room.

She stifled a yawn. 'Good morning, Philippa.'

I closed the door behind me. 'Good morning, Cordelia. Did you sleep well?'

'The humidity made it nigh on impossible to get comfortable. My preferred sleeping position is on my back, but my current state obliges me to lie on my side, a position I struggle to adjust to. And you?'

'I slept until the nuns rose.'

'Thankfully, my period of insomnia is earlier in the night, so they do not wake me. Would you mind if we miss our morning walk to Café Florian again, Philippa? I would be satisfied with a plate from the kitchen.'

We had not been for a morning walk since Friday and it was now Tuesday. Etiquette as well as fears for my safety forbade me

from venturing out *sans* chaperone, so I was effectively incarcerated.

'As you wish. I shall arrange for us to take breakfast in the garden.'

I approached the writing table, where her clothes were neatly arranged over the back of the chair, as laid out the night before. She stood in front of me, and I tightened the ribbons on her stays, careful not to press too much on the baby pushing out her centre. After adding pockets and other layers, I pulled on her blue silk dress, purchased in Venice as part of what she referred to as her 'with-child trousseau'. She sat down while I brushed and styled her hair into a braid and pinned it to her head, her preferred hairstyle of late, and added her necklace and earrings. This routine took at least half an hour and without a looking glass, she had no choice but to trust me entirely. We rarely conversed so soon after rising, and I allowed initial thoughts of the day to flow through my mind. In our sparse rooms with barely anything to eat and unable to leave the premises, we resembled a pair of prisoners. Lady Cordelia had committed adultery and by lying to those at home to justify our extended stay, I had become her partner in said crime.

Once she was ready, we moved to the garden where we sat in the shade of an apple tree, each of us with a small plate of bread and a cube of cheese with a jug of water placed between us. Sister Caterina had arranged for the table to be positioned there on the day we moved in, when Lady Cordelia stated her demands. The nuns could only accommodate so many of these, but they tried their best to satisfy the woman who had donated the greatest sum received for a generation. It would be another month or two before the apples on the tree, presently buds the size of pearls were ready to eat or transform into pies, although I doubted the

nuns would make anything delicious with them, each meal served intentionally bland. Lady Cordelia wrote letters and I wrote in my journal, longing for sugar after allowing my mind to wander into a world where apple pie existed. I pictured those brioches in Café Florian oozing custard when one took a bite and coffee in a china cup with sugar cubes picked up using silver tongs.

'When might I leave the convent, Lady Cordelia?' I said.

'Well, Philippa, I do appreciate your patience. On Friday, I need to sit for Signor Collina so you may accompany me, if you like. It would be impossible for me to return to England without the portrait, so I shall have to take the risk of him knowing about my situation.'

At least I would escape the convent in a few days, but this was not enough. And what would I do at Signor Collina's house? Remain indoors all day, presumably.

Friday came eventually, after days of doing everything possible to avoid being bored beyond anything I had ever known. An educated woman should never confess to boredom, but I needed to see Venice, taunting me from beyond the walls. If only I had the freedom to explore my surroundings. After breakfast, we walked to Signor Collina's house, situated on the other side of St Mark's Square, Lady Cordelia sporting the dress worn for other sittings. I had sewn in additional panels and to anyone who did not know of her pregnancy, she appeared to have consumed a vast quantity of spaghetti. Would Collina assume she had put on weight or would he suspect the truth? If he knew, there was a risk the news would spread as he painted portraits of members of the English aristocracy when they visited him in Venice, and he was due to visit England the following year to reside with his patron,

Lord Willoughby. To remain in the shade, we took the narrow streets encircling St Mark's Square, and I glanced longingly at Café Florian as we passed. To have the opportunity to enjoy Venice fully would be a blessing indeed. When we arrived at Signor Collina's house, I knocked and a maid showed us to his studio at the top of the house with a view of the Grand Canal.

'Good afternoon, ladies,' he said.

'Signor Collina,' Lady Cordelia said.

'You are glowing, Signora,' he said, kissing her hand.

He repeated the overfamiliar gesture with me and I took an instant dislike to the lecherous man.

'You are fortunate to live in a beautiful location,' I said.

'Indeed. You may wait in the drawing room and Gabriella will bring you a beverage.'

'Thank you,' I said.

Gabriella led me to a drawing room on the floor below with paintings of Venice and other parts of Italy cramming its red walls. French doors opened onto a balcony with a view of the Grand Canal not to be matched, a boat transporting crates of fruit and vegetables and men pushing oars through the water. However, once again, Venice taunted me as, rather than ambling, my role was as an outsider looking in. But then, I saw how the sun shone down on Venice, and seized the day by recording my experience as I observed this beautiful city. I placed my journal, writing paper and quill on the table and made the decision to write to the Dowager Duchess, to ask after Mama.

Signor Collina's servants brought us luncheon in the dining room and we ate *risotto al nero di seppia*, made with the ink from cuttlefish. We also ate shrimp, caught locally that morning. Then we consumed *osso buco,* braised veal shanks with potatoes. After

233

weeks of bland food served in meagre portions by the nuns, this luncheon was most welcome. He had made a fortune in recent times with demand for portraits from the English aristocracy at its highest and, from his substantial belly, gluttony was one of his flaws and money no object, advantageous for us. When his butler served a moist cake made with oranges and almonds, I sampled heaven for a mere moment, to be sure.

'This food is delicious, Signor Collina, and I thank you for looking after us so well,' Lady Cordelia said. 'However, I now feel ready for a nap and must ask how long you need me for this afternoon?'

'I should be able to complete the portrait from this morning's sitting,' Signor Collina said. 'However, I shall send a note to the convent if you need to come back.'

'Thank you, I am grateful for your patience due to my circumstances, and look forward to your portrait gracing the drawing-room wall at Heybury House.'

'And my interpretation of your physique will be from when we first met,' he said.

'That is most agreeable, thank you,' Lady Cordelia said.

'A good artist knows when it is in his interest to interpret what he sees to the benefit of him or her who sits for him.'

'I knew you would treat my situation as a professional,' she said.

After lunch, we returned to the convent, slowly, as Lady Cordelia was fatigued and ready for her siesta.

'Does he know you are with child?' I said.

'It was my hope that he would think I had gained weight due to overeating, but he knows I am staying at the convent, and put two and two together,' she said. 'He said he would endeavour to

keep my secret, but suggested his tongue might slip at a social event in England when consuming too much wine.'

'The nerve of the man,' I said.

'He is a slippery fellow, to be sure. All I could do was offer him an additional sum of money to remain quiet. He accepted my offer of double the amount I was due to pay for the portrait.'

This cast doubt in my mind. All we could do was hope and pray he did not tell someone in the earl and Lady Cordelia's social circle. We passed St Mark's Square once again and I thought about finding a chaperone whilst waiting for the baby to arrive. A quarter of a year was a long time to remain incarcerated in a city I longed to see more of. Now was not the time to broach the subject, but later I would ask if I could consult the nuns about someone accompanying me on walks.

Chapter Twenty-Nine

On the first warm evening of the season, the air conditioning at Peaches and Cream was broken, bringing the sweatiest of shifts. After the last customers on my section had left, I mopped my forehead with a tea towel and sprayed my tables before setting them up for the following day. Over the course of the evening, I'd considered Jake's offer, daydreaming about us speeding up the motorway with our shades on and music blasting. And during overnight stays, opportunities were bound to present themselves. If I really liked him, I should try to make it happen, shouldn't I? Despite Melanie giving me a telling off earlier for missing the previous day's shift, I approached her on a whim. She was at the till, organising receipts into piles, tapping numbers into a calculator.

'Melanie, how would you feel about me taking a few days off?'

'What, when?' She didn't smile at me these days, and stupidly, I'd burnt my bridges with the woman who'd given me a job when I needed it most. What was I thinking, asking her for a favour? It was too late to back out now, although if she said yes, I'd still have the issue of not being able to pay my rent. Perhaps Mum would lend me some money, for once? She was more flushed now Malcolm paid some of the bills.

'Err, from tomorrow.'

'Are you joking? Rachel, you can't just take a few days off whenever you fancy it, especially at such short notice and I can't believe you have the temerity to ask after being so unreliable lately.'

'So, that's a no, then?'

She sighed. 'Not necessarily. Nadia's sister, Clare, helped out when you didn't turn up yesterday, so perhaps she might be able to cover you. I can't promise anything though.'

'Okay, thanks. Shall I give you a call tomorrow morning?'

'You could do that, yes.'

I went upstairs to get my bag and, on passing the fire escape, I clocked JC having his fag. Should I tell him about my plan? I owed it to him really.

'So art gallery boy is back in town then?' he said.

'Yes, I'm not sure if you heard our conversation last night, but he lost his job in London.'

JC rolled his eyes. 'So, he's living with you permanently now?'

'I'm not sure.'

'Why don't you come back to my place tonight then, Rachel?'

'I can't.'

'Why not?'

He stubbed out his fag and placed it in the ashtray Melanie had put there just for him.

'Jake's asked me to go to Tuscany with him tomorrow and we need to talk tonight.'

I could end up looking like a fool by saying I was going when I hadn't told Jake yet. What if he'd invited someone else instead, like Penny, during my shift?

'And what about us?'

237

Why did JC suddenly care?

'What do you mean, what about us?'

'Let's face it. If you go with him, something is bound to happen.'

'The first thing you said after we slept together was that you didn't want a relationship.'

'Yes, but perhaps I see you as more than "friends with benefits" now we've spent time together.'

Now he seemed to want me more because Jake was in the picture. I'd been here before.

'Look, JC, we've had fun, but I can't see us becoming more serious. Can you?'

He shrugged.

'Go with him, see if I care. But don't expect me to be waiting when you get back.'

'Don't worry, I won't.'

I went down the stairs and he followed me, stomping in those heavy boots he liked to wear.

'Rachel,' he said, but I kept on walking. There was nothing more to say. After crossing the restaurant, I tried to open the door, but he somehow overtook me and blocked the exit with his broad frame.

'Rachel, listen to me.'

'Stop this nonsense, JC. It's over.'

But then I spotted a couple tucked into one of the booths, clearly watching us. I'd thought all the customers had left.

Melanie walked in our direction with a face of thunder. 'What's going on?' she said.

'Nothing,' I said.

'JC?' she said.

He looked at the floor and said nothing.

'Well, this is the last straw. Rachel, how dare you cause a scene in front of our customers? Go home now, please. And don't bother calling me in the morning. You can have your time off.'

'But will I have a job to come back to?' I said.

'I'll let you know.'

She went over to the couple and apologised, and as JC headed for the kitchen, it hit me that this was supposed to happen. It was time to stop wasting time with bad boys like JC and Chris and instead pursue Jake who had potential as a decent boyfriend, although there was still Penny to worry about.

When I got back to the flat, Jake was still watching cricket, a can of beer in his hand.

'How was work?' he said.

'It was all right.' This wasn't the time to tell him about JC and potentially losing my job, as I needed to follow through with what I'd started in the restaurant. 'Jake, I've been thinking about your offer.'

His face filled with the biggest smile. 'Really?'

I nodded.

'Rachel, I have something to tell you,' he said.

'What is it?'

'Why don't you sit down?'

After getting a glass of water from the kitchen, I sank into the sofa opposite him. Had he and his dad decided to sell the gallery already? I downed the glass of water, so thirsty from the sweaty shift that I wanted to get up and refill it, but sensed Jake was about to tell me something that boded well for me by the smile still plastered across his face.

'I'm breaking it off with Penny.'

'You are?'

239

'Yes, I'm going back to London tonight to catch her after the theatre.'

Was he doing this so we could be together?

'That sounds like a good idea.'

'So, did you ask about getting time off work then?'

'Yes, but I might not have a job to come back to.'

'You can sort out work afterwards.'

'Even if I do keep my job, how will I pay rent with all the lost shifts?'

'I've been thinking about that.'

'Oh?'

'When you moved in, I wasn't supposed to be here on week nights, so I need to reduce your rent.'

'Don't be ridiculous.'

'It's only fair. You didn't agree for me to be here all the time, getting on your nerves, hogging the TV.'

He had no idea

'You don't get on my nerves.'

'So, I'm going to halve your rent as compensation.'

'But my rent's already very reasonable.'

'I know, but I'd really like you to come with me to Tuscany.'

'Well, okay.'

'So, is that a yes?'

'Yes.'

'Why don't you pack a bag and we can leave in say half an hour? I can get the next train instead.'

'But you're going to see Penny?'

'I'll need to go to my place first, so you can wait there. Or you could get the train in the morning?'

'I wouldn't mind going to bed and getting the train tomorrow.'

'Let's do that, then. I'll pick you up from Clapham Junction.' He went to his room and grabbed a holdall. 'I'll book the Eurotunnel for three o'clock in the afternoon which should give you plenty of time to get to London.' He kissed me on the cheek and he was gone.

Jake picked me up at Clapham Junction and put my case in the boot and we were off, on our way to Folkestone to get the Eurotunnel.

'So, how did Penny take it?'

He glanced at me and then looked back at the road.

'She wasn't there and didn't reply to my messages, so I had to leave it.'

'Really?'

'Yes. She texted this morning to say she took her sister to the theatre instead of me. They went out drinking in Soho afterwards, and she stayed at her sister's place.'

'When will you tell her?'

'When I get back. I told her I'll be in Tuscany this week and that we should meet up next week in London.'

So, technically they were still in an on-again and off-again relationship. Did this mean nothing could happen between us on the trip?

We reached the Eurotunnel earlier than planned at two in the afternoon and by three o'clock we were in Calais taking the *autoroute* as we headed for Courmayeur. Jake played music on the stereo, working through his playlists on Spotify and I watched the scenery go by out of the window, any silence between us a comfortable one and it felt okay to not have to talk the whole time.

241

After we passed Dijon and stopped for a burger at the services, I drove so Jake could have a nap and we arrived at the bed and breakfast he'd booked online at eleven-thirty at night. We were given a double as there were no twins available. The room had a musty smell and the pink carpet was riddled with stains, and the sheets were brown with matching blankets and a floral bedspread on top. It wasn't the place to get it on with Jake, and besides we were exhausted.

'Sorry it's not very special, but it's cheap,' Jake said in a cheery voice.

'We're only here for a few hours.'

'Exactly.'

I went to brush my teeth in the shared bathroom and changed into my pyjamas. When I got back to the room, Jake took my place in the bathroom and I climbed into the bed, switching off the lamp on my side. At least the pillow seemed clean with a crisp white case, although it was a strange sausage shape and I struggled to get my neck in a comfortable position. Jake joined me in the bed and said, 'Goodnight.'

'Goodnight,' I said.

We faced away from each other and although the circumstances were not ideal, the thought of him being there, so close stopped me from sleeping, and I sensed he was also awake. But this was not the time or the place and I closed my eyes, doing my best to picture the next day. What would his dad's place be like and would he and his wife make me welcome? And would anything happen with Jake?

The alarm on Jake's phone woke us at six-thirty and while putting on shorts and a vest top in the bathroom, I studied the bags under my eyes in the mirror, a result of virtually no sleep. Sharing a bed

with Jake had been intense as I'd lain there imagining all the things we could be doing under different circumstances. His tossing and turning hadn't helped as whenever I did drift off, he woke me up. Downstairs, breakfast was a buffet and we sat at a table and drank coffee and ate pastries. Jake selected slices of salami and cheeses and picked up a whole baguette, tearing it in half.

'This will do for our lunch,' he said, making sandwiches and wrapping napkins around them.

While he settled up at reception, I went to the shop across the road and bought bottles of water for the journey. In the car, Jake keyed his dad's address into the satnav and we headed for Tuscany. When I checked my phone, there were no voicemails or messages from Melanie, and all I could do was hope she'd keep my job open. Despite this being highly unlikely, it was a risk I had to take. When would this opportunity arise again?

We took the motorway along the beautiful Aosta valley, surrounded by mountains and hilltop towns and castles, and it was the most scenic motorway I'd ever travelled on. As we approached Genoa, we passed through a huge number of tunnels and continued towards Pisa, where we pulled in at the services to refill the car and found a picnic table in the shade, under a tree and ate our sandwiches.

'Are you glad you came?' Jake said.

'Definitely.'

'We'll be there by around four o'clock, I think,' he said.

Wearing sunglasses gave me chance to study his face and today, his eyes were bluer than ever. His stubble was a couple of days old, and I liked him best like this.

'Will your dad and Maria mind me turning up?'

'Not at all. They're putting aside a room for you.'

'That's nice of them.'

'Dad will want to brainstorm ideas about how to save the gallery, so I may have to leave you alone at some point. Hope that's okay?'

'Of course.'

I didn't mind at all, although I could probably contribute to their conversation as, since he'd mentioned the gallery was in trouble, I'd been mulling over ideas, to help him but also selfishly to save my place in the flat.

'Have you ever thought about doing exhibitions for local artists?'

'No. Do you think that would make money then?'

'Well, you could invite an artist to do a talk perhaps and display their paintings. Do it in the evening and add prosecco and crisps, and who knows, you might get a few buyers?'

'Well, it would certainly get people into the gallery. I'll mention it to Dad. Thanks.'

I smiled. 'That's okay.'

We returned to the car and I opened my window until the air conditioning kicked in and we were off, on our way to the art school.

Chapter Thirty

Two weeks passed and we reached August, the hottest month. Signor Collina sent a note to inform Lady Cordelia he would not need her to sit again. However, he would not be able to finish the portrait until November as he was working on several projects at once due to high demand. That afternoon, after siesta, I took up my post in the kitchen garden and picked green beans from their stalks alongside Sister Caterina, dropping them into the pocket of the apron fastened around my waist as I walked. She was the only nun I conversed with at length, and she smiled and communicated with ease, perhaps because she was closer to me in age than any of the other nuns.

'Sister Caterina, might you be able to assist with a dilemma?' I said.

'Do tell me, Miss Elliott, and I shall try my best to help you.'

'Lady Cordelia is no longer able to accompany me to Café Florian each morning and I have not set foot outside the convent for two weeks.'

'And you need a chaperone?'

What better chaperone than a nun?

'Exactly.'

'On the mornings when I teach at the school for the orphans, I cannot accompany you. However, we could take a walk in the afternoons occasionally, after completing our work here?'

'You are most kind. Would it be possible to venture out today?'

'Tomorrow afternoon would be an option. I can show you parts of Venice only known to locals.'

'I would appreciate that, thank you.'

No more morning brioches were to be consumed at Café Florian, but at least I would have the opportunity to leave the premises, and there was a chance I might persuade Sister Caterina to accompany me to Café Florian on occasion if I offered to pay for her coffee.

The following afternoon at five o'clock, we met by the entrance to the convent, and Sister Caterina opened the front door. The air was thick with humidity, and we stepped into blocks of shade created by the buildings. People going about their business filled the streets and she led me along a passage barely wide enough for a slim person—Lady Cordelia would not have fitted—until we reached a quaint square where we sat on a wall beside a fountain as it trickled water over a pair of cherubs.

'Thank you for enabling me to leave the convent, Sister Caterina. As someone who likes to take frequent walks, being incarcerated has not been easy for me.'

'You are welcome, Miss Elliott. How long is it until your mistress gives birth?'

'Three months. We seem to have waited an eternity for the child to grace us with its presence.'

'And when the baby is born, you will return to England and forget your time in Venice, your life here a distant memory.'

Would it be so easy to forget our experience and the secret I needed to keep? Spending time with Sister Caterina reminded me of how good it felt to be on an equal level with someone socially. She had provided me with a means to escape the convent, and I would be eternally grateful.

After that day, we left the convent on Tuesdays and Thursdays and those walks were what I looked forward to the most. They provided material for my letters and my journal, and life became bearable once again. Often, we sat beside the fountain at the end of the narrow passage and I would write in my journal. One afternoon, I took the liberty of asking Sister Caterina about herself, unsure of how she would respond.

'Why did you become a nun, Sister Caterina?'

'Not by choice. I was an orphan, born in the convent and the nuns told me no man would want to marry me. Growing up with them in place of a mother, I lived in fear of doing things wrong and felt guilty most of the time. Some might say the older nuns were cruel in their treatment of me and other children, and I do my utmost to treat the orphans with more respect.'

'So you always expected to become a nun?'

'From an early age, I resigned myself to being confined to the convent for the rest of my days.'

'How content are you?'

'As content as a person can be in the world we occupy.'

Her situation made me realise how fortunate I was. Money was not a concern for the first time since Papa had died. However, our conversation made me aware that Lady Cordelia's child would be in a similar position to Sister Caterina and this thought worried me somewhat. Would Lady Cordelia not wish for her child to have a better life?

In September, I received a letter from the Dowager Duchess to say Mama had been suffering from influenza for several weeks and that because she ate little she had become especially weak. My heart yearned for Mama and I wished I were in a position to return to England to care for her, and to have my own house so she could reside with me. If she died in my absence, I could never forgive myself. My only option was to write letters and so I did just that every day, hoping to provide some means of moral support from afar.

As is usually the case when one waits for a significant event to occur, the days crept by, and when the baby came a fortnight earlier than expected at the end of October, my initial thoughts were *at last this period of transition is almost over*. One morning, Lady Cordelia cried out on the way to the dining hall as she produced a puddle on the floor. After establishing her in her room, I ran to fetch Sister Caterina, who brought towels and a bowl of water and other things required for the birth. For almost twenty hours, Lady Cordelia screamed and shouted while Sister Caterina and I took turns to mop her brow with a damp towel and to offer words of encouragement. Lady Cordelia roared like a wild animal, the sound strangely primal as she pushed and pushed, and the baby arrived, crying much to everyone's relief. Sister Caterina cut the umbilical cord and announced, 'It is a boy,' before swaddling him in a cloth and placing the dear child in his mother's arms.

'He will be called Edward, after my father,' Lady Cordelia said. 'And I would like him to take my maiden name, Watkins, as his surname and the middle name, James.'

'As you wish,' Sister Caterina said.

Clearly besotted, Lady Cordelia kissed her son's head tenderly, and I had no doubt that leaving the little mite would be a wrench for her.

We remained at the convent for another fortnight. Lady Cordelia spent her time feeding Edward and taking walks in the courtyard, and I had never seen her so content. The day before the wet nurse was due to arrive, I packed my belongings ready to undertake the journey home, for I longed to return and do something about Mama's situation. Lady Cordelia had promised I could reside with her at Heybury House until I found a suitable position. She summoned me to her room, and we sat on the bed with her clutching Edward to her breast, and the expression on her countenance told me the plan was about to change, once again.

'Dear Philippa, might you consider helping me with a way out of this situation?'

'How, exactly?'

'I have been filling my journal with an array of options and the same solution keeps presenting itself.'

'What solution can I offer you?'

'Well, I know this is a great deal to ask of you, but it is my only option, believe me. For I have explored every angle during those hours Edward kept me awake at night, and I beg you to consider my request carefully before you accept or decline. If you accept, I shall reward you generously, for life. Simply, I shall change your life, forever.'

Now, I was intrigued.

'What exactly are you proposing?'

'You are the only person who can prevent me from having to leave this dear child, the son of an earl and a baroness, albeit an illegitimate one; but that is no matter, for he is my son and does

249

not belong in this place. As you know, the children here live a basic existence and not all of the nuns are as kind as one would expect. So, would you consider bringing up Edward?'

I shook my head. 'My reputation would be destroyed. How could I work and live as a single woman with an illegitimate child?'

'Before you make a hasty decision, there is more, and you might wish to consider my request carefully. My suggestion is that I provide you with a house in London, a grand house in Mayfair. My father has a property we could use, with a butler and a handful of maids; your own lady's maid, of course, and a nanny for Edward.'

'And my reputation?'

'Ah, I have accounted for that as I am used to creating alternative worlds when writing my novels. No one in London would know you and we could say you are a widow, giving your fictional husband a name. It would be fun concocting a story together. Give him a backstory, make him a war hero, if you like. This is an opportunity for you to reinvent yourself, to elevate your status.'

'But the gestation period is nine months. Would anyone believe I met someone, got married and became pregnant so very quickly?'

'It would have happened rather fast, to be sure, and some might suspect you married because you were already with child. But that's a risk we would have to take.'

'A risk I would have to take.'

She nodded. 'Indeed. You are forgetting, my dear, that no one in London will know who you are.'

'I suppose you are right. Although what about Rogers, Mrs Baxter and the earl? And my dear Mama?'

'And you care about what they think because?'

'Because…Well, Rogers and Mrs Baxter are my friends. I wouldn't want them to think less of me as a person. And Mama, well she would be devastated to learn of my having an illegitimate child.'

She sighed.

'All I can do is ask that you might consider doing this for Edward's sake, if not for mine. Believe me, Philippa, I have tossed and turned for night after night trying to come up with the best solution to this problem. You could tell everyone you know that you gave birth on returning to London, if that helps.'

Lady Cordelia was deluded, but also used to getting what she wanted, and she was being her usual persuasive self. But how could we possibly fool everyone we knew? At the same time, after what Sister Caterina had told me about her childhood in the convent, I felt obliged to consider alternative options for Edward.

'May I have a few days to think about this?'

'Of course, my dear, for I am asking a great deal of you. As my portrait is still not ready, you have a week. Rest assured I would provide you with a generous income. I would expect to visit whenever I liked and to have a close relationship with Edward. I could be his godmother.'

'And do you intend to tell the earl he is a father?'

'That is not a possibility. One day it might be when the time is right, but my husband is his best friend and the man who saved his life at St Malo, do not forget. After a week, if you say yes, we shall need to formulate a plan, and this may take a few days. In the meantime, I intend to postpone the wet nurse's arrival with the excuse that we are extending our stay. The portrait must be ready before we leave as I shall not return to England without it. Then, we must travel home before winter truly sets in.'

251

She was placing me in a difficult position as if I rejected her proposal, how could I expect to stay at Heybury House? Instead, I would need to make arrangements to stay with Thomas and Mary, and our journey back to England would not be a pleasant one. For she was the kind of person who might turn on me if I did not fulfil her expectations.

That week, I carried on with my usual routine, walking around Venice with Sister Caterina who I longed to confide in. I wrote in my journal with a page of pros and a page of cons, doing my best to reach the right decision for Lady Cordelia, for myself and Edward. Here I was, aged twenty without a dowry, my only other options being to teach in a school or be employed in someone's home as a governess. Living in someone else's house meant a higher standard of living and it would never be lonely, as residing alone would be. But it meant sacrificing my freedom and operating under rules. Taking this route would mean there was a strong chance I would remain a spinster until the end of my days and become like Madame Dubois.

Lady Cordelia offered financial security, a situation I could never have imagined. I would have more freedom and a house in the finest part of London, with servants. No man would want me to be his wife if I had a child, presumably, but if I were to remain a governess or a teacher, I might not find a husband anyway. Mama could move into the house, enabling me to care for her. Then there was Edward. How could I abandon him in this convent when the alternative was offering him a life filled with love and the ability to see his mother regularly? Lady Cordelia would be broken beyond repair if she had to leave him in this place. She could take him back to England and ask another woman to bring him up, but could she trust that person to keep her secret?

If I took Edward, there would be little prospect of anyone finding out the truth. I would claim the child as my own from the moment there were ears to whom the truth mattered. Taking Edward would mean he might see the earl in social situations, for I could potentially access his circle through Lady Cordelia if she were his godmother. When Edward turned eighteen, she might agree for him to be introduced to his father. From the house in London, I could provide private tuition for boys before they went to boarding school, and teach French and Italian to young men before they embarked on their Grand Tours. The possibilities were endless. I could enjoy the theatre, galleries, parks and my family would be able to visit. Whilst mulling over the proposal, I became enthused by the possibilities and after the fifth day, one afternoon while taking a stroll by the lagoon with Sister Caterina, the burden lifted. As I studied the boats passing by, the water kissing the jetty and absorbed the Italian words floating on the air, I made my decision.

Now in a position to commence our journey home, we needed to collect Lady Cordelia's portrait from Signor Collina but it would not be ready for another week, and so we commenced work on our plan. The temperature was low, but the sun shone from a blue cloudless sky and we sat under the apple tree in the garden while Lady Cordelia held Edward to her chest, swaddled in a blanket. She dictated a list of terms, including specific payments she would make to me and what she expected from me as his mother such as nurturing an interest in art and educating him until he was old enough for school. After some negotiation, we had our agreement. I wrote out another copy and we signed our names on each.

'No one can set eyes upon this as it will be detrimental to both of us. I shall hide my copy under a secret floorboard in my

253

bedchamber, along with my private journals from our stay in Venice.'

She referred to the red ones purchased in the stationery shop, where she revealed real thoughts and feelings. The blue journals recorded activity and observations, revealing little of a personal nature. I would find a secure hiding place on moving into the house in London. Were we taking too much of a risk writing this information down? Lady Cordelia thought it important we document the terms in order to avoid a dispute at a later date, saying it was as much for my security as hers. The prospect of any dispute perturbed me, and I hoped we would not need to refer to the agreement again. Trust still played a role in the world we had created. For all she knew, I could take the money and give Edward to someone else, or tell the earl and the baron everything. Neither of us were lawyers, but Lady Cordelia had read many legal contracts over the years. If either of us broke the terms, who knew if it would hold up in court? But it was a means to reassure us both that the other had their best interests at heart.

A thought that niggled was what I would do if she passed away and there was no way to access her father's funds. But how likely could that be? This was not the time to bring up such a scenario and I cast the thought from my mind, expecting to raise the potential issue at a later date.

The following day, we bought a simple band made of silver to use as my wedding ring and set about conjuring up an imaginary late husband. I had met him in Venice, but we could not decide what occupation to give him, whether to make him English or Italian, and what the story of our first encounter was. He was handsome with dark hair and brown eyes and tall at around five feet and eleven inches. As we created our romantic hero, I

pictured the type of man I would wish to marry. He would be kind with good morals and a warm smile, and there would always be plenty to converse about. It was then that I thought of dear Rogers and the high hopes entertained in relation to a future with him. We had corresponded during my time in Venice, and I had hoped we might become more than friends upon my return to England. But it was doubtful whether he would be interested in a widow with a child, and by choosing Edward, my heart would be relegated. A sadness lingered as I came to terms with this fact. However, I hoped that Rogers and I would remain firm friends.

Lady Cordelia and I dithered over how our poor fictional man had met his end. Could he have been shot by a highwayman, killed in a brawl over a dispute, trampled on by a horse, killed by a terrible illness?—not tuberculosis because Papa had been taken that way, and Lady Cordelia said good fiction did not include coincidences. The finer details would be agreed before returning to England, and this would give us something to discuss on the long journey home.

Chapter Thirty-One

The road threaded amongst fields of sunflowers, past vines planted in neat rows and farmhouses with cypress-lined drives. There wasn't much traffic apart from the odd moped or car as we twisted and wound our way up and down hills and round blind corners. The thought of meeting Jake's father and stepmother made me anxious for a moment. What if they didn't make me welcome and I ended up feeling like a loose end until Uncle Pete and Aunt Patsy arrived? Jake turned off the main road, following a weathered sign pointing to *La Scuola d'Arte*, along a single-track lane, the car crunching on the gravel. As I opened the window, the scent of flowers infused my senses. We passed dense woodland with the chirruping of cicadas as our soundtrack. The sky was a deep blue with no clouds to be seen and the setting could not be more beautiful with rolling yellow hills and clusters of green forest. My phone vibrated in the bag next to my foot and when I retrieved it, Mum was calling me. I answered.

'Rachel, hello?'

'Hi, Mum.' But there was no reply. 'She's gone,' I said to Jake.

'Dad complains about the rubbish phone reception here,' Jake said.

'Ah, okay.' Mum never called my mobile, so this worried me. I'd tried calling her landline before leaving, but she was out so I left a voicemail to say me and Jake were driving to Tuscany. All I could do was hope she was all right and try to call back later. We reached a big old farmhouse made of stone, Jake parked, and we got out of the car to be greeted by an intense heat. Bees hovered around lavender bushes flanking the entrance. Jake pushed open the front door and a dog bounded towards us, jumping up at him, barking and wagging its tail. 'Hello Buster.' Jake pulled Buster to him, stroking his ears and kissing him on the head. 'Dad, Maria?' he called, slipping off his shoes and placing them on a rack under the coat stand. I stepped out of my flip-flops, the terracotta tiles cooling my bare feet. Paintings and photographs hung from whitewashed walls, and I was studying them when a slim and elegant woman appeared in a blue linen dress, a pair of sunglasses on her head.

'Jake, you're here.' They embraced, and she kissed him on both cheeks.

'Maria, this is Rachel,' he said.

She double-kissed me as well, instantly alleviating any anxiety about being made welcome.

'It's a pleasure to have you in our home, Rachel. Neil's gone to the market to get food. Let me show you around.' We followed her onto a terrace with views of emerald-green forests, patchwork fields and a town on a hill in the distance. 'That is Siena.' She led us down the side of the house, pushed open a door, and we followed her into a bedroom. 'This is Jake's room. The Wi-Fi code is in the information book, and you'll get a phone signal in this apartment, most of the time, or on the terrace. You won't get either by the pool or elsewhere on the property. There's plenty to drink.' She opened the fridge to display shelves packed with

water, Coke, milk, wine, beer. 'And here's a kettle. I know you English like your tea.' She led us through another door. 'This is your room, Rachel.'

There was a double bed with white duvet, matching pillows and red scatter cushions and it looked a lot more inviting than the bed in Courmayeur. French doors opened onto a terrace and an antique chest of drawers stood in the corner with gold animal feet like the Georgian furniture at Chipford Hall. In between the bedrooms was a bathroom complete with marble sink and a roll top bath. She took us back to Jake's room. 'Do use the pool, both of you. There are no guests today so make the most of it. Pool towels can be found in the bathroom cupboard. Or stay here and rest if you wish. Drinks are served on the terrace at seven o'clock.'

'Thanks, Maria,' Jake said.

I added my thanks.

'My pleasure.' Maria closed the door behind her, leaving us alone with a bed in the room, once again.

We looked at each other.

'Fancy a swim?' Jake said.

'Okay.'

We changed in our rooms and I put on a black bikini. I followed Jake down crumbling steps, treading carefully in my flip-flops, through an olive grove and past more lavender bushes until we reached the pool. It was surrounded by a garden of roses, and wild flowers in an array of colours. Jake dumped towels on a sun lounger then dived in to the deep end, launching into front crawl. While unrolling my towel, I couldn't take my eyes off him. His body was toned and muscular and he pushed his way through the water with ease. Church bells rang in the distance, and the din

from the cicadas was soporific. Lying on the sun lounger, I closed my eyes, breathing in the scent from the roses.

When I woke up, I had that disorientated feeling you get when sleeping during the day. Water dripped over me and I looked up to see Jake standing there.

'That bikini suits you,' he said. Admiring his firm bare torso through my sunglasses, I wanted to say he didn't look bad himself and my cheeks warmed.

Woozy from sleep, I said, 'What did you say?'

'You heard.' He took the sun lounger next to me and I got up and lowered myself into the pool using the steps. After I'd done a few lengths of breaststroke, Jake said, 'We ought to go and get ready for dinner.'

'Okay.'

As I climbed out, he eyed me up very obviously, and we exchanged a smile. If anything was going to happen between us, it would be here in Tuscany. When we got back to our rooms, I had a quick bath, rinsing my hair with an ancient-looking shower attachment that dribbled water, but did the job. No hairdryer was needed in the heat and I pulled on a vest-top and jeans. When Jake had washed, he dressed in shorts and a T-shirt, and we headed for the terrace. A man, presumably his dad, sat on a chair, holding a glass of red wine.

'You must be Rachel,' he said, standing up.

'This is my dad, Neil,' Jake said.

'Hello Neil, thanks for having me to stay.'

'It's good to have you here,' he said, smiling warmly before giving me the double kiss. He and Jake shook hands and they hugged and slapped each other's backs. 'We'd allocated the family apartment to Jake, so another person makes no

259

difference.' He gestured for me to sit beside Jake and Maria brought out glasses of prosecco.

'So, you met Jake when taking your painting to my gallery?' Neil said.

'Yes, he helped me work out what to do, finding pictures of the companion painting and the matching pen-and-ink drawing in your Canaletto book.'

'Well, how about that. I'm glad my book collection was finally useful for something. And you're waiting on Pimsy's?' Neil said.

'Yes.' I explained what they were doing, and that I needed to look for mentions of Philippa in the earl's journals.

'Lots to do then. It's like an episode of *Fake or Fortune*,' Neil said.

'Oh, and my uncle has hired a genealogist as we think Philippa may have been an ancestor.'

'And if the painting's authenticated, will you sell it?'

I laughed. 'Definitely.'

'Your aunt and uncle are coming out tomorrow,' Neil said.

Aunt Patsy had been pleased to hear about me visiting when I texted on the train to London.

'I'm looking forward to seeing them,' I said.

'And Jake mentioned you'll be going to Venice?' Neil said.

'We'll drive to Siena on Wednesday, and get the train to Venice at the end of the week, if that works for you, Dad?' Jake said.

'Of course. Valentino can drive you to the station,' Neil said.

Maria peeked her head out of the kitchen.

'Do sit down and I'll bring the starters.'

We moved to the table, and Neil directed me to a chair with a view, facing him. Jake sat beside me, opposite Maria, and filled

my glass with red wine. Maria brought out steaming bowls of ravioli with tomato sauce and grated parmesan. I cut into the pasta with my fork, and it was delicious.

'Cheers, it's good to have you both here,' Neil said, and we all clinked glasses.

'Chin chin,' Maria said. 'This is Chianti, produced by the vineyard next door. Do you like it, Rachel?'

When I took a sip, the wine was warm and rich with a velvet finish and as easy to drink as Ribena. 'Really good.'

Neil raised his glass.

'Here's to a good bunch of artists tomorrow.'

Maria rolled her eyes.

'Yes, let us hope none of them are challenging,' she said.

'Sometimes, we get an artist who is temperamental, or who complains about everything, annoying the others,' Neil said. 'Often I have to explain that this isn't a five-star hotel and we can't refurbish the rooms much because the buildings, dating from the seventeenth century, are protected.'

'Recently an art student left a terrible review on Tripadvisor,' Maria said. 'All because there wasn't a power shower.'

'It would be nice to get some good reviews from this group to move that one down,' Neil said.

'Well, I'm sure my aunt and uncle will do that,' I said.

I helped Maria clear our bowls and bring out breaded chicken and salad, followed by vanilla ice cream. The sky turned a shade of pink, then it got dark, and the lights came on. A rustle came from the bushes beneath the terrace, followed by a snort.

'What's that?' I said.

'Probably a wild boar,' Neil said. 'They come out at night and dig up the flower beds.'

261

'Poor Valentino has to redo them,' Maria said. 'Tomorrow night we shall have a party on the terrace with loud music and they will stay away.'

After dinner, Jake and I walked back to our apartment and he took my hand in his. This was it. After he'd unlocked the door, I went in first, then we stood opposite each other and he followed the outline of my face with his hand, sending a tingle down my spine. As he leant in to kiss me, his mobile rang. He retrieved it from the pocket of his shorts and pulled a face. 'It's Penny.'

'Oh.'

He slid his finger across the screen, and I should have left the room, but my feet were glued to the terracotta tiles. How could I not listen in when the conversation affected me?

'Hi, Pen,' he said, then not much else while she talked at him. 'I couldn't get a signal earlier. Yeah, well I tried getting hold of you after the theatre. I'm sorry I didn't call back.' He looked at me, shaking his head. 'Can I call you tomorrow? I've been driving all day and need to go to bed, Pen. All right, bye.' He hung up and raised his eyebrows.

'What did she say?'

'She's furious that I've come to Tuscany without her. Anyway, where were we?' He leant forwards again in an attempt to kiss me, but the mood was beyond ruined.

I didn't want our first kiss to be after he'd been on the phone to Penny. 'Let's leave it for now,' I said.

'Yeah, you're right. We have all week.'

'Goodnight.' I stepped into my room and turned round to close the door. He looked deflated.

'See you in the morning, Rachel.'

As I went to use the bathroom, it struck me that, once again, nothing had happened with Jake. I pulled on my nightdress and

got into the bed with its crisp white sheets and duvet. The mattress was firm and comfortable and, after no sleep the night before and a day in the car, it didn't take long to drift off, despite my disappointment. I took myself back to the moment when Jake was about to kiss me, and how it had made me feel, attempting to imagine what it would have been like to get lost in him. All I could do was hope it might still happen.

Chapter Thirty-Two

Lady Cordelia left Edward in the care of Sister Caterina while we returned to our morning walks and, to my delight coffee at Café Florian. What a way to spend our last few days in Venice. A mist hung over the lagoon and foghorns honked incessantly giving an eerie feel to the city. The temperature dropped dramatically as we progressed into winter and Lady Cordelia bought us cloaks lined with wool and muffs to keep our hands warm. Whenever we returned to the convent after these walks, she was so pleased to see Edward and I wondered how she would detach herself from him when the time came. One day, after lunch, she received a note.

'Will you accompany me to Signor Collina's studio to collect my portrait this afternoon, Philippa?'

'Of course, Cordelia,' I said.

And so, after siesta, we ventured out and when we arrived, Gabriella showed us upstairs to his studio where we waited. Lady Cordelia pointed to a portrait of a man, leaning against the wall on the floor. 'I wonder what he plans to do with that?' she said.

Signor Collina entered the studio.

'Good afternoon, ladies.' He raised our hands to his lips, one after the other looking us directly in the eye as he did so, a repulsive gesture which turned my stomach, and we sat down.

'The portrait of this beautiful woman is ready.' He approached his easel, removing a swathe of red velvet to reveal Lady Cordelia looking quite remarkable. He had captured her character and beauty perfectly while at the same time concealing her pregnancy.

'Do you approve, Lady Cordelia?' he said.

'Indeed, it was worth the wait, Signor Collina. Thank you.'

After summoning a servant to wrap up the portrait, he said, 'Can I offer you ladies *un aperitivo* to celebrate?'

'No, thank you all the same. Who is that gentleman in the portrait on the floor, and what do you plan to do with it?' Lady Cordelia said.

'That is the English art broker, James Mason who arranged for me to reside with Lord Willoughby in England in the spring. I painted his portrait as a thank-you gift, but he was killed in a carriage accident last week at Lake Como. If he had been married, I would have given it to his wife, so I shall use the canvas for another painting.'

'You are going to paint over his portrait?' I said.

'Certainly, it would be a waste of canvas otherwise,' he said.

Lady Cordelia threw me a look. 'Could you give us a moment, Signor Collina?' she said.

'Of course, I shall check to see if your portrait is ready. Giovanni will carry it to the convent.'

'Thank you.'

He left the room, and Lady Cordelia turned to me.

'Why not make this James Mason your deceased husband, and have your portrait done to match when Signor Collina comes to England? Although you will still be in mourning, you can wear a different dress for the portrait so it appears as though it were painted in Venice.'

'What a marvellous idea.' I said. 'But you will have to pay him for it.'

Lady Cordelia shrugged. 'That will not be an issue.'

When he returned to the studio, Lady Cordelia said, 'Signor Collina, I am rather taken with that portrait on the floor and it would be a shame to paint over it after all your hard work. Would you mind terribly if I added it to my collection for the same price as my portrait?'

'That is most generous, Lady Cordelia, but may I ask why you wish to own the portrait of a stranger?'

'I appreciate your talent, Signor Collina, and believe that one day your paintings will be admired by many as you become increasingly renowned in England. This portrait is bound to increase in value with time, is it not? Besides, it will fit nicely in a spot on my dining-room wall, recently vacated by another because I no longer like the person in it.'

'If you insist. Although your reasoning confuses me.' He summoned Giovanni and asked him to wrap up the painting.

'I have just explained, have I not? In addition, when you come to England, can we arrange for you to paint Philippa's portrait?'

'Of course, in London?'

'Yes, in March?'

'Let us correspond and Miss Elliott can visit my studio there.'

'And make her portrait smaller than mine, the same size as that one of Mr Mason, if you please,' Lady Cordelia said, her tongue slipping. Surely, she was making our plan obvious to Signor Collina? We exchanged a glance as she realised her mistake.

'As you wish. You are the client, after all,' he said.

He knew of Lady Cordelia's pregnancy and now we were buying a portrait of a stranger for no valid reason. Despite the

money he was being paid, she was giving him the power to destroy us both, especially if he discovered the truth about Edward when visiting England.

We left Signor Collina's house with Giovanni and another servant following close behind with the paintings. Lady Cordelia would entrust Giovanni with the money for Signor Collina when we reached the convent. And, on arrival, Lady Cordelia made arrangements for us to depart with Edward the following day. Our work in Venice was done.

Early the next morning, we said goodbye to the nuns, who Lady Cordelia said could keep the money, even though Edward was now coming with us. I thanked Sister Caterina for being my chaperone, and we agreed to correspond. I gifted her a lace handkerchief, made locally and she thanked me profusely.

We took the barge back up the Brenta canal, this time with Edward as our companion and now I was a 'widow' wearing a wedding band on my finger. The two portraits accompanied us and Lady Cordelia had several notebooks: journals in red and blue, research notes, and a first draft of her novel. She had been struck by a burst of inspiration after giving birth and said immense tiredness combined with the act of procreation had fuelled her creativity. Lady Cordelia had at last found the muse she had been searching for in Edward. When not looking after him, she had written all day and evening. The journey home would be long and harder than on the way out due to colder temperatures, but I looked forward to seeing Mama, Mrs Baxter and Rogers. As soon as the opportunity arose, I would invite them all to visit. For the first time in a while, the future brought hope rather than preoccupation, and I could not wait to start my new life.

Edward had not inherited his mother's love for travelling. On that first day in the coach, he cried incessantly, always wanting: to drink his mother's milk, to have his clothes changed, to be cuddled and kissed, to be talked and sung to. And it was clear the journey home would not be an easy one.

That night, we stayed in Verona at an inn with neighbouring rooms. Lady Cordelia took Edward, but he continued to cry and hearing the noise through the wall as I attempted to sleep, I knocked on her door at two o'clock in the morning.

She opened it, Edward swaddled in her arms. 'Dear Philippa, I am at my wits end. I cannot stop this child from crying. He has squeezed every drop of milk from me that I have to give, and never have I been so fatigued.'

'Let me take him.'

I held out my arms and she passed Edward to me. The poor mite's face was as red as a lobster and I offered him my little finger to suck. This tip, learnt from my sister-in-law satisfied him momentarily, and I swayed my hips from side to side, gently rocking him in my arms. Lady Cordelia slumped on the edge of the bed and sighed. 'You have saved me once again, dear Philippa.'

'Shall I take him to my room so you can sleep?'

'That would be most kind.' She followed me to my room with the drawer she was using as a makeshift crib, placing it on the floor. 'Thank you.'

She closed the door behind her. As if sensing his mother's departure, Edward recommenced his crying, so I used one hand to prop up the pillows on the bed and sat there with him in my arms singing quietly, 'Hush little baby, don't you cry.' After repeating the song a few times, he fell asleep. I laid him down

gently in the drawer on the floor beside my bed and blew out my candle. To sleep, at last.

A few hours later, at five o'clock, Lady Cordelia knocked on the door and entered, fully dressed. She leant down to retrieve him from the drawer, taking him in her arms and planting a kiss on his head as he began to cry.

'It is time to leave. I shall feed Edward while you get ready.'

She left with him and I dressed myself, then put my nightclothes in my trunk. We went downstairs for bread and milk before embarking on another day of travelling. The journey home would be one to endure with little opportunity to recharge at night and how I longed for one night of uninterrupted sleep.

We progressed to Lake Como, and then on to a small town, St Vincent in the Aosta valley where we stayed in an inn opposite the bell tower. Rising at five o'clock in the morning and exchanging Edward during the night meant we were too fatigued to converse in the coach the following day. Now we had begun to implement our plan, the idea seemed absurd, although I could sense Lady Cordelia's determination to carry it to fruition as well as her fear that I might change my mind about raising Edward as my own.

That night in St Vincent, Edward's crying had once again kept me awake through the thin wall between our rooms and Lady Cordelia eventually knocked, asking if I could comfort him whilst she slept. I took him into my arms and sat in a rocking chair facing the window. After opening the shutters, I watched the sunrise, a poignant moment as the weight of the responsibility I had taken on dawned upon me. My life would never be what it had once been.

The following morning at breakfast, we practised our story on the family who ran the inn. I am not sure whether the mother

believed us as she watched the way Lady Cordelia responded to Edward's crying, the look of love in her eyes revealing the truth. Once Edward did not need Lady Cordelia for milk, our story would no doubt be more credible. She had written to Gertrude, her lady's maid upon our return to England, asking her to arrange for a wet nurse to live with me in London, leaving Lady Cordelia free to detach herself. Gertrude was her late mother's former lady's maid, and apparently she was efficient as well as loyal.

After breakfast, we left for the Mount Cenis pass, and said farewell to Italy, a country I hoped to revisit.

However hard I tried, I could not erase Lady Cordelia's adultery from my mind. Certainly, Edward should not be punished for mistakes made by her and the earl. But was it such a mistake to introduce this small wonder to the world? The warm feeling that enveloped me when Edward smiled showed my heart should overrule my head under these circumstances. He had a right to be loved as much as any other child and to at least know his mother.

As we travelled towards England, I became used to the idea of what my life would become. Lady Cordelia and I talked through our story over and over again, to ensure no gaps remained. My husband, Horatio Giles (we amended the name from James Mason) was an English art broker who had died in a carriage accident before Edward was born. I had met and married Horatio in Venice, whilst there as companion to Lady Cordelia, who was writing her novel and waiting for her portrait to be completed. When Horatio had died, she offered to escort me and Edward back to England in her carriage. The plan had been to live in Horatio's house in Mayfair, with him returning to Venice occasionally for work. Arrangements had already been made and so this is where I would reside.

Lady Cordelia had written ahead to arrange for us to use a property owned by her father, Edward Jenkins, the shipping financier. Gertrude had been instructed to prepare the property for my use and to hire staff, including a nanny. She was aware of our situation so we could rely on her for assistance and Lady Cordelia insisted Gertrude could be trusted. Her father would provide her with the funds required, no questions asked. Being his only child, she tended to get what she wanted from him.

As the days passed, we progressed north, through France, sitting opposite each other in the carriage, taking the same route as on the way, to Lyon, then on to Paris and Boulogne where we took the boat back to Dover. Seeing those white cliffs was a comfort, despite my fears about our new fictionalised life. At the same time, I wished we could be back in Venice before I knew of Lady Cordelia's pregnancy, when life had seemed less complicated. A new era commenced the morning we landed in Dover. I was a dowryless daughter of a deceased vicar no more. Instead, I was Mrs Philippa Giles, widow of a gentleman, and mother to a beautiful son.

We arrived at the house in Suffolk Place, off South Audley Street late the following evening, and Gertrude greeted us. The modern house, painted white was four storeys high with tall windows and black railings flanked steps leading to the front door. This mansion came with conditions attached, I reminded myself. Gertrude introduced us to the butler, Mr Miller and housekeeper, Mrs Jones, a rotund, rosy-cheeked Welsh woman, who spoke with a charming lilt, and who seemed jolly and kind. Mrs Smith, a stern grey-faced woman of around sixty years old would be Edward's nanny. My lady's maid was young and pretty with an earnest manner, named Eloise, perhaps not a girl one would employ with a husband in residence.

For a mere moment, I appreciated Lady Eliza's reasoning for demanding the earl dismiss me, although I was nowhere near as attractive as Eloise, but I was young and unattached. No wife would want the kind of female who turned a man's head living in their home, where opportunities for liaisons might present themselves. Eloise took me to my bedchamber on the second floor, where a Flemish tapestry graced the wall behind the bed, and Gertrude showed Lady Cordelia and Edward to the bedchamber allocated for guests, complete with his first cradle carved from a dark wood.

Retiring to bed, exhausted, I pulled the crisp sheets over myself as a generous fire glowed in the hearth, comforted by the thought that I would no longer need to worry about being cold at night.

When refreshed by sleep, I would study and savour every last corner of my new home. And when Edward woke up in the night, Mrs Smith would be available to take over from Lady Cordelia. The wet nurse, Mrs Harper would arrive the following morning. The list of those aware of our situation included Gertrude, some of my servants who would no doubt inform others when gossiping at mealtimes; and Signor Collina, who when visiting England would no doubt understand why we had bought the portrait of James Mason and renamed him Horatio Giles. In March, when he painted mine to match, all I could do was pray he would not divulge our secret to anyone who mattered.

Chapter Thirty-Three

The clanging of church bells woke me from a deep sleep and I pushed open the shutters to reveal Tuscan countryside with Siena on a hill in the distance. The sky was a deep blue, promising another hot day and a butterfly fluttered around the geraniums in the window box. Birds tweeted and cicadas chirruped. I was in a fairy tale.

We ate breakfast on the terrace. Maria put out chunks of orange melon and brioches from the bakery, filled with custard or marmalade. She made us cappuccinos using her machine. Jake and I ate in silence, and I took in the view, thinking back to the night before when we'd almost kissed. Should anything happen between us before he'd officially called it off with Penny, or should we make the most of being in this incredible location? All I could do was see how the day went. The artists turning up, along with Uncle Pete and Aunt Patsy, might make it more difficult for us to spend time alone. Jake retrieved his phone from the pocket of his shorts as it buzzed and vibrated.

'Ah, it's Penny,' he said, sipping his coffee.

'You're not going to answer it?'

'After last night, no. I'll wait until I get back to London and speak to her then.'

He ate his brioche and the phone buzzed again.

'Ah, a voicemail,' he said, pressing the phone to his ear.

His face dropped as he listened. 'Oh, shit.'

'What?'

He didn't answer as he pressed the screen and walked to the edge of the verandah where he leant on a pillar. What did Penny want now? I wished she would just leave him alone. I took our cups and plates into the kitchen and slotted them into the dishwasher. Bunches of fresh herbs, giant tomatoes, lettuces with curly leaves, loaves of bread and melons cluttered the worktop from Maria's morning trip to the market. As I walked to my room to get ready for the pool, my phone rang. It was Mum. I should have called her back the night before, but had forgotten.

'Hi, Mum,' I said, unlocking the door to the apartment.

I went into my room and perched on the end of the bed.

'I'm so glad to get hold of you, finally, darling.'

This wasn't like Mum and my gut told me something was up.

'What's wrong?'

'Well, I wouldn't want to worry you while you're away.'

There was no going back now.

'What is it?'

'Malcolm dumped me.'

I scratched my head and stifled a sigh, knowing what this meant for me.

'Are you serious?'

'I got a bit grumpy with him for going off cycling when I wanted to go on a picnic together and said it was me or the damn bike.'

'Oh dear.'

'We had a row the night before last, but I thought we'd make up the next morning, like we usually do. But when I got back from my Tesco shop, his things were by the front door.'

The thought of him removing his crap from the spare room and his bike from the hall made me happy, but at the same time, Mum would be lost without him, as she always was when splitting up with a boyfriend.

'Where is he now?'

'He's moved back into his old flat.'

'I'm sorry, Mum.'

'Since he left, I haven't slept a wink and meditating has made no difference whatsoever. How will I pay the bills?'

This was her passive-aggressive way of asking me to move back in. My head said, 'Why should I?' after she'd suggested I move out in the first place. But my heart said I ought to be there for her.

'I guess I can move back in.'

Instantly regretting my words, I wished there was a way to retract them, but it was too late. After Nigel, I'd vowed to make Mum less reliant on me when she split up with a bloke, but here we were again. For ages, I'd blamed her for damaging my relationship with Chris. All had been going well between us with him buying the house in Dorking with views of the Surrey Hills, but when I'd visited Mum at weekends, Chris made a fuss, saying he should be my priority. Rumours went around town that he was seeing a girl from work during my absence, but he'd always denied it. After choosing Mum over him, I'd lost the money inherited from Gran, and there was no chance I'd get it back now. Taking him to court was likely to leave me out of pocket and after talking it through with Mum, we'd decided it wasn't worth the hassle and stress. Mum's issues had revealed Chris's true colours, and I was grateful to her for that, although not for the loss of the money.

'How thoughtful of you, darling.'

The door opened and banged shut as Jake came into the apartment and went into his room.

'I'd better go, Mum. Will be in touch.'

'All right. Speak soon.' She made kissing sounds and I hung up.

When I went into Jake's room, his face was serious.

'What did Penny say?' I said.

'She's on her way here,' he said.

'What? You're kidding.'

He shook his head.

'Nope. She's boarding a flight to Perugia as we speak.'

'Is there anything you can do to stop her?'

He shrugged and let out a sigh.

'Not really. And of course, I had to tell her you're here, so that was awkward.'

My gut tightened at the thought of Penny turning up, all guns blazing.

'But I can't share this apartment with you both,' I said.

'I'm not sure if there's anywhere else for her to sleep. As far as I know, Dad's fully booked.'

'Okay, well, I will pack my stuff and find somewhere else to sleep then.'

'You shouldn't have to do that, Rachel,' he said.

'What then?'

We stood there looking at each other for a moment, and he shrugged.

'I don't know what to do, sorry,' he said. 'Maybe have a word with Maria.'

It was as if he'd swapped bodies with someone like in one of those films from the eighties while on the phone. Who was this

version of Jake who didn't seem to care about me anymore? He went to the door and glanced over his shoulder.

'Dad's asked me to help him paint an outhouse today, thinking we can brainstorm about the gallery at the same time. Hope you don't mind me leaving you on your own for a bit?'

So this was it then. I had come to Tuscany and risked losing my job for nothing.

'I'll sit by the pool, work on my tan,' I said in an upbeat voice, throwing in a smile so forced it made my face ache.

'Thanks for understanding. I'll see you at lunch, and hopefully Maria will have found you another room by then.'

Uncle Pete and Aunt Patsy were due to arrive later, but how could I remain at the art school with Penny here and nowhere else to sleep? Booking myself into a hotel was an option, but I wouldn't have enough money in my account to pay for that as well as the flight.

For once, I wished I was at home with Mum. There was no chance I'd make it to Perugia in time for that day's return flight to Stansted, but I'd use Maria's computer to book a flight for the next day. I wouldn't get to see Venice after all, or Siena, and what were the chances of anything happening between me and Jake now? Even if Penny wasn't able to persuade him to stay with her, I'd be moving out of his flat on returning to Chipford and there would be no more reasons to spend time with him. This paradise was about to turn into hell and I couldn't wait to escape.

Chapter Thirty-Four

The following morning, the wet nurse, Mrs Harper, arrived and Eloise established her in a rocking chair in the nursery with Edward and Mrs Smith while Lady Cordelia and I breakfasted in the dining room. I wore a black dress for the first time in my new role as a fictional widow.

'It has been quite a journey, dear Philippa,' Lady Cordelia said.

'Indeed it has,' I said, spreading jam onto my bread.

Miller poured our tea from the pot and added milk. I looked forward to tasting milk from English cows once again.

'Mrs Jones enquired where you would like the portrait of your late husband to be positioned, Mrs Giles?' Miller said.

At first, I did not answer, as I was not used to being addressed under my new name, and he repeated the question, going along with our charade, as a butler does.

'Oh, thank you, Miller. Horatio belongs in the drawing room and my portrait will be hung opposite when it is ready.'

'Which drawing room, Mrs Giles?'

I had not yet seen the house, so was unaware of there being more than one drawing room.

'May I interject?' Lady Cordelia said. I nodded. 'I suggest you opt for the red drawing room, which lends itself more to portraits than the green drawing room, but you can view both rooms after breakfast.'

'May I inform you then, Miller?' I said.

'Of course, Mrs Giles.' He excused himself and left us alone.

'You do not need to ask a butler for permission,' Lady Cordelia said. 'Just tell him what you want to do. Be firm is my advice.'

'Very well.'

'Now, it is of the utmost importance that my son develops an appreciation for art,' Lady Cordelia said. 'I shall send over a selection of paintings, for I have several in storage, and you may choose those appealing to your taste. In due course, I shall dispatch someone to redesign the interior and provide you with decorators who will work on one room at a time so you do not need to live elsewhere. Next week, I shall endeavour to secure a meeting with Mr Hunter of Hunter and Son who worked on Heybury House as well as Chipford Hall. He is highly respected in his field.'

I was to live a life almost as privileged as Lady Cordelia's, a feeling most foreign. After breakfast, Mrs Jones showed me around my new home. She led me down to the basement to a large kitchen, the servants' hall, her parlour, and a butler's pantry. On the ground floor were the two drawing rooms, a library, a dining room, and a tea room. My bedchamber and four others were on the first floor along with the nursery, and on the top floor were the servants' quarters.

As we descended the stairs, Miller announced the arrival of Lady Cordelia's carriage. She went to the nursery and interrupted Edward's feed to hold him in her arms for one last time before

279

leaving. He cried because she had taken him away from his milk and I saw tears in Lady Cordelia's eyes as she handed him back to Mrs Harper and he latched onto her breast instantly. We went outside and Lady Cordelia sniffed and dabbed her eyes with a handkerchief, and it was clear her heart was filled with sadness. Imagine if we had left Edward in Venice?

'Goodbye, Cordelia,' I said.

'My dear Philippa, you have no idea what you have done for me. Next weekend, I shall return with Gertrude. In the meantime, you must acquaint yourself with the local vicar at St Mary's.' She pointed to the church at the end of the road. 'And arrange a christening in May. As agreed, I shall be godmother, and we can discuss the finer details upon my return.'

She joined Gertrude in the carriage, and we waved goodbye, before the horses pulled her away, down the street and out of my life momentarily. Lady Cordelia had been my friend and companion for several months and I would miss her company, despite her eccentricities.

I went back up the steps, into my new home and my new life. Here I was in a house filled with servants and two drawing rooms, when twice in the past eighteen months destitution had been a strong possibility. Who could have imagined that my rejection of the earl's proposal would produce more or less the same outcome? A residence in London with an allowance. Except, in this case, there was no requirement for me to commit adultery. However, I was committing another sin by lying about being married to a deceased man as well as being Edward's mother. Later that day, I would make my acquaintance with the local vicar and pray for forgiveness from the Lord.

Letters needed to be written and I established myself at the writing table in the library, my most important task being to

request the Dowager Duchess dispatch Mama to reside with me. There was no reason for the dowager to object to losing a companion who had become burdensome. All I could do was wait and hope that before long Mama would join me in London, then I could care for her as a daughter should. As soon as I received confirmation from the dowager, I would interview lady's maids.

Next, I wrote to Mrs Baxter and Rogers to inform them of my new address, and about Horatio and Edward. I invited them to stay, suggesting the weekend after next, assuming they could secure leave at the same time. The thought of seeing Rogers again especially filled me with joy, and I recalled that moment in Mrs Baxter's parlour before I left Chipford Hall. I doubted he would still look at me in a romantic way due to my newfound state of affairs, especially while I wore mourning dress. All I could do was hope we would remain friends. Then I wrote to Maud, Sister Caterina, the dear girls, my sisters-in-law and Mrs Braithwaite.

After that, I compiled a list of tasks relating to the arrangement of Edward's christening. A decision would need to be made on who should be godfather. Rogers seemed a suitable candidate, and Lady Cordelia was certain to approve of my choice.

The next morning, Eloise knocked and brought in breakfast on a tray, then she opened the curtains bringing in sunlight as my bedchamber looked onto the back garden. My daily routine in Mayfair was to be a privileged one, to be sure. The bread, baked by the cook, Mrs Larkin, that very morning, was accompanied by butter and cheese from Heybury House's Home Farm. Gertrude had arranged for provisions to be dropped at the house whenever they were brought to Lady Cordelia's London residence. Edward

would be reared on the finest beef, matured for months, as well as mutton, chicken and hams from the Heybury House estate. Lady Cordelia had reassured me the baron would not find out as she always dealt with household business.

As I breakfasted in the manner of a countess, I pondered upon my situation. Despite these new luxuries, I was entirely dependent upon Lady Cordelia. I dismissed negative thoughts urging me to escape this situation and seek a position in a country house or school. How could I abandon Edward? If I did, Lady Cordelia would struggle to find anyone whom she could trust as implicitly as me.

That first week passed as slowly as a stew bubbling on a stove when one was famished. Mrs Smith took daily walks with Mrs Harper and Edward in St James's Park, and sometimes, I would take Mrs Harper's place, allowing her to rest, for breastfeeding a baby required more energy than one expected, and she was always hungry, so I ensured Mrs Larkin fed her well.

The dowager wrote to say she would be delighted if Mama came to live with me as she needed to be cared for by a relative. Mama would travel to London with one of her maids for company the following week, and they would stop at inns en route. Relieved and delighted, I made a note to conduct interviews for a lady's maid to care for her every need.

Replies to my letters arrived one after the other with Mrs Baxter and Rogers agreeing to visit the house the following weekend, a thrilling prospect. Letters received were well crafted, congratulating me on my nuptials and newborn child, but at the same time offering condolences because of Horatio's tragic death. These letters moved me more than words could say, consuming me with guilt, and once again I reminded myself I was doing this for Edward and Lady Cordelia.

To live the lie, I had to transport myself into a fictional world where Edward's backstory was a creation, but Edward himself was very real indeed, and I loved him as if he were my own son. I spent more time with him than a woman of my newfound social status traditionally would because I felt responsible for his welfare, and I had always played the role of carer, teacher and giver.

Once I had arranged the christening for the end of May with the vicar, I prayed every morning at St Mary's. During my prayers, I asked Papa to forgive me, and to understand my reasons for taking on Edward. Without a doubt, Papa would prefer I live this life than the one offered to me by Earl Rupert.

Lady Cordelia wrote daily from Heybury House, and I kept her letters separate from the others, in the drawer of my bedchamber writing table. I locked it with a key, hidden in a compartment of my jewellery box, under the string of pearls gifted to me by my parents on my eighteenth birthday.

Lady Cordelia missed Edward a great deal and wrote that her life would never be the same now he had entered it. Her words were a rush of thoughts and feelings, converted to ink for my benefit and they read like journal entries. On Friday morning, I almost choked on my tea as I read that Lady Eliza was with child and I wondered whether the earl's first legitimate offspring would be a boy or a girl. Imagine if Lady Eliza only produced girls? Would Lady Cordelia then divulge the truth so the earl would be aware he had a son, albeit an illegitimate one? I had heard stories about members of the aristocracy being kind to illegitimate offspring and accepting them into the family in some way, although this wasn't always the case.

Chapter Thirty-Five

When the email confirmation appeared on my phone for the flight booking, I instantly felt better. I'd ask Valentino to take me to the airport straight after breakfast the following day. So, all I needed to do was cope with Penny, who'd no doubt be horrible to me.

Maria came into the lounge. 'We have no rooms available, Rachel, so I can only offer you the sofa bed in the living room of your aunt and uncle's suite.'

'Oh, thanks, Maria. I hope they won't mind.'

'It's only for one night. I am sorry you are leaving us.'

Although it was always nice to see my aunt and uncle, if I'd had enough money for a hotel, I would have stayed in Perugia. Aware of the need to get out of Jake's apartment before Penny arrived, I went to pack and changed into my bikini then wheeled my suitcase to the lounge so it could be moved into Aunt Patsy and Uncle Pete's room later. They were bound to be understanding about my situation. I went down the crumbling steps to the pool and set myself up on a sun lounger by the bed of pink roses, applied suntan lotion and closed my eyes, listening to the rhythm of the cicadas, the humming of bees, and the birdsong. Now I wouldn't get to see Venice, or even Siena, and it would be nice to at least get a tan before returning home.

By one o'clock, sitting in the heat had made me irritable and sweat dripped down the back of my neck, so I did a few lengths in the pool before heading back up the steps for lunch. Maria set out wooden boards of cold meats and cheeses and olives and roasted peppers with a basket of bread, fresh from the bakery that morning, and I sat facing the evergreen forests and fields beyond. Jake appeared at the top of the steps and took a seat opposite, his face shiny with sweat. Neil followed and went into the kitchen.

Jake picked up the carafe. 'Wine?' he said.

Anything to make it less awkward.

'Yes, thanks.'

He filled our glasses, and mopped his brow with a napkin. I helped myself to water, and poured some for him.

'How did painting the outhouse go?' I said.

He piled items from the wooden boards onto his plate and added a couple of slices of bread.

'It's not easy in the heat, but we should finish this afternoon,' Jake said, building a sandwich on his plate.

So, he planned to leave me on my own again. No one would have believed we'd spent the past few days together and almost kissed the night before.

Neil and Maria joined us from the kitchen. 'Did you have a good morning, Rachel?' Neil said.

I selected a slice of ham from the wooden board, and picked up a triangle of cheese.

'Yes, thanks. I went to the pool. The water is a lovely temperature. When does everyone arrive?' I said, the queen of small talk.

'Around four o'clock,' Neil said. 'Once they've settled in, we'll serve prosecco on the terrace before dinner.'

Maria passed me the salad bowl and I used the servers to pile rocket onto my plate. A few more hours to mentally prepare myself, although I would have liked to get any initial interaction with Penny over with. Jake hoovered up the food, downed his wine and stood up.

'Sorry, I have to get in the shower, then I'll take a nap until it's cooled down a bit. Shall I meet you at around three o'clock, Dad?' he said.

'All right, see you later,' Neil said.

Jake walked across the terrace and turned down the side of the house towards what was now his and Penny's apartment, without giving me a second glance. A morning in the sun combined with wine had made me sleepy and I fancied a nap myself. Now I'd moved out of my room, the only options were the terrace, lounge or pool. It didn't seem right to ask to be let into Patsy and Pete's suite before they'd arrived. Neil and Maria carried the plates into the kitchen and I got up to help.

'You stay here and relax,' Maria said, placing a hand on my shoulder and I sat back down. 'Would you like a coffee, Rachel? If I give you a takeaway cup, you can go back to the pool.'

It would give me chance to make the most of the sun.

'That would be great, thank you,' I said, waiting for her to make the coffee before descending the steps once again to return to the pool.

The crunch of car tyres on gravel woke me from my nap, then another car followed. They were here, and the time on my phone said ten minutes to four. How had I been asleep for over an hour? Trying to be clever, I'd set up an umbrella to avoid getting burnt while snoozing, but the sun had moved, producing a red stripe down my right arm, across my stomach to the right of my belly

286

button and along my right leg. On top of everything else, I would look like a complete idiot when I met Penny. As I moved my sun lounger into the shade, I made the decision to find Uncle Pete and Aunt Patsy in a bit, giving them chance to settle in before closing my eyes and drifting back to sleep.

The sound of voices woke me and as I sat up, a group of people came into sight, led by Maria. Stupidly, I hadn't thought they'd come down here. Self-conscious in my bikini, I put on my T-shirt, and as it brushed the back of my neck, I realised that part of me was burnt as well. Great. As I pulled on my shorts and zipped them up, the group appeared from behind an olive tree.

'Here is the pool. Oh hello, and this is Rachel,' Maria said.

While scanning the group for Penny, I nodded and smiled. 'Hello everyone.'

She wore a cream maxi dress, her blond hair lifting in the light afternoon breeze as if she was in a music video. How could I compete?

'These are the art students: Frank, Sally, Hilary, John. Patsy wanted to get a hat out of her case so she and Pete will come down shortly. This is Penny.'

They chorused, 'Hello', apart from Penny who threw me the filthiest look.

'What's happened to your face?' she said.

So my face was burnt as well.

'What do you mean?' I said.

'It's all red on one side.' Penny laughed in the manner of a school bully, and the others laughed with her. Peak humiliation. I couldn't dislike her any more.

'A little too much sun this afternoon, I think, Rachel.' Maria looked me up and down as if to say, *You English people have no idea*, then turned to address the group.

287

'There is time for a quick swim before dinner, if you wish. We shall serve prosecco and nibbles on the terrace from six o'clock.'

'Oh yes, I would love to have a splash about,' Hilary said. 'Shall we go and change, Sally?' Sally nodded, Maria told them to pick up their keys from Valentino at reception, and they left.

'That view is spectacular,' Frank said, pointing in the distance. 'I particularly like the way the roses around that wooden square frame Siena. I'm going to grab my sketchbook and make a start right now.'

'I'll join you,' John said.

They headed off up the steps.

'I washed my hair this morning, so shan't be swimming,' Penny said. 'Could you just show me to my room please, Maria? I'd like to make use of the air conditioning.'

'Ah, we do not have air conditioning here, Penny,' Maria said.

Penny frowned. 'Really? How very *passé*.'

Ever the smiling hostess, I wondered how much crap Maria would take before she cracked.

'Rachel, I shall escort Penny to her suite. Why don't you explain your situation to Pete and Patsy when they come down?'

'Your situation? Sounds serious,' Penny said.

'It's nothing serious, don't worry,' I said.

'Oh, I'm not.'

To my relief, Uncle Pete and Aunt Patsy appeared.

'Let's go, Penny,' Maria said.

As they left, it occurred to me that getting through this evening would be harder than previously thought. When Pete and Patsy kissed me on both cheeks, the right one felt sore.

'How are you, my darling?' Patsy said.

Pete walked around the pool, snapping photos on his phone.

'He can't wait to document our trip on Facebook, bless him,' Patsy said. 'Ooh, your face is a bit burnt.'

'I made the mistake of falling asleep in the sun.'

'I've got some cream for that.'

'Thanks, Patsy. I have a bit of a problem.'

'What is it?' she said.

'Penny, who was with Maria just now has been seeing Jake, on and off, and I've been sharing his apartment. She turned up out of the blue to surprise him and Maria suggested I take the sofa bed in your living room tonight as the art school's fully booked. It's just for one night as I'm flying home first thing.'

'You don't mind Rachel sleeping on our sofa bed tonight, do you Pete?'

'Not at all, love,' Pete said.

I breathed a sigh of relief.

'Ah, thank you, both.'

'Pete, why don't you go and get your trunks on. We girls need to have a catch up.' She winked at me.

'All right, see you in a minute.' He headed off, sliding his phone into the pocket of his shorts. Patsy turned to me.

'Tell me what's going on.'

I told her about the past few days, and that since that morning, Jake had been painting the outhouse with his dad, leaving me on my own.

'Oh, how awkward. Do you think she knows about you and him?'

I pulled a face.

'Yes, and I expect she'll confront me later.'

'Well, you have me and your uncle to look after you. No one messes with your uncle Pete. Let's go and make you look fabulous.'

Fat chance with my sunburn, but I smiled, relieved to have the support of my lovely aunt. I grabbed my things.

'I'm so pleased you're here,' I said.

She threaded her arm through mine.

'Safety in numbers, my love.'

At seven o' clock, I headed for the terrace with my aunt and uncle, glad they were here to fight my corner. I wore a black top with a white lacy wrap and chunky grey necklace, both borrowed from Patsy, with jeans. The sunburnt patch on my face was covered in thick foundation and looked better than it had. Jazz played through giant speakers, placed at each end of the terrace on stands and there was a long table with food and drink. At one end, glasses of prosecco were arranged in rows and a barrel was filled with ice and bottles of beer. The other end was crammed with bowls of olives and crisps and salted almonds and plates with triangles of cheese and cocktail sticks pushed through Parma ham and chunks of orange melon.

The art students hovered around the nibbles, clutching drinks as they talked. There was no sign of Jake or Penny and I looked over at the dinner table glowing with tealights, under the veranda, wondering who I'd end up sitting next to.

Pete handed glasses of prosecco to Patsy and me, and as I took a sip, Jake and Penny approached from the side of the house, Penny wearing heels and the lemon dress from the wedding photo on Facebook. Her tan was already deeper than my pathetic attempt and it had to be straight out of a bottle. Jake was nicely bronzed from painting the outhouse and he wore a crisp white

shirt, open at the neck. All I could do was pretend not to see them until they made contact.

Patsy clearly spotted them, as she nudged Pete and said, 'Why don't you update Rachel on your findings?'

'Well, Rachel,' Pete said, taking a swig from his bottle of beer, 'the genealogist and I have been working hard. We went to the National Archives in Kew last week and have worked our way back to the family living in your mum's house in 1820. There's a way to go, but I'm confident we'll find out what we need to know.'

'That's interesting. Thanks, Uncle Pete,' I said.

'If you keep looking for evidence linking Philippa to Chipford Hall, we can try to find a way to connect her to Ivy Cottage.'

'I'll do that when I go in next week,' I said.

'Hello, all.'

I turned to see Jake standing there. Penny was talking to the art students and didn't seem to have noticed he'd made his way over. He and Pete shook hands and he double kissed Patsy. We nodded at each other briefly, and I wasn't sure if he was blanking me, or just didn't want to piss off Penny.

'We're very grateful to you for organising this for us, thank you, Jake,' Patsy said.

'It's a pleasure.' He flashed a grin, looking better than ever, his skin kissed by the sun. 'Are you enjoying your visit so far?'

'I love it here,' Patsy said. 'The scenery is magical, and I can't wait to get out the watercolours tomorrow.'

'What will you do, Pete?' he said.

'After visiting the marble quarries at Carrara, I'll work on my tan,' Pete said, with a grin.

Valentino approached, dressed in white tie, gesturing towards the table.

'It is time to eat.'

We thanked him and headed over and Maria said we could sit where we liked. I ended up opposite Patsy, between Pete and Frank, with thankfully Jake and Penny at the other end of the table. Now I just had to get through this meal and go to bed, then I'd be out of there before anyone woke up in the morning. Neil filled our glasses with a choice of red or white wine, and I opted for white. Maria served dishes of steaming ravioli and Valentino came round, grating parmesan over the top.

'Did you get any sketching done?' I said to Frank.

'I did indeed and look forward to getting my paints out tomorrow. What will you be painting?' he said.

'Oh, I'm not an artist,' I said.

'You don't need to have made a sale to call yourself an artist. We are all artists, just by wanting to be,' he said.

I laughed.

'That's not what I mean. I came out here with Jake.'

'Isn't that his girlfriend over there?'

'Yes, kind of. Jake and I are friends.'

'Oh, I see. That's what they all say.' He winked and turned to Hilary on his other side.

Pete was engrossed in conversation with Sally and Patsy talked to John about her plans for the following day. Everyone seemed to want to speak to anyone but me, and all I could do was tuck into my ravioli. As I put down my fork, my phone buzzed in my back pocket and not wanting to be rude, I discreetly checked it in my lap, in case it was Mum needing more moral support. But it was a text from Jake.

Meet me in the lounge.

I looked up the table at him. Penny was deep in conversation with Neil, clearly trying to get into his good books, but Jake rested his chin in his hand, looking over at me. I pushed back my chair and got up, feigning a trip to the loo and headed for the lounge where I sat on a stool at the bar. It was lined with bottles of spirits ranging from Cinzano to Peach Schnapps to Jack Daniels. An ice machine crunched and hissed and there was a plate with slices of lemon arranged in a neat circle. The fridge was filled with cans of tonic, soda, lemonade and bottles of prosecco. Tempted to make myself a generous vodka and tonic, I wondered if he was still coming when he appeared and softly closed the door behind him.

'Hi,' he said.

'Hi.'

He sighed and looked down at me.

'Look, I'm sorry about everything. Maria said you're flying home in the morning?'

'Yes, there's no point in staying here now.'

He shook his head.

'I meant everything I said the other night, but worry Penny will create a scene and damage Dad's business. He's so reliant on Tripadvisor reviews, it's ridiculous and I couldn't be responsible for another one of his ventures going down the pan.'

I nodded, forcing myself to say, 'I understand. Are you still going to break up with her?'

'Yes, but I'll wait until she's left this place. Next week, in London, will be the best time. Then I'll come and see you.'

As he squeezed my forearm, I wondered if I'd misjudged him. Did he mean what he was saying, or was he keeping his options open? Maybe he saw me as a conquest and once we'd slept

together, he'd go back to Penny who despite being a bit high maintenance was stunning, after all.

'I'd better get back or people might work out that we're together,' I said.

'All right, I'll go through the kitchen and carry a couple of plates or something.'

He leant forward and kissed me on the lips and stayed there and I allowed him to, wishing we could go back to his room, despite my new doubts about him. I pulled away and he twisted the door handle and headed for the kitchen from the back hallway. When I returned to my seat, Penny looked across at me and it was clear she knew about my rendezvous with Jake in the lounge and a knot formed in my stomach, tightening by the second as there were two courses to get through. Jake appeared from the kitchen, a bottle of wine in each hand and topped up the carafes.

'Jake, there's no need to help us tonight,' Maria said.

Valentino cleared our plates and he and Maria served steaks, cooked rare, and bowls of salad and platters of fried potatoes and courgettes and green beans with slices of garlic scattered over them. He refilled our glasses and Penny's increasingly frequent looks drove me to knock back the wine. Despite Jake's best efforts, something inside me said she might create a scene anyway.

After the main course, every other person was asked to move two seats along and I found myself opposite Penny and away from Patsy, Pete and Jake. There were no protectors here; it was just me and my nemesis and I wanted to be sick all over the giant wedge of tiramisù placed before me by Valentino. What was I doing stuck in a love triangle in the middle of Tuscany for goodness' sake?

'So, Rachel, Jake's told me all about you and your painting,' Penny said.

I picked up my spoon.

'Has he?'

'He explained how much he's helped with the research and how you visited Pimsy's together. And that he kept the painting in his safe for no charge. If it turns out to be a real Canaletto, it's only fair he gets a share of the value. I mean, without him you wouldn't have got your lead about the companion painting being in Venice. And you would have left your painting in the safe at Chipford Hall, where the manager would no doubt have found a way to make it the property of the ATP.'

Deciding against the tiramisù, I put down my spoon. The situation combined with the wine, ravioli and steak was producing a spin cycle in my stomach and I couldn't fit in another mouthful.

'I'm sure the ATP wouldn't have done that.'

'If they'd found evidence of the painting being owned by Chipford Hall at some stage, they could have claimed it belonged to them. So, if the painting is real, you'll owe Jakey a fair amount of money which will help us pay for his flat to be renovated. He spent time doing your research instead of focussing on that deal that went wrong, the reason he lost his job.'

'I wouldn't say that's entirely true. He's been offered another one, anyway.'

'That's beside the point. He's been talking about turning it down, saying he's burnt out and wants to do something more fulfilling. Your influence, no doubt.'

I didn't know where to start with absorbing this information. Her calling him Jakey was disturbing enough. Had he been talking about my painting as if he was going to make money from

295

it? Did he engineer the trip to Tuscany as part of a grand scheme to dupe me? Had I been wrong to trust Jake all along and was he in cahoots with Penny, and possibly with his father, whose businesses were struggling? And even Maria, who had been less friendly since Penny's arrival on the scene? All I wanted to do was get out of there right now, but leaving the table mid-dessert was tricky.

'Your version of the way Jake has helped me is surprising,' I said. 'And I had no idea you were moving into his flat.'

'I was supposed to move in before Christmas, but we put it back a few months. So what?'

'That's not what I heard,' I said.

'Do you seriously think he finds you attractive?' She threw me a smug smile. 'I mean, you're hardly his type.'

I laughed nervously, looking around for moral support. Patsy was leading Pete to the terrace, now a makeshift dance floor, with Valentino at the decks, 'Celebrate' blaring from the speakers. Some help they were. Sally and Hilary joined them and it was clearly time to make my escape. Clutching at straws, I pulled my phone onto my lap, and pressed 'Mum', urging her to pick up, ready to talk to her voicemail if I had to, pretending to be in conversation with her. For once, she answered, and I pressed the phone to my ear.

'Hi, Mum. Hold on a minute.' I put my hand over the phone and said to Penny, 'Excuse me, my mum's been trying to get through since yesterday.'

Penny shook her head as I placed the phone against my ear, willing my mum to help.

'Hello, darling,' Mum said. I stood up, and pushed my chair under the table, then headed for Pete and Patsy's suite in the main house.

'How are you?'

'I'm all right. When are you coming home?'

'Tomorrow.'

'That's great. I can't wait to see you.'

As I passed the lounge, her voice broke up.

'The signal's going. I'll text when I get back tomorrow night.'

'Okayyyy.'

She had gone, and I unlocked the door to the suite and ran into the bathroom and lifted up the toilet seat and sat on the floor, and puked into the bowl, holding back my hair with my left hand, my eyes watering, but then thick, heavy tears came. I wiped them away with loo roll and stood up to look in the mirror. My mascara had run down my face, removing foundation covering the red stripe. I was a bloody mess. After flushing the loo, adding half a miniature bottle of shampoo for good measure, and washing my hands thoroughly, I brushed my teeth. Plonking myself on the sofa bed, I wondered if Jake had been taking me for a ride all this time. Had I been a huge fool to trust him?

Chapter Thirty-Six

Lady Cordelia visited the following Saturday morning, having travelled to her London residence from Heybury House the previous day. Miller brought her into the red drawing room where I had been replying to letters at the writing table by the window, overlooking the garden. Maud's mother was unwell, leaving her with no one to look after her daughter, Jane while she worked as a maid and I had replied to say Rogers would take her an envelope of money at his earliest convenience en route to Bath. As Edward was due to take his nap, we went straight to the nursery so Lady Cordelia could hold him while he was awake.

'It is so good to see you again, little one,' she said as Mrs Harper passed him to her. For a few minutes she held him in her arms and smothered him with kisses, and then he began to cry.

'He is tired and ready for his sleep. Will you be accompanying us on our walk?' Mrs Smith said.

'What do you think, Cordelia?' I said.

'Yes, it would be good to stretch my legs,' Lady Cordelia said.

We put on our cloaks and bonnets and followed Mrs Smith who carried Edward in a sling. As we walked up South Audley

Street, the cold wind brushed my face and despite my discomfort, the fresh air was invigorating.

'How are you, dear Philippa?' she said.

'I am well, and how are you managing without Edward?'

She sighed.

'You will have gathered from my correspondence that I am suffering immensely.'

'I can only imagine,' I said as we crossed the road to St James's Park.

The leaves on the trees had turned and we were blessed with a vision of red, orange, yellow and brown. Nature really did lift the spirits. I kicked the piles of leaves on the ground with my boots, a pastime much enjoyed as a child. Lady Cordelia, being more mature than me stepped around them as if they were an irritation.

'However, I remain eternally grateful to you,' she said.

Glad to receive her praise, I smiled.

'Edward's sleep has improved now he has settled in to a routine. So thankfully has mine, now I have a nanny and wet nurse to assist.'

'That is good news. I, on the other hand, suffer from an insomnia worse than ever experienced.'

'Your anxiety is understandable.'

'Since returning from Antigua, my husband has been bedridden with a terrible illness. I cannot help blaming myself as, since I committed adultery, the Lord has punished me with one problem following another.'

Lady Cordelia was clearly distressed by this development and I called ahead to Mrs Smith to go on without us and meet us at a nearby bench after circling the lake.

'Let us sit over here for a moment,' I said.

We settled ourselves on the bench with a view of the water, and my eyes were drawn to a gaggle of geese as they honked and hissed while chasing each other around.

Pulling my gloves on more tightly, I said, 'Life has a habit of treating us in this way, no matter what we may have done and you must not hold yourself responsible for the baron's being unwell. What, may I ask, is wrong with him?'

She removed a handkerchief from her pocket and dabbed her eyes.

'The doctor says he has syphilis.'

'How unfortunate.'

'Evidently he conducted relations with other women in Antigua.'

'So this illness is of his own making. How does one go about treating syphilis?'

'With mercury, although the skin is falling from his face, quite literally and from all over his body for that matter, and he has lost most of his hair. I fear he will not be with us for much longer, Philippa. He has the appearance of a monster from some ancient fable and I cannot bear to look at my own husband.'

'I am so sorry, Cordelia.' I gave her arm a gentle squeeze, and she cast me a look of affection.

'There is nothing to be done except wait for the inevitable end.' She drew in her breath and closed her eyes momentarily, then wriggled her shoulders as if to compose herself.

'Let us talk of brighter things. Have you given any thought to who should be Edward's godfather?'

'The obvious choice is Mr Rogers,' I said.

Lady Cordelia raised her eyebrows.

'The earl's valet,' I added.

'I know who he is. Do you not think we should seek someone more…' She looked ahead as if searching for the right words.

'More what?'

'Suitable?' she said.

'You mean of a higher social rank?'

'Quite.'

'I understand your point, but remember, Edward is meant to be my son, and my rank is inferior to yours.'

'Might I suggest Earl Rupert?'

'Why on earth would he agree?'

'He owes you for rescuing his sister from the lake, and you lost your position at Chipford Hall due to his wife's meddling. Approaching me was driven by his guilt, after all.'

What on earth was she referring to? At that moment, Mrs Smith reappeared from behind the trees and we got up from the bench to follow her along the path. I no longer felt any inclination to kick the leaves, my mood altered by what Lady Cordelia had said.

'What do you mean, exactly?' I said.

'Are you not aware that Earl Rupert suggested I find you employment? My plan had been to secure you a position locally, before discovering my lady's maid was a thief shortly before departing for Italy, thus creating your role as my companion.'

'My position with you was his doing?'

'Why else do you think I approached you? He informed me of his offer to buy you a house in London and to make you his mistress.' She laughed, although I did not join her.

He had approached her despite my asking him not to and now I was further in his debt. In an effort to remain calm, I inhaled in order to regulate my breathing.

'The earl and I have confided in each other since we were children, remember. Despite our dalliance, we remain friends.' How would he view their friendship if he knew the truth? 'Would you mind terribly, Philippa if I asked him to be Edward's godfather on your behalf? If he accepted, I would be delighted.'

'As I am supposed to be Edward's mother, would he not expect me to do the asking?'

'He is more likely to say yes if I do it in your stead. Furthermore, you are forgetting how persuasive I can be.'

This was indeed true.

'Would such a request not arouse his suspicions about Edward's paternity?' I said.

'He is too preoccupied with managing his mistresses to allow such a thought to enter his mind.' Earl Rupert, ever the cad. 'When he visits Heybury House next weekend, I shall have a quiet word.'

Lady Cordelia had once again coerced me into making a decision in order to satisfy her own agenda and all I could do was hope this was the last time.

'As you wish. If he declines, can Rogers be our second choice?'

'Do you not have brothers?'

'Yes.'

'And their occupations?'

'One is a vicar, the other a naval officer.'

She clapped her hands together, her eyes lighting up.

'A vicar would be ideal.'

'It would be inappropriate to involve him in our grand deception.'

'And the officer?'

The time had come for me to be firmer with Lady Cordelia, otherwise she would continue to trample all over me.

'We are not close. Besides Rogers is a good man and since he is the earl's valet, Edward might see his father on occasion.'

And I hoped it would allow me the excuse to spend more time with Rogers as well.

'All right. If the earl declines, you have my permission to approach him.'

It was becoming increasingly difficult not to resent Lady Cordelia for giving minimal consideration to my suggestions, but for as long as she was my financial provider, she would be the decision maker. My role was merely of a cog in her rather complex wheel of a life. We left the park, returning to the streets of London and waited for a carriage to pass before following Mrs Smith across the road back to South Audley Street.

We returned to the house, settling by the fire in the red drawing room and I asked Miller to bring us a jug of water to quench our thirst.

Lady Cordelia gestured above my head. 'Seeing the portrait of Mr Mason reminds me that Signor Collina will visit his patron, Lord Willoughby, in March before embarking on a tour of England and you need to ask him to paint you before the christening in order that guests can see you on the wall opposite. Do not forget, he supposedly created your portrait in Venice.'

Signor Collina was not a man I wished to see with his wandering eyes and lewd comments. We had an obligation to provide evidence of my fictional marriage, and it was not in Lady Cordelia's nature to forget a detail enhancing our story. I had become a character in one of her books.

'A letter will be despatched to him tomorrow,' I said.

'Excellent. Let us hope the vile lech does not divulge our secret. He will visit Chipford Hall as well as Heybury House and Lord Tankford is desperate to commission a portrait, apparently.'

'If he betrays us, we shall be finished,' I said.

'Well, I paid him quite a sum in Venice to keep quiet.'

If anyone was going to let the cat out of the bag, it would be Signor Collina, despite Lady Cordelia's bribe.

On Monday evening, Mama arrived after three days of travelling. The moment Miller brought her into the drawing room, the shock of seeing how her weight had plummeted since we parted moved me to tears. The fight to hold them back was a challenge as I perused the skin on her face, stretched taut over her cheekbones, an outbreak of lines ageing her ten years. When embracing her skeletal frame, I feared the dowager had not cared for her sufficiently and guilt consumed me for being abroad. A mere stranger had taken precedence over my own kin. At least, now I was in a position to do everything in my power to aid her recovery.

'Mama, I am glad to see you,' I said.

She detached herself from our embrace and proceeded to cough for what seemed an eternity and I was dismayed to hear it reached the depths of her chest. Miller appeared with our refreshments and I handed her a glass of water.

'And I you, dear Philippa,' she said, after taking a sip, her voice a rasp.

Her hands tremored continuously, another development, and I gestured for her to sit down.

'You seem fatigued, Mama.'

'The journey has been long and hazardous with holes in the road and the constant threat of highwaymen if we did not reach

an inn before dusk. Anxiety resided in my chest throughout and I did not sleep well. My room in the first inn had a draught because the window would not shut properly and in the second inn, bugs resided in the bed and feasted on my feet.'

'Now you are here, I shall take care of you. A maid can attend to your feet before you retire.' I rang the bell and Catherine appeared.

'Catherine, would you mind soaking my mother's feet in water with a few drops of vinegar?'

'Certainly, Mrs Giles.'

'That would be welcome, to be sure. When will I meet my grandson?'

'In the morning. After Catherine has brought you breakfast, I shall take you to see him.'

Mama gripped Catherine's proffered arm.

'Thank you, my dear. I bid you goodnight.'

'Goodnight and sleep well, Mama.'

She hobbled like an elderly lady as they left the room, and I struggled to believe the change in her during the course of our time apart. The fear of her not being with us for much longer was very real. I went to my bedchamber and wrote in my journal, read one of my father's sermons on family and prayed the Lord would allow me more time with my mother, so I could redeem myself for neglecting her.

Mama and I waited for Mrs Harper to finish feeding Edward, while Mrs Smith looked on. Catherine had informed me that Mama returned most of her breakfast to the kitchen that morning and this concerned me somewhat.

'Dearest Mama, may I ask if you have been eating sufficiently?' I said.

'Food does not interest me as it once did, perhaps because old age has made digestion my nemesis.'

Less than a year earlier, she had boasted a curvaceous physique and her lack of appetite explained the loss of weight, but how long could she survive whilst eating so little?

Mrs Smith took Edward from Mrs Harper, rubbed his back until he belched and brought him over.

'My weakened state renders me unable to hold my dear grandson, although to do so would bring me immense joy.'

Instead, Mrs Smith handed Edward to me and he began to cry. I rocked him, kissed his cheek and inhaled the fresh scent of his skin.

'It is all right, my darling child. This is your grandmama,' I said, using the soft voice reserved for him. Momentarily, he stopped crying and I lifted him up for Mama to see, supporting the back of his neck with my hand.

'Look how your son loves his mama. And he has your papa's eyes,' she said.

'Indeed, he does,' I said, uncomfortably aware of the irony of her comments.

The delight on her countenance as she allowed him to grip her finger with his tiny hand cemented my decision not to reveal the truth. Edward wriggled in my arms and burst into a wail of deafening volume and Mrs Smith took him back, cooing like a wood pigeon as she rocked him in her arms until he ceased crying.

'Let us move to the library where we can exchange stories from our time apart.'

My stories would be as heavily edited as my letters had been, as if she caught wind of my grand deception, it would damage any chance of a full recovery, to be sure.

Chapter Thirty-Seven

The next morning at six o'clock, my phone, placed in the pocket of my pyjama top, vibrated, prompting me to get out of the sofa bed, switch on the light and get dressed. My head throbbed and my stomach was sore. I folded up my nightclothes and put them in my suitcase then washed my face with a flannel, brushed my teeth, and dabbed foundation over blotchy patches and along the horrendous stripe, not that it made much difference. After closing the door quietly behind me, I headed to the breakfast room, suitcase in tow, my rucksack slung over one shoulder.

Uncle Pete and Aunt Patsy were plastered when they fell into the suite at two o'clock in the morning, waking me up. They'd talked and giggled for some time, raiding the mini-bar next to the sofa bed before disappearing into their room and closing the door. I took the precaution of putting in my emergency travel earplugs so as not to overhear anything embarrassing. But then my sore head kept me awake and I couldn't settle into a comfortable position with all my sunburnt parts. So I stared into the darkness, consumed by misery after the turn the day had taken, then must have fallen asleep for an hour or so before the alarm on my phone went off.

In the breakfast room, famished from having emptied my stomach the night before, I helped myself to a couple of biscuits from the cupboard.

Valentino appeared, back in his usual jeans and T-shirt and muttered, *'Buongiorno'*, before wheeling my suitcase to his white Fiat Uno. I climbed into the back seat and as we didn't have a language in common, I stared out of the window, feeling sorry for myself.

As we moved slowly up the drive, bumping in and out of potholes, things couldn't be more different from when I arrived, sitting alongside Jake, blown away by the beautiful scenery. The extreme beauty of the surroundings and azure sky somehow made my situation seem worse. I switched on my phone, skimming the screen out of habit, despite there being only one bar and no signal. No updates. Putting it away, I did my best to appreciate the scenery as we pulled onto the main road and headed for Perugia airport. We passed fields of sunflowers and farmhouses with rows of Cypress trees leading up to them and when Valentino sped around the blind corners, I closed my eyes, hoping to get home in one piece.

At the airport, I used my last Euros to buy a ham and mozzarella sandwich then went through customs and waited for my flight in the lounge by the gate. After boarding the plane, I switched my phone to flight mode and couldn't help shedding tears as we took off, my emotions stirred by the events of the past few days. I pulled a travel pack of tissues from my rucksack, dabbing my eyes. When we landed, I switched off flight mode and an email pinged into my inbox from Pimsy's.

Dear Rachel,

Our handwriting expert, Adam Moore would like to visit Chipford Hall on Tuesday, as we understand you will be there that day. Would you be able to show him the journals you mentioned, written by Earl Rupert? In the meantime, our Canaletto expert will visit Venice to study the companion painting and we shall contact you after this with our analysis.

All good wishes,
Randolph

Excited by this ray of hope, I replied while passengers got their luggage from the overhead lockers. First, I asked Randolph to send Adam to the staff entrance of Chipford Hall at eleven o'clock, and then I quickly emailed Mike to let him know.

After going through customs, and finding my way out of the airport, I took a coach to Oxford, then another to Bath. A regional bus took me to Chipford and I arrived at nine o'clock in the evening, shattered. As I let myself into the hallway leading to Jake's flat and lugged my suitcase up the steep staircase, I was ready for bed, but also so hungry. The Chinese takeaway opposite was shut, I couldn't face Peaches and Cream and there was nothing in the fridge, apart from a tub of margarine. The bread on the counter was mouldy and I grabbed a handful of crackers from the cupboard. With no milk for tea, I filled a glass with water and climbed into bed fully clothed. I texted Mum to say I was home and would be over in the morning.

Before switching off my phone, I couldn't help checking Facebook and saw Jake had been tagged by Penny in a selfie of them sitting on the terrace, her über-glamorous in a pair of ginormous sunglasses and he was smiling, but who knew if it was

genuine? Irritated, I switched off my phone and stared at the wall. He wouldn't be home for a few days and at least there was the weekend to get my belongings organised. The next day, it would be back to real life.

Passing traffic woke me the next morning, and the rumbling of my stomach reminded me I'd eaten nothing substantial since the sandwich at Perugia airport. I pulled on tracksuit bottoms and a sweatshirt and went downstairs to the bakery to buy a bacon baguette and coffee and sat on a stool by the window, tucking in. Although the cappuccino was not as good as those made by Maria, the crispy, salty bacon tasted like home. On leaving the bakery, I spotted JC through the window of Peaches and Cream having a meeting with Melanie. She hadn't contacted me since the end of my disastrous shift, and it was more than likely she was going to sack me.

Not ready to face either of them yet, I returned upstairs to sit on the sofa and finished my coffee as I checked my phone. The only update was a reply from Mum, saying, 'Okay'. There were no more taggings of Jake on Facebook, and I went to the verging-on-stalkerish trouble of checking Penny's Instagram account, but she'd added no new photos. The pink circle glowed around her profile photo to show she'd created an Instagram story, and I couldn't view the story because she'd be notified. When clicking back to Facebook, I saw Uncle Pete had created a photo album and tagged me and everyone present apart from Penny. I spotted myself sitting opposite her during our awful conversation. As if I needed a reminder. There was no way I'd be adding that photo to my timeline. Glancing at my watch, I expected JC's meeting with Melanie must be over and forced myself to call her.

'Hi, it's Rachel, back and ready for work,' I said, adopting a cheery voice.

'Rachel.' She paused. 'I'm sorry to tell you there is no work.'

'Right, I'll call back tomorrow.'

'There is no need.'

'Maybe the day after?'

'Nadia's sister, Clare, helped out in your absence and I've taken her on permanently as she always turns up on time and comes drama-free. Sorry, Rachel.'

'Do you think that's fair?' I said, trying it on in case she changed her mind.

'You can't expect to take a week off whenever you like, Rachel. Look, it's very busy and I don't have time to chat.' And she hung up before I could reply. My pointless trip to Tuscany had cost me my job. What would I do for money now?

Texting ahead, I made my way down the high street towards Ivy Cottage to see Mum as promised the night before. After letting myself in, I found her at the kitchen table, attempting a Sudoku puzzle in the paper.

'Hello, darling,' she said.

I leant down to kiss her on the cheek. 'How are you doing?'

'I've been better.' Her voice cracked and she burst into tears.

'Oh, Mum.' I joined her at the table and squeezed her arm. 'I'm so sorry about Malcolm.'

'I'm not bothered about him. It's just that I've been so lonely without any company. Are you moving back in?'

'Yes, tomorrow. I've lost my job.'

'How?'

I explained.

311

'You and me both. The gym's cancelled my Tuesday yoga class as I'm not meeting the minimum number of attendees, apparently.'

'Sorry to hear that.'

'They're trying to save money, now they have screens for virtual classes. How can a virtual teacher adjust someone so they're in the correct position?'

'What a pair we are,' I said.

'How about I make us a cheese toastie?'

'Sounds good.'

She got the sandwich maker out of the cupboard, and started to grate cheese into a pile on a chopping board. My phone vibrated in my pocket and I checked it to see a message from Jake.

'Are you home?'

What did he want? I would reply later.

Mum pressed the cheese between slices of bread. 'We'll be all right. We always are,' she said.

Were we? In the past week, I'd lost JC, Jake, my job and I was moving back in with my mum. All I needed now was for the painting not to be a real Canaletto. That would be the icing on the cake.

Chapter Thirty-Eight

The following Friday afternoon, Mrs Baxter and Rogers arrived at my new home in London, and I was delighted to see them. Mrs Jones showed them to their bedchambers and then Miller brought them to the red drawing room. The previous day, I had received a letter from Lady Cordelia to say Earl Rupert had declined to be Edward's godfather. After much consideration, he regretted he could not take on the role and she suspected Lady Eliza had exerted her influence. However, he asked Lady Cordelia to pass on his regards and to wish me well. At least, I was now at liberty to ask Rogers in person during his visit, and I would need to engineer an opportunity for us to be alone together.

'We were saddened to hear of the passing of your husband, Philippa,' Mrs Baxter said, 'but delighted to hear you have a son, and I for one cannot wait to meet him.'

'Thank you, Mrs Baxter. My news is indeed bittersweet.'

'Were you very much in love with your husband, for you married so hastily?' Mrs Baxter said.

At this moment, Miller brought in a tray of tea and scones, allowing me time to compose a response. I gestured behind me.

'As you can see from his portrait, painted by the distinguished Massimo Collina, Horatio was a fine-looking man and we were very much in love, despite only knowing each other a short time.'

'He was indeed handsome, Philippa,' Mrs Baxter said. 'That is a wonderful painting, and I can see why Collina is currently in demand by the aristocracy.'

'My husband wanted us to return to this house as a married couple, and thankfully he had already made arrangements for our return,' I said. 'Alas, it was not meant to be. Every day I pray to the Lord that he rests in peace.' Telling untruths to my friends produced feelings of discomfort and I endeavoured to change the subject.

After positioning the strainer in a cup, I picked up the teapot. 'Shall I pour?' They nodded simultaneously and I filled their cups. Mrs Baxter, ever the housekeeper, took charge of milk and sugar. I proffered the scones, sliced in two and lathered with clotted cream and strawberry jam and they both selected a half to put on their plates. 'You will find that the cream, brought here from...' A restless night, due to anxiety about Mama had momentarily made me forget my fictional life and I stopped myself from enthusing over the cream, churned by a milkmaid at Heybury House.

'From where?' Mrs Baxter said.

'I beg your pardon?'

'You were saying the cream was brought from where?'

Knocking over my cup as a distraction, spilling tea onto the trestle table, I rang my bell to summon Miller, who instantly appeared.

'You called, Mrs Giles?'

'Ah, Miller, I have had a silly accident. Please may you arrange for this mess to be cleared up and bring another cup and saucer?'

'Certainly.'

He left the room and returned with Andrew, who proceeded to soak up the spillage with a cloth before replacing my cup and saucer. Sighing, I said, 'I apologise for my clumsiness,' and proceeded to pour myself another cup of tea.

'How are you finding motherhood?' Rogers said, my saviour.

'With the assistance of a nanny and wet nurse, I am rather fortunate to find it a rewarding experience,' I said.

Rogers selected another half scone.

'Still, raising a child, even with assistance, is a responsibility.'

'My life has changed beyond recognition, but I consider myself blessed. How is daily life at Chipford Hall?'

They exchanged a look.

'The presence of his lordship's new wife has greatly altered Chipford Hall,' Mrs Baxter said. This did not surprise me.

'Oh?'

'Well, she does not have quite the same…charisma as his lordship,' Mrs Baxter said, diplomatically.

'To be frank, the way her ladyship addresses the servants is abominable and she has brought in a handful of her former employees. They have rocked the boat somewhat and a number of lower servants have left already. More are likely to follow,' Rogers said.

'Will you both stay?'

'My loyalty remains with his lordship, until he no longer requires my assistance,' Rogers said.

'And mine goes back many years, working for His Grace,' Mrs Baxter said. 'Abandoning the Chipford family is not an option, and next spring, I shall be retiring.'

'One more winter,' I said.

'Indeed, winters in the country are a challenge. Next spring, I shall move into my sister's house in Bath. Recently widowed, she will appreciate the company.'

'Speaking of Bath, Mr Rogers, may I ask if you have visited Maud recently?'

'I regret to say that I have not been in contact with the girl,' he said.

'Her recent correspondence implied she is struggling financially because her mother is unwell, leaving her unable to work. If it is no trouble, might I ask you to take her an envelope of money on my behalf?'

'You are kind to her. I shall pass through her village next week when visiting my aunt,' he said.

'Thank you, Mr Rogers.'

'That is an honourable gesture.' Mrs Baxter said. 'What a pity we are unable to help care for her child.'

'If only I were in a position to make a difference to Maud's life,' I said. 'Now, would you both like to accompany me on a walk? Or do you need to rest, Mrs Baxter?' I hoped she would retire to her bedchamber in order for me to spend time alone with Rogers.

'Would you mind terribly if I had a lie down, Philippa?'

'Of course not.'

'And you, Mr Rogers? We can accompany Edward and his nanny, Mrs Smith.'

'I would be delighted to join you, Mrs Giles.'

'Then I shall meet you in half an hour by the front door.'

316

I rang the bell and Miller appeared.

'Please would you arrange for Mrs Jones to take Mrs Baxter to her room, Miller.'

'Yes, Mrs Giles.'

'Do let my housekeeper know if you need anything at all, Mrs Baxter.'

'Thank you, my dear.'

We followed Mrs Smith who carried Edward in his sling as they circled the lake, partially covered with ice, and for a moment the incident at Chipford Hall came to the forefront of my mind, but I swished it away, determined to forget that dreadful day. Small piles of snow from a recent fall lined the paths and clung to the trees, and although the temperature was exceptionally low, the sky was a deep blue and the sun shone so brightly, I squinted in order to see ahead, treading carefully in order to avoid the occasional patch of ice on the path.

'I wonder if you might consider being Edward's godfather, Mr Rogers?'

He stopped walking and cast me a surprised look, but at the same time the corners of his mouth lifted into a smile. At that moment, it struck me that he knew Lady Cordelia had asked Earl Rupert the same question the previous week. He would assume he was my second choice and there was no way to explain Lady Cordelia's hold over me. All I could do was hope he would forgive me for asking his master before him. We recommenced walking in order to catch up with Mrs Smith who had stopped ahead to feed the ducks.

'It would be an honour to undertake such a task for someone I view as a dear friend.'

317

His words warmed my heart and Edward would be in safe hands. The state of Lady Cordelia's mind concerned me and her son would be lucky to have a solid, reliable man in his life. Now I could plan the christening.

'Thank you for accepting and for your kind words, Mr Rogers.'

'Anything for you, Mrs Giles,' he said.

'Edward and I are most grateful.' Anxious to change the subject, to distract him from my supposed error of judgement, I said, 'How is your father?'

Rogers shook his head.

'He was encouraged to resign as a footman at Seeley House because he made mistakes. His memory does not serve him well, and his hands frequently shake. However, his lordship has provided me with a small cottage where my father can reside in comfort during his final years, or I fear months. If need be, he can move to Bath and live with his sister, my aunt during his remaining days.'

'That is kind of his lordship,' I said.

'Indeed he can be kind when he sets his mind to it,' Rogers said. 'I am sorry he declined when Lady Cordelia asked him to be godfather, Mrs Giles.'

So he did know.

'Mr Rogers, I would not want you to think that…'

'There is no need to explain. I understand your reasons.'

Should I tell him Lady Cordelia had offered to have a word with the earl due to her elevated position as a favour to a friend? I did not wish to get myself into deeper water, and so opted to say nothing.

We caught up with Mrs Smith who passed me a slice of stale bread, pulled from a paper bag. I thanked her and tore off pieces

to throw at the ducks as they gathered at our feet, fighting to gobble them up as they quacked and flapped their wings. She passed Rogers a slice and he joined me in feeding them. Sharing the activity with him lifted my spirits.

'Life's small pleasures bring immense joy,' Rogers said.

'I agree. Seeing a parent decline breaks one's heart, does it not? My mother's health deteriorated rapidly while I was abroad, and now she resides with me. Today, she is resting in her room as she struggles to conquer a persistent cough.'

He turned to look at me, concern in his eyes.

'I am sorry to hear that, but expect she is in good hands in your home. My mother's death was sudden, and at the time I wished there had been more time to absorb the news of her impending departure. But now, to have notice of my father's departure wounds the heart more than one can imagine. To see the skin drop from his face and his knees wobble when he walks and to hear his voice shake, to repeat the same replies to the same questions over and over as his memory plays tricks. All of this brings me great sadness.'

'Mr Rogers, I am so sorry. It is a consolation at least to know you are undergoing a similar experience. Mama's sudden decline has been shocking and I fear she will not survive another winter.'

'It is a challenging season for a person of advanced years.'

'I cannot help feeling guilty for being abroad when I should have been caring for her.'

'You can be forgiven for not foreseeing the current situation, and I forbid you to feel an ounce of guilt.' We exchanged a smile. 'How good it is to see you again, Mrs Giles,' he said.

As he threw me a fixed look, I sensed love in his eyes, or was I mistaken? If this were true, it would be inappropriate to make

his feelings known while I was so recently widowed. Did I love him? Or were we merely friends who confided in each other?

'I always enjoy your company, Mr Rogers,' I said.

Mrs Smith passed us more slices of bread and as we broke them into pieces, we ceased to converse, for in the company of Rogers there was no obligation to fill the air with needless words. My dear friend lifted the clouds from my mind that day, as not only had he agreed to be a rock for Edward to lean on, but also when my mother passed away, his letters and visits would be a comfort. And I in turn would provide the same support for him when his father departed.

Winter, as always was a season to be endured. Christmas came and we decorated the house with holly, ivy and mistletoe collected from the park by the servants. Mrs Larkin made an excellent plum pudding and Lady Cordelia sent a joint of beef from Heybury House big enough for Mama, myself and the servants to share. Despite being in poor health, Mama made an effort to play cards and to sing songs while I played the pianoforte in the red drawing room. She gifted me a diamond brooch given to her by Papa, and for the first time in my life, I was able to purchase her something truly special and I gave her a pair of pearl earrings which she was delighted with. They did not leave her ears for days. As we progressed through January and February we were blessed with small increments of light each day, allowing us to take walks with Edward a little later in the afternoon, and to rely less on candles at home. And soon life seemed less bleak with the promise of spring.

However, Mama's cough showed no signs of abating, and my only hope was that warmer temperatures would aid her recovery. I interviewed several lady's maids, to no avail, with not one of

them appearing to be responsible or kind enough to serve my dear mother. When selecting this member of staff, admittedly, I took more care than usual and an idea sprang to mind on receiving a letter from Maud. Her mother, sadly, had passed away and as the rent was long overdue, her landlord had given her one week to find the money with the threat of eviction. She had secured work as a maid in a country house in Wales and was on the cusp of accepting an offer from her cousin to adopt Jane.

The thought of Maud being forced to give up her daughter compelled me to take action. Here was an opportunity to help Mama as well as Maud, who would be entirely suitable as her lady's maid. There was plenty of space in the house for Maud and Jane, who would be company for Edward. They were no doubt half-siblings, although I could not divulge this information to anyone. Rather pleased with myself, I wrote to Maud with my suggestion, saying that if she accepted my offer, I would despatch a coach to collect her and Jane immediately. She accepted by return of post and by the end of that week she and her daughter had moved into our home.

Each day, I visited St Mary's church at the end of the road to pray or attend a service and additionally, I had meetings with the vicar to discuss details of the christening. Telling him I was the widow of a fictional man as well as Edward's mother made me loathe myself, but the thought of Edward growing up in the convent reassured me I had no choice. Invitations were despatched to my brothers and their wives as well as Lady Cordelia, Mrs Baxter and Rogers. All of my servants and Mama would attend and it promised to be a special day spent with dearest friends and family.

In the first week of March, Eloise and I went to Signor Collina's studio in Mayfair. We had selected a green dress from my trousseau, a respite from wearing mourning dress and an emerald necklace to match, borrowed from Lady Cordelia's jewellery collection. Eloise had an extensive knowledge of fashion, having worked as lady's maid for a French countess and her judgement was to be trusted. Gabriella answered the door and led us upstairs to a vast room with floor to ceiling windows overlooking the chimney tops of London. Signor Collina stood up from behind his easel and kissed my hand, a move I tolerated because of what he was doing for me.

'Welcome, Miss Elliott.' I had no intention of informing him of my new name. 'It gives me pleasure to see you again.'

'Good morning, Signor Collina. I trust you are enjoying your time in England?'

'Certainly. Lord Willoughby has arranged a great deal of work for me, although I miss Italian food and will be relieved to return to Venice in June.'

'Oh yes, I imagine.'

'Now, there is no time to waste. Do take your position over there and let us begin.' He gestured towards a chaise longue and I did as he suggested. Eloise stood awkwardly as he looked her up and down before approaching to kiss her hand.

'And who may I ask is this beautiful woman?' he said.

'My lady's maid, Eloise, who selected my dress for the occasion.'

'What wonderful taste she has,' he said, his eyes fixed on her ample bosom.

'Her knowledge of fashion is extensive as she used to be employed by a French countess.'

'Evidently.'

My imagination ran away with me and I fabricated a story to protect Eloise.

'It is a pity she is betrothed, and soon I shall have to find a replacement.'

Eloise cast me a glance, acknowledging her gratitude.

'A pity, indeed.'

Sighing, he dismissed her to the back of the room with a wave of his hand and she sat down. After repositioning his easel and stool, he stood in front of me, wielding his palette, mixing the colours blue and yellow to produce a shade of green to match my dress. This took some time and I did my best to remain patient. Putting down the palette, he squatted and re-arranged the way my dress fell onto the floor and pulled strands from my French pleat, occasionally brushing my face with his hand—intentionally, I gathered. Using his fingers, he applied rouge to my cheeks and pomade to my lips.

Such intimacy made me uncomfortable, but being his subject fulfilled an obligation, so I inhaled softly and endured the procedure. And then he began. Remaining still without a book, quill, or conversation to hand was more of a challenge than anticipated. The only way to entertain myself was with my mind and I allowed thoughts to wander to Mama's health, to Edward's christening, to my strengthened bond with Rogers, to Lady Cordelia's spirits. And ultimately to the fear that our grand deception would be revealed. Eloise, hands resting neatly in her lap, looked out of the window. I did not have the same option as Signor Collina asked me to tilt my head slightly in the opposite direction, facing a whitewashed wall, with not even a painting to study.

We continued thus every day for a week and when he announced the end of our final day together, I was relieved. But then he said, 'Miss Elliott, creating this work of art has made me appreciate your beauty.'

'Oh?' was all I could muster.

He approached me.

'Do you think we might acquaint ourselves further?'

A wave of nausea passed through my stomach as he unpinned my hair until it fell around my shoulders and stroked my locks as if I were a cat. Then he ran a finger along my cheekbone, down to my mouth where he followed the outline of my lips. His actions took me by surprise and I looked over at Eloise, whose face remained without expression.

'Is it necessary to touch me in this way, especially now I no longer need to sit for you?'

'An artist must know his subject to produce his finest work, Miss Elliott.'

'Surely we are sufficiently acquainted for you to complete your task?'

'Do not forget, I know information about you and your acquaintance, Lady Heybury.'

'I beg your pardon?'

'You are both fortunate that until now, I have chosen not to reveal your secret from Venice.'

Gasping at the nerve of this man, I stood up.

'Are you attempting to lure me into conducting intimate relations with you?'

I shook my head as he placed the hairpins in my hand.

'If we become better acquainted, perhaps I will be less likely to tell all about you and Lady Heybury, a veritable sinner, when I grace the dining rooms of England's finest gentry. Lord

Willoughby has arranged for me to attend several events before returning to Venice. Who knows what I might say after consuming a few glasses of wine?'

'Please rearrange my hair, Eloise,' I said.

She came over, pulled a comb from her pocket and set about pinning my locks back onto my head.

'Signor Collina, I am grateful to you for completing this portrait, however I refuse to be blackmailed. Conducting a liaison with you is not a possibility. Furthermore, I recall my acquaintance paying you a vast sum of money to keep your lips firmly sealed.'

He raised his arms in the air. 'What money is it you refer to?'

'You forget I was present at your house in Venice when she pressed an envelope into those very hands.'

'Sometimes memories play tricks on us, do they not? Perhaps she might have a receipt for such a payment?'

'A receipt? Of course not. Why would she risk…?' He took me for a fool. 'Eloise, please leave my hair as it is. We must depart, at once.' She put the comb away and opened the door.

'It is a pity we have to part like this, but perhaps you might reconsider once you have calmed down?' he said.

'Calmed down? You jest, do you not?' I said.

He rang his bell and Gabriella appeared.

'When you have come to your senses, you will be in a better position to consider your limited options. Please show out Miss Elliott, or should I say, Mrs Giles?' he said with a wink. How did he know of the change to my name? 'You have one week to make your decision. After that you must return, in person to collect the portrait, with your payment, and advise me of your answer.'

I descended the stairs, closely followed by Eloise, without saying goodbye, stuck in a quandary as I needed that portrait. He

did not call after me, I supposed because he had the upper hand. Oh, the power he had to destroy our lives. My only option was to write to Lady Cordelia, informing her of our exchange. Ever the optimist, perhaps she could find a solution to this problem. However, creating a fictional character would do nothing to help us this time. In fact, by doing that we had produced this very situation.

Eloise and I walked home in silence and upon returning, I went straight to my writing table in the library and asked Miller to bring me a jug of water.

A week later, I returned to Signor Collina's house with Lady Cordelia. In her reply to my letter she had insisted on accompanying me.

'Good afternoon, Mrs Giles, and your ladyship. What a pleasure. I was not expecting to see you as well.'

'That is because I wanted my presence to be a surprise, Signor Collina.'

Concern plastered on his countenance, he gestured towards the chaise longue and performed a perfunctory bow. Clearly, he was more afraid of Lady Cordelia than of me.

'Please do take a seat, your ladyship, and Mrs Giles.'

His use of my new name unnerved me and I endeavoured to remain calm for both our sakes.

'Where is the portrait?' Lady Cordelia said.

He approached the easel and lifted the velvet sheet to produce a most excellent portrait and I was relieved he had not used our conflict against me.

'That is a good likeness, to be sure,' Lady Cordelia said.

'You are pleased, Mrs Giles?'

'You have captured me well. Thank you, Signor Collina,' I said.

'Now, there is the matter of your fee.' Lady Cordelia handed him an envelope.

'Thank you,' he said.

'Included in that fee is the second instalment of the money I paid you in Venice,' she said.

A wave of confusion crossed his face, then he nodded. 'Ah, yes,' he said.

'With that payment, we shall have an understanding that no further conversations are to take place regarding what you raised with Mrs Giles last week. Is that clear, Signor Collina?'

'Most clear, your ladyship.'

'Simply, there will be no more attempts at extortion,' she said.

'That is enough.' He dismissed her with a wave of his hand.

He rang his bell. Gabriella appeared and they spoke in Italian. She went away, and a few minutes later two footmen appeared, wearing white gloves.

'They will follow you with the painting,' he said.

We descended the stairs, and although comforted by Lady Cordelia's intervention, I wasn't certain Signor Collina could be trusted, despite her payment. What was to stop him from asking for a third instalment or a fourth?

Chapter Thirty-Nine

By the end of Sunday, I'd moved my belongings back into Ivy Cottage. At least now there was Wi-Fi, thanks to Malcolm, although I expected he'd stop paying for it at the end of the month. Over the weekend, Jake had found me on Facebook, through Uncle Pete's photo album, I presumed and sent me a friend request. Without accepting, I had a look at his profile for updates but he hadn't posted anything new. On Monday, he texted,

Are we OK?

The aggro accompanying Jake lately had become too much and I didn't reply. Moving out of his flat would give me a fresh start, and that morning, I had my meeting at Chipford Hall with Adam Moore, the handwriting expert from Pimsy's. I pictured him being around sixty-five years old with frizzy grey hair and a beard, dressed in tweed. He was bound to be an academic type, absorbed by the world of history and art.

I showered and dressed and drove there with half an hour spare to get a coffee in the servants' hall before he arrived. Edith and Betty were established at the table with lemon drizzle cake and cups of tea. Daphne wrote in a notebook at the end of the

table. Harry and Jack were in the kitchen pressing teabags into cups of hot water and I grabbed a coffee from the filter jug sitting on the machine.

'Morning, all,' I said, approaching the table in the servants' hall.

Edith and Betty looked up.

'Hello dear, how are you?' Edith said.

'Not bad, thanks.'

Daphne looked up and smiled.

'Where have you been hiding, Rachel? I missed you last week.'

'In Italy.'

'That sounds wonderful,' Betty said.

'Yes, it was,' I lied in an upbeat voice. Why bore them with the state of my love life?

'Any progress with the painting?' Daphne said.

'There's a handwriting expert coming today. He'll compare the writing on the note I found with the painting to that in the earl's journals.'

'What will that do then?' Betty said.

'Well, it will help with provenance, enabling Pimsy's to give it a value if it's an original because it links the earl to the painting. And then we have the inventory, found by Daphne saying he brought the painting from Venice, along with its companion.'

Mike entered the room. 'Right everyone, can you get to your posts, please.'

He stepped aside to reveal a nice-looking bloke around my age, dressed in a charcoal suit and pale-blue shirt, open at the neck. Not what I expected, at all. Edith nudged Betty who looked up and they exchanged a glance.

'There's someone here to see you, Rachel,' Mike said.

I stood up and the bloke, presumably Adam, stepped forwards to shake my hand.

'You must be Adam Moore,' I said.

'Hello, Rachel. Yes, I am. Delighted to meet you.'

He was straight out of the TV programme, *Made in Chelsea*.

'Thanks for coming all this way,' I said.

'That's all right. I'm combining this with a visit to my grandmother, who's in a care home nearby, so I'm staying overnight in Chipford.'

'Oh right. Where are you staying?'

'The Old Bear. Do you know it?'

'Yes, it's a nice pub.'

'Let's get on with it then, folks, as I have things to do,' Mike said.

Adam, clearly a bit of a gent, gestured for me to go first as we followed Mike down the hall. Mike opened the glass bookcase and, directed by me, retrieved one of the earl's earlier journals for Adam and the last journal for me.

'Rachel will set you up on a desk, so I'll leave you both to it,' Mike said.

'Thank you,' Adam said.

As Mike left, I cleared the photo frames from a Georgian writing table in the corner, moving them to a nearby shelf. Adam had brought the note from Pimsy's and retrieved the envelope from the inside pocket of his jacket. He unfolded the note, and placed it in front of him, with the earl's journal beside it.

'I'll be over here.' I pointed to the writing table at the opposite end of the room.

With one last journal to get through, I hoped to find answers on Philippa's connection to the earl and to Ivy Cottage. We sat there for a couple of hours in silence and I turned each page,

searching for a clue. Eventually, I reached an intriguing paragraph:

Last weekend when we visited Heybury House, Lady Cordelia asked me, on behalf of Philippa if I would be godfather to Philippa's son, Edward. Although I wished to help the girl who saved my sister from the lake, I could not accept due to the prospect of my wife's protestations; and so I reluctantly declined. Afterwards, I regretted my decision, and Rogers informed me he has been asked in my stead. He seemed delighted to be given such an honour, despite being her second choice and if I were not mistaken, he is rather fond of Mrs Giles.

I photographed the paragraph with my phone to add to my research folder as it linked Philippa to the earl, helping with the provenance of the painting, especially if the handwriting matched. But I still needed a way to connect her to Ivy Cottage and hopefully Uncle Pete would get to the bottom of that. A visit to Heybury House was in order, to see if information on Lady Cordelia could give any clues about Philippa's life. When I got home, I'd google the website to see if there was any information on there as well.

Adam and I sat quietly for a further half hour, with him taking photos of the journal until Daphne wandered in with a tour party, then she moved to the next room. When random visitors came in not long after that, it was down to me to explain the history of the room. I was in the middle of explaining the gold rug was a replica to a group of ladies from the local Women's Institute when Jake appeared behind them. While he stood there, I finished showing them around and thankfully knew my subject so well I was able to reel off the usual stuff about various objects whilst wondering

why on earth Jake had turned up out of the blue and how to deal with him in front of Adam. This was going to be awkward, as all situations involving him seem to be lately. The ladies, satisfied with the information given moved to the next room.

'What are you doing here?' I said to Jake. Adam looked up, and when I caught his eye, he looked back down again.

'You haven't replied to my texts, or accepted my Facebook friend request. And I just got back to the flat to find you've moved out. What's going on?'

'This isn't the time or the place, Jake,' I said in a low voice. 'Tuscany was a disaster, and now I've lost my job at Peaches and Cream because I took those days off, and for what? I didn't even go to Venice in the end.'

'But I explained I'd deal with Penny in London. Didn't you believe me?'

'I don't know what to believe anymore. All the things she said made me doubt you.'

He sighed. 'What did she say?'

'Don't you know?'

'No, that's why I'm asking.'

'She implied you only want to know me because of the painting and that's why you've been so nice to me.'

'You think I want money if the painting's an original?'

'That's what Penny said.'

'How can you believe her?'

'What am I supposed to think? She said you'd use the money to renovate your flat before she moves in.' He shook his head and looked at the floor. 'Look,' I said, 'it's all been a bit stressful and my mum's a wreck from Malcolm dumping her, and I could do with a break from all this aggro.'

332

'Sorry to hear about your mum, although I think she's probably better off without Malcolm, from what you've told me. But how could you believe Penny over me?'

'As soon as you knew she was coming to Tuscany, you went off to paint that outhouse with your dad.'

'In all fairness, Dad wanted to talk about the art gallery. But I am sorry for leaving you on your own like that.'

'You should be. I felt like an idiot.'

'I was the idiot. Please believe me when I say I like you, Rachel. In fact, I think I love you.'

Did he mean this, or was it all part of his scheme?

'I don't know what to say, Jake. Can we talk later? I've got this man here from Pimsy's.' I gestured in the direction of Adam, whose tipped head implied he was listening while pretending not to. 'He's here to check the earl's handwriting, and this exchange is a bit embarrassing.'

'Okay. I'll call you.'

'All right.'

He left the room, leaving me dumbfounded. Did he love me, really? And how did I feel about him? I was so confused and didn't know what to believe anymore.

'I'm sorry about that, Adam,' I said.

'No worries. Man trouble?'

I shrugged, thinking he was overstepping a little, but he seemed to mean well.

'How are you getting on?'

'It looks like a match.'

'So, are you done?'

'For the moment, yes. I'll sort out the paperwork on return to the office.'

This was good news.

'Ah, right. Well, thanks for coming all this way.'

'I'm off to visit my grandmother now, but would you like to meet for a drink tonight?'

'Whereabouts?'

'The Old Bear, where I'm staying?'

'I know it well.'

'See you at around seven o'clock?'

'Perfect.'

He said goodbye, leaving me at the writing table but all I could do was picture the moment when Jake said he loved me, wondering if it was true or not.

That evening, I went to meet Adam. Mum was moping around at home and with no job, it was good to have a reason to leave the house, at least. My bank had texted to say I'd re-entered my overdraft and I borrowed twenty quid from Mum, hoping it wouldn't be too expensive an evening. Adam was sitting at a table in the corner when I arrived and he stood up to greet me, kissing me on the cheek. That afternoon on the drive back from Chipford Hall, I'd made the decision not to pursue anything with Jake as all he seemed to bring was drama and I didn't need any more of that in my life. Hopefully, he'd go back to London eventually.

'Can I get you a drink?' Adam said.

'Yes please, a vodka and tonic, thanks.'

He approached the bar and I took the booth seat facing the room, pulling off my jacket and placing it beside me. A few minutes later, he returned with drinks.

'So, what do you have left to do with the painting now?' he said.

'I'm waiting for the Canaletto expert to compare the companion painting in Venice to mine. And my uncle's working on the family tree with a genealogist, to help with the provenance. We think Philippa in the note may be an ancestor as my mum's house has been passed down generations along with a tailor's business.'

He raised his beer glass. 'All sounds promising, good luck.'

'Thank you.'

He studied me with his brown eyes.

'So, let's talk about you.'

'What about me?' I said, suddenly flustered and unsure whether I was ready for another liaison after JC and Jake, but at the same time craving attention and affection as a distraction from all that had gone on.

'Tell me about yourself.'

This was first date territory and an information exchange seemed mundane.

'Why don't we start with you?' I said.

'All right. I'm from Wimbledon and grew up there until the age of thirteen. Then I was packed off to boarding school like every other male member of the Moore family.'

'How was that?'

'Character building, but apparently boarding schools are better these days. You even get your own room, I heard. My nephew does anyway.'

'How did you become a handwriting expert?'

'My grandfather was into antiques. He used to take me to auctions in school holidays, and I grew fond of the world of history and art.'

'That sounds wonderful,' I said.

'Yes, he had a sports car and it was a bit like that programme, *Antiques Road Trip*. Do you know it?'

'Yes, I don't mind a programme like that, as well as the *Antiques Roadshow*.'

Adam Moore was all right, and I would kiss him if he made a move, and might even stay in his room upstairs. Was that so wrong? He bought more drinks and I got a couple with mum's twenty quid, and then the door opened and Jake walked in with some bloke, I guessed an old school friend. He didn't see me as he headed for the bar and I pretended not to have seen him. Then, the door opened again and who should walk in but JC? This was not a great situation to be in. Jake and his companion took a table that I'd have to pass to reach the front or back door and JC stood at the bar with Ralph, so I was stuck in this corner of the room for who knew how long? Adam went to the gents and I pulled out my phone and tapped away, keeping my head down, hoping neither JC nor Jake would spot me. But then, I sensed someone standing over me and looked up to see Jake.

'Hi,' he said.

'Hi,' I said.

'So?'

'So, what?'

'I'm sorry about turning up at Chipford Hall like that, but I had to see you.'

'I don't think we should see each other anymore, Jake.'

'Are you serious?'

'Yes. Don't you think it should be easier than this?'

'Perhaps, but it isn't always at the beginning, especially when there are other relationships to sort out. I finished with Penny for good.'

'But still, I don't know if I can trust you.'

'It hurts, Rachel, that you'd believe Penny over me.'

I shrugged, and Adam came back. How awkward. I looked over Jake's shoulder and he turned round and shook Adam's hand.

'Hello, again,' Adam said, exasperation showing in his voice.

'Don't worry, she's all yours,' Jake said.

I watched Jake walk away, thinking perhaps I'd been too hasty. Should I give him another chance? All I could do for now was focus on Adam. Despite his looks, we had little chemistry and he was perfect one-night-stand material.

Jake went back to his table and talked to his companion, throwing me the odd glance and then I looked over at JC who seemed to be knocking back tequilas at the bar with Ralph and I leant forwards.

'Why don't you show me your room?' I said.

Adam beamed.

'Let's go,' he said before downing his pint.

We stood up and I picked up my jacket, following him towards the bar, past Jake who looked as though he couldn't be in more pain when spotting us, and then we passed JC who said, 'Rachel, how are you?' and I ignored him and carried on walking, towards the back of the room, outside and across the passageway to the residential side of the pub. Adam led me upstairs and to his room where he instantly took me in his arms and kissed me. There was a knock at the door. We ignored it, but whoever it was persisted. Adam pulled away from me.

'It's probably a member of staff. I'll tell them to go away.'

He opened the door and I heard a familiar voice.

'Is Rachel in there with you?' It was Jake.

'What do you care?'

'Look, she's only trying to get back at me.'

337

'Hasn't she already told you twice today to leave her alone?'

'Yes, but...'

'Well, why don't you do that, then? You're verging on stalking territory, mate.'

Adam firmly closed the door, and Jake knocked again.

'Don't call me "mate". Rachel, I know you're in there. What are you doing with this stuck-up pillock?' He stomped down the stairs and that was it, he'd gone.

'Sorry about that,' I said, trying my best to sound upbeat.

Adam sighed and raised his eyebrows, and even though Jake was no longer there, the moment was lost. I picked up my jacket and pushed my arms through its sleeves.

'I'd better go.'

'Good idea,' he said.

'Sorry about all this.'

'What can I say?'

'I hope this won't impact your handwriting analysis?'

'What? Don't be ridiculous. That wouldn't be very professional of me.'

I left The Old Bear to go home to Mum. On the one hand, I was furious with Jake, but on the other, his interruption had given me a minute to consider what I was doing. It was time to stop having flings with random blokes to give myself a confidence boost. If I couldn't be in a relationship with someone who treated me well, I'd stay on my own until the right man came along. Adam seemed decent enough and his ego was probably dented a little bit, but I was certain he would have women throwing themselves at him all of the time.

As I walked down the high street, I wondered if Jake had meant everything he said that day. There wasn't anyone I could ask about his character locally and it was all down to me to decide

whether he was the real deal. It would be best to keep my distance for now as I needed to be there for mum and to get another job, as well as get to the bottom of finding out the provenance of the painting. The next day, I would go to Heybury House to find out more about Lady Cordelia, and her connection to the earl and to Philippa. Once I would have asked Jake to accompany me, but now I would have to go alone.

Chapter Forty

The day of the christening came in May and from my bedchamber, I looked out of the window at the pink and purple rhododendron bushes in my garden, bursting with clusters of flowers so vibrant and puffy it was as if the Lord had decorated them especially for us. Lady Cordelia had travelled from Surrey the night before and Mrs Baxter and Rogers stayed at the earl's London residence. Thomas was at sea and Mary had declined her invitation due to suffering from influenza, but my other brother Matthew and his wife, Enid came. Guests assembled in the red drawing room where Miller attended to beverages, and then the entourage of family members and servants, led by me and Cordelia followed Mrs Harper, who carried Edward in a sling towards St Mary's church.

'I am rather nervous, dear Philippa,' Lady Cordelia said quietly into my ear. Her shoulders drooped as if she carried the weight of the earth upon them and I feared she might let the cat out of the bag before Signor Collina had the opportunity to do so.

'You have no reason to be, Cordelia,' I said, doing my best to smile, despite my own state of mind. We were deceiving the Lord with our lies, but I prompted myself to think of the situation as a whole once again.

In the church, Lady Cordelia, Gertrude, Rogers and I sat together at the front with Mama, Maud and Jane in the pews on the other side of the aisle. We sang hymns and the vicar read psalm 89, with one sentence resonating.

I will maintain my love to him forever, and my covenant with him will never fail.

When I turned to Lady Cordelia, she was dabbing her eyes with a handkerchief. We approached the front of the church with Rogers and the vicar marked the sign of a cross on Edward's forehead before pouring water over it. Dear Edward let out a scream of the highest pitch, but settled down once I returned him to the safety of Mrs Harper's arms, and before long we were back at the house eating luncheon in the dining room. Mrs Larkin cooked meats brought from Heybury House and the occasion was an enjoyable one. Once Lady Cordelia had a glass of wine in her hand, she seemed to relax a little and made the effort to converse with Matthew and Enid. After luncheon, we retired to the red drawing room for tea, then everyone left and I retired to my bedchamber early, exhausted but relieved the day had been a success.

When Lady Cordelia returned to Heybury House, she wrote to me once again. Her letters had become more erratic and her state of mind preoccupied me.

My husband's health has deteriorated further and I fear it is my fault for committing adultery and giving birth to an illegitimate child. The Lord is rightly punishing me. The baron can no longer leave the house or take part in his

favourite pastimes: hunting and gambling. I am grateful at
least that he cannot continue with the latter, however.

My heart broke for her and I spent a day mulling over my reply, understanding her plight and suggesting she visit Edward to ease her suffering. I wrote,

I can assure you the world is a better place with Edward here
to make us smile.

With the warmth brought by spring, Mama's health improved somewhat and she coughed less frequently. I hoped she would live to see another year, at least, although I dreaded winter, responsible for the demise of elderly people everywhere. In the meantime, I endeavoured to enjoy every moment of her company.

Rogers wrote to say he and the earl would return to Venice in July to purchase more antiquities for Chipford Hall. The earl had commissioned a portrait by Signor Collina, who would have returned from London and this concerned me. We were still not rid of the threat this man held over us and the news kept me awake at night. I wrote to inform Lady Cordelia, who already knew of the tour. She agreed Signor Collina remained a problem and jested (I hoped) that we should employ a thug to do him in, adding that her father was acquainted with several men of that ilk. I laughed to myself, although a part of me worried she might be serious.

As spring became summer, then autumn, I watched dear Edward grow. He reached the stage of being able to sit on a blanket on the floor and play with his wooden toy soldiers and I had taken

to sitting him on my knee and telling him stories. Once he began to crawl, poor Mrs Smith was obliged to watch him closely for his every waking moment. After that he used furniture to pull himself up off the floor and we watched with joy as he attempted to walk. On occasion, he played in the nursery with Jane, who liked to boss him around and tended to snatch toys from him, despite being younger. But then he would seize them right back. They would no doubt become firm friends in time.

In September, I received a letter from Lady Cordelia to say the baron had died, and she blamed herself entirely. He had been a mere twenty-five years old. I replied immediately to express my condolences and she wrote to thank me for my swift response. The funeral was to be organised under her close supervision then she would need to deal with the matter of his will.

She disclosed that Signor Collina had written to demand another payment to prevent him from divulging our secret to the earl. There was no way he could know the earl was Edward's father. However, his knowledge of the pregnancy was more than enough to destroy us. Signor Collina's associate in London, Luca Scarpa would collect the money from her and inform him of its receipt. Shocked, I replied after some contemplation to say all she could do was pay him. For what would we do if the earl found out? And what if Signor Collina told others in Lady Cordelia's circle? We would be a laughing stock and Edward's life would be ruined. She responded to Signor Collina to say that, once the baron's will had been settled, she would pay him, and hoped he would understand this would entail a short delay. I wondered whether the late payment would be an issue for such a ruthless man.

Rogers wrote from Venice, his letters a comfort, to ask after me and Edward. As his godfather, he took a keen interest in the boy's wellbeing. He spent much of his time at the studio with the

earl, who sat for the portrait and confessed he had not taken to Signor Collina, his words being,

He gossips with the earl in the manner of a disgruntled scullery maid and only his talent redeems him.

The next time I wrote to Lady Cordelia, I did not hear back for a few days. It was the week of the baron's funeral and she would be grieving. Writing again, I said I hoped the funeral had gone as well as it could, and received the reply of all replies.

It has been discovered this week that my husband was in more debt than one could imagine. Apparently, his gambling had become out of control in recent years, yet no one had thought to inform me, his wife. He owes every aristocrat in the land, and furthermore has invested heavily in the earl's uncle's sugar plantation in Antigua without my knowledge. It will take all the money I have to pay this off, and more. The sale of the bulk of our paintings and artefacts will barely make a dent in this mountain of debt. My father, who would usually be willing to assist is at sea and there is no way to contact him. Then there is the matter of our friend, Signor Collina. This is a fine mess, dear Philippa. Perhaps you and Edward might visit next month to lift my spirits?

I wrote back to say Edward and I would visit with Eloise, Mrs Harper and Mrs Smith in the first week of October, if that suited her and I would do everything in my power to support her during this trying time. Every night, I wrote in my journal about these problems, attempting to find answers, but they did not exist. If Luca Scarpa did not receive a payment before the earl returned

344

to England at the end of October, we might as well invite every town crier in the land to shake his bell and announce our secret.

It seemed the promise of payment had not been enough for Signor Collina because Rogers, my dear friend and ally wrote to me.

I am sorry to be the bearer of bad news, dear Mrs Giles, and this is a sensitive matter, but as your friend and godfather to Edward, I feel it is my duty to inform you of the following. By doing this, please be aware that I am betraying the trust of my master, and I have been pondering for days on how to proceed. I have chosen you over my employer, so there we are. The artist has informed my master of information I do not need to divulge here, as you will know what I refer to. Initially, the earl did not believe him, and so the artist advised my master to speak to the sisters at the convent. We visited today, and after receiving a significant payment from the earl, to pay for a repair to the church tower one of the nuns confirmed Collina's story. I am writing so you and Lady Cordelia can prepare yourselves for my master's return. Presently, he is furious, but once he has calmed down, I shall stress that you have been most noble, giving up your life to raise his son.

On a personal note, I must divulge that this revelation has brought me some relief. For I fear I misjudged you based on assumptions that should not have been made. And I am sorry for this.

What assumptions did Rogers refer to? When Lady Cordelia asked the earl to be godfather, had Rogers thought Edward was the result of a liaison between me and the earl before I departed

for Venice? How on earth should I respond to this letter? The earl knew, and how might he react on his return? And who else might Signor Collina inform? I doubted the earl would tell anyone, apart from Rogers. My quandary was whether to write to Lady Cordelia, or to wait until we visited. Her state of mind would be fragile while grieving for her husband and so I decided to wait. This would give me more time to find a way to tell her. Unable to confide in anyone, I wished I could speak to Mama who had always guided me until Edward's birth. What would she say if she discovered the truth? Edward brought joy to her life and she referred to him as 'My grandson' each day. The news would shatter her world.

A few days after receiving the gloomy letter from Lady Cordelia, Gertrude visited and Miller brought her into the drawing room.

'Good morning, Gertrude. Why are you here without your mistress?'

'I have some news, Mrs Giles.'

'Do sit down, and Miller can bring us some tea. Do you like ginger cake, dear? Mrs Larkin made some this morning.'

Gertrude sank into the chair opposite me, her face a shade of grey, and all instincts told me she was not the bearer of good news.

'No thank you. I have lost my appetite. Mrs Giles, your acquaintance and dear friend, Lady Cordelia Heybury is dead.'

'What?'

'She passed away two days ago, and considering your friendship, and all you have done for her regarding Edward, I thought it my duty to visit you in person rather than write to divulge this information.'

There were no words. Edward's mother was dead, and I had lost my friend as well as my financial provider. Who would

support me and Edward now, especially considering the baron's debts Lady Cordelia had inherited?

'How, may I ask, did she die?'

Gertrude inhaled, clearly devastated by the loss of her mistress.

'The doctor believes she took the mercury dispensed to her husband for his syphilis, as there were traces of it on the nightstand by her bed. And she left a note. My mistress had been in low spirits for some time, even before the baron's death, and when she learnt of his debt and how it would affect her life, with no idea when her father would return from his latest sea voyage—sometimes he is gone for years—she took the mercury with the intention of it doing her considerable harm; nay causing her death.'

'Oh, Gertrude, I am so sorry for your loss.'

'The servants do not know what to do and there is no one to advise us.'

Despite my devastation, it was my duty to seize control of the predicament Gertrude found herself in.

'Do not fret. It will be my duty to arrange her funeral and to ensure you are all paid and given references. I shall pack immediately and leave for Heybury House first thing in the morning.'

'Thank you, Mrs Giles. I am grateful for your assistance.'

'This will be a difficult time for all of us, and we must be strong for Edward. You must stay here tonight. In the meantime, may I ask you to go to her father's house in London to see if you can find news of his whereabouts?'

'Certainly, Mrs Giles.'

The following morning, I left for Heybury House, shortly after Gertrude, my emotions tearing at me. Since Gertrude had delivered the news, guilt consumed me because I had not stopped this tragic event from occurring. Could I have prevented Lady Cordelia's death? Should I have visited on receipt of the letter where she said she was in low spirits? I wrote in my journal, pouring my feelings into ink, so I could attempt to deal with them. Gertrude had visited Lady Cordelia's father's house the day before, returning to say there was no information of his whereabouts, and so we could not notify him of his daughter's death. This was a time to draw upon my strength, to pray to the Lord, to remember Papa and imagine what advice he would dispense.

On arrival at Heybury House, Gertrude greeted me and Mrs Watkins showed me to the bedchamber I'd stayed in before departing for Venice. Thankfully, I had kept all payments made to me by Lady Cordelia and all I could do was use this money to pay her funeral costs as well as her servants' wages. Gertrude provided me with a list of all employed, and I dismissed most of the servants immediately, giving them references, leaving me with Gertrude, the butler, the housekeeper, one footman, two scullery maids, a cook and a gardener. These remaining servants were given two weeks' notice, so they could look after the house while I arranged the funeral, and prepare food for the wake.

Gertrude showed me the note, left by Lady Cordelia.

Life has a way of breaking you and I am clearly broken, for I cannot continue in this manner. I am grateful to two people for their loyalty and kindness until the end, and their names are Gertrude, my lady's maid and Philippa Giles, my dear friend who I entrust to deal with any arrangements which

need to be made with regards to me and my estate. Any money left shall be passed to Philippa Giles, to use to raise Edward and I trust she will take care of Gertrude, ensuring she has another means of employment and an income. I request that Mrs Giles oversees the sale of Heybury House and my London property, and she will need to liaise with my attorney, Mr George Hayes in London with regards to all of the aforementioned business.

When Lady Cordelia and I discussed the terms of the agreement with regards to Edward in Venice, she had said her father would take care of us financially but who knew when he would return from his sea voyage? At least she was leaving everything to me so I could pass that money onto Edward, although, judging from her previous letter, it was unlikely there would be anything left, even after the sale of her properties and their contents.

I spent a week at Heybury House, organising the funeral, and informing Lady Cordelia's acquaintances of the news. And at her writing table, I found a letter.

Dear Cordelia,

I have discovered a matter which has shocked me. I only need to mention Massimo Collina and the convent in Venice for you to know to what I refer. Why did you not consult me? We have always been friends, and I would have acted in your interest under these circumstances. I appreciate your situation was made difficult because your late husband was my dear friend, and because he saved my life. The guilt you must have suffered will have been intolerable, but I played my part as well in our liaison.

Since my initial fury, I have had chance to calm myself, assisted by my loyal valet, Rogers—and I can see you were only doing your best to manage the circumstances you found yourself in. It is a blessing you did not leave our son with those nuns as when I saw the orphans there, dressed in rags and as thin as rakes, I could not imagine my child being amongst them. By the time I return to England, I shall no doubt have come to terms with this news, and I wish to become part of my son's life. You will hear from me in due course, and I shall visit Philippa upon my return.

Yours,

Rupert

So, the earl would contact me on returning from Venice, wanting to see Edward. Now he knew the truth, I hoped he would provide for us if I failed to contact Lady Cordelia's father. Surely it was not in the earl's character to neglect us? All I could do in the meantime was write to her attorney until I was able to return to London after the funeral.

Chapter Forty-One

The next morning, I went to Heybury House and passed through black and gold gates and along the drive, which went on for around a mile with sheep on the grass verges. I reached a car park bordered by a high wall made from red brick, wisteria hanging all along one side, a shock of purple. I bought a ticket as Heybury House was privately owned and followed a path to the house, smaller and more modern-looking than Chipford Hall, built in red brick with white pillars at the entrance. I entered a Grand Hall with marble floor and white statues of Roman and Greek figures. An elderly man handed me a plan of the house and I followed the signs through a drawing room, a library, another drawing room, a tea room, wondering if I was wasting my time as there was no information to support my quest to find provenance for the painting.

Heybury House was like any other Georgian country home with the usual antiques and paintings. But then I headed upstairs to the bedrooms and in Lady Cordelia's bedroom, my eyes were drawn to a glass case with objects in it. There was a red book, a pile of letters and a document, referred to as an agreement. I read the information board next to the case:

351

Our builders recently found these objects under the floorboards in this bedroom during renovation work to fix an outbreak of woodworm. You will see her secret journal, letters and an agreement made between Lady Cordelia Heybury and Philippa Giles in Venice. Lady Cordelia clearly hid these objects because they revealed secrets about her life. The red book is a separate journal from the official one, stored in the library downstairs, revealing that she gave birth to an illegitimate son when in Venice in 1780. She knew the father of the child was Rupert Wootton, the Earl of Chipford. At first, she intended to leave the child in the convent in Venice where she gave birth, but instead she drew up an agreement to say her companion, Philippa Elliott would raise the child, Edward as her own on returning to England. We know little about Philippa, except she and Lady Cordelia concocted a story to say Philippa married a British art broker when in Venice and gave birth to Edward on returning to London. They said her husband had died in a carriage accident before she returned home and even went to the length of buying a painting from Massimo Collina—the artist of the moment amongst the aristocracy—of a deceased man who they renamed Horatio Giles before Philippa would claim him to be her late husband. Furthermore, she arranged to have a matching painting of Philippa done by the same artist to hang opposite. During their stay in Venice, Collina had painted the portrait of Lady Cordelia Heybury, which can be found in the green drawing room downstairs—do take a look. He concealed her pregnancy in this painting, at her request.

What an exciting development. I took photos of the text and the objects in the case to send to Randolph and Uncle Pete. The

earl, Lady Cordelia and Philippa were all connected to each other, and the earl must have meant in his note that the painting was a thank-you gift for bringing up his child when saying it was a symbol of his gratitude. I went to look at the portrait of Lady Cordelia Heybury in the drawing room. She wore a green dress and was strikingly beautiful, a pile of blond curls on her head and a pendant around her neck, but there was no sign of her pregnancy. The ATP clearly was not aware of the link between Chipford Hall and Heybury House and Daphne would no doubt be interested in exploring this further. Now I just needed Uncle Pete and his genealogist to connect Philippa to Ivy Cottage.

On the drive back to Chipford, I sang along to *Shake it Off* by Taylor Swift on the radio with the windows down and it occurred to me that not only had I reached a turning point with my new discoveries, but also doing research in relation to the painting was fun. Had I found my vocation at last? Perhaps it might be possible to get a paid job with the ATP? Daphne would know the answer.

The next day, I drove to Chipford Hall to find Daphne as I couldn't get the idea of being paid to work for the ATP out of my mind. I found her in the servants' hall before her tours started and told her about my trip to Heybury House.

'Well, this is just wonderful, Rachel. Thank you for going. If your painting turns out to be a real Canaletto, I'll speak to Mike about exploring links between the houses for an exhibition.'

'Daphne, I wanted to ask you how I'd go about applying for a paid job here at Chipford Hall?'

'What qualifications do you have?'

'A history degree.'

'And what would you like to do?'

'Some kind of research job, I guess?'

'Well, I'm not sure if anything is available at the moment, but I expect a research or archivist role might suit you. All jobs are added to the ATP website and you apply through their database. I would register and then they'll notify you if anything comes up.'

'That sounds great, thank you, Daphne.'

'It's a pleasure, and I think you would be totally suited to working here. Fingers crossed something becomes available.'

When I got home, I set up a login for the ATP website and although there were no positions open at Chipford Hall, I signed up for notifications. In the meantime, I needed to find another way to earn money and considered walking into local cafés with my CV.

On Friday, when I woke up, there was no milk or bread in the house and I approached the high street in pouring rain to get a fresh croissant and coffee at the bakery. Being out of work wasn't great and apart from my novel idea to enquire about paid work at Chipford Hall, a pie-in-the-sky idea probably, how would I make money to live on in the meantime? When passing Peaches and Cream, I kicked myself for losing my job over a stupid waste-of-time trip to Italy that went wrong. I'd take a look at ads in the back of the local paper later on.

While queuing at the bakery for a much-needed cappuccino, I clocked that the woman behind the counter was struggling to keep up with the morning ambush of men in vans buying coffee and bacon rolls. The queue snaked around the shop and when someone opened the door and couldn't get in, I said, 'Excuse me, do you need a hand?'

'Not unless you know how to work a coffee machine.'

'I do.' I smiled. 'Would you like some help?'

'My assistant, Alice hasn't turned up, and I'd be ever so grateful, thank you. Who knows where she is?' The lady lifted a flap in the counter and I passed through to the other side. 'What's your name?' she said.

'Rachel,' I said.

'I'm Denise,' she said, handing me an apron.

I pulled the apron over my head and tied it behind my back.

'Here are receipts for the coffees. If you can get started on those, that would be lovely.'

'Okay.'

I spent half an hour or so making cappuccinos, flat whites and Americanos until everyone had been served and the morning rush was over.

'Thanks, Rachel. I appreciate you stepping in. Do you fancy sticking around to make up sandwiches for the fridge?'

'No problem.'

'I'll pay you, of course.'

'Thank you,' I said, thinking *ooh, money, at last.*

'If you can make up five tuna mayo and five ploughman's to start with, using rolls in that basket. You'll find fillings in the fridge.'

Working at the bakery was fun and the morning flew by. Before I knew it, customers were buying sandwiches for lunch and those in the fridge sold out so I had to make them to order. I was in the middle of making a ploughman's for Steve, a builder working across the road when a familiar voice called my name and I glanced over my shoulder to see Jake.

He studied me from the other side of the counter.

'Oh, hi,' I said.

'You're working here now?'

355

'I'm helping out today as a member of staff didn't turn up.'

'You lost your job at Peaches and Cream because of me and I'm sorry.'

'It was my decision to come on that stupid trip.'

He sighed.

'If it's any consolation, I tried talking to Melanie yesterday, but she wouldn't listen.'

'Thanks,' I said. More evidence he was on my side, although trusting him was still a step too far. I handed Steve his roll.

'One tuna and cucumber, one cheese and tomato; both on crusty,' Denise called over, and I started on the next batch.

'So, are you seeing that posh handwriting bloke then?' Jake said.

I shrugged, secretly pleased that he seemed to be jealous, despite my decision to try and forget him. I got the tuna mayo out of the fridge.

'Nothing happened and I left shortly after you.'

He smiled as if this pleased him.

'Rachel, I need to talk to you.'

'When will you give up?' I said.

'It's not about us.'

'Oh?'

'Look, I planned to drop by your house today to ask for help with something gallery-related.'

Adding slices of cucumber to the tuna mayo roll, I said, 'What's that then?'

'I thought about your idea.'

'Which idea?'

'About having an exhibition for a local artist. Marcus Wilde delivered a couple of paintings yesterday and when I ran your suggestion past him, he was really keen to get involved. His

356

paintings are of the local area and he's very talented. Marcus offered to do a short talk about his work and, because he's likely to sell paintings, he wouldn't ask for a fee, giving me a budget for wine and snacks.'

After putting the rolls into paper bags, I handed them to the waiting customers. 'So why do you want to talk to me?'

'Would you like to be in charge of the publicity?'

'I can't afford to work for free.'

'You'd be paid as Dad and I agreed to invest in the gallery to try and save it. We'll receive a percentage of money for paintings sold, so I would pay you a fixed fee or per hour, whatever you prefer.'

'What if you don't sell any paintings?'

'I'll have to take that risk. Whatever happens, you'd still get your fee with half in advance. I can pay you today.'

'I'll do it for £500,' I said, plucking a figure out of the air before he changed his mind.

'Done. So, when can you meet to talk properly?'

Astonished that he'd accepted my figure, I smiled. 'I finish here at one.'

'Come to the gallery then and we'll sort out the payment.'

'All right.'

Within the hour, I'd have £250 in my bank account as well as cash from Denise. Not a bad morning, after all.

At twelve-thirty, Alice called to speak to Denise. After hanging up, she said, 'Rachel, how do you feel about working here for the next month? Alice has broken her foot and didn't call earlier as she was in A&E and her phone ran out of battery.'

'Okay,' I said.

'How about every morning from nine until one, apart from Sundays when we're closed?'

357

'I can't do Tuesdays,' I said.

'My mum can manage one morning a week. Oh, and lunch is on the house. Get yourself a sandwich and a coffee, if you like.' She opened the till and handed me forty quid.

'Thank you,' I said, glad to have money again. Then I assembled two ploughman's rolls and made two cappuccinos, putting money in the till for Jake's lunch and coffee before heading next door where he stood at the counter.

'Hi,' he said.

'I've brought lunch.'

'Brilliant, thank you. Shall we step into my office?'

He went to the front door and turned the sign round.

'I'll close for an hour. We don't usually sell anything at this time anyway. Or at any time really.'

'Well, that's all about to change with your exhibition.'

'Do you think so?'

'Yes, I'm confident we can turn this place into something amazing. It just needs a bit of love.'

He looked at me as if I was talking about us.

'It would be good if we could do that,' he said, gently.

My gut hopped. Now he wasn't with Penny, we were free to do what we wanted. We could go upstairs to his flat. These thoughts warmed my cheeks.

'Why don't you grab some paper and a pen, and we can get started,' I said in a matter-of-fact voice.

He put an A4 pad in front of me with a biro and I wrote down a list of what had been running through my mind since he came into the bakery. Possible dates, timings, availability of Marcus, what food and drink? Followed by ideas for promotion: flyers, posters for local businesses, ad in local paper, a press release with photo of Jake and Marcus, ask local journalist to attend event and

perhaps a writer for *Cotswold Matters* magazine. I could do social media promotion as well.

'Does the gallery have a Facebook Page?' I said.

'Yes, but it's only got about twenty likes.'

'I used to update the Facebook Page for Pizza Town. If you make me an admin, I can manage the gallery's page on your behalf and increase the number of likes. If you have a budget, we can set up some ads aimed at the local community.'

'I wouldn't know how to do that, so why don't I give you my password, and you can make yourself an admin using my login?'

I shrugged. 'All right.'

He scribbled Rachel10* at the top of my pad.

'What's this?'

'The password.'

'Your Facebook password is my name?'

'Yes.'

'Why?'

'I had to reset my Facebook password in Tuscany when my account was hacked, just before Penny arrived.'

'Oh,' was all I could say. Maybe he was genuine, after all. Or was this all part of an elaborate plan?

'On the way home from Italy, I stayed in that Bed and Breakfast in Courmayeur and made some notes about the gallery. I'm going to invest some of my redundancy money and go for it.'

'I'll change your password.'

'No, don't.'

'Why?'

'Because it's easy to remember.'

'What does the ten mean?'

'It's my birthday, 10 April. But also, it applies to you.'

359

Ripping off the sheet of paper, I was lost for words. 'What do you mean?'

'Because' —he put his hand on mine, and I let him— 'to me, you are perfect in every way.'

This was too much. Flustered, I said, 'Well, I'd better get started. Do you have a budget for newspaper and Facebook ads?'

'What do you suggest?'

'£150?'

'All right. Write down your bank details and I'll pay you right now on my banking app, plus half of your fee upfront as agreed.'

I scribbled my details on the notepad and he keyed them into his phone.

'Done,' he said.

'Thanks,' I said, overjoyed to have money coming into my account. I stood up. 'See you later, then.'

'When shall we meet next?' he said.

'You're the boss.'

'Tomorrow?'

'We don't need to meet every day.'

'How about a pub lunch on Friday?'

'My shift at the bakery finishes at one, so I'll meet you after that.'

'I'll pick you up on the way.'

'Okay.'

As soon as I got home, I checked the banking app on my phone and the money was there already. Although £150 was to use on ads, it was in my account for now, and I needed to be careful not to spend it by mistake. For the first time in a couple of weeks, I was in credit. Denise would pay me in cash for working at the bakery, and so I'd gone from having no money and no job to

having a really successful morning, after all. An email pinged
into my inbox and it was from Pimsy's.

Dear Rachel,

*Thank you for sending the photos from the glass case at
Heybury House. We have added them to our files. Here
follows an update on your painting.*

*Adam Moore has confirmed to us that the handwriting on
your note matches Earl Rupert's journals at Chipford Hall.*

*A Canaletto expert has been to the Galleria di San Marco
in Venice and after using X-ray techniques and analysis of
paint used along with other methods, we can confirm your
painting is attributed to Canaletto.*

*In order to complete the documented evidence of
provenance, we shall need Peter Brown to confirm the
identity of Philippa Giles and we understand he is in the
process of undertaking this research with a genealogist.*

*We shall then submit a request for the Canaletto estate to
include your painting in their catalogue, and once this has
been actioned, we shall be in a position to auction your
painting at Pimsy's on your behalf.*

Best wishes,
Randolph

I'd call Uncle Pete later to find out the latest information. This
really was turning out to be a good day.

On Friday, at the end of my shift at the bakery, Jake came in and
perched on a stool by the window, tapping away on his phone.
Working on this exhibition with him was a good way to forget
what had happened between us, and I couldn't wait to spend time

with him. I removed my apron and grabbed my bag containing the notes made at home. Denise handed me my cash and I approached Jake.

'Hi,' I said.

'Ready for lunch?'

'Yep. I've brought notes for us to go through.'

'Good,' he said.

We walked to The Old Bear in silence. Should I make conversation about the exhibition, or be more like when we were friends?

'So, I got an email from Pimsy's,' I said.

'Oh yes?' he said.

'The expert went to Venice and said the companion painting matches mine.'

'That's good, I'm happy for you.'

'Thanks. It's exciting.'

We reached the pub and went in, and he suggested we sit at a table in the corner.

'What can I get you to drink?' he said.

'Sparkling water?'

'It's Friday lunchtime and you've just finished your shift. Why don't I get you a proper drink?'

'What are you having?'

'A pint.'

'A glass of house white then, thanks.'

Jake went to the bar and I sat down, watching him as he ordered, thinking, *imagine if he was mine?* He brought over the drinks and I got a notepad out of my bag.

'So, would you like an update?' I said.

'Go for it.'

'I've made a list of dates, mostly Thursday evenings and created graphics in Canva to show you.'

'Sounds good.'

I pulled up the graphics on my phone and passed it to him.

'They look great. Use them,' he said.

'Okay, I'll add the date to the graphics when it's confirmed. So you need to call Marcus and fix the date, then I can get flyers printed. Would your Facebook friends mind me inviting them to like your page?'

'Yeah, why not? Those with their own businesses are always asking me to like theirs. And my dad's a member of the local community Facebook Group so he could post in there as well.'

'That would work well.'

He passed me the menu. 'What can I get you for lunch? I'm having the fish and chips special.'

'I'll have the same, please.'

He went to order the food and returned with a bottle of Pinot Grigio and a glass for him.

'So, are we done with the work stuff?'

I glanced at my notes.

'Yes, we could have done this over coffee.'

'I know, but it's nice to see you.'

Smiling, I wondered if us working together was a ploy to get me back into his life. He refilled my glass and we chatted about general stuff until the food arrived.

As I put down my knife and fork, he said, 'How do you feel about coming back to the flat?'

'What?' I said.

'You heard.' He grinned, studying me with those blue eyes. Tipsy from the wine, I was tempted, but it was too soon. Still the thought niggled over whether I could trust him.

'I can't.'

'All right.' He downed his wine and refilled our glasses. 'You need to admit to yourself that you want to be with me.'

'Why, after Tuscany?'

'But I'm making up for it now.'

'You made me feel insignificant and unwelcome when it was you who persuaded me to go there in the first place. I lost my job.'

'I am sorry. You have another one now. Well, you have two.'

'I need time to get to know you again and to feel I can trust you.'

He sighed.

'Of course you can trust me.'

'Can I?'

He looked at me with puppy-dog eyes that were hard to resist, but said nothing. Even if I could forget Tuscany, it was still a matter of pride. The new me couldn't fall into his arms without him knowing how he'd made me feel. Standing up, I pulled my bag onto my shoulder. 'Thanks for lunch.'

'When's our next meeting?'

'Once you've confirmed the date with Marcus, give me a week or so to organise the promotion.'

'All right, I'll find you at the bakery.'

The thought of him coming in every morning would brighten my days. He stood up and leant forward to kiss me on the cheek, sending a rush of desire right through me, and I really wanted to go back to his flat. But my decision was made. He sat back down and I headed for the door, turning to glance at him as I twisted the handle. He was looking over his shoulder at me, and it was then I knew we'd be together. Just not yet.

When I got home, Mum was out doing a food shop and I checked my phone on the sofa with a cup of tea. A text from Uncle Pete flashed up on the screen.

Rachel, I'm getting close to finding the link between Philippa and the house. With the genealogist now, so this is quick, but thought would let you know. Will be in touch. Adios.

Putting down my phone for a moment, I took a deep breath. If the painting turned out to be real, I'd never have to worry about being overdrawn again. My life ought to have a purpose in order for me to be fulfilled though, and the idea of a paid job at Chipford Hall still appealed. I remembered the dilapidated terraced cottage that had been on the market for months, thinking it would be a fun project to take on. I'd always wanted a cat. And I had always fancied writing a book, and wondered if one about the story behind the painting would appeal to a publisher. Of course, Randolph might still email to say some issue had come up and my painting wasn't worth a penny after all. Then I'd stop daydreaming about possibilities. The wine had made me sleepy and I went upstairs for a nap, feeling hopeful as I climbed into bed.

Chapter Forty-Two

A few weeks after Lady Cordelia died, the earl and Rogers returned from Venice and came to my house. Miller showed the earl into the red drawing room, while my dear friend, Rogers acquainted himself with my library. I hoped the opportunity would arise for me to spend time with him again. Since reading the earl's letter at Heybury House, I had been anticipating his visit, hoping he would be understanding and able to help Edward and me financially. We sat by the window, facing the garden and Miller brought the earl a generous glass of brandy and tea for me. The earl took a sip and swirled the drink in his glass, and I made a show of pouring myself a cup of tea through the strainer, in order to avoid looking directly at him as the situation made me uncomfortable.

'So, Philippa, I know everything there is to know about your Grand Tour to Venice.'

I added milk to my cup and a lump of sugar.

'Everything?'

'Yes, I know Edward is my son and that you and Cordelia, God rest her soul, concealed this information from me, and that you had good reason to do so. Initially, Rogers will tell you, I

was furious with you both. But the journey home gave me time to ponder upon the circumstances we find ourselves in.'

'All I can do is ask you to understand,' I said, lifting the cup to my lips and allowing our eyes to meet as they had for the first time in the library at Chipford Hall. I recalled thinking I loved him, but it had been mere infatuation for he was handsome and virile and eligible. But as I had predicted when we parted, our destiny was to be friends.

'Indeed, my son could still be in that convent. Collina put two and two together when you bought the portrait of the deceased man and discovered from the nuns that you had taken Edward to England. And in London he discovered you were mourning a fictional husband.'

All I could do was put this down to one of my servants talking to someone paid by Signor Collina, but there was no way of being certain.

'He demanded that Lady Cordelia pay him vast sums of money, and she was asked to pay another instalment to his associate in London while you were in Venice. She was not in a position to pay as the baron has saddled her with a vast amount of debt.'

'I am aware of that,' he said.

'This is her father's house and he is at sea so remains unaware of her passing away.'

'You must pack your things, and I shall arrange for you to move into another property in London. And then I shall ensure you and Edward have all you need. You may take your servants with you, of course. Money is no object.'

'Thank you. I have been lying awake each night, worrying about the future.'

367

'Then it is settled. I shall send servants to assist with moving into your new home on Monday.'

'That will give me plenty of time.'

'Thank you for what you have done for Edward. I have a gift that I shall give to you in due course.'

'There is no need to give me anything. I am grateful for your financial assistance.'

'No, I insist. This particular item belongs with you and Edward.'

I shrugged, not knowing what to say. 'That is most kind.'

'In the meantime, I wish to meet my son.'

'Certainly, he is in the nursery.'

I led the earl upstairs to where Edward played on the floor with Jane and asked Mrs Harper to remove Jane from the room, even though I suspected she was also his child. This was not the time to press that information upon him. Mrs Smith picked up Edward and passed him to me, and I sat on a chaise longue beside the earl, who I imagined had no desire to hold his son, but at the same time would want to get a good look at him. Mrs Smith excused herself, leaving us alone.

'This is your son,' I said.

'This is my son,' he said.

Tears pricked my eyes as they looked at each other, and the earl proffered his hand, allowing his son to grip his finger, and Edward, who had the same eyes as his father, looked at the earl, their brown eyes, the colour of cocoa, meeting for the first time, and cooed. During that moment, I knew I had done the right thing, and all I could wish for was that Lady Cordelia witness them meeting.

'If only his mother were here.'

'Indeed. Such a tragedy. She was a dear friend for as long as I can remember. So, now it is up to you and me, and to Rogers, his godfather to give Edward the best possible life. I am most grateful to you, Philippa.'

'It has been a pleasure to care for your son and I am glad you can now get to know him.'

'Now it is clear Cordelia asked me to be godfather because she wanted me to be part of his life. Collina is a rat, but at least I can assist you financially, and watch my son grow up. I shall arrange for him to be registered at Eton immediately, and I expect you to teach him French and Italian, and about the arts. When he turns eighteen, I shall take him on a Grand Tour.'

'He has a promising future, indeed,' I said.

The earl stood up. 'Now I must leave. If you need anything, do not hesitate to write and I shall action your letters as a priority.'

I showed him downstairs, into the hall and out of the front door, and pondered upon our encounter. The earl was choosing to be part of Edward's life and this brought immense joy. And now, I no longer needed to be preoccupied with where I would live or whether there would be enough money to pay the servants, and to pay for provisions for the house. Now the earl knew the truth, everything would be all right.

The earl and I spent some time together over the following few months, and he visited my new home in Curzon Street often, to spend time with Edward, but also we took walks and drank tea while discussing our mutual love of Shakespeare, amongst other things. He kindly took over responsibility for dealing with the baron and Lady Cordelia's estate. Then one day, he came to the house, holding a package wrapped in brown paper.

369

'Dear Philippa, I must divulge that the matter of the baron's will is almost completed. However, I must travel to see my uncle in Antigua to ask for money invested by the baron, so we can settle his debts. Then we shall know how much can be passed on to Edward.'

'That sounds like a sensible option, although we shall miss you dearly. When will you leave?'

'There is no time to waste. I shall travel to Plymouth tomorrow. We must resolve these matters so we can continue with our lives.'

'To be sure, you are right.'

'Rogers will remain here and I have entrusted him to care for you and Edward in my absence.'

'That will be much appreciated.'

He handed the package to me.

'This gift is for you to open after I have left. There is no doubt in my mind that this item belongs with you. When I return, I shall add you and Edward to my will.'

'Thank you for your gift and for all you have done for me.'

It did occur to me that I would be in dire straits if something happened to the earl on this voyage, and I hoped and prayed he would return safe and well. Who would take care of Edward and me if he did not?

'It is my pleasure.'

'Now you know the truth, a weight has been lifted from my shoulders, and it is a comfort to know Edward and I are secure, financially.'

The earl stood up and kissed my hand, and as Miller showed him to the door, I looked at the package, wondering what on earth it could be. When Miller returned, I asked him to bring me a knife and requested he open the package on my behalf. It was my

favourite Canaletto and I was delighted. For a few minutes, I studied it as I had that evening at Chipford Hall, drinking in Canaletto's depiction of St Mark's Square.

'Would you arrange for this painting to be hung in the red drawing room as soon as possible, Miller?'

'Certainly, Mrs Giles.'

There it would serve as a reminder to pray for the earl's safe return every day.

And so when the earl left for Antigua, he was once again out of my life. Rogers remained in his London residence, visiting most days. Now his father resided with his sister in Bath and Rogers no longer needed to worry about him forgetting to blow out a candle or burning himself on the stove. We passed many hours walking in the park, at the house on Curzon Street and on occasion he accompanied me to church. We confided in each other on several matters, and one afternoon, he told me of his concern about something Lady Eliza had done that would make the earl furious.

'What is it?' I said.

'During the earl's absence, Count Monte went ahead with a visit to Chipford Hall, planned a long time ago, and Lady Eliza entertained him and his entourage, and according to both Mr Banks and Mrs Baxter, she allowed him to take the remaining Canaletto from the wall of the drawing room. He wanted the one gifted to you to match his pen-and-ink drawing, but was still apparently delighted to take home this treasure as one might imagine. The earl's instructions had been not to give the Canaletto to the count under any circumstances.'

'But why would she do that?' I said, horrified at Lady Eliza's actions, and upset that the earl would no longer have the companion to the painting he had gifted to me.

'Well, I believe it is to repay his lordship for all his philandering. Her lady's maid told us Lady Eliza was tired of hearing rumours about the earl's illegitimate offspring scattered around the country, and even abroad. She knew that losing this painting to Count Monte would anger him a great deal.'

I wondered if she knew about Edward, and could only hope Lady Eliza would do nothing to harm his future.

One Sunday, Rogers walked me back from St Mary's after a pleasant sermon.

'Now I know the truth about Edward, and that Horatio Giles was a figment of your imagination, this changes everything,' he said.

'Whatever do you mean, Mr Rogers?'

'Well,' he paused. 'I can now divulge that you are more than a friend to me, although I no longer know what to call you. Mrs Giles does not seem to fit.'

We arrived at my front door and Miller came outside and this seemed to stop Rogers from finishing what he had started to say.

'And you are more than a friend to me as well, Mr Rogers. We are firm friends, indeed.'

'Until tomorrow,' he said, his eyes glazed over as if he were consumed with deep thoughts.

As I watched him walk down Curzon Street, it became clear he had been trying to tell me something. Was he about to say he loved me? And what if that were the case? I did feel closer to Rogers than anyone else and if I had to choose who to spend my time with, I would select him. Besides, since his return from

Venice, I had noticed he was rather handsome and found myself imagining him taking me into his arms and pressing those lips against mine.

Several weeks after the earl's departure, Rogers visited and Miller showed him into the library where I was writing letters. His stooped shoulders made me aware something was wrong, and I suspected his father had passed away. Recently, his health had deteriorated and Rogers had been visiting more often. We sat in the chairs by the fire, and I filled our cups with tea.

'Mr Rogers, do tell me what is the matter.'

'There is no easy way to give you this news,' he said.

'Is it your father?'

'No, although I expect he will pass away before long. I have received notice of the earl's death at sea from typhoid fever.'

Horrified, I put a hand to my chest. 'No.'

'I am sorry, Mrs Giles for your and Edward's loss.'

'And I am sorry for yours,' was all I could say. This was a shock and I did not know how to react, acutely aware that Rogers had worked for the earl for many years. This was as great a loss to him as it was to me.

We sat in silence, our tea going cold, the gingerbread untouched. Not only had I lost the earl as a friend and father to Edward, but also as my financial supporter.

'What will happen to Edward and me?'

'I shall take care of you both.'

'You will?'

'Do not fret, Mrs Giles. My instructions from his lordship were to care for you in his absence. And if they were not, my natural instinct would be to look after you both.'

'You are our saviour.'

'The earl has provided me with enough money to last you six months. Therefore, we can refrain from being preoccupied about your circumstances, for the next two months, at least.'

'That is a relief. We must go to the church to pray for him.'

'Indeed. And I will take care of you both financially, I promise,' Rogers said.

'You are kind, but how will you be in a position to do that?'

'I have saved a significant sum of money over the years, as the earl has paid me handsomely, but I have spent barely a penny. Therefore, I can buy a home, albeit a modest one compared to this, for you and Edward, although it will sadly not be in London. And I can find employment in a country house nearby.'

'You would do that for us?'

'Of course.'

'Thank you, dear friend.'

He stood up. 'I must go. There are many tasks to undertake back at the house.'

'And how is Mrs Baxter?'

'She is upset, evidently, but she will move to Bath to live with her sister and my father, earlier than planned.'

He kissed my hand, and although this gesture sent a frisson down my spine, it was not the time to be daydreaming about whether Rogers and I would ever be anything more. Miller saw him out, and I remained in the chair, stunned by the news, but grateful that Rogers would take care of us. It had always been entirely possible the earl would die as many ships did not survive the journey to Antigua and there was always a high risk of catching some dreadful disease at sea. But I had been in denial that he would actually die, and without taking care of the finances for Edward and me. All I could do in the meantime was walk to St Mary's and seek solace within its walls.

Chapter Forty-Three

On the day of the exhibition, Jake and I set up in the afternoon. We bought prosecco along with orange juice and crisps, mini sausages and spring rolls. Twenty people had booked using Eventbrite, and I hoped they would all turn up. We arranged chairs in rows with a stool for Marcus to sit on while delivering his talk. Jake had cleared the wall behind where Marcus would sit and we hung his paintings there, then I took photos for the Facebook Page. Before Marcus was due to arrive, I put my bag in the office where Jake was sitting at the desk.

'Thanks for helping me with this,' he said.

'It's been fun.'

He seemed about to add something else, but then said, 'You'd better get out there as Marcus will be here any minute. I'll join you shortly.'

In the gallery, I used selfie mode on my phone to put on lip gloss, and Marcus came through the door. He was in his mid-fifties with a shock of grey hair and matching beard, and he wore green cords and a yellow shirt. The colours in his outfit would work well in the photos.

'Hello, Marcus, I'm Rachel. Jake will be out in a minute.'

We shook hands and Marcus studied the set we'd created of his paintings displaying local scenes.

'Rachel, you've done a wonderful job displaying my paintings. Thank you.'

The evening went brilliantly. I took lots of photos for the Facebook page and the local journalist said he'd write up his piece the following week. Marcus talked about his inspiration, and how he became an artist and then went through each of his paintings, telling a story to go with them. More than twenty people turned up, and three bought paintings, paying Marcus handsomely for his time, and giving the gallery a substantial profit.

After everyone had left, Jake and I cleared up and when I went to get my bag from the office, he put a hand on my arm.

'What a huge success,' he said.

'I'm so pleased.'

'Thank you, Rachel.'

'Glad to help,' I said.

'How do you feel about doing more of these? I have a couple of artists in mind for next month.'

'Definitely.'

He handed me an envelope.

'What's this?'

'A present.'

Curious to know what it was, I tore open the envelope and pulled out a plane ticket to Venice for the following afternoon.

I looked at him, confused.

'Why are you giving me this?'

'Will you come to Venice with me?' he said. 'We can see the companion painting, like we were supposed to.'

'Where would we be staying?'

'I've booked a boutique hotel, recommended by Maria. Don't worry, we have separate rooms.'

'This will take up most of your profit from tonight, though.'

'Tonight was about getting the ball rolling with the exhibitions, and at the start it was a way to see you, even though now I get what a great idea it was.' So, it had been a ploy to spend time with me. Perhaps I'd let him suffer for long enough. 'So, are you coming?' he said.

'Yes!'

'That's great,' he said. 'Bring something to wear for dinner. I'll pick you up from yours at one o'clock, okay?'

'Okay.'

He kissed me tenderly on the cheek, and as I walked down the high street, nothing was going to wipe the grin from my face.

The next day after my shift at the bakery, Jake picked me up from Ivy Cottage and we headed to Stansted airport for the flight to Venice. I'd told Mum about our escapade and now he'd dumped Penny for good, she was rooting for us to get together. One of the students from her old class at the gym had suggested Mum do her own virtual yoga classes. All the payments would go to Mum rather than a cut going to the gym and she planned to record some trial classes while I was away with tech help from the student.

'If you can't beat them, you might as well join them,' Mum said.

It was good to see her managing without a man in her life for once and I hoped she wouldn't rush into another relationship for the sake of it.

In the car, I looked across at Jake who was focussing on the road ahead, allowing me to study him and picture us together in

Venice. After all the false starts, would something actually happen?

'How is your mum managing without Malcolm?' he said.

I told him about the yoga classes and that she seemed to be getting her act together for once.

'That's good for you,' he said.

'It is.'

I liked being able to talk to him properly again as after Tuscany it had been a bit awkward at first. We'd started as friends, and I'd never experienced a friendship turning into something more, but knew from all the romcoms I'd seen that it was supposed to be a good foundation for a long lasting relationship. I was ready to tell him everything about myself and wanted to know everything about him.

'My mum hasn't always been the easiest person,' I said.

'That must have been hard to deal with,' he said.

'It meant I had to grow up sooner than my peers. She moved from one boyfriend to the next with me in tow and I was the one who had to comfort her after break-ups. Eventually, she settled down with Nigel in Dorking who she was with for a few years. They were on course to get married, but then he decided to go for a woman ten years younger. Mum was devastated and had nowhere to live, so she moved into Ivy Cottage which had been a holiday let since Gran's death, and I had to come back at weekends to make sure she was okay.'

'Well, on the upside, if it wasn't for Nigel and his wandering eye, you wouldn't have found the painting and we wouldn't have met.'

'Good old Nigel,' I said.

He put a hand on my leg and squeezed it, and I placed my hand on his as he pulled onto the acceleration lane for the M4. It

378

wasn't quite time to tell Jake about my absent father, the American businessman who Mum had a fling with in the London hotel where she worked as a waitress in her early twenties. All I knew was he looked like Robert Redford and was called Ted. I usually said my parents were divorced when anyone asked, but one day, I'd tell Jake the truth, when I was ready.

We landed at Marco Polo airport at eight o'clock that evening, and after passing through customs, Jake got us a water taxi. He told the driver the name of our hotel and we stepped into the boat with its grey leather seats, open at the back, and set off across the lagoon at some speed. The wind blew through my hair and I tied it back with a scrunchie. The sky was tinged with pink as the sun began to set and the boat went faster and faster, bumping us around. I fell onto Jake and we laughed and he put an arm around me, squeezing me to him and kissed me on the cheek.

Venice came into view with grand old buildings rising up from the water and rows of gondolas lined up along the jetty. We approached the hotel via a series of canals and the driver got out and messed about with ropes, then held out a hand for us to grab as we stepped onto dry land. The hotel was quaint and adorable with tables and chairs outside and balconies with window boxes bursting with geraniums in red and pink clamped to the railings.

I waited on a sofa while Jake checked us in and we got in the lift with our suitcases. In the mirror, I saw the reflection of us together and thought we looked like a nice couple. Was that what we'd be when we checked out? As promised, Jake had booked two rooms and he gave me the key for the room next to his. The walls were whitewashed, a gold eiderdown covered the double bed made with crisp white sheets, and the bathroom suite was made from marble. I heard a knocking sound and saw it was

coming from a door in the wall. So, our rooms were inter-connecting. When I went to open it, Jake was standing there.

'What do you think?'

'I like it,' I said.

'Shall we have a look at the mini-bar?' he said, gesturing for me to go into his room.

I followed him and sat on the bed, looking out of the open doors at the balcony with two chairs and a table and a view of Venice beyond. The sunset was a deep pink now and it was almost dark. Jake got a half-bottle of prosecco out of the fridge, popped off the cork and filled two glasses before handing one to me as I stood up.

'Thanks for bringing me here,' I said.

'I'm glad you came.'

We said, 'Cheers,' and clinked glasses and I took a sip, the bubbles bringing that joyous feeling they always brought, and then our eyes met and he took my glass and put it on the coffee table. Then he took me in his arms and kissed me, gently pushing his tongue into my mouth and because we'd had to wait for so long, it was charged with heat, and he peeled my top over my head and I pulled his T-shirt over his, and then he unhooked my bra and placed his hands on my breasts, inhaling deeply as he did so, and I undid the belt on his jeans and unzipped his flies, and put my hand on his hardness, and he groaned and removed the rest of my clothes and then his, and we fell onto the bed and he ran his hands over my bare skin, moving his hand down there, and he studied me with those blue eyes as if drinking in my nakedness. There was no need for foreplay; I just wanted him inside me.

'You are beautiful,' he said, sliding his fingers into me.

'Do you have any condoms?' I said. I'd brought some, but they were in my room.

He got one from his suitcase and put it on in record time and then he entered me and it was everything I'd imagined when lying in bed at night thinking about him. And now here we were, with him making love to me, and it was making love rather than having sex.

Being in bed with JC, Chris and the men who'd preceded them had been perfunctory with it usually being about their pleasure. Here now with Jake, it was about both of us, and he took his time, and we found our rhythm, moving steadily as one, and he waited for me before finishing and I cried out as I came and then he groaned a long and satisfied groan and we lay there with the weight of him on me, and I couldn't wait to do it again.

We didn't leave the hotel room that evening and Jake ordered steak and chips from room service and a bottle of prosecco. After eating on the balcony, wrapped in towels, we returned to bed to devour each other's bodies with some sleep in between. The next morning, we had a late breakfast of pastries and coffee and fresh orange juice on the balcony with a view of the canal below and we watched passers-by and the boats as they came and went. I didn't want to leave the room, but we had to go to the art gallery before it closed and so we got dressed and headed for the Galleria di San Marco to see the companion painting.

It was a ten-minute walk to the gallery and Jake bought tickets for both of us. The building was old and grand with marble statues and busts everywhere, and using a plan, we headed for the Canalettos in room 82, up a few flights of stairs. We passed through a series of rooms until there it was, hanging alongside the pen-and-ink drawing that matched my painting.

The companion to my painting was another view of the square from a different angle and we studied it while standing side by side. The description on the wall said it had been donated by the Monte family in the 1950s, matching the information on the website. I still wasn't sure how the painting had got from Chipford Hall to the Monte family, but could only presume the count had found a way to steal it as Earl Rupert had suggested he might in his journals. Sky took up a lot of the canvas with a full view of the bell tower through an arch in the foreground. We also studied the pen-and-ink drawing, comparing it to the photo of my painting on my phone and it showed more of the left-hand side of the square. If I hadn't found the painting in Gran's loft, we wouldn't be standing here now. We exchanged a smile and Jake took my hand in his and squeezed it.

'Shall we go to the square?' he said.

We left the museum and followed the signs to Piazza San Marco. All routes seemed to go there, and Jake picked out the quickest one using Google Maps on his phone. Tourists filled the streets, ambling slowly and looking in shop windows and eating ice creams, and we had to squeeze our way around them. On reaching the square, we used photos of the paintings on my phone to work out where Canaletto sat at his easel. Classical music played at the nearby Café Florian, and there were musicians dressed in black tie, playing violins and a cello and a grand piano.

I took a selfie of us with the scene from my painting in the background and, after putting my phone away, Jake leant forwards and pressed his lips to mine and we kissed.

'I love you, Rachel,' he said. 'And don't feel you need to say it back.'

'I love you,' I said, meaning it.

'That makes me very happy,' he said, kissing me again and squeezing me to him. 'Shall we get something to eat? I'm starving.'

We'd burnt a lot of calories in that hotel room and hadn't eaten since our late breakfast. He took my hand and led me over a bridge and we searched for a restaurant that wasn't too touristy. We found a quaint place tucked down a side street on the canal and ate *spaghetti alle vongole* and shared a bottle of Chianti. The waiter filled our glasses and we raised them.

'Here's to us,' Jake said.

'To us.'

I had no idea what would happen when we got home, and hoped he wouldn't expect me to move back in with him. Although I loved him, it would be too soon and I wanted to take it slowly and find my own way in life before we embarked on anything serious, by getting the right job, and hopefully I would buy that terraced cottage I'd been dreaming about. But, for now, I couldn't wait to get back to the hotel room and spend another glorious night with him before flying back the following morning.

Chapter Forty-Four

Grieving for the earl was an endurance for Rogers and me, and we did our best to comfort each other. He remained at the earl's house in London with other servants while the will was being dealt with by an attorney and visited most days, accompanying me on Edward's walks. When he went to Bath, I missed his presence. Mama liked him and we often dined together. He came round one afternoon and we sat in the red drawing room.

'Our prayers have been answered, Miss Elliott,' he said. He had reverted to calling me by my maiden name in recent weeks.

'What is it, Mr Rogers?'

'The earl has left me a substantial sum of money, putting me in a position to buy a house and to fulfil my dream. I can afford to buy out the vile Mr Wicks who is apparently ready to retire and I shall visit Chipford tomorrow to make him an offer he cannot refuse.'

'Oh, I am thrilled for you.'

'Now, I have done a great deal of thinking recently and it is time to take action.'

'What do you mean?'

'Dearest Philippa, will you do me the honour of being my wife?' Although I had suspected that Rogers loved me, this

sudden proposal was unexpected. He stood up and came over to me and kneeled on the floor, taking my hand. 'I love you, Philippa and have done since the moment I first saw you in my aunt's parlour.'

My heart was fit to burst with joy. At last I was sure I loved him.

'It would be an honour to be your wife, Mr Rogers.'

'That is wonderful news.' He kissed my hand while looking at me intently with his blue eyes and there it was, that frisson once again, but now I could be certain of my feelings towards him. 'Therefore, I think it is time you called me by my real name, Jonathan.'

'Jonathan it is, although this will take some time to adjust to.'

We laughed, and he pulled me to my feet then proceeded to lift me into the air and spin me around.

'And Edward can take my name and I shall treat him as if he were my son.'

'What a lovely family we shall be,' I said, delighted. 'And can we have our own children too?'

'Of course we can. There is just one thing I need to ask of you, my dear Philippa.'

'What is that?'

He cast a glance at the wall.

'Please would you kindly take down that portrait of Horatio Giles?'

'Yes, yes, of course! I have been meaning to ask Miller to arrange that.'

He leant forwards and pressed his lips to mine, and in the midst of that magical moment, my very first kiss, tender and sublime, I knew for certain that we were destined to be together.

I stood in front of the looking glass, studying my reflection, and recalled the moment when Jonathan said he would ask me to dance if we were at a ball. So much had occurred since that day and now I was wearing Mrs Baxter's dress for the very first time, along with the string of pearls from my parents. Mama had worn them on her wedding day. A knock came at the door and I went to open it.

'Why, you are beautiful, dear Philippa.'

'Thank you, Mrs Baxter.'

'Are you ready?'

'Yes, I think I am.'

'Very well, the carriage is waiting outside and I have word from St Andrew's that all of the guests have arrived.'

We went downstairs and John, the footman from Chipford Hall, who had offered to lend us his services for the day helped me and then Mrs Baxter into the carriage before joining the coachman upfront. Jonathan and I were getting married at St Andrew's where dear Papa had been vicar, and I hoped he would be there with us in spirit. Mr Brigstock was officiating the ceremony, and I had requested the inclusion of hymns and psalms that Papa would have approved of.

'I must tell you something, dear Philippa,' Mrs Baxter said.

'What is it?'

'I knew about Lady Cordelia's situation when you were in Venice.'

'What, how?'

And then it dawned upon me.

'Fanny wrote to me, saying she tried to tell you before you left, but you were interrupted by the housekeeper.'

'Ah, yes, I remember. But, does that mean Jonathan knew?'

'I could not put him in the position where he had to choose whether to tell his master or not.'

'Oh, Mrs Baxter, that must have been difficult for you.'

'It was, my dear but' —she patted my knee— 'somehow, I knew it would all work out. For the earl had arranged to go to Venice to have his portrait done and I hoped he would discover the truth from that artist who had a reputation for being a tattle-tale.'

'And he did.'

'Indeed.'

For a mere moment, I wondered if Fanny telling me about Lady Cordelia's pregnancy would have made a difference to how everything played out. Would I still have gone on the Grand Tour? For now, all I could do was try to remain calm as we moved the short distance to St Andrew's.

When we arrived, carriages and horses belonging to our guests lined the street and nerves passed through my entire being. As we walked up the path and approached the open door, Mrs Baxter whispered, 'Good luck, my dear girl,' and she handed me the bouquet of white roses before taking her seat. Standing at the entrance, I looked inside and there he was, Dear Reader. Jonathan Rogers waited for me to walk up the aisle and into his life for ever.

We found a gem of a home, Ivy Cottage in Chipford, opposite the tailor's business that Jonathan bought back from Mr Wicks, who had been in ill health and therefore thankfully seized the opportunity to sell. Jonathan, Edward, Mama, Maud, Jane and I moved into the house. Maud would help me to look after Edward now we could no longer afford to keep on Mrs Smith.

Jonathan found a position for Gertrude at Seeley House as lady's maid to one of Lord Tankford's daughters. Lady Eliza accepted a proposal of marriage from Massimo Collina's patron, Lord Willoughby, a widower. I reassured Maud that Jane could remain in our home until she was ready to leave, either through marriage or employment.

Having lived in houses belonging to others since leaving home, Jonathan and I had to purchase furniture for the first time. We found a bed and a pair of nightstands, and a couple of chairs for the drawing room at a local shop and would buy more furniture when we had time.

One afternoon, shortly after moving in, Jonathan was in the kitchen, unpacking some of the crockery and glassware given to him by his father. Sifting through items in a large trunk used to transport miscellaneous items from London, I came across the Canaletto painting, still wrapped in brown paper and string. I took a knife from the kitchen and cut the string, and unwrapped the brown paper and sat with the painting on my lap, reading the accompanying note over and over again. I shed a few tears as I pondered upon the journey taken since the earl first showed it to me, recalling how he said I would never visit Venice. But I had stood upon the spot where Canaletto sat with his easel as he captured a moment forever.

Taking it into the kitchen, where Jonathan was washing a set of plates, I said, 'Will you help me find the best position for this in the drawing room?'

He put down the plate he was holding. 'I do not think it belongs there, my dear.'

'Where then do you think it should go?'

He took my hand and led me into the drawing room, gesturing for me to sit down. He took the chair opposite me, in front of the fireplace. I rested the painting on my lap and ran a hand over the gold swirls decorating the frame.

'Now is as good a time as any to tell you this, I suppose.'

'What is it?'

He ran a hand through his hair and inhaled, as if what he were about to divulge had been praying on his mind for some time.

'I am grateful to his lordship for treating me well as his employee. And for leaving me a generous sum which has allowed us to live here, and for me to own the business I dreamt of being mine for years. With regards to the painting…' He paused and leant forwards.

'Yes?'

'Philippa, this is difficult.'

'He gifted me this painting because of what I did for Edward.'

'That is true, but there was another reason.'

'What was it?'

'He loved you.'

'Jonathan, now you are being absurd.'

'Before leaving for Antigua, he informed me that on his return, he planned to divorce Lady Eliza and ask you to marry him.'

'Are you serious?'

'Indeed I am.'

Astounded, I did not know what to say. Once I would have been overjoyed to hear that the earl loved me and intended to make me his wife. Clearly a sensitive subject for Jonathan, and so treading carefully was paramount. He was my husband, and I loved him.

'Your revelation surprises me somewhat,' I said.

'Do you think he visited you in London all those times because of Edward?'

We had grown closer during that period, but having forgotten my initial infatuation, I had viewed him as a firm friend rather than anything more.

'He was making up for lost time with his son.'

'The earl was pleased to see Edward, to be sure, but it was you he especially wanted to spend time with. Do you think men of his lordship's ilk are that interested in their illegitimate offspring?'

'You should not talk about Edward in that way.'

'I am merely trying to prove my point.' Jonathan loved Edward as he would a son of his own, and I knew he did not mean any harm with the words used. 'Philippa, if I ask you a question, will you give me an honest answer?'

Taking a handkerchief out of the pocket of my dress, I brushed a speck of dust off one of the gold swirls on the frame.

'All right.'

'If he had returned, and proposed, what would you have said?'

Shaking my head, it struck me what this was about. Jonathan was under the impression that I had settled for him because the earl hadn't returned from Antigua. Did he really think I would marry a man who, despite his charm and good looks could be shallow and spoilt and would never commit to being with one woman? Did Jonathan really think I would choose Earl Rupert over the man I truly loved? A man who was handsome in a less obvious way than the earl, but who was kind and caring, and who I could converse with for hours on the same level without becoming bored.

'Oh, Jonathan, how could you possibly think that I would have said yes?'

'He was one of the most eligible men in England, and he could provide for you.'

'As you are doing.'

'Not to the same extent.'

'I loved you all along, but it took time for me to realise that. There is no doubt that I would absolutely have declined his offer.'

'That is comforting to hear.'

Refolding the brown paper around the painting, I said, 'My dear husband, I think it is best if we put this painting out of sight for its mere presence clearly upsets you, understandably.' I retied the string around the package.

'You would be prepared to do that for me, despite its beauty?'

'It can go in the attic along with some other items that do not need to be in the house on a daily basis. Perhaps in a year or two, you might feel differently, and we can bring it back down.'

We stood up and embraced, and he kissed me gently on the lips, squeezing me to him.

'I love you, my precious Philippa.'

'And I love you.'

The following afternoon, Maud helped me carry the oak trunk given to me by Lady Cordelia up the narrow staircase leading to the attic. The previous occupants had used this excuse of a room as a bedchamber for a housemaid who must have been freezing cold during winter months. The floorboards did not cover the whole attic, and it seemed as though someone had been in the middle of nailing down more planks but abandoned the idea with some of them in a pile by the door. We took two of these planks and rested them across two beams in the far corner, placing the

trunk upon them. I concealed the painting behind the trunk, so there was no way Jonathan would come across it by accident when putting things in the attic. He did not need to be reminded of the earl's apparent love for me.

Chapter Forty-Five

Jake pulled up outside Ivy Cottage and lifted my suitcase out of the car.

'Do you want to come over later?' he said.

'Okay.'

He leant over and kissed me on the mouth, and I put my arms around his neck and we snogged right there in Sidney Road without a care in the world. After detaching myself, I pulled up the handle on my case and wheeled it down the path.

'Come over at seven,' he said as he got back into the car.

He drove off and, beaming from ear to ear, I went inside to find Mum in the kitchen.

'How was Venice, darling?'

'Wonderful.'

'So, are you and Jake an item then?'

'He said he loved me.'

'Really?'

I nodded.

'Don't let him mess you about, will you?'

'Don't worry, I won't.'

'Your Uncle Pete called here earlier when he couldn't get hold of you.'

'My phone's been on flight mode this afternoon.'

'Call him back now. He said leaving a message wouldn't do what he had to say any justice.'

I did as she said and he answered straight away.

'Rachel, I've found the information you wanted.'

'Really?'

'Me and the genealogist have completed our family tree on my and your mum's father's side all the way back to Philippa.'

'That's great, Uncle Pete. What did you find?'

'Philippa did indeed live at Ivy Cottage with her husband, Jonathan Rogers and sons, Edward, James and George. Because we had her surname as Giles, it took a bit of time to find the connection between her and the house. She and Jonathan moved there in 1782 and he bought the tailor's business, naming it Rogers and Son, passing it down the family until Gran sold it after your grandad died. At some stage, it was passed to a daughter and her husband, hence the reason our surname is Brown rather than Rogers. I assume Philippa put the painting in the loft with the note, for whatever reason, I don't know,' Uncle Pete said.

At last, I hoped to have all the information needed for Pimsy's to proceed.

'Thank you, Uncle Pete for all you've done.'

'It's my pleasure, Rachel, but wait. There's more.'

'Oh really?'

'In case you're interested, we managed to get hold of a copy of some old plans for Ivy Cottage, and where my old bedroom was, now your spare room, I think, there was a narrow staircase leading up to the loft. They referred to it as an attic back then and the genealogist says servants might have slept there. I guess the

394

staircase was removed at a later date to make the fourth bedroom bigger.'

'That explains why the spare room is an unusual shape with the extra bit in the corner, and the plastering looks as though it's out of sync with the rest of the wall.'

'Yes, and one last piece of information that you might like to know.'

'What's that?'

'Philippa is actually our ancestor.'

'What? Well, that's exciting.'

'We are descended from James, the middle child. He inherited the tailor's business instead of Edward, who joined the navy.'

'So, we aren't descended from the earl then.'

'No, sorry to disappoint you, Rachel.'

'It's still great to know we have that connection to Philippa, that the painting was given to her and we descended from her son.'

'So, I'll email you copies of all the documents as a PDF, and you can send them to the auction house. That's what you wanted, isn't it?'

'Yes, thank you. I'll need to pass the information on to Pimsy's and they'll be in a position to go ahead and auction the painting once it's been added to the catalogue for Canaletto's work, as long as there are no issues with that.'

'Hopefully, this will give them all they need relating to provenance.'

'I hope so, Uncle Pete. Thanks again.'

After hanging up, I told Mum everything.

'This is fantastic,' she said, doing a happy dance around the kitchen as if she was Chandler from *Friends*.

'Don't do your back in, Mum.' She rolled her eyes, and I joined her, and we properly laughed together for the first time in ages. Anyone watching would have seen pure joy on our faces.

'And to think I always deleted those My Lineage website emails thinking they were a waste of time,' she said.

'What shall we do to celebrate?' I said.

'Why don't you go and buy a bottle of prosecco.' Mum handed me a tenner out of the kitty.

While walking to the corner shop, I mulled over everything Uncle Pete had told me. I thought about how Philippa's life would have been so different from mine because of when she was born. Women of my generation still had a long way to go in terms of lots of things, but I certainly had more choices than she'd had. In the end, she'd married Jonathan Rogers, and presumably led a happy life with him, but still, why did she put the Canaletto in her attic?

The day of the auction at Pimsy's arrived and I attended with Mum and Jake. Uncle Pete was in Italy, visiting marble quarries at Carrara but wished us luck. It was the first time Mum had seen the painting in real life. Although she'd seen a photo, I hadn't managed to get her to the gallery before Jake and I took it to Pimsy's. As we studied the Canaletto up close before the auction, she squeezed my arm.

'It's magnificent, Rachel. Can you believe that masterpiece was in our loft all those years?'

'Isn't it ridiculous?' I said.

'And if you hadn't found it, we wouldn't have met,' Jake said.

'You just treat my daughter well,' Mum said, throwing him a stern look, but then she smiled. They'd met a few times and she

thought he was wonderful, but liked to tease him every now and again.

'I will, Mrs Brown, don't you worry,' he said, putting an arm around me and kissing me on the cheek.

He was now my boyfriend, but we'd agreed to take it slowly. The painting sold for £1.5m to The Pelican Gallery in Mayfair and Randolph said he would do his best to arrange for the painting to be loaned to Chipford Hall for the autumn exhibition I was working on with Daphne. Mum, Uncle Pete and I had already agreed to split money from the sale three ways, leaving me with a very welcome £420,000, after fees had been paid. It was difficult to contain my excitement while registering I'd have enough money to buy the dilapidated terraced cottage and do it up. Mum would be able to clear her debts and she planned to set up her own yoga studio. Uncle Pete wanted to give his sons deposits so they could buy their own flats. We were all very lucky indeed.

I arranged to look round the terraced cottage in Chipford and from the outside, paint peeling on the windowsills and an overgrown front garden didn't faze me. A neglected rose bush grew up the wall, and I imagined how it would look when brought to life with an abundance of pink flowers by the entrance. Once the faded limp petals had been removed, it had real potential. Inside, there were two bedrooms upstairs, a living room and kitchen/diner downstairs with a south-facing terrace at the back with room for a table and chairs and a few pots of flowers.

'I'll take it,' I said to the estate agent.

As the house was empty, and with me being a cash buyer, it only took six weeks to go through.

Jake helped me to move in one afternoon, and we carried the trunk from Mum's loft into the living room. She'd been more than happy for me to take it to use as a coffee table. He carried on unloading the car, but I couldn't resist opening the trunk, and taking the clothes out of it. I opened the window due to their musty smell and then studied the dresses, underskirts, a corset. What stood out the most was a beautiful cream dress with short sleeves and a collar made from lace. All of this presumably belonged to Philippa, and I spent some time admiring the items of clothing before placing them to one side. Members of staff at Chipford Hall often wore period costumes, especially at Christmas and I was sure Daphne would love to have these clothes for the dressing-up room.

Grabbing a dry cloth from the box of cleaning items I'd nicked from Mum's cupboard under the kitchen sink, I gave the inside of the trunk a dusting thinking it would be great for storing board games. Something sharp caught the side of my hand, and there was a clicking sound. Peering inside, using the torch from my phone, I spotted a latch and twisted it, and the base of the trunk clicked open. I lifted what appeared to be a false bottom to reveal a secret compartment.

There lay a brown leather book, along with a pile of letters, addressed to Philippa Elliott at a *convento* in Venice as well as at a *pensione*, and there were two addresses in London with the name changed to Philippa Giles. I picked up the book and held it to my nose to inhale its earthy sweet scent. A piece of paper fell out, and I unfolded it. The agreement to match the one Lady Cordelia had, seen in the glass case at Heybury House. Jake was carrying a box upstairs, and I called out to him.

'Jake, you have to see all this.'

I flicked through pages of beautiful cursive handwriting, the letter 's' looking like an 'f' like in the earl's journal and in his note. There was a purple flower pressed between two of the pages, and it was labelled as 'A keepsake, found by a stream at the Mount Cenis pass.' The name, Philippa Elliott was written inside the front cover. It was Philippa's actual journal. At last, I had a window into her world.

'What is it?' Jake said.

'I found lots of things belonging to Philippa, and this is her journal. Can you believe it?'

'What, really?' I explained about the secret compartment, and he sat down. 'Tell me, what does it say?'

'Lots about the journey to Venice. It was given to her as a present by Jonathan before she left.' I read what she'd written on the last page.

5 November 1782

I have been on quite a journey since Jonathan gave me this journal as a gift. But somehow, it has all worked out. We are married, and happy, and I foresee us having a good life together. Soon, I hope we shall have children of our own, although Edward will always be treated as if he were ours. When he is eighteen, we shall tell him about his parents as he would want to know where he came from. Now, I am placing this journal in the attic along with some letters, the agreement, clothes from Venice, and the dress worn on my wedding day. Jonathan cannot bear to have the Canaletto in the house because it reminds him of Earl Rupert's apparent love for me, and so it shall remain concealed behind this trunk until I can persuade him to change his mind. It is a pity to keep such a beautiful painting hidden away, but there you are.

I am grateful to have gone from being on the verge of destitution when Papa died to finding a husband who loves me with all his heart. And I love him more than words can say. When I first moved into Chipford Hall, who would have thought this life was possible for me?

I wanted to read the journal from beginning to end, along with the letters before passing them to Chipford Hall for the exhibition. Daphne would be delighted with this discovery, as I was. These items completed the story of the painting, the last piece of the puzzle.

When we'd finished unloading the car, we opened a bottle of champagne, and clinked glasses.

'To new beginnings,' Jake said.

'Yes, to us,' I said.

He moved to put his flute on the trunk.

'No, we have to use coasters,' I said, suddenly all house-proud.

'Do you have any?' he said.

I shook my head, and unwrapped some newspaper from around a vase in a nearby box.

'We'll use this for now,' I said, placing it on the trunk.

He rolled his eyes, and we laughed, putting down our flutes, and he leant forwards to kiss me. There was a lot of building work to be done, and I'd have to stay at Jake's flat when it got too much, but I had moved into a house that I owned, and felt very fortunate.

While preparing for the exhibition at Chipford Hall, I received a notification from the ATP website about an archivist role and applied. And with encouragement from Daphne, I submitted an

idea for a biography of Earl Rupert to the ATP's publisher. I prepared a synopsis, first three chapters and an outline, accompanied by a letter telling the story of the Canaletto, and hoped for the best.

The day before the opening of the exhibition in September, I spent the day in the drawing room with Daphne, where the Canaletto was hung above the fireplace. Fires were not lit in the hearth so there was no risk of damage. We set up a stand with giant printouts telling the story of the painting and there was a blown-up photo of its companion. Earl Rupert's portrait had been moved from the Grand Hall and hung beside the one of Lady Cordelia by Massimo Collina, loaned from Heybury House.

After reading Philippa's journal, I started to search for her portrait by Collina, and hoped to find it one day. Uncle Pete was giving me a hand, as he missed doing the family tree research, and like me, he wanted to know what our ancestor looked like.

A few weeks after the exhibition, I got a kitten from Cats Protection and called him Max. He was beautiful, with green eyes and I liked having him around as a companion when writing. Jake continued to organise exhibitions and talks at Chipford Art Gallery with me doing the publicity and his sales increased by a huge amount, meaning he was in a position to renew the lease. After an interview with Mike's superiors, I was offered the role of archivist at Chipford Hall and not long after that, I received an email from the ATP's publisher, offering me a book deal and they proposed I call it, *Finding Canaletto*. Thinking back to what a mess my life was in the day I found the painting, it struck me that the discovery had been a catalyst for me finally getting my act together. At long last.

Acknowledgements

Thank you for helping to make this book happen:

Editor: Lorraine Mace for the exceptional structural edit which helped me get The Venice Secret where I wanted it to be plot-wise. **And to proofreader: Evelyn Ryle** who took The Venice Secret to the next level with her outstanding knowledge of grammar, punctuation, eighteenth century history and hereditary titles.

Cover Designer: Cathy Helms at Avalon Graphics who has designed an absolutely stunning cover for The Venice Secret. **And to website designer: Anne Ricciardi** who designed anitachapman.com beautifully.

Blog tour organiser: Anne Cater for organising the most fabulous tour, and to the book bloggers who have kindly taken the time to read The Venice Secret and leave reviews. **And to cover reveal organiser: Rachel Gilbey of Rachel's Random Resources**, and to the book bloggers who made such a lot of social media noise on cover reveal day.

Author quotes: Nicola Cornick, Celia Rees, Jenni Keer, Christina Courtenay, Jules Wake aka Julie Caplin, Angela Petch, Sue Moorcroft, Donna Ashcroft, Clare Marchant, Liz Fenwick for taking the time to read an advance copy of The Venice Secret and to write lovely quotes for me to use.

Research:

Mark Poltimore at Sotheby's for taking the time to answer questions in person about how you'd go about proving a painting found in your loft was an original Canaletto. This conversation helped me get the story going in the right direction during earlier drafts. And to Charlie Smith for putting me in touch with Mark. **And to Mark Harvey at Hatchlands Park** who emailed me copies of the house story display posters. Fanny Boscawen, a bluestocking lived at Hatchlands Park in the eighteenth century and I found information about her helpful when developing the character of Lady Cordelia.

Jules Wake, Donna Ashcroft and Liz Cooper for your friendship and fabulous company over the years. **And to Ian Skillicorn, Katrina Power and Alison Morton** for your friendship and generous advice. **Laurence O'Bryan** at Books Go Social for being exceptionally helpful. **And to my social media followers and supporters:** on Twitter, Facebook, Instagram and TikTok.

To my late mother: who took me to country houses and art galleries from an early age, including to The National Gallery in London to see the Canalettos. Her love of Italy, art, history, books and writing all contributed to the production of this novel. **And to my father:** who has always inspired me with his can-do approach to life and who drove us to Italy via the Great St Bernard Pass almost every summer on our own version of the Grand Tour when I was growing up. **To my husband and two children**: Thank you for supporting me with my writing. I promise I won't talk about structural edits, cover design, formatting etc for a while (not until the next book, anyway).

Research Books

Here follow a few books that you might be interested in reading if you enjoyed The Venice Secret. There are more, but these are the main ones I used for research and inspiration.

Non-fiction:

Observations and Reflections Made in the Course of a Journey through France, Italy and Germany Volumes 1 and 2 by Hester Lynch Piozzi

Autobiography, Letters and Literary Remains of Mrs Piozzi (Thrale) (2nd Ed) (2 vols)

Ladies of the Grand Tour by Brian Dolan

The British Abroad: The Grand Tour in the Eighteenth Century by Jeremy Black

High Society in the Regency Period 1788-1830 by Venetia Murray

Her Ladyship's Guide to the British Season by Caroline Taggart

Boswell on the Grand Tour: Italy, Corsica and France 1765-1766 edited by Frank Brady and Frederick A Pottle

A Governess in the Age of Jane Austen: The Journals and Letters of Agnes Porter edited by Joanna Martin

Behind Closed Doors: At Home in Georgian England by Amanda Vickery

Fashion in Focus 1600-2009 by Grace Evans

The English Country House: A Grand Tour by Gervase Jackson-Stops and James Pipkin

The Art of Dining: A History of Cooking and Eating by Sara Paston-Williams

Canaletto by J.G. Links

Novels:

A Room with a View by E.M. Forster

Where Angels Fear to Tread by E.M. Forster

The Remains of the Day by Kazuo Ishiguro

Jane Eyre by Charlotte Brontë

About the Author

Anita Chapman enjoyed writing stories from a young age, and won a local writing competition when she was nine years old. Encouraged by this, she typed up a series of stories about a mouse on her mum's typewriter and sent them to Ladybird. She received a polite rejection letter, her first. Many of Anita's summers growing up were spent with her family driving to Italy, and she went on to study French and Italian at university. As part of her degree, Anita lived in Siena for several months where she studied and au paired, and she spent a lot of time travelling around Italy in her twenties.

Anita likes to read journals and diaries from the past, and one of her favourite pastimes is visiting art galleries and country houses. Her first published novel, The Venice Secret is inspired by her mother taking her to see the Canalettos at The National Gallery in London as a child. Since 2015, Anita has worked as a social media manager, training authors on social media, and helping to promote their books. She's run several courses in London and York, and has worked as a tutor at Richmond and Hillcroft Adult Community College.

Find Anita's website at anitachapman.com and she is on social media at the accounts below:

facebook.com/neetschapman

twitter.com/neetschapman

instagram.com/neetschapman

tiktok.com/@neetschapman

Made in the USA
Monee, IL
21 September 2023

43142538R00246